Additional praise for *Practicing Mortality*

"Lyric, poignant, thoughtful, and lucid, *Practicing Mortality* is a masterpiece of the contemplative life. Here, philosophy, art history, hermeneutics, seeing, sensing, thinking, reflection, prayer, wonder, listening, loving and recollection breathe as a unified cosmos, and do so amidst the lanes and forests of rural New England. With quiet, beauty-filled humility, and in a seamless blending of voices that rarely occurs, Professors Ziegler and Dustin, art historian and philosopher, return pedagogy to a creative, religious significance and substance that is at once deepening and liberating. The architecture of the book is splendid; in essentially a dozen sections, the authors ask (from a world of different and over-lapping vantage points): What does it mean to be fully human? Their replies come from lives richly tested and nuanced. They include their own discoveries, while embracing and embodying relationships with such diverse luminaries as Emerson, Heidegger, Sloane, Plato, Kakuzo, Socrates, Pieper, and Thoreau. As the voices emerge, addressing self, nature, place, people, craft, practice, garden, vision, body, culture, tea, form, conduct, beauty, vanity, ritual, intimacy, justice, dwelling, the soul, the divine and the world, the reader is invited to enter a transformative depth, based on remembering or recollecting; in this way, life and liturgy become one. The reading journey carries with it a calm that restores hope in a time of chaos. This contemplative seeing which our authors espouse requires no journey to exotic places, 'only' to the matters directly in our hands and at our fingertips. Ziegler and Dustin's way of beholding re-unites the active and contemplative life, exposes intellectual materialism, and returns beauty to her original, royal, servant/leader status. The chorus thus assembled in this wonderful volume constitutes a practical recovery of intuitive vision and contemplative beholding that is second to none. I recommend this book to everyone, regardless of profession, age, stature, religious identity. That it will be a tremendous asset in all humanities classrooms should come as no surprise, but it is my hope that *Practicing Mortality* will also find its way into every nursing and medical school curriculum in the country, for the culture of medicine would itself be healed by contemplative seeing. If you are at all concerned with the inner life and the ultimate dimensions of the human-making curriculum, this book renews body and soul. Thoroughly American, fully grounded, highly textured, radical in its candor, confident and peace-filled, *Practicing Mortality* is sure to become a spiritual classic: read, re-read, and read again by everyone who enters its world."

—Therese Schroeder-Sheker, Chalice of Repose Project and
The Catholic University of America

Practicing Mortality:
Art, Philosophy, and Contemplative Seeing

Christopher A. Dustin
and
Joanna E. Ziegler

First published in 2005 by
PALGRAVE MACMILLAN™
175 Fifth Avenue, New York, N.Y. 10010 and
Houndmills, Basingstoke, Hampshire, England RG21 6XS
Companies and representatives throughout the world.

PALGRAVE MACMILLAN is the global academic imprint of the Palgrave Macmillan division of St. Martin's Press, LLC and of Palgrave Macmillan Ltd. Macmillan® is a registered trademark in the United States, United Kingdom and other countries. Palgrave is a registered trademark in the European Union and other countries.

Library of Congress Cataloging-in-Publication Data is available from the Library of Congress.

ISBN 1–4039–6591–9

A catalogue record for this book is available from the British Library.

Design by Newgen Imaging Systems (P) Ltd., Chennai, India.

First edition: March 2005

10 9 8 7 6 5 4 3 2 1

Printed in the United States of America.

For Joe, Trisha, and Abigail

CONTENTS

PREFACE

Education is the ability to listen to almost anything without losing your temper or your self-confidence.

—Robert Frost, *Collected Poems,
Prose and Plays*

The book you are about to read has been written by two teacher–scholars who have fallen in love with the possibility that "real seeing"—contemplative seeing, as we call it in the pages that follow—can somehow help us lead fuller lives. This is a philosophical claim, but one that encompasses art as well because it assumes a practiced sense of sight.

We did not begin our explorations with this claim. Rather, we began by wondering what philosophy can learn from art and how art may be philosophical. We did this wondering in the classroom with college students, and between ourselves. We came to realize that contemplative seeing is the foundation for both disciplines—philosophy and art history. We also discovered (and in some cases rediscovered) writers and artists for whom the "doing" of philosophy or the "making" of art is, fundamentally, an exercise in contemplative seeing. Despite the differences between them, the point of the exercise remained essentially the same. For these seers and thinkers, the practice of art or philosophy seemed inseparable from the practice of being alive. We have come to discover that this is the reason we do these things, too. We see these activities as constituting and shaping a full and well-lived life. This discovery led to the writing of this book.

Some truly unexpected ideas came to light during our teaching and thinking—wonderful ideas, but somewhat inconsistent with today's academic practices. While art and philosophy have always been inseparable for us, in a way that distinguishes our work from other interdisciplinary approaches, our intellectual self-confidence remained largely confined to those areas. It was in these areas, after all, that we were "schooled." In tracing these pursuits back to their common root, however, it seemed unavoidable that issues defined in terms of "religion," or spirituality, would have to be addressed. We are both frankly surprised to find ourselves led in this direction though we ought to have seen it coming. After all, many writers and artists who concern themselves with the core issues of human life are

also concerned with the source and ultimate meaning of that life—something most often understood in religious terms. The questions that arose, as we wondered about art and philosophy, forced us to look not so much beyond as ever more deeply into their, and our, ultimate source. To sound out these fundamental issues, we, too, took up this concern.

This has been an exhilarating, if risky, pursuit. Whenever we look for (or at) the core of reality and human life, we are dealing with fundamentals—a kind of thinking about which our Postmodern academic culture has serious reservations.[1] Current scholarship and Postmodern theory have abandoned altogether the pursuit of fundamentals, or essences, because of their perceived problematical role in marginalizing women and "others." In former times, scholars used to generate "objective" criteria—fundamentals, that is to say—on the basis of which to include or exclude accomplishments. Nowhere has this perspective been more vigorously criticized than in the history of the arts, where the so-called canon has been being scrutinized and revised zealously for well over a decade now.[2] So for us to look, long and hard, at fundamental values may seem to people—mostly academics, we suspect—to be conservative, nostalgic, or just plain wanting in intellectual rigor. We have tried throughout, then, to address the matter of fundamental values thoughtfully and seriously.

As academics we naturally hope that our peers will read this book, but we also hope it will speak to a broader, interested readership. Writing to a diverse audience has its own challenge for the general reader may find the book too scholarly, while the scholarly reader may find it too unspecialized. We believe, however, that contemplative seeing and living well have consequences for both groups of readers, but each must proceed willingly and patiently. The authors have deliberately crossed a number of fields and boundaries searching for effective ways to articulate these consequences—from philosophical garden writing to ancient philosophy to Americana to Abstract Expressionism. Alerted to this from the outset, readers may find themselves open to the sorts of ideas that have arisen because of our own welcoming of the unexpected.

Our sense, from teaching and reading, is that the best approach to these ideas is to provide readers the opportunity to experience the ideas for themselves. We thus provide occasions for this by narrating our own experience in ways we believe will open possibilities for readers to encounter what we have, and enact it on their own. In other words, we do not "study" or "analyze" the authors and artists included in this book; rather, we read and look at them contemplatively, approaching them as the repository of the very sort of experience that this book seeks to illuminate.[3]

The texts we cover, then, are works of art and we approach them as such. They are not storehouses of data but possibilities for contemplative seeing. We want our readers to participate in the performance of an artistic event, a well-made thing as we call it later on. The beauty of ideas, the willful, sometimes wandering, paths these texts take, frequently diverging from clarity into mystery, all of this artistry and craft we hope readers can experience for themselves with us as guides.

A few things to consider, then. We had to have intimate knowledge, long exposure, and deep experience with the texts to perform this task well. Our texts may seem to be overly localized, focusing too much on New England to be able to speak to readers living elsewhere. But, this is because New England is where *we* live and work, and writings about the place come most easily to us as occasions for intimacy and familiarity. It is thus the case that much of our reading centers on woodcraft and the changing of the seasons that are particular to the Northeast. But, particularity is precisely the point. You will soon learn that without an intimate connection to what is "particular," be it in forms or places, the very notion of contemplative seeing loses its substance. How else, then, to talk about and experience the particular than by talking about particulars themselves? Our focus on New England, on woodcraft, and the seasons is intended to act as a *particular* example of how to see contemplatively, rather than a template to be applied universally.

In this way, although *Practicing Mortality* speaks about living (and even offers ways to conceive of living well and fully), it differs very much from the standard self-help literature available today. We have avoided anything that resembles formulae or easy recipes for living. Rather, we engage fundamental values—the sorts that shape a well-lived life—directly and experientially through the act of reading, conceiving the writings as genuine craft, as authentic works of art.

In the classroom, we often read aloud lengthy passages with our students, returning to particular portions time and again, saying "look, notice!" and "now, look again." We do this here by citing extensive passages, keeping them intact whenever possible, performing close reading with (rather than to) you, not in order to substantiate a point but to provide a certain element of the contemplative experience. We are literally demonstrating our point, not just arguing for it.[4] To bring the life of the classroom—where we have lectured in the traditional sense, as a performance, as a sort of craft itself— to a text to be read silently—this is what we hope to achieve.

<div align="right">

CHRISTOPHER A. DUSTIN AND JOANNA E. ZIEGLER
College of the Holy Cross
Memorial Day, 2004

</div>

ACKNOWLEDGMENTS

The chapters that make up this book are based, in large part, on lectures delivered in courses we were privileged to teach together, including: *The Philosophy of Architecture, Art and Philosophy in Everyday Life*, and a College Honors course on *Human Nature* (which we enjoyed teaching with Professor Robert Garvey). We would like to thank Stephen Ainlay, Vice President for Academic Affairs and Dean of the College of the Holy Cross, for supporting us in this collaborative work. We would also like to thank our students for their engagement, their questions, and their insights. Individual students have contributed to the project in unique ways, David Gyscek and Melissa Ivers among them. Nancy Burns deserves a special mention for having suggested the use of *The Book of Tea* in an introductory art history course.

Holy Cross generously provided the two of us with Faculty Fellowships for the Fall semester of 2003. This gave us the time we needed to complete the writing of this book. The Committee on Fellowships, Research and Publication also awarded us a grant to help cover the cost of permissions and illustrations. We also wish to acknowledge the support of The Center for Contemplative Mind in Society.

We are grateful to the following individuals who have read portions of the manuscript or discussed our ideas with us: Marcia Brennan, Robert Cording, Mark Freeman, Joseph Lawrence, Judith McQuade, Joanne Pierce, Denise Schaeffer, Therese Schroeder-Sheker, Janne Siren, Janice Sioui, and Mrs. Eric Sloane. We have benefited from their comments and encouragement. Beth Johns, James Kee, Bruce Morrill, S.J., and William Reiser, S.J. were especially supportive of the project from its conception.

Lisa Dunn gave generously of her time to assist in editing the penultimate draft. Both her editorial recommendations and her substantive comments were enormously helpful. Eleanor Binnall, Slide Librarian at the College of the Holy Cross, provided valuable assistance in researching and acquiring permissions for the illustrations. Faye Caouette, Secretary for the Department of Visual Arts, helped in ways too numerous to mention. Margaret Nelson, Media Lab Supervisor and Educational Technology Support with ITS, assisted with the preparation of the text and illustrations.

Debby Aframe, Director of the Worcester Art Museum Library, and Jennifer Clarke, Assistant Curator of Prints and Drawings at The Art Institute of Chicago, helped us locate a number of objects for the illustrations.

We are grateful to Amanda Johnson, Associate Editor at Palgrave Macmillan, for her enthusiasm and support for this project. We have also to thank Erica Buswell for helping with the Index.

Finally, our heartfelt appreciation goes to Joe Vecchione, Patricia, and Abigail Dustin—indispensable partners in the practice of contemplative seeing and living. We have learned more from them than they, or we, realize.

ILLUSTRATION CREDITS

Plate 1 Door and Latch, southern New England, early nineteenth century. Author's photo

Plate 2 Pottery bowl by Ann Newbury, Cape Cod, Massachusetts, 2003 (collection of the author). Author's photo

Plate 3 Temple at Paestum, late fifth century B.C. Author's photo

Plate 4 Chapel (*Saal*), The Cloister, Ephrata, Pennsylvania, eighteenth century. Author's photo

Plate 5 Eric Sloane, "The Old Barn," from *A Reverence for Wood*, 1965. Courtesy of Mrs. Eric Sloane

Plate 6 *Trencher and Paddle*, wood, Blackstone Valley, Massachusetts, date unknown (collection of the author). Author's photo

Plate 7 *Cathedral of Saint-Etienne*, Bourges, France, 1195–1214. Author's photo

Plate 8 George Hanners, *Mug*, silver, ca. 1720 (Worcester Art Museum). Courtesy of the Worcester Art Museum

Plate 9 Woods near Concord, Massachusetts. Author's photo

Plate 10 Robert Motherwell, *Beside the Sea #34*, oil on paper, 1962 (The Art Institute of Chicago). Courtesy of The Art Institute of Chicago

Plate 11 John Singleton Copley, *Paul Revere*, 1768 (Museum of Fine Arts, Boston). Courtesy of the Museum of Fine Arts, Boston

INTRODUCTION

What It Means to See

In his remarkable book *Only the Lover Sings: Art and Contemplation*, Josef Pieper laments:

> Man's ability to see is in decline. Those who nowadays concern themselves with culture and education will experience this fact again and again. We do not mean here . . . the physiological sensitivity of the human eye. We mean the spiritual capacity to perceive the visible reality as it truly is.[1]

Understanding the kind of vision to which Pieper alludes is the central concern of *Practicing Mortality*. Like Pieper, the authors of this book believe that living is deeply entwined with seeing (as distinct from simply looking), that is to say, seeing contemplatively and with full awareness.

This is a genuinely collaborative undertaking between an art historian and a philosopher, rather than two separate treatises clothed as one, in which art is indentured to philosophy or the other way around. It comes from a decade of teaching together, and countless hours of conversation. Indeed, this book is, in large measure, a conversation on what we love about art and philosophy, and how that love has ineluctably become part of our own living.

We talk about how art and philosophy can help one live life more fully, each and every day. This may seem odd, or overly sentimental, to those who regard art and philosophy as occasional activities, at best. Art and philosophy are generally thought of as being quite separate from everyday life, as well as from each other. Art—so-called high Art, with a capital A—is usually set apart, in museums, often behind glass, or in upscale and rather forbidding galleries. It can frequently seem to be about things very few people understand or care about. Philosophy, meanwhile, is identified with the most abstruse and isolated of academic pursuits. With its abstract arguments and highly technical vocabulary, it, too, is seen as impractical and often irrelevant—as specialized as the art world seems to be. While philosophy

claims to address questions of importance to all of us, its own pretensions (or pretentiousness) sets it apart from the everyday cares and business of living in much the same way that the pretensions of "high Art" seem to do. Not only do art and philosophy seem to be isolated from "real" or "everyday" life, but also seem to be as separate from one another as thinking and feeling, experience and analysis have come to be.

The authors of this book see things differently. Although most people presume to know what real or everyday life is all about, without the help of art or philosophy, we question this presumption. There are many books, both academic and popular, that are concerned with the "art of living," or with the idea of philosophy as a way of life. Yet, for the most part, the writers of these works do not envision the act of reading the text as an occasion to work through and actually practice its content. One of the ambitions of our book is to provide that opportunity as a pattern (not a formula or prescription) for a life-fulfilling practice of contemplative seeing. Art and philosophy, as invoked here, are to be lived and not merely talked about. We make the case that art and philosophy are not at odds with daily life; they are, in fact, essential to life itself.

For us, the vital connection between art, philosophy, and life lies not in the application of a set of ideas but in the very act of seeing. In making our case, we are appealing to multiple audiences. Since our vocations place us, as Pieper contends, among "those who nowadays concern themselves with culture and education," students are at the center of our attention. We are fortunate to have taught in a liberal arts setting, with young undergraduate minds open to change and transformation. Because the work presented here was shaped by our own academic experience, we believe that teachers— that is, other academics—might also benefit from this book. In our view, its central theme bears directly on their work—work they should be doing, but are uncertain how to do. Contemplative seeing has wide-ranging implications for the development of pedagogical method in many disciplines. Focus, concentration, and awareness are vital to education itself, as well as to living fully. In addition to students and teachers, this book is addressed to a wide range of practicing and general readers. Craft and creativity are central to our thinking about art and philosophy. In our view, the practice of mortality and the practice of the arts are not simply analogous to one another, nor does the latter serve merely to supplement or ornament the former. This book tries to revive the sense in which they are fundamentally one and the same. In helping others discover life in art, we hope that artists themselves will find affirmation and renewal in, and perhaps learn something from, what we see in the activities that comprise their daily work. The arts we discuss include painting, architecture, and music (among others), but also such seemingly humble pursuits as gardening and even walking. While this book addresses what is often referred to as the "inner life," the authors also intend to show how attendance upon the "inner" presupposes an engagement with the world around us. By deepening our understanding of the practical dimension of contemplative practice, our work dovetails with that

of others who are concerned with similar approaches to spiritual direction. The recovery of the inner, we shall argue, requires faithful attention to and a certain kind of reverence for the "outer." The spirituality that comes to the fore here is coupled with a renewed sense of, and appreciation for, materiality—both our own and that of the world around us.

What, then, does it really mean to see? How does one begin to answer this question, or even to show that it needs to be raised? We have chosen to begin with Eric Sloane, who might be unfamiliar to some readers. Sloane (who lived from 1905 to 1985) was what used to be called an Americanist; that is, a student of Americana. Artist, illustrator, and writer, Sloane collected and observed material facts and objects reflective of the early American way of life. Buildings and tools were among his principal passions, as were weather and wood. His observations, descriptions, and illustrations of these everyday things, and of the lives they reflected and shaped, reveal both a keen physiological sensitivity *and* a profound spiritual capacity. They also display a full sense of humanity. Sloane was drawn to the endurance, attentiveness, and reverence that characterized the pioneer farmers of eighteenth- and early-nineteenth-century New England. While an unlikely source for art historical or philosophical research, he and his work have taught us a great deal about what it means to see.

In *Diary of an Early American Boy* (a historically based account of the everyday life of a boy named Noah, from the year 1805) Sloane observes:

> In modern times when everything a person needs may be bought in a store, there are very few hand-made things left. So we are robbed of that rare and wonderful satisfaction that comes with personal accomplishment. In Noah's time, nearly every single thing a person touched was the result of his own efforts. . . . This is why those people had an extraordinary awareness of life. It was this awareness of everything about them that made the life of early American people so full of inner satisfaction, so grateful for life and all that went with it. Nowadays modern conveniences allow us to be forgetful, and we easily become less aware of the wonders of life.[2]

Here, Sloane is not simply making a claim about history. His observation is grounded in his own historical awareness, but it is not simply an observation about the objective conditions of rural existence in 1805. It is an observation about the meaningfulness of that existence, and about where the source of that meaningfulness might ultimately be seen to lie.

What Sloane is recalling may look like a quaintly antique way of life. The academically minded would probably see it as a social construction—a fable at best, a mendacious fiction at worst. To see it in either of these ways is to miss the deeper point. This is not just an academic point about historically conditioned ways of life. It is a point about life itself, and what it could mean

to be fully human. In attributing an "extraordinary awareness" and "inner satisfaction" to otherwise ordinary people, Sloane hopes that we, too, might be made aware of something. He is recalling us to something he thinks we have forgotten—not just the facts of (early-nineteenth-century) life, but the *wonders* of life. To see the point would be to experience the inner satisfaction he describes. It would be to "realize" something, in both senses of the word. Sloane's aim, in writing about the things he does, is to foster this kind of realization. It is also the aim of the present book.

In the passage quoted above, Sloane explicitly differentiates between two ways of living. One is characterized by a vital and direct engagement with things. These include, in the first instance, humanly made things, objects of art, or craft, for which natural things and even nature itself are seen as providing the ultimate source. To look upon, work with, or "touch" a handmade thing is not just to see the results of one's own efforts, or a confirmation of one's power and control over nature. What Sloane calls the "rare and wonderful satisfaction" that issues from "personal accomplishment" extends beyond the merely personal, or even the merely human, to become an awareness of and gratitude "for life and *all* that went with it."

It is not just our technological abilities that provide us with this inner satisfaction. Technological production, as such, may instill a feeling of confidence or convenience, security, or self-reliance. But Sloane is not talking about mere *self*-satisfaction, about comfort or pride, or even about happiness (in the modern sense of the term). This is the deeper point of the contrast he makes between handmade things and what he calls modern conveniences.

When Sloane associates making things with a profound awareness of "the wonders of life," he is not describing an attitude in which we enjoy or exult only in what we have created or can make happen all by ourselves. What moved these early American people to wonder, what they were able to be grateful for, Sloane thinks, was not the means to a "better" life, but life itself. Sloane is describing an attitude of acknowledgment and of thanks— acknowledgment that what creates the need for these things is what ultimately provides for the satisfaction of those needs. He is describing a life that reflects the marvelous creatures that human beings are, in the sense not just that we ourselves are to be marveled at, but that we are capable of marveling at the world around us. It is our own creative activities that provide the occasion for this, but only to the extent that we can see these activities as a way of giving thanks for and acknowledging a gift that we do not simply give ourselves.

The creative activities to which Sloane refers are regular and routine. They are woven into everyday life. Day in and day out, these activities, and the life that is fashioned through them, enabled human beings to find contentment—which differs from convenience or comfort—and to experience wonder in a world that is never wholly free of sorrow or hardship but one that is wonder*ful* nonetheless. To put it in a way that anticipates the fundamental thesis of this book: art, or human creation, both

originates in and promises to yield a loving awareness of that which we ourselves do not make. It is this realization, if we are capable of it, that makes us fully human.

Regardless of what the current market in inspirational or self-improvement literature may suggest, a way of living cannot be reduced to a single formula. If we were to identify a single phrase that best captures the attitude Sloane is describing, however, it would be *the attitude of mortality*. This attitude is, fundamentally, a contemplative one—a way of being that is grounded in a way of seeing (the "extraordinary awareness" to which Sloane refers). It is also a fundamentally practical one; for this way of seeing is itself grounded in a kind of activity that is essentially different from what we commonly recognize as productivity or busy-ness. The latter is what characterizes the other way of living to which Sloane alludes with his talk of "modern times" and "conveniences." While it would be easy to describe this modern way of living as the opposite of the one Sloane wishes to celebrate, or as simply lacking the awareness that Sloane thinks early American people possessed, this, too, would miss the point.

Sloane would no doubt join those of us who lament a way of living that is characterized by a reckless, unthinking abuse of nature and of one another—one that all too often seems to involve the living of pointless lives. This is a way of living dominated by a way of *seeing* that regards nature—indeed regards everything, life itself and all that goes with it—as subject to control rather than a realm for which to be thankful.

Sloane's primary concern, however, is not that "modern conveniences" will make us more manipulative and violent (though that may indeed be the case). It is that they can make us less aware. His insight (the insight we develop in this book) is not just that there is something missing from our modern way of life despite the material abundance and security it provides; it is that our way of seeing can make us forgetful of that which we are no longer able to see. The problem is not that we are failing to live fully human lives, for how would one "prove" that? The real danger is that we are so easily allowed to forget what that could mean, where this forgetfulness is not simply the result of our short attention span or memory—after all, we can retain more "information" than ever before—but of our way of seeing and being in the world. We don't know what we're missing, and can't recognize it when it is right before our eyes.

As a way to explore this more profound, and more dangerous, form of forgetfulness, consider how we "moderns" might make sense of the way of seeing what Sloane is trying to recollect. The attitude of mortality, as we would describe it, is fundamentally contemplative, but also fundamentally practical. How can it be both? When we think of a contemplative attitude, after all, we tend to conceive of it as one that is spontaneously receptive and open, but essentially passive. We picture the meditative trance of the mystic, the speculative musing of the philosopher, or the rapt gaze of the nature-lover. To contemplate, in this sense, is to think or to see in a way that may be thoroughly immersed in a transcendent or metaphysical reality,

but is essentially detached from the concrete realities surrounding us. Philosophical contemplation is, perhaps, the paradigm for what is ordinarily conceived of as a purely "theoretical" *and essentially "impractical"* way of thinking about or observing things. The contemplative mystic, for example, is the common template of the religious person who lives an essentially solitary life in a cell, as opposed to the active life of the saint who goes out into the world and does not merely contemplate but *does* something.

If seeing and thinking are the opposite of "doing," in the way that theory is the opposite of practice and contemplation that of action, how are we to conceive of an attitude that is at once fundamentally contemplative and fundamentally practical? If we have difficulty conceiving of this, it is because we have forgotten what seeing, thinking, and practice themselves might mean, what they might involve, and how they essentially belong together. Or so we argue in this book. What follows, however, is not just an account of our failings. It is an exercise in recollecting that there is a kind of doing that is not simply a matter of producing results, or a means to an end; and that contemplative seeing could, in this sense, be the most deeply practical and the most fully human of human activities. That is, an attempt to remind us that "practical" does not simply mean "useful."

This is exactly what Sloane is getting at. He reminds us of the more fundamental sense in which art or craft is practical. Craft—as we shall see more clearly in Chapter Six: *Making* Kosmos *Visible*—is not simply a useful art, as carpentry or metalwork might seem to be when compared, say, to sculpture. Both are practical in the same fundamental way. They are *routinely practiced* and they *require practice.* This is what we intend to make clear about the way of living that Sloane describes, and which he explicitly contrasts with our own. He would not deny that modern conveniences are often genuinely beneficial for life, nor would we. The point is that, in being simply present and provided for us, on demand and in surplus, such conveniences are practical only in the narrow sense of being useful, at our disposal, and ultimately disposable. Our using them does not involve the deeper dimension of practice that our engagement with handmade things does. Though it may be an overly simplistic example, raising and milking one's own cows, animal or vegetable husbandry, requires practice, and is something one practices daily. Purchasing milk at the supermarket does not, however, require practice. It may be more practical in one sense, but is far less practical in this more fundamental sense.

The way of living Sloane describes is one that is characterized by an extraordinary awareness of life itself, by gratitude and inner satisfaction, one that is governed by routine and daily habit—that is, by daily practice. It is, at the same time, a profoundly contemplative way of life. It draws its sustenance from a capacity for wonder. We are unaccustomed to (and perhaps incapable of) thinking about wonder as something that is practiced, either as an activity that is performed regularly or as one that requires preparation and full-bodied participation. If we are unable to make sense of the "practicality" of contemplative seeing, it is because we have forgotten

how it is originally related to both art and craft, not simply in the way that these might produce useful results, but in the way that they themselves might be experienced as occasions for wonder and as sources of revelation. To remind ourselves of this would be to recover the awareness of our own mortality, the very thing our modern way of living seems designed to help us overcome. It would be to recollect—literally, to "regather"—our humanity.

All of this could easily be seen as just a nostalgic, contemporary view of modernity and its discontents. Sloane, after all, was writing in the mid-twentieth century. But the distinction he draws between a life filled with aesthetic and spiritual richness on the one hand, and an arid, perplexing, and often meaningless existence on the other was as familiar to the ancients as it is today.

The modern world is full of books that are critical of modernity. One difference between the present book and many of these others is that it is not a polemic. The way to recollect, or realize, the fullness of human reality is not, we believe, to identify the problems of modern life in the hope of somehow fixing them, or to diagnose the complaints of the modern condition in the hope of escaping from it. This is partly because our situation is too complex for that. Too many writers and thinkers have made us aware of the fundamental mistakes involved in attempting either to retreat from or to move beyond the modern condition—to resurrect a "pre-" or reconstruct a "post-" modern world. But if we choose not to proceed in a radically polemical way, it is primarily owing to the conviction that what we are attempting to recover is, in reality, nearer at hand than we think. That is why we have used, and will continue to use, the language of recollection and forgetting. This is not just a matter of phrasing. It is a matter of method: a method we believe is better suited to—and crafted in response to a deeper understanding of—the nature of the problem we face. The problem is not modern life as such, as if this were something one might hope to rid oneself of, like a head cold. To picture the problem this way is to forget that it is a problem we live, and not a problem we face objectively, in the way that we face problems with our cars or our plumbing. The problem, to say it again, is realizing what it means to be fully human, fully alive.

Though this book is not a polemic, it does present an argument. It is even contentious at times. This is to be expected, since we are contending with the very troubling problem of living in today's world. Our primary contention is that *we have allowed ourselves to become forgetful of our own mortality and of the need to "practice" it.* Having lost sight of this need, we have, in a sense, lost the ability. This is something that should be obvious with regard to art or craft (though it is becoming less obvious to some teachers and students). If one ceases to practice, or no longer recognizes the need to do so, whatever talent one had will cease to develop and may be lost. This book tries to demonstrate how and why it is also true with regard to contemplative seeing, and ultimately with regard to being human.

In wondering about what it could mean to practice mortality, about what this practice might concretely involve, we have spent considerable time with, and drawn insight and inspiration from, other writers and thinkers, as well as artists. In writing this book, we engage with and acknowledge them as sources, not in a narrowly documentary or merely academic sense, but in what we hope will prove to be a vital and viable way. Our initial reading of Eric Sloane, to whom we shall return more than once, may serve as an illustration of this. Similarly practical readings and interpretations are woven throughout this book. This is partly to demonstrate how reading and thinking can themselves be practiced in the way that a craft is practiced—not just by using texts to illustrate or support a point but revisiting them habitually. It is also because we believe that these particular writings can serve as vivid reminders of what contemplative seeing (and thinking and reading) is really all about.

We read philosophers, historians, art historians, essayists, and naturalists. We see a striking concurrence in the guidance they offer, even though they may be writing thousands of years apart from one another, in (or about) vastly different cultures, and to vastly different audiences. From Plato to Thoreau to Heidegger and beyond, we gather a family of thinkers who desire to live more fully, to be fulfilled in their daily existence, by seeing contemplatively and with such heightened awareness that all the senses are fully engaged; thinkers who see how the things we create may reflect, and recall the beholder to, a divine point of origin.

Essential to the understanding of practice that we put forward in this book is the notion (one that should be familiar enough to practicing artists and craftsmen) that repetition is progress, that one does not make progress simply as a "result" of doing something over and over again, but that the progress lies in the routine itself. The book is structured in such a way that it both exemplifies this point and provides the reader with an occasion to experience it. This is an experience that may frustrate some readers, as we find ourselves circling back to questions and ideas again and again. For instance, throughout these pages, we frequently return to Pieper's idea of perceiving "the visible reality as it truly is." We do so in the hope of progressively developing and deepening our understanding of this idea. Along the way, we hope also to inspire our readers to pursue for themselves what Pieper calls the "spiritual capacity" for such a seeing and living of their own lives. It is not simply the case that we have read these texts and now wish to explain and clarify them for our audience, presenting only the results of our research. We have tried to write this book in such a way that we read and engage with these sources actively and in the present tense, so that our readings and interpretations might unfold along with those of our own readers. We hope that our readers may be inspired to revisit these sources on their own, to see them (as Pieper would say) "with their own eyes."

Our thinking has taken root in ideas first conceived by ancient philosophers. When the pre-Socratic philosopher Anaxagoras was asked the question, "Why are you here on earth?" (an alternative translation might be,

"What is your purpose in living?") he replied, "To behold." What is it about the idea of "beholding" that could make it an understandable, let alone viable answer to a question such as this? How could "seeing" be so central to human fulfillment?

The beginnings of an answer can be sought not simply in how the Greeks defined these terms, but in how they were understood and experienced. This is where etymology can be of help to us. This is, of course, an extraordinarily complicated task, fraught with intellectual risk, and it is imperative that we reflect upon and try to gain as clear a sense as we can of the spirit in which we undertake it. We must ask ourselves what it could mean to return to the "original" meanings of words, or to forms of experience and understanding as they are expressed in ancient writings. The idea that ancient linguistic, as well as textual, sources can be recalled or recollected in a vitally illuminating and not just a documentary way, is fundamental to the argument of this book. We must confess, here at the outset, to a certain prejudice in our own philosophy of language. The search for word origins is not just a matter of researching and identifying meanings that were associated, as a matter of historical fact, with certain combinations of letters. The question of how words were "defined" is, in fact, a uniquely modern question—one that reflects a uniquely modern and practical (in the sense of useful) conception of the function of language.

Words must be used, whether they be written, spoken, or sung, before they can be defined. We do not simply call upon them to say what we have to say (this is the modern conception of language as a tool, or instrument). Words themselves are *called for*, one might say they are called forth, by basic forms of experience from which their meaning originates. This is what we are trying to recollect when we search for the original meanings of words. We are not just talking about what certain words used to mean. This would leave us open to the objection that they now mean something very different. The difference we would insist upon is one between not knowing what something once meant, and having forgotten what something originally means. More is at stake where the latter is concerned, and in this regard, we believe, a thoughtful return to ancient textual sources, one that is motivated by human as well as academic interests, can be of vital help to us today.

As an example, let us return to seeing. What could it mean to say, with Anaxagoras, that one's purpose in living is to behold? The phrase Anaxagoras actually used is *eis theorian*, a verbal form of the noun *theōria*, of which the Latin *contemplatio* was a translation. This is where our own "theory" comes from. It may seem appropriate, then, that contemplation would be understood, by us, as "theoretical." But what does *this* originally mean?[3] While *theōria* can and did mean "study," its original meaning is very different from the distinctly modern sense of theory as detached observation or analysis, where theory is opposed to practice. *Theōria* is originally derived from *thea*, outward appearance or show, as in "theatre," and *horaō*, to see or look at something, closely and attentively. With a view to its primary

meaning, *theōria* is best translated as "spectating" and *theōros* (theorist) as "spectator." But care must be taken in understanding the spectatorial attitude of the *theōros*. A *theōros* is someone who sees (or studies), but this seeing (or studying) does not imply detachment in the way that a theoretical stance is supposed to be detached. *Theōroi* were, most commonly, ambassadors to sacred festivals who *actively participated* in the spectacles they beheld by offering sacrifices, and by taking part in the dances and games that formed an integral part of the practice of divine worship.

To recall the original meaning of theory is to recall the original meaning of the human activity of theorizing, grounded as it is in the experience of *theōria*, not an object of detached observation or purely cognitive analysis, but a performative spectacle in which one takes part with one's body as well as one's mind, with one's senses and emotions as well as what we now conceive of as thoughts. The seeing that lies at the heart of *theōria* was active and experientially engaged. The *theōros* did not just examine. He was literally and figuratively moved by what he saw.

It should be emphasized that these spectacles were not purely visual, but that music and dance were essential components. And while, as a matter of historical fact, such spectacles usually took the form of religious festivals, *theōria* was understood as religious in a more profound sense. The Greek *theá* (with the accent on the second syllable) also means goddess: the *thea* of theatre can also be read as the *thea* of "theology." Ancient etymologists tended to assume that this was the real root of *theōria*, and that a *theōros* was someone who performed service to, or cared for, a god (*ōra* means "care"). In this sense, the *theōros* not only attended a religious festival. He attended the divinity whom the festival celebrated.

Modern linguists tend to reject these ancient readings. But if we bear in mind that accents were not introduced into the Greek language until the third century B.C., and that their introduction may not so much reflect as effect a differentiation between elements of meaning that were experienced as belonging together, we do better if we understand the root of *theōria* as being both divine and spectacular, and to understand theory as originating in a seeing that was itself a form of worship. Martin Heidegger's reading of *theōria* as a "reverent paying heed to the unconcealment of what presences" recalls us to this more original meaning, and to the experience that underlies it.[4]

The ability not simply to examine or explain, but to gaze attentively upon, to dwell with, the outward appearances in which "the core of all things, the hidden, ultimate reason of the living universe, the divine foundation of all that is" is made visible, is what Pieper means by contemplative activity.[5] When he says, "to contemplate means first of all to *see*," he means that all genuine theorizing is, fundamentally, an experiencing of the divine. It is a beholding in which one participates fully in what one sees. By harboring mystery, such spectacles move us to wonder. It may be worth noting here that the ancient sources often use *theōros* to refer to a person who travels to a sacred place to consult an oracle. Oracular sayings are not

simply informative. They are revelatory, but also notoriously obscure. The wonder to which they give rise is inseparable from the illumination they promise.

Another ancient source enables us to trace what may be the deepest root of *theōria* back to this experience of illuminating wonder. In Homer, the verb *theaomai* (for which *thea* is a cognate) means "to gaze upon with wonder" or to see with wondering eyes. Both the verb *thaumazein* (to wonder or marvel), and the noun *thauma* (a wonder or marvel) are closely related to *theaomai*, and thus to *theōria*. If it is the mind that thinks, in Homer, it is the eyes that wonder. Wonder wants a spectacle. This is the origin of theory ("it is owing to their wonder," Aristotle later says, "that men now begin and at first began to philosophize"). And while scholars may claim that this archaic understanding of *theōria* has already given way to a more modern sense of theory in Plato, we do well to recall how Plato's *Republic* begins: Socrates left the center of Athens and went down to the harbor to attend a religious festival. He wanted to say a prayer to the goddess as well as to behold the spectacle. Socrates is a *theōros*—one who goes to see and to pray.

The opening scene of the *Republic* preserves the unity of these moments. To see, in the ancient sense of *theōria*, is to pray. While the theoretical discussion that follows appears to move away from this participatory (and prayerful) vision, and toward a way of seeing that is less experientially engaged (and more purely intellectual, or "Platonic"), it is only a stubbornly modern interpretation that fails to see the connection between the origin of the discussion and its ultimate goal. *Eidos*—the word Plato himself uses for what we call a Platonic "idea," or ideal form—is also rooted in the Greek words for (and concrete experience of) seeing and being seen. This is a link that our association of ideas with "concepts" has severed. *Eidos* still draws its meaning from its original source in Plato's own characterization of a philosopher as a *philotheamonas*—one who loves the "spectacle" (the "sights and sounds") of truth. If we ourselves were better able to read Plato's text with wondering eyes, attentive to and moved by the particularities of the spectacle he paints in words, we might better understand what he has to say about the practice of philosophy. Such readings can and should recall us to what we shall later describe as the "liturgical" function of theoretical contemplation, to the original unity of thinking, seeing, wonder, and worship.[6] While the very idea of oracular seeing (and hearing), and of ritual journeys to places of wondrous revelation, may seem impossibly remote to us, this book will show that it lies much closer to home than we are often able to realize.

In the pages that follow, we attend to other writers with this same interest in beholding and participating in the realm of "the visible" as a revelation of the divine. For all of them, a capacity for this kind of contemplative seeing both originates in and is a source of beautiful art and well-made craft. It is the source of genuine philosophy by which we mean the daily-lived love of wisdom, and the source of our humanity as well.

To see with wondering eyes, for these thinkers as well as for the present authors, is an activity that makes one fully human. This is the prepared vision that Thoreau actively celebrates on his walks—one that is fully open and responsive to nature as a source, rather than just a resource, and is practiced "religiously" in a sense that we shall come to appreciate. It is the cultivated vision described by Okakura Kakuzo in *The Book of Tea*—a way of seeing that "regulates our existence on this tumultuous sea of foolish troubles we call life," and thus "beatifies the mundane." It is the direct, intuitive vision involving not just the intellect but the whole soul, which Plato describes as the culmination of philosophical thinking. It is the loving acceptance of reality that Eric Sloane recognizes in the early American craftsman's "reverence for wood," a love that is enacted and a reality that is known, not just by the cognitive faculty but through the movements of the hand. It is the heart of Esther de Waal's insistence on "mindfulness" in her splendid book, *Seeking God*. It is what Heidegger seeks to recover in leading us to think reverently and patiently, following "the path of a responding that examines as it listens." Following such paths, Heidegger says, "takes practice." It is, essentially, the practice of a craft. Such a way of thinking, Heidegger shows, is in itself a way of being.

This practiced seeing and insightful beholding, rare but achievable, is what Pieper and all the thinkers gathered here call to our attention. The fundamental ideas of these writers will be brought to life in the work that we are undertaking—the work of learning to behold the visible reality as it truly is.

We shall set about this task by looking attentively at—indeed, dwelling with—works of art as well as philosophical ideas about art and craft in relation to each other and to everyday human experience. We hope that our readers will come to participate in this text as its own sort of spectacle; that from it they will be moved to wonder, sensuously and emotionally as well as intellectually, about human nature and about the nature of their own experience. We pose the question: What do art and philosophy contribute to the fullness of human reality in such a way that we may ultimately come to see that to live artfully and philosophically is what it means to be truly alive. That a capacity for contemplative seeing is the source not only of art and philosophy, but of our humanity—that the ability to see with wondering eyes is what makes us fully human—is not a thesis for which we merely argue (though we can and will argue for it). It is something we seek to demonstrate by engaging the reader in the kind of participatory vision that we shall be discussing.

Such a hope presents special challenges. How to create a book that can become an occasion for practicing what it preaches, *as it preaches*, is in itself somewhat daunting. It cannot rely on a passive consumption of information or factual material. There will be no dates to memorize. The idea of practiced seeing, that is, of contemplative beholding is not reducible to algorithms. As we said, there can be no simple formula or recipe for living

fully. This is not a study of human nature (in the modern sense of "study"). It is a book about living fully by practicing our humanity every day, where we begin that practice in the very act of experiencing the contents of this book.

Living artfully and philosophically is not the same as taking a philosophy course alongside an art course. It is not an interdisciplinary undertaking, where one operates in two separate departments (or compartments) at once. As we hope the following chapters will help our readers to realize, to live philosophically *is* to live artfully, and *vice versa*.

In his well-known essay on "Self-Reliance," Emerson describes the "primary wisdom" that he calls "intuition":

> In that deep force, the last fact behind which analysis cannot go, all things find their common origin. For, the sense of being which in calm hours rises, we know not how, in the soul, is not diverse from things . . . but one with them, and proceeds obviously from the same source whence their life and being also proceed. We first share the life by which things exist, and afterwards see them as appearances in nature, and forget that we have shared their cause.[7]

Such a passage is far too rich to digest fully in what was intended merely as an "overture" or introduction. A deeper (and, we daresay, uncommon) reading of Emerson's essay will provide the theme for the concluding chapter of this book. But, we should already be able to see how Emerson might join with Sloane in articulating what they take to be our most profound need as human beings—*to recall that sense of connectedness with things, that alone makes it possible to be connected with ourselves.* By drawing on artistic as well as textual sources—sources that, however historically remote, can be seen as still living—we seek not only to identify but also to address this need. We look forward, in other words, to a practical recovery of the intuitive vision to which Emerson so passionately attests. While Emerson's intuition and Thoreau's walking might appear to be very different, as thinking and doing appear to be different, together they help us to realize that it is with the idea of "practice," as preparation and as regular activity, that contemplative seeing becomes everyday. This idea of practice, rooted not only in craft but in the making and beholding of all art, is a form of human work that ultimately connects us in wonder with God's work.

This is what we mean to show in the following chapters. In so doing, we call upon a number of texts not as static entities but as voices with which we are in dialogue—voices that we have, as it were, practiced hearing. We also call upon works of art that we have practiced seeing, in order to demonstrate what this kind of seeing involves, and what it might reveal. In this practice, this returning again and again to the object of admiration, we find one of the most important aspects of contemplative seeing.

An example of this practice is the appreciation of great music. Having heard Bach's *St. Matthew Passion*, for instance, one would hardly be justified in saying, "There, I've heard it, I don't need to hear it again." On the contrary, we not only enjoy hearing the piece on other occasions, but find new depth and shadings in the music each time, further defining not only the work itself but also the ways in which we ourselves are changed, deepened, and enriched through our relationship with it. This same process occurs in revisiting Plato's *Republic*, or a painting by Robert Motherwell, or any other great work of art. Indeed, that a work of art provides the occasion for such an experience is perhaps the chief criterion of greatness. This intimate familiarity with a piece of music, a text, or any work of art, born of repeated experience as a daily practice, is a *theōria* in the same sense in which Thoreau's walking is a *theōria*. Such "knowledge" demands and begets full participation. It does not answer any and all questions, but rather moves us to wonder in deeper and deeper ways.

The participatory nature of listening, reading, and seeing is fully akin to the idea of contemplation that will be developed in this book. Contemplative seeing is like "studying" the stars: how they differ and yet remain the same in summer and on cold winter nights, or how they looked when you were four years old and wished upon them, or how, in later life, the heavens appear so much more vast and infinite though one still discerns an undeniable ordering of the cosmos. It is like studying the face of one you love, and how well you recognize that face, because of how often you have seen and *really looked* at it. Seeing that face has meant becoming familiar with its particularities, its unique curves, texture, and luminousness. The more minute the detail, it seems, the greater we cherish the whole person who frames it.

These instances have to do with a very specific way of seeing—the stars across the seasons and throughout your life, your beloved's face in countless times and settings—a way that we believe leads to a unique kind of knowing. This is a theoretical knowing in the original sense, and yet it is also essentially practical in that the visible particulars have been dwelt upon day in and day out . . . a dwelling that is practiced and participatory and, as a result, rich with mystery and fulfillment.

The works that we discuss here are known in this same way. They are texts and images to live with and to love. They are sage and wise. In this book, the reader has the opportunity to be enriched and changed by these works, to be informed in the deepest sense by taking them to heart as we have done. The essays informed by our own encounters with these texts and images form a whole; and yet, each is its own starting point. While they could almost be read separately, they should be read together, with the understanding and willingness to begin again. Through reading and looking at these texts and images, participating in them as spectacles, you may come to know them the way you recognize a much-loved silhouette in the early dawn. In this way, we hope, you may have occasion to practice a way of

living that is filled with insightful beholding and illuminating wonder, with extraordinary awareness and gratitude. As C.S. Lewis writes:

> . . . In reading great literature I become a thousand men and yet remain myself . . . I see with myriad eyes, but it is still I who see. Here, as in worship, in love, in moral action, and in knowing, I transcend myself and am never more myself than when I do.[8]

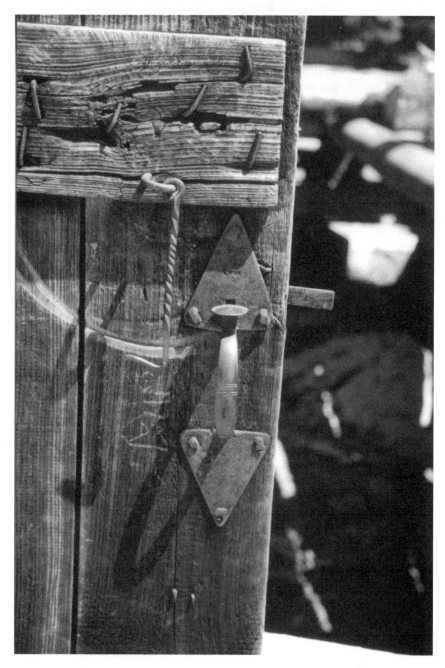

Plate 1 Door and Latch, Southern New England, early nineteenth century. Author's photo

CHAPTER ONE

Walking: Thoreau's Prepared Vision

> It is pleasant to walk over the beds of these fresh, crisp, and rustling leaves. How beautifully they go to their graves! how gently lay themselves down and turn to mould!—painted of a thousand hues, and fit to make the beds of us living . . . They teach us how to die. One wonders if the time will ever come when men, with their boasted faith in immortality, will lie down as gracefully and as ripe . . .
>
> —Thoreau, "Autumnal Tints"

> Wisdom does not inspect, but behold. We must look a long time before we can see.
>
> —Thoreau, "Natural History of Massachusetts"

What does walking have to do with seeing? The connection seems obvious: they are related as means and ends. If you wish to see something, you need to get close enough and position yourself so as to gain a clear and unobstructed view of it. You must be "moved," in a purely physical sense. Conversely, if you wish to get somewhere, you need to see where you are going—to watch out for obstacles, that is, to watch out for yourself, and to be sure that you are headed in the right direction. Otherwise, you might get lost, and never reach your destination. In the first case, walking is the means and seeing is the end; in the second, it is the other way around. In both cases, the end is distinct from the means (even if both happen at the same time).

The idea of walking that comes into play here is a matter of efficient movement while seeing is a matter of clear and unobstructed perception. Our everyday notions of walking and seeing typically acknowledge no closer connection between them than this: to walk is to "do" something (to "get there"); to see is to simply "look" (or to "look out"). Neither walking nor seeing, thought about in this way, bears any essential relation to what we have called the attitude of mortality.

Thoreau recalls us to a very different idea of walking and of seeing. We turn to Thoreau as a "philosopher" (without embarrassment, we should say, since Thoreau's standing within academic philosophy is questionable to say the least). What draws us to him is the very thing that contemporary academic philosophers find off-putting. Thoreau presents us not just with an idea, but with a *practice*. By this, we do not mean a prescription for living, which is what Thoreau is popularly regarded as furnishing. A prescription for living is, after all, just another idea. What we find in Thoreau is not a prescription but an enactment. The point is not simply that Thoreau "practiced what he preached," and then wrote about it. What he preached is enacted in and through his writings. We must be mindful of this if we are fully to appreciate what he has to offer.

While Thoreau's practice may seem foreign to us, it is nonetheless everyday. It is, perhaps, more deeply everyday than many of our own practices. Some will claim that much of what Thoreau was saying and doing is no longer as foreign to us as it was to his contemporaries, that a great deal of what he was advocating in the first half of the nineteenth century has now sunk in (under the heading of environmental ethics). This may be so, but there is something about Thoreau that should seem more foreign to us than it does. We have more work to do if we are to truly understand him. This is not just a matter of pushing his so-called "wilderness ethic" still further or simply hoping that Thoreau's ideas become more common (as, in fact, they have); it is a matter of how we read him. If we fail to appreciate the coincidence of the extraordinary and the everyday in Thoreau's writing, we shall have missed what he has to offer us: some insight into how walking and seeing can "teach us how to die," and thus, to live more fully human lives.

To know some things about Thoreau's own life may prove helpful in this endeavor. Biographical and historical considerations will figure in our discussion. But the kind of reflection we are engaged in cannot just be a matter of supplementing our reading of Thoreau's own writings with some relevant facts about how he really lived. After all, how he "really lived," his practice of living, was, in large measure, to write (he kept a voluminous journal that provided the material for much of his published work). But the practice to which Thoreau is recalling us does not end there, as if we were left with only documentary traces of his travels and observations. In the final chapter of *Walden*, Thoreau insists that:

> The earth is not a mere fragment of dead history, stratum upon stratum like the leaves of a book, to be studied by geologists and antiquaries chiefly, but living poetry like the leaves of a tree . . . —not a fossil earth, but a living earth.[1]

In encouraging us to view the earth differently, Thoreau may also be encouraging us to read differently. If the leaves of a book are anything like the leaves of a tree, could they not also be viewed as living poetry? It would

depend, of course, on what gave life to those pages, on the kind of vision that was originally communicated through them. What Thoreau sees on his walks is not "fossilized" in his writing, to be studied the way a geologist studies a landscape. It needs to be "studied" the way Thoreau himself studied it. This makes reading Thoreau no less vital, no less living and breathing, an activity than Thoreau's own. It becomes something that we too must practice in the way that walking and seeing were practices for Thoreau.

We cannot place ourselves in Thoreau's shoes or even walk through and observe the same landscape for a variety of reasons—both natural and cultural.[2] The question: can we live like Thoreau if such landscapes are no longer available to us, is an important one. But we first have to understand what we really mean when we ask it. There are, in fact, far more trees and forests in New England today than there were when Thoreau lived and walked. He looked at a landscape that was extensively cleared for farms and for fuel (if not for what we like to call development). Where he saw open fields, we see regrowth. But we should still hesitate to say that it is easier for us to experience nature than it was for Thoreau. For it is a question not just of the availability of nature, where "availability" boils down to the measurable extent of forest or sheer numbers of trees, but of the nature of an experience. Whether there is any "nature" still available to us is a claim at least one contemporary writer would dispute, while others would insist that the meanings we attach to it today are necessarily different from those of a century and a half ago.[3] One could make a similar point about art and music, that however authentic the performance (however well-informed we may be about period styles and instruments), we cannot hear the *St. Matthew Passion* through Bach's ears, or even those of his contemporaries.

But if it is a mistake to try to reconstruct Thoreau's vision in that sense, there is still a vital sense in which we can see what he saw or rather, see *as* he saw. For there is a landscape that remains available to us, one that lies closer to home than we might imagine. If what Thoreau preached, his practice of walking and seeing, is enacted in and through his writings, it could also be enacted through our reading of them. We would have to journey through his writing the way he journeyed through the landscape that brought it to life. This chapter tries to shed some light on what this practice of walking and seeing involves.

A careful reader will detect a paradox here: the goal of this reading of Thoreau is, in effect, to arrive at an understanding of how to read Thoreau. Thoreau would not want us to be deterred by this paradox. If seeing is just a means, if one needs accurate vision to ensure that one arrives at the correct destination, then this circularity will seem paralyzing: to reach one's destination is to learn how to see. We confront the same paralysis if we think that reading is just a means, or that living is. For Thoreau, the possibility that autumn leaves can teach us how to die, and thus to live, does not simply reveal itself to a clear and unobstructed perception. It is not something one sees by "just looking" or simply placing oneself before it. How one arrives at this insight is a puzzle (if puzzle is the right word). This chapter goes no

further than to articulate this puzzle. Thoreau can help us to overcome our paralysis, but he will provide no insurance against getting lost.

<p style="text-align:center">★ ★ ★</p>

Part of the joy of reading Thoreau stems from the ability to locate oneself within what he is writing about. This is especially true of the writings on which we focus on here. The idea of reading "A Winter Walk" as the season's first snow falls or "Autumnal Tints" as the maples begin to turn may seem quaint, but it can help to remind us that what Thoreau is talking about is real. This is reinforced by the strong sense of locality that comes across in these and other works. This may seem obvious in the case of *A Week on the Concord and Merrimack Rivers*, or "The Natural History of Massachusetts." But the idea is not just that one can take *Cape Cod* or *The Maine Woods* to the beach or on a camping trip to better relate either to the text or to one's surroundings. Even when the location remains unnamed, even when we cannot find it on a map, Thoreau's writing locates us in a specific way. We are given the sense that we are somewhere in particular—a sense that not every survey of the local flora and fauna will necessarily provide. The writings that convey this sense most strongly are often those that celebrate walking, either directly or indirectly. These writings are as concerned with the progress through or to a place as they are with the place itself, both with what there is to see, and with how one comes to see it ("A Walk to Wachusett" provides but one example). This is what gives them their unfixed, "rambling" or "straying" character. This can be a source of frustration in reading them, but it reminds us of something else that is real: that location is not a simple matter. Even if we know where we are in geographical terms, the question remains: what does it really mean to be in a place? What does that have to do with who, and how, we are?

The complexity of locating ourselves in Thoreau's writing is mirrored by the complexity of locating Thoreau himself. Who was Thoreau, after all? What do we know about him? We know that he loved nature, and that his love for nature moved him to write about it, to write essays. Many of these are described as "natural history" essays. While these essays are not as well known, or as frequently cited as Thoreau's longer works, they represent a substantial portion of his writing.[4] Natural history is today more closely related to science than to art or literature. But this was what Thoreau (and others) saw as his occupation: promoting the development of a science of nature. Thus, in "Natural History of Massachusetts" he proclaims,:

> The true man of science will know nature better by his finer organi- zation; he will smell, taste, see, hear, feel, better than other men. His will be a deeper and finer experience. We do not learn by inference and deduction and the application of mathematics to philosophy, but by direct intercourse and sympathy. It is with science as with ethics,—we cannot know truth by contrivance and method . . .[5]

The "sciences of nature" (zoology, botany, ornithology, entomology, among others) have since come to occupy their own compartments within the biology department, and have become extremely specialized. Contrary to the spirit of Thoreau's proclamation, they have developed highly sophisticated instruments and methods upon which they rely; they seek truth less by "sympathy" than by "inference and deduction." But they began as (and to some extent remain) descriptive activities based on the meticulous observation of (or "direct intercourse" with) natural phenomena. ("Autumnal Tints" provides an example of this, with its minute, almost tedious attention to detail, its taxonomy of species, and so on.) Thoreau does wonder and speculate about the causes underlying these phenomena (as in his essay on "The Succession of Forest Trees"), but he primarily wonders not about why things happen but about what there is to see in the first place. Thoreau was a naturalist, like John James Audubon, whose observations (also made in the field) ultimately took the form of beautiful works of art, but were also intended to be of scientific value. It is often assumed that Thoreau's attitude toward nature is one that rejects thought in favor of raw intuition or feeling. But as John Elder points out, Thoreau "liked to know things, to measure, count, and name."[6] "Let us not underrate the value of a fact," Thoreau himself writes, for "it will one day flower in a truth."[7]

Thoreau's work was not ultimately seen as being of scientific value, either by his contemporaries or by us. But to see it as something altogether different—as (mere) romanticism, religion, environmentalism, or poetry—is to miss the tension it embodies. As Robert Sattelmeyer reminds us, the naturalist was viewed from the outset as a suspicious figure in America:

> The naturalist was doubly suspect because he was concerned about wild plants and animals, and—perhaps even more disturbingly—*because he seemed to do no work.* His studies necessitated the kind of patient observation of often minute phenomena which could only seem trivial to the mass of his contemporaries.[8]

The naturalist was politically suspect insofar as his interests seemed to run counter to a social and economic order that was primarily based on the subjugation of nature. But he was more fundamentally suspect because his "business," like that of the philosopher or artist, seemed to be essentially contemplative. He was in the business of seeing, of wandering the countryside and observing, and his seeing seemed to produce no useful results. His "deeper and finer experience" made him an enigmatic human being.

This is something else we think we know about Thoreau: that he was not just a social critic (witness "Civil Disobedience"), but a true outsider. In the essay we cited at the very beginning of this book, Josef Pieper regrets the loss, not only of our capacity to see, but, more specifically, of the ability to see "with our own eyes." It is precisely this that is so difficult, he says, adding that:

> ... in this ... continuing process [of decline] there exists a limit below which human nature itself is threatened, and the very integrity

of human existence is directly endangered . . . [O]nly through seeing, indeed through seeing with our own eyes, is our inner autonomy established.[9]

We typically understand Thoreau as someone who believed that, in order to live an authentic life as a true individual, thinking for oneself and seeing with one's own eyes, one had to leave society, everyday life and culture, behind. The only way to find fulfillment, as a human being, was to go back to nature.

This is how Thoreau is invoked (and criticized) even by such astute and inspiring writers as Michael Pollan. In *Second Nature: A Gardener's Education* (a book that has much to offer readers who are concerned with the questions we are addressing here), Pollan finds himself arguing with Thoreau, who, he notes, "would prefer a swamp to a garden." Thoreau, he asserts, "strove to drive a wedge" between nature and culture; assuming that "human culture is the problem," he "looked to nature as a cure for culture." Nature could only "exert its 'sanative influence,' " however, when "the crust of culture" was scraped off of it, that is, when we return to a nature that is pure and untouched. Pollan's critical contention is that

> The habit of bluntly opposing nature and culture has only gotten us into trouble, and we can't work ourselves free of this trouble until we have developed a more complicated and supple sense of how we fit into nature.[10]

Pollan is right. When we understand Thoreau as "bluntly opposing nature and culture," however, we are not seeing what he wrote with our own eyes. We overlook the ways in which he might help us to arrive at the sense of fit that Pollan is asking for. Thoreau was critical of what he saw as the modern way of life, but his response was not to leave culture and go back to nature. Yes, there was the retreat to Walden Pond; but Thoreau himself described it as an "experiment." The result of this experiment was the book *Walden.* This book was written not in the woods but back in town (almost ten years later). It was written to, and for, other people. Thoreau did not turn his back on human culture. He addressed it. "With regard to nature," he said, "I live a sort of border life."[11] This is part of what makes him an extraordinary human being. He speaks a word, not simply for nature or for culture.

While he was no ordinary sort of guy, Thoreau was a practical person, a surveyor among other things. He would spend long hours, not only in the field, forests, and swamps, but in farm lots. His field work, taking the measure of the land, provided the occasion for his observations. This contributes to the sense one gets (or should get) from reading Thoreau, not just of real things and experiences, but of real places or what we called localities. Here is a person who *is* somewhere, not a person who is hopelessly detached. His being somewhere is essential to his being some*one*—to his being a human being. We think of Thoreau as an individualist, but then we often fail to

notice what is involved in his being an individual: the idea, actively conveyed in his writing, that he owes his individuality (his personality, as it were) to the world around him. In contrast to the self-absorbed individualist, Thoreau learns who he is by paying close and careful attention to something other than himself.

Thoreau's work did not end when he returned home from the field or even when he finished writing in his journal. His essays, like Pieper's, are "occasional," meaning not that they just happen once in a while, but that they are occasioned, called for, by something. Pieper's essays were occasioned by the kinds of "feasts" they celebrate (such as the opening of an art exhibition). Many of Thoreau's essays, like Pieper's, originated as public occasions. All of his later natural history essays began as lectures (before "lecture" became a dirty word). These were not narrowly academic but broadly cultural events. Thoreau's words were read aloud before an audience, not of scientists or philosophers or other specialists, but of everyday ("cultured") people.

But then, there is a further point about Thoreau that we need to consider before we plunge directly into his writing. We have to envision him not only in the swamp, up to his neck in mud, but also dressed in a frock coat, standing on stage—a human being addressing other human beings. Here again is the tension: not only between the everyday nature of these events and the philosophical or artistic (the extraordinary) nature of Thoreau's writing, or between the cultural situation of his work and the "wildness" of his own life and character. This is a tension within Thoreau himself. It is the tension reflected in Pieper's claim that "to contemplate means first of all *to see*—and not *to think*."[12] What kind of seeing is Thoreau in the business of doing? What kind of thinking might it issue in? The natural history essays reveal an increasingly careful attention to particular material things, and to describing what is particular about them. But then, together with this concentration on the particular, and interwoven with it, there are the "universal realities" Pieper speaks of—the "essences," "archetypes," or "primordial forms" of things. How does Thoreau succeed in capturing both? To contemplate usually means to stop "doing" (to stop working) and to gaze at something—something so captivating and absorbing that we become unaware of anything else. For Thoreau, seeing seems to put him in touch with everything around him—the minutest details of his environment as well as what Pieper calls "the hidden, ultimate reason of the universe, the divine foundation of all that is" (p. 23).

Thoreau was not just a gazer. He was a "doer." What he did was walk, averaging (by his own estimate) at least four hours each day, no matter the weather, after which he would carefully re-create from a pocket notebook the accounts of his journeys that came to fill his *Journal*. Thoreau walked (and wrote) "religiously," regularly, and habitually. Of course, the mere fact that an activity is performed every day does not make it religious in the deepest sense. But what does, then? When Thoreau maintains that he "cannot preserve [his] health and spirits," unless he spends at least four hours a

day "sauntering through the woods and over the hills, absolutely free from all worldly engagements,"[13] it is easy to picture his walking as an utterly spontaneous ("free") affair; its sole purpose to keep him fit and happy. But the writing paints a different picture. Our contention is that only by seeing Thoreau's walking as the disciplined and engaged practice that it is, can we fully appreciate its religious nature. Only then can we answer the question with which we began: what does walking have to do with the kind of beholding Pieper thinks our humanity ultimately depends on?

This question can only be answered in a participatory way—by following Thoreau on one of his walks and trying to understand, or rather experience, the kind of seeing this kind of walking makes possible. It is tempting to turn directly to Thoreau's famous manifesto on walking (the posthumous essay that bears that name). We shall certainly draw from it, but we first have to understand that Thoreau is not just writing "about" walking (in this or any of his essays). His writing embodies the walking itself. This is, after all, where the word "essay" comes from: an effort, or attempt (the Latin root is *agere*, to drive, impel, or move). Thoreau's essays *are* walks, walks in which we can join, even if we cannot follow in his actual footsteps. Thoreau's way of walking, a "going to look," with "purposeful indirection," is not only reflected in his writing style, but is what his writing is. It is also what our reading should be.[14] It is not just Thoreau's effort that the essays require, as if they were the end result or finished product of that effort. It is our own.

<p style="text-align:center">★ ★ ★</p>

We start out on "A Winter Walk." What kind of walking is this? Long walking in the cold, up before dawn, out before breakfast. How many of us really do this? If we got up this early, it would usually be to get a head start on our work, or to "work out." That is, as a means to an end. But this *is* Thoreau's work:

> We sleep, and at length awake to the still reality of a winter morning. The snow lies warm as cotton or down upon the window-sill; the broadened sash and frosted panes admit a dim and private light, which enhances the snug cheer within. The stillness of the morning is impressive. The floor creaks under our feet as we move toward the window to look abroad through some clear space over the fields. We see the roofs stand under their snow burden. From the eaves and fences hang stalactites of snow, and in the yard stand stalagmites covering some concealed core. The trees and shrubs rear white arms to the sky on every side; and where were walls and fences, we see fantastic forms stretching in frolic gambols across the dusky landscape, as if Nature had strewn her fresh designs over the field by night as models for man's art.[15]

This does not sound very scientific. If anything, it might seem to be an example of the kind of aestheticizing idealization of nature Pieper would

warn us against. After all, it is very cold out there. That cold can be very threatening, not only to us but to other creatures. We (like many of them) need to take shelter from it. This is where the opposition between nature and culture seems to arise. We cannot simply go back to nature; not just because we couldn't survive, but because we would be relinquishing certain aspects of our humanity. The fullness of human reality includes the shelters we erect, the tools we make, the fires we build, the very "walls and fences" that the forces of nature seem here to have obliterated.

What, then, is Thoreau trying to call to our attention? He is describing nature in a way that makes it seem very beautiful. Is he telling the truth about it? In his own essay on "Work, Spare Time, and Leisure," Pieper poses the question: what is required to celebrate a feast?

> Obviously more than a day off from work. This requirement includes man's acceptance of the ultimate truth, in spite of the world's riddles, even when this truth is beheld through the veil of our own tears; it includes man's awareness of being in harmony with these fundamental realities and surrounded by them. To express such acceptance, such harmony, such unity in nonordinary ways—this has been called since time immemorial: to celebrate a feast.[16]

Pieper goes on to characterize this attitude as one of *loving* acceptance. Is Thoreau moving us toward such a loving acceptance of reality, or is he romanticizing, covering it up (with white fluffy snow)?

What Thoreau sees out his window, and what we ought to see in his writing, is not the obliteration of "man's art" by nature, but rather its illumination. Superficially, the walls and fences are covered up. But this covering enables us to see something we might not have been able to see before, when, in the course of an ordinary business day, we glanced out and saw what we were always accustomed to seeing. On such days, as we hurry to accomplish what we need to accomplish, we pay little attention to our walls or fences unless we happen to notice that they are broken (in which case we attend not to them, but to the need to repair them). What the snowfall enables Thoreau to see are "fantastic forms"; forms that, instead of taking the place of man's art, provide the "model" for it. There is no complaining here about human artifacts spoiling nature's show. Thoreau does not look out and rejoice that the "crust" of culture has been scraped away from a nature that now stands pure. He sees culture enshrouded and yet set into relief by nature—the familiar made unfamiliar. This is what is extraordinary about this morning: we awake and are *impressed* by its stillness, we *hear* (and perhaps feel) the creaking of the floor as we move across it, we *see* not only the trees and shrubs but the surrounding rooftops, thanks to nature's "fresh designs." And yet, there is no reason why such sensory experiences should not be available to us every day.

Thoreau does speak of "the wonderful purity of nature" in this essay. But this is not an indiscriminate invocation of the purity of nature as such. It is

a particular kind of purity that nature exhibits *"at this season"*—a purity, moreover, that Thoreau associates as much with confusion as with clarity.[17] "Nature confounds her summer distinctions. . . . The heavens seem to be nearer the earth. The elements are less reserved and distinct. Water turns to ice, rain to snow" (P. 58). The snow conceals, not only the evidence of man's work, but the works of nature itself, the decayed stumps and dead leaves Thoreau otherwise tends to revel in. Nature's own self-concealment—its seeming to shelter itself in snow—calls the need for man's art into question:

> Probably if our lives were more conformed to nature, we should not need to defend ourselves against her heats and colds, but find her our constant nurse and friend, as do plants and quadrupeds. If our bodies were fed with pure and simple elements, and not with a stimulating and heating diet, they would afford no more pasture for cold than a lifeless twig, but thrive like the trees, which find winter genial to their expansion . . . All things beside seem to be called in for shelter, and what stays out must be part of the original frame of the universe . . . It is invigorating to breathe the cleansed air. Its greater fineness and purity are visible to the eye, and we would fain stay out long and late, that the gales may sigh through us, too, as through the leafless trees, and fit us for the winter,—as if we hoped so to borrow some pure and steadfast virtue, which will stead is in all seasons. (Pp. 54–55)

Readers who associate Thoreau with the "natural" as opposed to the "cultural" sometimes fail to appreciate the rhetorical quality of his writing, assuming that he wrote as naively as (they think) he lived. Thoreau uses words artfully. There may be awkwardness and excess in his writings (as there was in his character), but there is also more design than one may initially detect. Thus, Thoreau knew perfectly well that plants and quadrupeds *do* need to defend themselves against heat and cold, and he does not really believe that our "original" nature is to live as lifeless twigs. The effect of such "extreme statements" (to use a phrase Thoreau himself sometimes uses to characterize his writing) is to ensure that the origin and aim of man's art remains an open question. And there is a hint. Why would we stay out, "long and late," in conditions to which we are not naturally conformed? In the hope that we might *borrow* something that will "stead us in all seasons," inside as well as out:

> As we stand in the midst of the pines in the flickering and checkered light which straggles but little way into their maze, we wonder if the towns have ever heard their simple story. It seems to us that no traveler has ever explored them, and notwithstanding the wonders which science is elsewhere revealing every day, who would not like to hear their annals? Our humble villages in the plain are their contribution. We borrow from the forest the boards which shelter and the sticks which warm us . . . What would human life be without forests, those natural

cities? From the tops of mountains they appear like smooth-shaven lawns, yet wither shall we walk but in this taller grass? (P. 57)

Nature provides a model that culture is meant not simply to imitate, but from which it is meant to borrow. In one sense, the idea that we might "borrow" trees from the forest in order to build a shelter is as ridiculous as asking someone if you might borrow a match. Given the use to which it is put, it cannot be returned in its original condition. But while we often tend to think about borrowing in such narrowly materialistic terms, this is not the sense in which Thoreau is using it. Nor is he simply reminding us that the wood that is cut and split to supply clapboards for a house will eventually rot, and may in that sense be given back. While it might be fruitful to envision man's art as matter for compost, Thoreau is calling our attention to something more fundamental. The emphasis is not on *what* we have borrowed, materially speaking, and what we have to give back or restore. There is occasion "in the midst of the pines" to stop and think: what would it mean to conceive of our own creative activity as a "borrowing"? What difference would it make in terms of the activity itself? How might it shape, or reshape, our creations?

Before we think about what we have to give back, we must remember that to borrow is to owe. This is the question we need to ask about any of our cultural creations (or re-creations): do we see ourselves as owing, or as owning them? Those of us whose work is of a more intellectually creative sort will often talk about borrowing an idea. Taken in a purely material sense, this is as nonsensical as asking to borrow a match. But there is (or ought to be) more to it than simply giving credit to the original author of the idea—a deeper sense in which we might acknowledge its source (particularly if the idea is not just being "used," but is animating or inspiring one's own thought). The author we cite may have his own sources to thank for an idea that seems to have originated with him. These sources may include other thinkers and the words they have written or spoken, or they may issue from a broader experience of the world. Such is the case with the authors of this book, and such was the case with Thoreau. Here (in the midst of the pines) is an acknowledgment that what we make (our humble villages, our books, our lives) is, in some sense, on loan.

What nature contributes may indeed be subject to corruption, and there is no doubt that Thoreau is drawn more to the source than to what man's art generally makes of it:

Here reign . . . a health and hope far remote from towns and cities. Standing quite alone, far in the forest, while the wind is shaking down snow from the trees, and leaving the only human tracks behind us, we find our reflections of a richer variety than the life of cities. The chickadee and nuthatch are more inspiring society than statesmen and philosophers, and we shall return to these last as to more vulgar

companions. In this lonely glen . . . our lives are more serene and worthy to contemplate. (P. 59)

Thoreau's preference for nature over culture is not an exclusive one. While the place where he finds himself, and the experience it affords, may be "remote," he is not utterly removed from towns and cities, or other forms of human society. "How much more living is the life that is in nature!" (P. 58). But then art is not necessarily devoid of life. What we owe to nature, without realizing it, is culture itself. To "go back" to nature is not to retreat from culture, but to draw closer to its original source. There is a truth (a reality) here from which our political, scientific, and philosophical "truths" are built, like the boards we borrow from the forest, or the villages that are its contribution. When we become forgetful of the source, however, our cultural achievements are cut off at the root, and instead of living, they wither and die (or become desiccated, "preserved," or mummified, intact on the outside, but lifeless and hollow on the inside). "How much more living is the life that is in nature" is not just a celebration of nature but of what gives life to culture.

This is the problem with saying that Thoreau would simply reject the garden as an artificial (or cultural) construction, and replace it with a swamp. He declares his preference in the long essay on "Walking," but in a rhetorically artful way:

> Yes, though you may think me perverse, if it were proposed to me to dwell in the neighborhood of the most beautiful garden that human art ever contrived, or else of a Dismal Swamp, I should certainly decide for the swamp.[18]

What could underlie such a deliberately perverse preference? If we look carefully, we shall see that this "extreme statement" points, not in one direction or the other, but to the vital, if forgotten, connection between them:

> I derive more of my subsistence from the swamps which surround my native town than from the cultivated gardens in the village. There are no richer parterres to my eyes than the dense beds of dwarf andromeda . . . which cover these tender places on the earth's surface. Botany can go no further than tell me the names of the shrubs which grow there,—the high-blueberry, panicled andromeda, lamb-kill, azalea, and rhodora,—all standing in the quaking sphagnum. I often think that I should like to have my house front on this mass of dull red bushes, omitting other flower plots and borders, transplanted spruce and trim box, even graveled walks,—*to have this fertile spot under my windows,* not a few imported barrow-fulls of soil only to cover the sand which was thrown out in digging the cellar. Why not put my house, my parlor, behind this plot, instead of behind that meager assemblage of

curiosities, that poor apology for a Nature and Art, which I call my front yard? (Pp. 98–99)

Why not, indeed? Such an extreme statement harbors good advice for the gardener after all (speaking for those of us who have tried to grow azaleas in "a few imported barrow-fulls" of soil). We may pride ourselves for having a more enlightened view of the benefits of wetlands than prevailed in Thoreau's own time. We know that they help to control run-off and provide sanctuary for numerous plants and animals, and we generally work to protect them (unless the benefits are economically outweighed). Thoreau sees something more fundamental than this. What is corrupt about human cultivation is its refusal to acknowledge its debt to the kind of fruitful corruption of which swamps provide an abundant supply. There is no creativity, no fertility, without rot; no creation without decay; no life without death. What Thoreau sees in a swamp is generosity, the inexhaustible (or bottomless) provision of the stuff of which culture is made. What he sees in contemporary culture (what we can still see in our own) is a niggardly ingratitude toward this very source. Thoreau does not eschew the man-made house, or even the furnished parlor, for the uncultivated swamp. He asks for a dwelling that is near enough to its source that it can still be seen (even from the sitting-room window) for what it is, that is, a way of living that remains connected to the source of life itself, however unstable or "quaking" it may be. The problem with the "front yard," or the "cultivated gardens in the village," is not simply that they are unnatural. The problem, as Thoreau sees it, is that they are *poorly cultivated*, a "poor apology for a Nature *and* [an] Art." What Thoreau prefers about a swamp is what it does for a city or town, for a civilization, or for a human life:

When I would recreate myself, I seek the darkest wood, the thickest and most interminable and, to the citizen, most dismal swamp. I enter a swamp as a sacred place,—*a sanctum sanctorum*. There is the strength, the marrow of Nature. The wild-wood covers the virgin-mould,—and the same soil is good for men and for trees. A man's health requires as many acres of meadow to his prospect as his farm does loads of muck . . . A town is saved, not more by the righteous men in it than by the woods and swamps that surround it. A township where one primitive forest waves above while another forest rots below,—such a town is fitted to raise not only corn and potatoes, but poets and philosophers for the coming ages . . . To preserve wild animals implies generally the creation of a forest for them to dwell in or resort to. So it is with man . . . The civilized nations—Greece, Rome, England— have been sustained by the primitive forests which anciently rotted where they stand. They survive as long as the soil is not exhausted. Alas for human culture! Little is to be expected of a nation, when the vegetable mould is exhausted, and it is compelled to make manure of the

bones of its fathers. There the poet sustains himself merely by his own superfluous fat . . . (Pp. 100–101)

What we see and do not see in Thoreau corresponds to what we see and do not see in the world around us. The poet who is supposed to have said "give me nature rather than culture" is the one who actually says: "*Give me a culture* which imports much muck from the meadows, and deepens the soil," as distinct from one that trusts *only* to "improved implements" (P. 110). The poet who, by famously declaring that "in Wildness is the preservation of the World," seems to be calling a halt to human progress is actually holding out for a vision that is culturally promising and fundamentally hopeful. It is not only suppler than we take it to be, but is genuinely "workable." It is a way of seeing and of being that invites future cultivation, as opposed to the implementation of a culture that, because it is thoroughly manufactured, has nothing left—no living source to draw upon. This is what Thoreau means when he says:

> I would not have every man nor every part of a man cultivated, any more than I would have every acre of earth cultivated: part will be tillage, but the great part will be meadow and forest, not only serving an immediate use, but preparing a mould against a distant future, by the annual decay of the vegetation which it supports. (P. 111)

What does this mean for those of us who do not, or are unable to, live near forests and swamps? It would make things easier if we could say that Thoreau was using forests and swamps as symbols or metaphors; that he is talking about a way of life that remains connected to these sources in a merely figurative sense. But Thoreau does not make it so easy for us either to understand or to practice his point. Must we take him literally, then? We should, if only to remind ourselves that arriving at "a more complicated and supple sense of how we fit into nature" constitutes a real problem for living (and not just for theorizing). But even if we were to take Thoreau literally, paying close attention to the particularity of what he sees and writes, it would still not drive a wedge between nature and culture. This is one of the truly striking things about Thoreau's natural history writing: it is as keenly observant of human phenomena as it is of nature itself. Thoreau does not leave man's art behind, or try to see past it in his visionary questing after some truth that nature alone can reveal.[19]

Consider these "sightings" from "A Winter Walk":

> Let us go into this deserted woodman's hut, and see how he has passed the long winter nights and the short stormy days. For here man has lived under this south hillside, and it seems a civilized and public spot . . . After two seasons, this rude dwelling does not deform the scene . . . Thus, for a long time, nature overlooks the profanity of man. The wood still . . . echoes the strokes of the axe that fells it, and while

they are few and seldom, *they enhance its wildness,* and all the elements strive to naturalize the scene.[20]

See yonder thin column of smoke curling up through the woods from some invisible farmhouse . . . as where we detect the vapor from a spring forming a cloud above the trees. What fine relations are established between the traveler who discovers this airy column from some eminence in the forest and him who sits below! Up goes the smoke as silently and naturally as the vapor exhales from the leaves, and as busy disposing itself in wreaths as the housewife on the hearth below. It is a hieroglyphic of man's life, and suggests more intimate and important things than the boiling of a pot. Where its fine column rises above the forest, like an ensign, *some human life has planted itself,*—and such is the beginning of Rome, the establishment of the arts . . . (P. 62)

And now we descend again, to the brink of this woodland lake, which lies in a hollow of the hills . . . We fancy ourselves in the interior of a larger house. The surface of the pond is our deal table or sanded floor, and the woods rise abruptly from its edge, like the walls of a cottage. The lines set to catch pickerel through the ice look like a larger culinary preparation, and the men stand about on the white ground like pieces of forest furniture . . . *They seem not unworthy of the scene* . . . (Pp. 63–64)

Thoreau contemplates scenes like this for the duration of his walk (and of his essay). This might seem strange. Such a human presence should appear unwelcome to someone who is more interested in observing the fish than the fishermen, all the more so since the presence is not that of the passive spectator (another hiker, perhaps) but of the active interloper. Ice-fishermen, like woodsmen, are not among those who strive to leave no trace in their dealings with the natural world. And yet, Thoreau sees as much in their traces as he does in the surrounding landscape:

Far over the ice, between the hemlock woods and snow-clad hills, stands the pickerel fisher, his lines set in some retired cove . . . with dull, snowy, fishy thoughts, himself a finless fish, separated a few inches from his race; dumb, erect, and made to be enveloped in clouds and snows, like the pines on shore. In these wild scenes, men stand about in the scenery, or move deliberately and heavily, having sacrificed the sprightliness and vivacity of towns to the dumb sobriety of nature. *He does not make the scenery less wild,* more than the jays and muskrats, *but stands there as a part of it* . . . He belongs to the natural family of man, and is planted deeper in nature and has more root than the inhabitants of towns. Go to him, ask what luck, and you will learn that he too is a worshiper of the unseen. (Pp. 68–69)

It is not just man and nature, fishermen and fish, that model one another in this scene. It is the observer and the observed. ("What fine relations are

established between the traveler who discovers this . . . from some eminence . . . and him who sits below!") What Thoreau sees in the pickerel-fishermen is what we should see in Thoreau: someone who, in the way that he "moves deliberately" through the natural world, "stands there as a part of it"; someone whose activity separates him but "a few inches from his race"; someone who is at work (not a mere contemplator) and yet "a worshiper of the unseen"; someone whose bodily, sensory, and intellectual engagement with nature is at once observational, practical, aesthetic, and philosophical, *someone who is a "theorist" in the original sense of theōria.*

Thoreau is a *theōros* (no pun intended!). He is a "student" of nature. But it is clear that his interest does not lie with nature objectified, set apart, on its own, the way we expect a scientist to study it. To study something objectively is to stand back from it, to isolate it, to be detached from it, not to let our feelings about it get in the way of or distort what we see. To be moved by the beauty of nature is one thing; to see it as it really is, is another, we think.

What (and how) does Thoreau think? "Wisdom does not inspect but behold." Thoreau speaks of (and for) a way of participating in nature that brings us closer to it, physically as well as intellectually. This kind of participation allows us to see both nature and ourselves as we really are, in Pieper's sense of "perceiving the visible reality as it truly is." To see something as it truly is, in this sense, is not just to know (or merely think), but to "realize" it. What Thoreau is looking for on his walks is a realization of our own human reality. He finds it in places like the ones he describes. But it is not just the fish and the fishermen who realize this, as if Thoreau were citing these as examples of what he is talking about. He finds what he is looking for in his own walking and seeing. We find it there, too. If what Thoreau beholds in these spectacles sheds light on what it means to be a spectator, the same light may be shed upon us as we behold Thoreau. Thoreau thinks not only with his eyes but with his feet. Participatory engagement is what he himself embodies. It is not something that he merely "inspects," nor is it something he does and subsequently talks about. It carries over into the writing itself in such a way that our own way of seeing can and should follow suit.

Of course, walking can be as detached as seeing or thinking can be. Thoreau realizes this, too:

> Of course it is of no use to direct our steps to the woods, if they do not carry us thither. I am alarmed when it happens that I have walked a mile into the woods bodily without getting there in spirit. In my afternoon walk I would fain forget all my morning occupations and my obligations to society. But it sometimes happens that I cannot easily shake off the village. The thought of some work will run in my head and I am not where my body is,—I am out of my senses. In my walks I would fain return to my senses. What business have I in the woods, if I am thinking of something out of the woods?[21]

To be out of one's senses is to be irrational in the usual meaning of the phrase. For Thoreau, to be rational, if we associate rationality exclusively with the head or with the imperatives of "work," *is* to be out of one's senses. But this is a narrow conception of rationality, and it is not Thoreau's. For him, one is not truly rational if one is not "where one's body is." What, then, does it mean to be in one's senses, or really to be thinking of something *in* the woods—if simply being in the woods, and thinking about something (even something that one sees in the woods) does not ensure that one is thinking in and with one's body? What does it mean to be truly rational?

An answer to this question will emerge over the course of this book. What we have come to see is that Thoreau is not just standing back and "inspecting" the world around him, nor is he simply standing back to admire its beauty. What he sees is realized in the kind of participation he observes and exemplifies. The farmer's living and working, like the fisherman's worthiness of the natural scene, are particular instances of the borrowing Thoreau speaks of. They have this in common with his own attentive seeing: they are each neither objective in the usual sense, nor are they merely subjective. They both bring us closer to things.

So does Thoreau's own writing. It is important that when he speaks of borrowing from nature, or of a way of life that remains connected to its source, he is not just talking about something we ought to do. He is not delivering a prescription (yet another "obligation to society," or to nature). He is describing something he sees. How might we respond to this vision? If Thoreau sees, not just something that *ought* to be, but something that *is*, how can we be (or become) that way too? Not simply by relinquishing culture, but not simply by clinging to it, either. It is, we recall, the *humble* village that can be seen as a "contribution," whose sheltering boards and warming fires (whose poetry and philosophy) harbor and sustain a way of life that understands itself as owing and not simply as owning. It is here that the attitude of mortality holds sway. This is what Thoreau's winter walk makes visible. If we are able to see, hear, and feel more, and better—that is, more acutely—in this "cleansed air" so that its very "fineness and purity are visible to the eye," it is not just what we perceive that becomes a tacit source of value. It is the newly sharpened perception itself. Thoreau's vision finds meaning not just in nature or in our own sensory engagement with it, but in the reciprocity between the two. He finds meaning in a way of seeing that is made possible by a fully embodied, actively participatory relationship with nature.

This is what underlies the seemingly paradoxical motif that runs throughout "A Winter Walk"—the idea of feeling summer warmth in winter. It is our enlivened sense perceptions that generate an "increased glow of thought and feeling." The "slumbering subterranean fire in nature" is made visible, so to speak, by the intense cold, but only insofar as it answers to a "subterranean fire . . . in each man's breast."[22] Each is a condition for, or serves to awaken, the other, as if it were this very reciprocity of nature and our own engaged, intensified experience of it, that produced the warmth by

which life is sustained. "In winter we lead a more inward life," Thoreau observes (p. 70). This is not because most of us tend to stay inside. It is the inwardness of life that we can see all around us, as we make our way through the frozen landscape. Its very resistance (because it is frozen, it is less easily penetrated, like the ice through which the fishermen must thread their lines) lends greater intensity to the liveliness that lies beneath the surface. If our own lives are deepened by this experience, it is because we are taking upon ourselves the conditions that prevail out-of-doors.

<p style="text-align:center">★ ★ ★</p>

We said that Thoreau's way of seeing things, while not "objective," might actually bring us closer to things. What can we say, now, about this "closeness"? In an essay entitled simply "The Thing," Martin Heidegger invites us to reflect on what it truly means to be close to, or distant from, some object or place:

> All distances in time and space are shrinking. Man now reaches overnight, by plane, places which formerly took weeks and months of travel. He now receives instant information, by radio, of events which he formerly learned about only years later, if at all. The germination and growth of plants, which remained hidden throughout the seasons, is now exhibited publicly in a minute, on film. Distant sites of the most ancient cultures are shown on film as if they stood this very moment amidst today's street traffic . . . The peak of this abolition of every possibility of remoteness is reached by television, which will soon pervade and dominate the whole machinery of communication. Man puts the longest distances behind him in the shortest time. He puts the greatest distances behind himself and thus puts everything before him at the shortest range. Yet the frantic abolition of all distances brings no nearness; for nearness does not consist in the shortness of distance. What is least remote from us in point of distance . . . can remain far from us. What is incalculably far from us in point of distance can be near to us. Short distance is not in itself nearness. Nor is great distance remoteness. What is nearness if it fails to come about despite the reduction of the longest distances to the shortest intervals? What is nearness of it is even repelled by the restless abolition of distance? . . . What is happening here when, as a result of the abolition of great distances, everything is equally far and equally near? . . . Everything gets lumped together into uniform distancelessness.[23]

Heidegger wrote these words more than a half-century ago, but his observation was penetrating, and prescient. Where he refers to air travel, radio, and television, we need only look to our computers to see the truth in what he is saying. Perhaps he can also help us to see the truth in what Thoreau is saying, and doing. Thoreau, after all, would always prefer to walk

rather than ride.[24] Still less would he have wanted to fly. For him, covering the greatest possible distance in the shortest possible time does not bring us nearer to places and things. Like a purely objective way of seeing, it only leaves us more detached. But then, perhaps this truth is not so easy to grasp. This is the problem we ran into when we asked what it would mean, for Thoreau, to be "connected" to the swamps and forests or to other sources of life. Does he mean it literally, or figuratively? Heidegger is questioning the reduction of nearness and remoteness to mere physical distance—the kind that can be gauged in purely quantitative, objective terms according to a uniform standard of measurement. This is the sort of measuring Thoreau would have done when he was surveying. But, there is a kind of nearness that cannot be measured, a closeness that cannot be achieved in this way. There is a real and important sense in which one can feel closer to a remote spot in the mountains than one does to the shopping center just around the corner. This sense of proximity or distance may seem purely metaphorical, more a matter of "feeling" than of actual closeness, of something's being "dear" than its actually being near. And yet, Heidegger seems to suggest (and goes on to argue) that there is more truth in this sense of nearness than there is in the other.

Qualitative nearness is what we *actually* experience. Quantitatively measured, purely physical, or objective, distance always remains an abstract possibility, however much of it we in fact cover. After all, it is not the lines of the map that we actually traverse. It is the contours of the land, the winding of the path through the forest, or the instability of the swamp. The greatest example of our "restless abolition of distance"—"the reduction of the greatest distance" in time as well as space "to the shortest intervals"—is the "virtual" contact we can achieve with people, places, and things, thanks to the Internet, e-mail, and instant messaging. But such virtual contact is not actual contact. It is, in a way, the furthest thing from that. This is clearest where other human beings are concerned. The irony is that when we communicate with other people by email, overcoming distance in physical terms, we have not achieved physical nearness at all. Whatever closeness we have achieved, whatever contact we have made, is completely disembodied.

In this virtual environment, everything becomes equally near and equally far. Actual places no longer matter (they lose their material substance as well as their concrete meaning). Such communication is, in fact, as close to "immaterial" as one can get (even when we are supposed to be communicating about important matters). With no tone of voice or facial expression, no physical gestures, it becomes difficult to understand what is meant as it is meant. All meaning becomes surface meaning, as is therefore easily mistaken. Because we do not actually "stand behind" the words we exchange (our words are not where our mouths are, so to speak) and because the "delete" button is so close at hand (making everything we say seem more like a possibility than a concrete actuality), we often say things we shouldn't, things we ourselves are not fully prepared to stand behind, or would not say in person. We think we are being more courageous when we use

e-mail—that it "enables" us to say such things. But what it really does is provide an illusory sense of insulation; it is cowardice in a way and not courage that it promotes. The point is not simply that writing is a poor means of communication as compared to actual speaking. Real writing can really communicate; E-mail writing is not even real writing but is virtual writing. It eliminates the physical presence of the hand, or of the words that stand physically on the page. It is by preserving the physical that real writing (and reading) also preserves depth of meaning and the possibility of substantial "communion" between persons.

But we digress. When Thoreau "surveys" the landscape on his winter walk, he is not taking the measure of the land, or covering ground in a quantitative or objective sense. This is different from the work he does when he is (actually) surveying. And yet these activities could (and for Thoreau, they often did) coincide. For Thoreau, "true" or actual closeness (the kind that enables us to "know truth" in a way that objectively scientific methods do not) is not just metaphorical; it can only be experienced in physical, or bodily, terms. Notice we did not say "merely" physical. Where Heidegger seems to identify the physical with the objective or quantitative, Thoreau does not. When Thoreau talks about being where his body is (being in rather than out of his senses, or about thinking of something in rather than outside of the woods), he is talking about a way of seeing and thinking, about a way of being, that is essentially qualitative and meaningful. These qualities and meanings have their source not just in our own feelings or imaginations. They are not subjective sentiments or private associations that are projected onto things (it is not just the fond memory of some pleasant and relaxing vacation that makes me feel "close" to that remote spot in the mountains) nor are they merely objective facts about things. They have their source in the reciprocity we spoke of earlier—that is, in a fully engaged encounter with things, a kind of engagement for which certain kinds of things provide the occasion.

For Thoreau, the things that allow for this kind of engagement are primarily natural things, plants, animals, whole landscapes, air, water, snow, rain, darkness, and light. But this is not a landscape that excludes any trace of culture. It is this very reciprocity that is realized in the scenes to which Thoreau is calling our attention, when he invites us to *see* that "thin column of smoke curling up through the woods from some invisible farmhouse . . . as where we detect the vapor from a spring." These are the places where "some human life has planted itself," and this, for him, is "the establishment of the arts."

Such encounters are as full of perception and thought as they are of feeling and emotion. The fact that Thoreau sees meaningfully does not imply that he fails to see "accurately." It implies only that he sees more than the bare fact. Of course he could make mistakes in the way that he classifies or explains things. But these are not failures to think; rather, they are the sorts of mistakes that anyone who is thinking is prone to make. What Thoreau is alerting us to is a way in which our observations themselves can be

mistaken. Not that we simply miss or overlook things or that we fail to notice particular details, as we often do when, for instance, we see "a tree" rather than a tree of a certain sort, with a unique habit or form, but that we are prone to *mis-take* things in the very act of perceiving them. We take things apart where we should see them whole, or we take them together when we should see differences between them, or (and most fundamentally) we take our observations themselves in the wrong direction. Rather than devoting the whole of our energy and attention to seeing "the visible reality as it truly is," we "reduce" it (as Heidegger would say) to something that suits our own interests, our preoccupations or preconceptions, our desire to find a solution to a certain problem, prove a point, confirm a theory, or answer a question. We do this *in the very act of seeing*, forgetting that the questions themselves, the "riddles" Pieper speaks of, are what we should be trying to see.

Pieper insists that "even the most intensive seeing and beholding may not yet be true contemplation":

> Rather, the ancient expression of the mystics applies here: *ubi amor, ibi oculus*—the eyes see better when guided by love; a new dimension of "seeing" is opened up by love alone! And this means contemplation is visual perception prompted by loving acceptance! I hold that this is the specific mark of seeing things in contemplation: it is motivated by loving acceptance, by an affectionate affirmation . . . And yet, nothing in this affirming closeness to reality smacks of false idealization, nothing is embellished as if all reality were wholesome and without rough edges—not even in those instances where her statues succeed in embodying "beauty" itself.[25]

If there is a problem with what Pieper says here, it is that it is very abstractly formulated. One finds oneself merely "thinking" it, "theoretically" (in the modern sense), and not actually seeing or experiencing it. What Thoreau helps us to see is that seeing itself is an activity. To see the point about seeing, and thinking, we have to see it enacted. Ultimately, we ourselves have to enact it.

Here is Thoreau, in "Autumnal Tints":

> If, about the last of October, you ascend any hill in the outskirts of our town, and probably of yours, you may see—well, what I have endeavored to describe. All this you surely *will* see, and much more, if you are prepared to see it,—if you *look* for it. Otherwise, regular and universal as this phenomenon is, whether you stand on the hilltop or in the hollow, you will think for threescore years and ten that all the wood is, at this season, sere and brown. Objects are concealed from our view, not so much because they are out of the course of our visual ray as because we do not bring our minds and eyes to bear on them . . . The greater part of the phenomena of Nature are for this reason concealed

from us all our lives. . . . There is just as much beauty visible to us in the landscape as we are prepared to appreciate,—not a grain more. The actual objects which one man will see from a particular hilltop are just as different as the beholders are different. . . . The scarlet oak must, in a sense, be in your eye when you go forth. . . . A botanist absorbed in the study of grasses does not distinguish the grandest pasture oaks. He, as it were, tramples down oaks unwittingly in his walk, or at most sees only their shadows. I have found that it required a different intention of the eye, in the same locality, to see different plants, even when they were closely allied . . . How much more, then, it requires different intentions of the eye and of the mind to attend to different departments of knowledge! How differently the poet and the naturalist look at objects![26]

This is a challenging statement, both to understand and to put into practice. It reminds us of the challenge (the tension we spoke of earlier) that Thoreau himself faced in making sense of his own calling, or in finding his own direction. Thoreau's vocation was to realize a vision—a way of seeing and of writing that was at once humanly poetic and faithfully observant of nature. Poetry is part of culture. The poet is, literally, a "maker" (from the ancient Greek *poiēsis*, which originally refers to the very activity of "composing," putting together, or making up). How can a nature that is expressed through poetry, or poetic writing, reflect the visible reality as it truly is? How can the poet avoid "making up" what he sees, gilding it with his feelings and emotions, or substituting his own designs for those of nature, assuming that nature has *any* designs, since this very notion may be an embellishment or false idealization. This is, after all, what all cultural productions seem to involve, and Thoreau's essays (like the invisible farmhouse that catches his eye) are cultural productions. How *does* Thoreau look at objects: as a poet or as a naturalist? And what about that farmhouse? Is this dwelling (this way of life) artificially poetic, or "natural"?

Thoreau's words seem to suggest that there is a fundamental and irreconcilable difference between these two "departments," between feeling and thought, between a subjective and an objective way of seeing. But then he turns this around. It is not the poet who fails to see what is really there; it is the botanist who, preoccupied with his research interests, "tramples down oaks in his walks." It would be easier to picture this if the botanist were concerned exclusively with oaks; then, he might literally trample down the grasses in an attempt to get closer to and gain a better view of what he is studying. As it is, however, we can better appreciate Thoreau's point. The "trampling down" is done with the eyes, and not just with the feet. In the botanist's case, both seeing and walking are a means to an end. Thoreau's way of seeing (and of walking) differs from this botanist's. But how? What is it about his way of seeing that makes it any more "faithful" to reality than that of anyone else with normal or accurate vision? If anything, Thoreau might seem to be calling the very idea of seeing "the visible reality as it truly

is" into question by insisting on the relativity of vision to human interests and concerns: "The gardener sees only the gardener's garden," he writes. "A man sees only what concerns him" (pp. 173–74). What we see is always, in some way, a reflection or product of our feelings, desires, or fears.

But there is more to hope for than this. A way of seeing that projects or imposes itself upon things, one that remakes reality to conform either positively or negatively, to its own image, is a common enough condition and is not confined to poets. And so Thoreau wonders: what could get in the way of seeing "the visible reality as it truly is"? Is it simply a matter of normal or accurate vision, of our perceptual apparatus being intact, or of our having a clear and unobstructed view of things? Sensing that an objective view might itself prevent us from seeing what is truly there, Thoreau maintains that "objects are concealed from our view, not so much because they are out of the course of our visual ray as because we do not bring our minds and eyes to bear on them . . . " The possibility that the fullness of visible reality could still be revealed to us is one Thoreau wants to hold open. It is not just certain aspects or departments, but *the greater part of the phenomena of Nature*" that "are *for this reason* concealed from us all our lives."

If Thoreau were speaking only of the relativity of vision to human interests and concerns, we might expect him to promote the Postmodern idea of a plurality of perspectives among which we could choose over the course of our lives or even of a single day. I could be a naturalist in the morning (when I am doing my work) and a poet in the afternoon (when I leave my work behind to enjoy a stroll in the forest). I could have my grasses during the week and my oaks during the weekend. But this is not what Thoreau is promoting. It is not a matter of selecting between interests, each of which might reveal some part of the visible reality. If a failure to bring our minds *and eyes* to bear on reality conceals the greater part of it from us *all our lives,* then it is fundamentally a matter not just of particular "perspectives," but of ways of living, of who we are and how we live as human beings. It is a matter of our own nature: "The actual objects which one man will see from a particular hilltop are just as different from those which another will see as the *beholders* are different."

Assuming both men had normal eyesight, the fact that they climbed to the top of the same hill and share the same point of view should entail that they see the same things. This is the idea of walking as a purely mechanical means, and of seeing as a purely mechanical activity, with which we began. If one of these two men sees something more, or something different, from the other, it must be because he has his own (subjective) "take" on what lies before his eyes. Fundamentally, their physiological perceptions are the same. It is their responses that are different. Perception, what lies in the course of our visual ray, is a matter of (objective) fact. So are "the actual objects" that constitute "the visible reality."

If Thoreau seems to be questioning whether the visible reality really does stand before and apart from us as an objective fact, it is not because he thinks that what we see will inevitably conform to our individual interests and

expectations. Certain kinds of expectations reveal more than others. What Thoreau is really questioning is whether our capacity to see things and our capacity to respond to them can be separated from one another. When he claims that "there is just as much beauty visible to us in the landscape as we are prepared to appreciate," he is not referring merely to "aesthetic" qualities or values to which one might or might not be sensitive (in truth, the woods at this season are *not* all sere and brown). He is referring to something that is part of the visible reality, something that is "there," but not as an objective fact; something that is possible for us to see, but only if we have eyes for it.

Thoreau's vision was not normal; it cannot be neatly classified as poetic or as scientific, as philosophical or as artistic, as contemplative or practical. It is a blurring of all these categories or departments. What enables him to see things that "everyday" people do not? Seeing is not the same as mere sensory perception. *What you are able to see depends one what you bring to what lies before your eyes.* But what must that be? A pair of binoculars? It is not a question of just one's interests and preoccupations, but of one's occupation (in the deepest sense), or one's self. What there is to see is not just what is objectively there. Seeing requires "an intention of the eye." "Intention" suggests will or desire, and Thoreau does say that in order to see something, one has to actively look for or seek it. One must anticipate or expect it to want to see it. One needs to know what one wants, and somehow know in advance that it is there.

But we need to read more carefully. Thoreau does not use the language of desire here. While it sounds as if all men see only what "concerns" them, it is people like the botanist who are guided by the kind of practical intentions that can obstruct their vision. These are the people whose manner of walking, whose direction in life, leads them to "trample down" what they do not see (even if the trampling is committed in the act of seeing itself). The naturalist's way of seeing is, in this sense, *not* objective. It is governed by the expectation of certain results, of solutions to problems or answers to questions, rather than the questions that reality itself sets before us. In his pursuit of knowledge, he does not see the entire range of objects that stand before his eyes and beneath his feet. He fails to respect the fullness of visible reality. He may be observant, but he is not fully "in his senses." His seeing is governed by a thinking that leads him out of the forest (or the field) even as he moves more deeply into it.[27]

What does Thoreau bring to what he sees? An "idea," he writes, or image: "The scarlet oak must, in a sense, be *in your eye* when you go forth." This is not just a mental image or representation of something. The intention to see things objectively overlooks the fullness of visible reality insofar as it abstracts from the full range of our own sensory and emotional, our immediate bodily, experience. The modern theorist's way of studying things differs, in this respect, from that of the ancient *theōros*, and from Thoreau's. But then, Thoreau points to an even more fundamental difference: "All this you surely will see, and much more," he says, if you are *prepared* to see it.

What Thoreau brings with him on his walks is not an abstract idea or a preconceived image. Nor is it a concrete expectation or practical intention. It is a certain kind of preparedness. What does he mean by this? He is not referring to the kind of "preparation" the botanist may have received in graduate school. As we know, Thoreau did provide himself with this kind of preparation (however informally); he read and studied the scientific literature and natural history of his day. As important as this kind of preparation may be, however, by itself it does not fully prepare us to see. It all depends on the direction in which one takes it, on the kind of walking one does. We should notice that Thoreau does not use the word "preparation" here, which refers to something static—like a certain kind of training or body of background knowledge that one might acquire before one sets foot in the forest or fields. He talks about being "prepared." By what? By his very activity of walking. It is this that fosters the kind of engagement that makes real seeing possible.

Walking, too, requires an intention of the mind as well as the body. If Thoreau walks intently, it is not because he has a specific goal or plan in mind. His walking is not a means to an end. Nor is it an idle or pointless wandering. It is an end in itself, characterized by what John Elder described earlier as a "purposeful indirection." Thoreau knows where he is going, and what he is going to do. But his aim or destination, his work, is fulfilled by the walking itself, not by something he expects as an outcome. It is a "going to look." "The walking of which I speak," Thoreau writes, "has nothing in it akin to taking exercise . . . but is itself the enterprise and adventure of the day."

> Roads are made for horses and men of business. I do not travel in them much, comparatively, because I am not in a hurry to get to any tavern or grocery or livery-stable or depot to which they lead . . . However, there are a few old roads that may be trodden with profit, as if they led somewhere now that they are nearly discontinued . . . What is it that makes it so hard sometimes to determine wither we will walk? I believe that there is a subtle magnetism in Nature, which, if we unconsciously yield to it, will direct us aright. It is not indifferent to us which way we walk. There is a right way; but we are very liable from heedlessness and stupidity to take the wrong one. We would fain take that walk, never yet taken by us through this actual world, which is perfectly symbolical of the path which we love to travel in the interior and ideal world; and sometimes, no doubt, we find it difficult to choose our direction, because it does not yet exist distinctly in our idea.[28]

The roads that truly lead somewhere (the ones that can be trodden "with profit"), Thoreau finds, are the ones that are for all practical purposes abandoned, roads that are no longer used simply to cover the distance from one point to another. Such "discontinued" roads may, in fact, be useless for this purpose, owing to their condition. It would seem more profitable to select

a better-maintained and more efficient route, not only because the way itself is clearer (and easier and faster) but because it provides a clearer sense of where one is going ("This is the road to Boston"). How *does* Thoreau find his direction? His walking is guided, he is "moved," not just by a practical (or purely theoretical) intention, but by love. That is, a love for that to which the walking itself promises to restore him, not just health and happiness but an "awareness of being in harmony with the fundamental realities" that surround him. Thoreau does not walk in order to get somewhere or even to see something. His walking is itself a visionary activity. It is not motivated by anything else. What he sees is what moves him.

This is a hard point to grasp. When Thoreau walks, it is not simply the case that walking and seeing are happening at the same time (as is the case with most of us). They happen together, as one and the same activity. To describe this activity as "self-contained" is misleading, for it is essentially related to something outside the self. Thoreau sees with his entire body— with his senses, emotions, and intellect fully engaged—and he does so habitually, routinely, every day. This is what enables him to remain connected to his source, to learn from autumn leaves how to live and die. What Thoreau brings with him on and in his walks makes him not just more attentive, but more open and receptive to what there is to see. He discerns the "true" and varied colors of things, and in seeing those colors, responds to their beauty as well as their rough edges. He pays heed, at the same time, to what this beauty reveals—to its "ultimate foundation." He can see this because his way of seeing does not assimilate what he sees to himself and his own interests (what might ultimately be an interest in living *rather than* dying). This is what Pieper wants us to see about love. The "true contemplator," who practices the loving acceptance Pieper speaks of, does not remake the object of his love to suit himself. He does not possess it, like a piece of knowledge and "use" it for something. The transformation works the other way. Rather than turning it into him, he turns himself into it, so to speak. It becomes a model not of but for his making. He "borrows" it, like the farmer and the fisherman and is grateful for the gift. Our ability to see nature, to discern and to participate in its "ultimate reason," depends on our own nature, just as our own nature depends on it.

★　★　★

If there is a philosophical insight coming from Thoreau, it may be this: that there are things by which one has to be moved, things one has to love, in order to really see them. These are not merely "subjective" things. They are fundamental realities. We shall come back to this insight and explore it more deeply when we turn to Plato. We are not accustomed to thinking about seeing in this way. It is a challenging idea. The actual practice of this way of seeing is, perhaps, an even greater challenge. Thoreau brings this challenge to the fore when he speaks of preparedness. How *do* we prepare ourselves to see? Do we just open ourselves up, open our eyes and minds and start

walking, with no other aim in view? It cannot be that easy. *Purposeful indirection* is an art—in living as well as in writing. We cannot simply model our own walking on Thoreau's in the hope that what has been concealed from us will suddenly be revealed. That would be to treat the preparation (learning to walk) as a means (to learning to see). To participate in Thoreau's visionary walking, we would have to see as he saw. The question remains: how might we learn to do this?

This challenge is acute. It is not just a personal, but a cultural challenge. "The capacity to perceive the visible world 'with our own eyes,' " Pieper writes, "is indeed an essential constituent of human nature."

> We are talking here abut man's essential inner richness—or, should the threat prevail, man's most abject inner poverty. And why so? To see things is the first step toward that primordial and basic mental grasping of reality, which constitutes the essence of man as a spiritual being.[29]

Writing in the late 1980s, Pieper believes that the threat has prevailed, as did Heidegger a few decades earlier and Thoreau a century before that. All three seem to have thought that they (and we) were living in what Pieper calls "barren times," that something was getting in the way of our seeing what there is to see, something we could not see for that very reason and so could not easily avoid or cast aside. Heidegger suggests that our primary cultural achievement, the "abolition" of time and space, has reduced everything to a "uniform distancelessness" and made it impossible for us to experience anything as truly near or as truly remote. Neither he nor Thoreau believe there is any easy answer to the question: what are we to do?

Thoreau brings us to the point of acknowledging the reason for this. He enables us to see the nature of the challenge we face and to respect it as the challenge that it is—as a challenge not just for abstract philosophical thinking, but as a practical challenge. This does not necessarily mean that it calls for a practical solution (that this is a problem that needs somehow to be "fixed"). It means that it takes a certain kind of practice to meet it.

The fundamental problem is this: if one has to love in order to see, how does one come to see? Does one first have to fall in love with something before one is really able to see it? If so, how is one moved to love it, if love is a precondition for seeing it in the first place? To truly love something, one would have to see it as it really is. One would have to see it with one's own eyes in order to see what is truly lovable about it. But if Pieper is right, seeing something with one's own eyes ("seeing things in contemplation") must itself be motivated by love. One has to be moved in order to see, but one has to see to be genuinely moved. How does this work? How does this affirmative beholding come about, if to learn to see one must learn to love? Which comes first? Who, or what, would have to move us, and what would this "moving" experience have to involve?

There seems to be no way to analyze this problem, to separate the loving from the seeing in such a way that we could explain how one causes the

other and that may be just what Thoreau wants us to see. If we cannot solve it analytically, we have no choice but to walk into it in the hope that something, or someone, will guide us. This hints at an answer to an earlier question: is there a *religious* insight coming from Thoreau? We hope that an affirmative answer to this question has emerged over the course of these pages. It should be clear enough (and is fairly well known) that Thoreau's essays do not advance any religious doctrine (not even a distinctly Transcendentalist one). To reduce Thoreau's insight to any kind of formula would be a mistake (to mis-take it, in the sense we discussed earlier). Alternatively, one could look to Thoreau's frequent references to the spiritual, or to the more isolated instances of mystical experience that are conveyed in his writings. While we would not want to discount these, there is another, more prevalent sense in which Thoreau declares himself to be a religious thinker. Thoreau not only walks religiously, his walking is itself a religious practice, a ritual.

"Ritual" is a word that has come to be defined in specific ways, demarcated by the field of Ritual Studies. It originally derives from the Latin *ritus*, meaning not only a custom or usage (as in the English "rite") but a "going" or "way." Its deepest routes may actually lie in the Sanskrit *ri*, meaning "to flow" (as in a river or stream). While the meaning of the word may have changed, these sources have not entirely dried up. We need not picture ritual as merely a compulsory (or compulsive) repetition or routine. We can also see it as active movement, a passage or way that leads us somewhere, not as a means to an end, but in the way that the old roads (or routes) Thoreau liked to follow led him somewhere only when they are "nearly discontinued." A ritual is, in this sense, a way "that may be trodden with profit." It is a process, but not one that is merely productive. It is a routine, not in the ordinary sense (in which it means simply "ordinary"), but in the sense in which this word too refers to a "route."

Thoreau begins his essay on "Walking" with his own speculative proposal as to the origin of the word "sauntering." It is "beautifully derived," he claims, from *Sainte-Terre*: a "saunterer" was originally someone who walked, or made a pilgrimage, to the Holy Land. "They who never go to the Holy Land in their walks, as they pretend, are indeed mere idlers and vagabonds," he writes, "but they who do go there are saunterers in the good sense, such as I mean."[30] Thoreau's etymology could itself be an idle jest (fanciful as it seems, the derivation of "saunter" remains uncertain). But there may indeed be an "original meaning" that lurks here; that is, a truthful insight into how something as everyday as walking might constitute what Pieper calls "an activity that is meaningful itself." Thoreau's walking is fundamentally contemplative, and contemplation, Pieper suggests, is fundamentally religious:

> Whenever in reflective and receptive contemplation we touch, even remotely, the core of all things, the hidden, ultimate reason of the living universe, the divine foundation of all that is, the purest form of all archetypes (and the act of perception, immersed in contemplation, is

the most intensive form of grasping and owning), whenever and wherever we thus behold the very essence of reality—there is an activity that is meaningful in itself taking place. Such reaching out in contemplation to the root and foundation of all that is, to the arche-types of all things, this activity that is meaningful in itself can happen in countless actual forms.[31]

The fact that Thoreau's walking is entirely physical, fully embodied, and puts him directly in touch with material reality—the "particulars" of the world around him—makes it more and not less contemplative, more and not less religious. It is his faithful observation of the autumn landscape that yields a fundamental lesson in the meaning of life and death, while our own "boasted faith in immortality" seems not to have taught us to "lie down as gracefully and as ripe." At the very end of this same essay (which Thoreau wrote as he lay dying), he offers a curious gloss on the passage, quoted above, where he talks about seeing as requiring an "intention of the eye":

Why, it takes a sharpshooter to bring down even such trivial game as snipes and woodcocks; he must take very particular aim, and know what he is aiming at. He would stand a very small chance, if he fired at random into the sky, being told that snipes were flying there. And so it is with him that shoots at beauty; though he wait till the sky falls, he will not bag any, if he does not know its seasons and haunts, and the color of its wing,—if he has not dreamed of it, so that he can *anticipate* it; then, indeed, he flushes it at every step . . . The sportsman trains himself, dresses, and watches unweariedly, and loads and primes for his particular game. He prays for it, and offers sacrifices, and so he gets it. After due and long preparation, schooling his eye and hand, dreaming awake and asleep . . . he goes out after meadow-hens, which most of his townsmen never saw nor dreamed of, and paddles for miles against a head wind, and wades in water up to his knees, being out all day without his dinner, and *therefore* he gets them. He had them half-way into his bag before he started . . . The true sportsman can shoot you almost any of his game from his windows: what else has he windows or eyes for? . . . The geese fly exactly under his zenith, and honk when they get there, and he will keep himself supplied by firing up his chimney . . . The fisherman, too, dreams of fish, sees a bobbing cork in his dreams, till he can almost catch them in his sink-spout.[32]

What the hunter and fisherman (and Thoreau himself) are "anticipating" is a kind of fulfillment, that walk that "we would fain take," whose direction is subtly indicated to us and which we are mysteriously able to discern. It is for this that he prepares "unweariedly," "schooling his eye and hand." It is for this that he prays and offers sacrifices. And it this that he is able to discover, not just in the remote fields and forests (where we would initially expect such game to be found) but much closer to home—right outside the

window, and even in the kitchen sink. That is, in particular everyday places where the unprepared would not know to look (and where, even if they looked, they would not see):

> These bright leaves which I have mentioned are not the exception but the rule; for I believe that leaves, even grasses and mosses, acquire brighter colors just before their fall. When you come to observe faithfully the changes of each humblest plant, you will find that each has, sooner or later, its peculiar autumnal tint . . . (P. 177)

"What else have we windows or eyes for?" Thoreau might have included feet and hands here. For while his walking, and the prepared vision that goes along with it, is indeed contemplative, it should lead us to question a way of thinking about contemplative activity that Pieper himself seems to share. "An activity that is meaningful in itself," he insists, "cannot be accomplished except with an attitude of receptive openness and attentive silence—which . . . is the very opposite of the worker's attitude marked by concentrated exertion."[33] Thoreau's contemplative attitude is indeed characterized by receptive openness and attentive silence. This is what he brings with him on his walks. But the walking itself, the physical movement or sauntering, into and through the forests and fields is no less essential. An attitude can be fully and deeply contemplative without being (what we sometimes call) meditative. If we fail to appreciate the "concentrated exertion" that accompanies Thoreau's equally concentrated perception, the way in which this perception is embodied, then we overlook not just the means to but the very nature of his visionary activity. We fail to appreciate precisely what it is that makes his vision a *prepared* one. More importantly, we will not see how fully available to us this vision really is.

"If I have learned anything in the garden," Michael Pollan writes,

> It is that the romantic's blunt opposition of nature to culture is not helpful. The romantic metaphor offers us no role in nature except as an observer or worshipper; to act in nature is to stain it with culture.[34]

There may well be romantics out there, past and present, who really think this. But Thoreau is not just an "observant" worshipper, in this sense. Indeed, it is only by understanding the sense in which Thoreau *does* act in nature that we can see him as truly worshipping it. This is the kind of worshipful interaction he describes on his walks, the borrowing for which nature provides the model, or source, and which Thoreau's activity (his walking and his writing) models for us. Thoreau *is* a worker. His is not the attitude of the worker for whom the work is only a means to an end, an action that is aimed entirely at a separate result. We shall have more to say about how the work of contemplation might differ from the kind of productive work by which our lives are largely if not wholly governed, and about how it bears its fruit. Thoreau can help us to understand what contemplative seeing

might really involve. But we ourselves will not see this if we do not attend to the doing in which his seeing is embodied. Thoreau's work offers an insight into what the work of both the artist and the philosopher might fundamentally involve. But ultimately it offers an insight into the work of being human. For the attitude Thoreau models for us *is* the attitude of mortality.

> So we saunter toward the Holy Land, till one day the sun shall shine more brightly than ever he has done, shall perchance shine into our minds and hearts, and light up our whole lives with a great awakening light, as warm and serene and golden as on a bankside in autumn.[35]

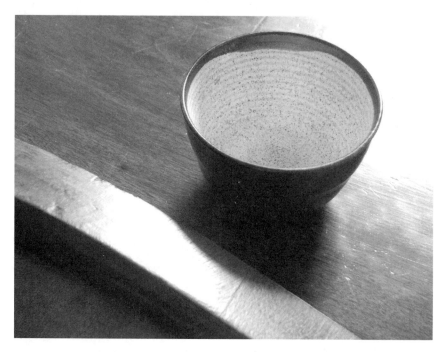

Plate 2 Pottery bowl by Ann Newbury, Cape Cod, Massachusetts, 2003 (Collection of the author). Author's Photo

CHAPTER TWO

The Beatification of the Mundane

> At the moment of meeting, the art lover transcends himself. At once he is and is not . . . It is thus that art becomes akin to religion and ennobles mankind.
>
> —Okakura Kakuzo, *The Book of Tea*

Faraway lands and exotic delicacies, graceful tea ceremonies, warrior swords, kingly harps, and exquisite quills play across the surface of this diminutive text—*The Book of Tea*.[1] An odd turn to take, especially after Thoreau's frankly down-to-earth field of study with which the tea ceremony makes a rather odd coupling indeed. After all, Okakura Kakuzo lived considerably far removed from woods, in Asian tea-rooms and the galleries of high art museums, among fabled myths and ravishingly gossamer images of "the Orient" in pen-and-ink. Art connoisseur, curator, defender of Japan's cultural legacy, Okakura is no Thoreauvian American naturalist. On the face of it, the consummate formality and absolute aestheticism of *The Book of Tea* look utterly and impossibly opposed to the rustic walking celebrated by Thoreau.

Yet, odd as it may seem at first, these authors hold more than a few ideas (and even practices) in common. Thoreau and Okakura both were critical of "Western" ways. Okakura's critique was, if anything, less restrained than Thoreau's. But the message of *The Book of Tea* is not simply "Go East, young man." Thoreau and Okakura were both concerned about the effects of industrialization on how we live and who we are as human beings. The "West," for both men, was not so much a place as an attitude—one intimately bound up with industrialization and its impact on culture. Thoreau left the city for the country not to forsake culture but to regain a wholeness by returning to its source; Okakura strove to save culture through an urbane way of living. While Thoreau tends the root, one might say, Okakura looks to the flowering. Either way, a shared perspective on the bane of industrialized living everywhere stands at the heart of their philosophy.

This point of view, often taken for nostalgia or at least a dose of antimodernism, continues to feed a somewhat negative reception of their works. Both are charged not only with a certain kind of conservatism (ironic, perhaps, in the case of Thoreau), but more fundamentally with what our students often see as a brand of elitism. As they see it, the lessons both authors expect to pass on are hardly relevant to most of us living in the modern world. A similar charge might be directed at this book, as well. Indeed, throughout these pages, we often call upon what may seem unfamiliar or exceptional, and perhaps even elitist. We do so, frankly, in hopes of raising our level of existence, not maintaining it as it is or—and this is important to stress—turning it back to the way things were. From ancient philosophy to the seemingly esoteric visions of Heidegger and Robert Motherwell, we introduce these images and ideas in the hope of channeling what is exceptional into what is everyday. We are mindful of the charge of elitism, then. But we also need to be mindful of what the word itself really means. Privilege can be a source of unwarranted pride or prestige, of unjustified superiority or authority. But then, it can also be an occasion for gratitude, when we are reminded that something is a privilege rather than a right.

Thoreau and Okakura devoted their professional time to writing about living, especially about what constitutes a life well lived. They were concerned with the problem of character and how it is most deeply informed by the attitude toward mortality. They both explored the notion of daily living not as an abstract idea, but a concrete performance, and the contentment it could afford. Both considered "practice" to be central to this process, in the sense of routine actions, the sorts of tangible and specific activities in which we habitually engage. We use the word "ritual" in this book to refer to and summon the deepest essence of that activity, in which thought and action are inseparable, all the senses are at work, and the body becomes a primary locus of meaning. For Thoreau and Okakura, habits of ritual cultivate attitudes in us—attitudes that in turn hold forth the promise of living a meaningful life.

Walking "religiously" was for Thoreau an activity of that sort. Certainly the idea of contentment developed here is not the usual one. It has nothing to do with the unlimited availability of "goods"—scores of cereals, hundreds of cable stations, nearly unending options of clothes and home decorations.[2] Contentment, as we mean it, is different. It is marked by the "loving acceptance" that Pieper associates with our ability to "celebrate a feast," not the exceptional feast that we celebrate only on certain holy days, but the feast that is life. It is in this sense that the ability to celebrate a feast, as a ritual practice, is essential to our humanity. It is a source of contentment not because it "satisfies" us, but because it promises to make us fully human by restoring us to the fullness of life itself.

This is the kind of contentment that Sloane also celebrates in his own way. For Sloane, it means accepting life and all that goes with it, not just the pleasant or profitable. As Sloane sees it, such acceptance is realized through

craft, making and use, and through working with wood in particular.
Walking was Thoreau's way, for it ensured that he participate in nature open
and aware, observing it "poetically," with a body and mind that were
engaged, receptive, and discerning. Thoreau was seeing "contemplatively,"
but he was seeing through walking. In this way, his living became active,
animated, and reverent.

Okakura offers some of these same lessons about contentment and living
well. Tea, he contends, teaches us "the art of life." Like the wood with which
Sloane so loves to work, it provides the occasion for a certain kind of
activity—not just a means to an end—but the kind of activity that Pieper
describes as meaningful in itself. Tea, for Okakura, is or should be an object
of reverence, not in the cultish sense, but in a sense that we develop
throughout this book. It is perhaps too easy to regard the Japanese tea
ceremony as a ritual, given its religious associations. Even for those who are
unfamiliar with the historical or cultural background, the ritualistic aspects
of this otherwise ordinary activity are superficially striking. It is a
"ceremony," after all, in a way that Thoreau's walks seem not to be—not at
first glance, at least, or on the surface. The ritual character of Thoreau's
walking, however, is not superficial. Nor, we would argue, is the ritual char-
acter of the tea ceremony. There is a deeper layer of meaning, or of mean-
ingfulness, that Okakura's text (as elegantly crafted as the ceremony itself)
helps bring to light. What Okakura sees in tea is what Sloane sees in wood:
something that invites us to perform, or practice, certain actions every day.
We can treat tea differently, of course; or rather, we can treat it the way we
treat most things. That is, as just an ordinary beverage we occasionally enjoy,
"occasionally" in the sense of "from time to time." In this sense, it really does
not take much practice, or demand any kind of ritual observance. This is the
way we usually treat walking, as something we act upon. As Okakura sees it,
there is something about the nature of this "thing" that calls for actions that
are not just performed casually and carelessly, but are "occasioned" in a
deeper sense.

Drinking tea is a daily, and thus a repetitive, occurrence, like Thoreau's
walking. It forms habits, of a particular sort, and this is essential to Okakura.
These are not the mindless (and inherently meaningless) habits that border
on addiction, like the "habit" of drinking three cups a day. The ritual
significance of the tea ceremony derives from these habits. The tea cere-
mony displays and imparts "values" or qualities that are not merely aesthetic
but (hopefully) also human—qualities such as simplicity, regularity, beauty,
and humility (the very opposite of what we usually mean when we cry elit-
ism). The tea ritual thus cultivates refinement and helps to "regulate," in
Okakura's term, our daily existence according to the same features that
regulate it.

How could living, which we think of as being so practical, be regulated
by anything as impractical as a formal tea ceremony? For Okakura, the
formalities of the tea ceremony do not operate like zoning or parking
regulations—as something imposed from above. He means regulation in the

sense of a habit, something that through its repetition, its daily nature, gives form to our lives, quite literally. This sense of "regulation" is drawn from the Latin, *regula* meaning rule, order or measure, not so much a set of rules as something that was regular, straight, or properly adjusted (like a ruler or a carpenter's square). Out of the practice of doing, out of the habit, the particular qualities of the formal elements of the practice become embodied, literally taken into our bodies. Drinking tea, in this sense, is like walking.

How is it that such exceptional rituals have something to teach us—we who live in the present? In some ways, Okakura's lessons might appear more remote, less germane than even Thoreau's. After all, walking, even religiously, is not all that alien. Yet those four hours of daily walking were hardly ordinary. They were undertaken with discipline, as a habit and with eyes that see more widely and deeply than our personal and professional interests normally allow. More importantly, like Okakura, Thoreau wrote down his experiences. In that way, both men were planted in culture, sustained by the art of writing. They speak to us even as, and largely because, they are able to nourish their solitude.

Thoreau left nature behind to return to culture and so to work through the immediate and unmediated power of his personal, physical experience. The fruits of this working through are the essays he wrote in Concord (not at Walden Pond) and they are works of art. The labor of walking—work that is not just a means to an end—comes to us through his literary work. Thus, although Okakura inhaled atmosphere that was sweet and rarified, compared with Thoreau's crisp and more familiar New England air, both demonstrate that being alive, being fully human, has its roots in what seems at first to be exceptional and elitist, and hardly commonplace. And yet, as they teach it, each is a daily and thoroughly habitual action: the solitary life of a walker and the exquisite formality of a tea drinker.

We now may speak to the notion of elitism more forthrightly, for now we can see how something that is exceptional can at the same time be habitual and everyday. Perhaps we would do well, then, to distinguish between the "ordinary" and what in this book the authors mean by everyday. The everyday, in this sense, is what we do *every* day. It has more to do with habit and discipline, with the nature of our routines, than with what it has come to mean in our culture where art and philosophy are set apart from what we experience as "everyday life." These days, the "everyday" is taken to be synonymous with the ordinary. Both have come to represent what is *not* special, what is disposable, precisely that which lacks the quality of the festive (in Pieper's sense). In this book, we view what is everyday as fundamentally concerned with the daily performance of activities that do possess these qualities, and that promise to restore them to our lives. Our aim, in doing this, is not merely to draw a technical distinction in the meanings of words, but to encourage this same fundamental concern in our readers. Viewed this way, Thoreau and Okakura, and their exceptional routines, help us to picture some specific ways to live well every day. To

restore a sense of the meaningfulness of daily practice to daily life is what these texts ultimately help us accomplish.

* * *

In actual fact, Okakura was geographically closer to Thoreau than we might suspect, working in Boston, and thoroughly immersed in Western culture. He was Curator of the Department of Chinese and Japanese Art at the Boston Museum of Fine Arts and at "Mrs. Jack Gardner's Museum" on the Fenway, where he first read aloud *The Book of Tea*, in English, at one of his patron's celebrated *salon* gatherings in 1904.[3] His background, the circles in which he moved, the sort of art he esteemed, all played into Okakura's sense that the tea ceremony encompassed qualities of form above all else. The form of the ritual was the nucleus of meaning: the precise choice, color, and placement of flowers mattered, specific gestures and costumes carried ethical weight, and materials (from the tea itself to the serving implements) were selected for their ability to guide intuitions toward subtle meanings of life. In these and other ways, the tea ceremony offered formal gifts to its daily celebrants.

It was an epoch-making time, the turn of the twentieth century, when abstraction was burgeoning and nationalist art movements reigned. Okakura was a central figure in the national art movement in Japan, leaving an intriguing legacy of contacts and impacts, not the least of which was *The Book of Tea*, curiously enough, given its genesis and intended audience in the United States. He was one of the key figures in founding an art of nationhood, similar to his contemporary, Akseli Gallen-Kallela of Finland.[4] These men brought cultural treasures from what then were considered the geographical margins to what was taken to be the centers of the art world—America and, in Gallen-Kallela's case, Paris. Both artists sought to preserve what was distinctive, indeed what was definitively "ethnic" about their country's art, while showcasing its superior artistic accomplishments for international audiences. With his involvement in such an undertaking, it is not surprising that Okakura knew and admired a number of figures prominent in the "art for art's sake" movement in the English-speaking world, John La Farge and James Abbot MacNeill Whistler. These were key figures in developing and promoting an abstract art—an art in which formal concerns are given primacy over symbols or stories. They sought to define painting as its own language, a hermetic language of abstract color and form. The lyricism of line, the density of hues, the patterns on the surface of the composition, these are the formal concerns through which, it was argued, one arrives at essences, deeper values, where the real subject matter is light, color, weight, solidity, and so on.

These associations supported and fed Okakura's belief that form alone is the most significant source of meaning, though he carried this a step further, as we shall see, in his understanding of the relationship of art to daily

life. Curiously, for being so avant-garde in terms of trends in contemporary art, Okakura turned his back quite emphatically on almost everything else in contemporary culture, especially, as we noted, the rampant industrialism lurking in the masonry canyons of the urban landscape. The Gardner Museum—where we picture Okakura being very much at home—epitomized a privileged environment, literally walled off from the urban world, a sacred shrine for art, where objects and pictures were sequestered from the hustle and bustle of ordinary life and ceremoniously displayed in the vaulted silence of gardens, fountains, and hushed footsteps. Okakura was deeply immersed in that place where nostalgia, it might easily be argued, held court; where everything from building style to the collection of exotic plants to the kind of music wafting through the open court windows recalled a bygone era. Okakura's intimacy with the Gardner Museum is telling, for everything about the world Okakura inhabited shunned commercialism, mass production, and mechanization.

The Book of Tea bespeaks this seemingly elitist, esoteric world, so exotic, so foreign with its refined language, pristinely conceived ceremony, rare flowers, lavishly painted scrolls, and songs of kings, warriors, and harpists. The text itself not only reflects such a world, it belongs to and in some sense is such a world. It reads as the very embodiment of what is outside of and beyond the ordinary, the effete, the aesthetic, and the beautiful. Indeed, Okakura's aestheticism has been perceived as a sort of Orientalism, the very essence of exotic, different, and "other." He himself was well-aware of this construction of Asian identity by many in the West, and was in reaction sharply—and perhaps too inclusively—critical of it:

> The average Westerner, in his sleek complacency, will see in the tea ceremony but another instance of the thousand and one oddities which constitute the quaintness and childishness of the East to him . . . We are pictured as living on the perfume of the lotus, if not on mice and cockroaches.[5]

By comparison, Thoreau seems firmly grounded in our own America, even if most of us do not live in the woods or sit by the hearth in the dim glow of twilight. Nevertheless, the authors of this book believe that what Okakura helps us to see, in and through the "oddities" of the tea ceremony, may actually guide us in our lives, just as well as Thoreau does. Okakura helps us see the opportunity for our everyday routines to become practical—and practiced—ways for us to live artistically and philosophically, by which he means *more beautifully*. It is this opportunity that both he and Thoreau set over and against a complacency that is too often mistaken for contentment, but is in reality strangely mixed with restlessness and the hectic pursuit of we know not what.

This is the aim of the present essay: to ask why living should *not* be an art, why our daily rituals should *not* be "artistic," and what this could

really mean. Okakura provides an answer, but to hear it, let alone to learn from it, our own judgments about art must be left behind, at least momentarily. Here again we need to be careful. If we do not approach Okakura's views sensitively, seeing through and with him, this notion of "living beautifully" will seem like mere aestheticism, the surface appearance and superficiality of form. We know people who have surrounded themselves with beautiful objects, but have otherwise eschewed the art of living beautifully. No habits, no "practices" surround these things, which are merely nice to look at in what is indeed the most superficial of senses. Money can buy fine art, but it cannot purchase the ethically transformative experience that accompanies a contemplative awareness of, and openness to, the beauty of form.

This kind of awareness, and all that it entails, is what Okakura means by living artfully and beautifully, that is, a profound engagement with what is fundamental in art. Of the many books concerned with "the art of living"—the phrase has become so commonplace even in philosophical discussions that the very idea is practically drained of all sophistication and depth—few, if any, reflect upon what it means to say that something is an art. Nothing much is illuminated by all this talk about the art of living in the absence of any real wonder about what art is. Here, Okakura distinguishes himself with clarity and perspicacity of judgment. Like Thoreau, it is his eye for detail evident in the subtleties and nuances pervading *The Book of Tea* that enables Okakura to offer more than just a slogan.

Okakura does not mean art, as our culture ordinarily understands it, as a class of objects housed in museums or exhibited in art galleries. Fine art is art, too, of course, as Okakura was well-aware, since he lived in such close proximity to so much of it. It was precisely because he lived with it, however, that Okakura was able to understand art in the way in which we are trying to understand it in this book: as a place of connectedness, through particularized awareness, between ourselves and fundamental sources of meaning. Art, for Okakura, is not just a cultural product. Nor is it merely an "object" of experience, which we confront as mere "subjects." The kind of experience for which works of art provide the occasion is, for Okakura, the same kind of experience that originally gives life to them. Art, then, is a mode of awareness. It comprises the "formalities" both of the work itself and of our response to it. Art is an attitude of reverence for the particular forms that beauty takes: its ephemerality, its regularity, its fleeting color, the simply drawn shapes of petals, the lines of pathways, and so on. Whatever, through daily habit, cultivates a way of seeing in which doing and thinking are unified, in which we, the beholders, participate fully with all our senses prepared to embody and embrace this particular beauty—this is art. Art is active seeing. Thus, drinking tea is not just "an art." It is art.

Viewed as a constellation of habits, rather than a category of object, art is both a mirroring and a molding of our lives. For Okakura, it is the very precision and refinement with which we execute daily ritual that matters; for there, in the smallest detail, we both reveal and realize who we are. The

subtlest action manifests the greatest and most profound insight:

> For life is an expression, our unconscious actions the constant betrayal of our innermost thought. Confucius said that "man hideth not . . ." The tiny incidents of daily routine are as much a commentary of racial ideals as the highest flight of philosophy or poetry. (Pp. 20–21)

That the most ordinary actions reveal our innermost condition is central to the thinking of this book. Understanding this, our seemingly trivial and commonplace daily routines become settings in which the real and most fateful drama of our lives is played out. Certainly, the current practitioners of the discipline of sociology make profitable use of the interactions between routine and the construction of identity, or self in their terms. Okakura's text helps us to think about this in a fresh way. Beyond observing the interaction between rituals and persons, we must acknowledge that changing the rituals can and will change us, as well. This is not just a social science fact; it is an ethical promise. This is why reading *The Book of Tea* matters: it is a superb example of how one such ritual inculcates the sort of inner character that helps us live a life that is not just artificially elevated, or "elite," but genuinely uplifted by what its gaze is set upon.

In our time and culture, the extraordinary events—weddings, graduations, birthdays, holidays, and funerals—are what matter most. We seldom realize that the marrow of human life is being fed day in and day out, when we wash dishes, scrub floors, clean teeth, bathe, eat, and drink.[6] Okakura's text—not despite, but rather because of its artful qualities—encourages us to attend more closely to these activities. Performing them artfully *or* mindlessly determines, whether we know it or not, the innermost reality—and ultimately the distinctive meaning—of our lives.

This is not as easy to see as it seems, or as many books make it sound. There is still more to our view of art that gets in the way, just as it gets in the way of a perceptive reading of *The Book of Tea*. The question of "Art *versus* art" is further confounded by the fact that everyday life, what was popular or familiar, migrated into Art in the 1960s. With artists like Andy Warhol and Roy Lichtenstein, such ordinary things as soup cans and cartoons, found their way into museums and the world of high art. That hushed space of untouchable objects was filled with images of Vietnam and Marilyn Monroe, coke bottles, and TV ads. This trend continues in the twenty-first century, where art remains largely preoccupied with social and political issues, feminism, consumerism, racism, media-communication, "texting," and the like. Many greet this as a welcome coincidence of art, ethics, and everyday life, or of art's recovering its sense of moral responsibility. But is it, really? Ultimately, this is life becoming Art; not art becoming life. If we fail to see this difference, we shall be unable to appreciate the seemingly paradoxical lesson of *The Book of Tea*: that what *seems* extraordinary and effete, this art of drinking tea, is more genuinely celebratory of the everyday than any Warhol. It is also more genuinely "ethical," bearing in

mind the origins of this word, from the Greek *ethos*, which concerns not just what is morally or politically correct but a whole character or way of life.

Works by Warhol fetch millions of dollars and artists like him continue to layer their imagery, however current, with a tough theoretical veneer, quite impossible for most of us to get through. This has led, if anything, to a new and more insidious form of elitism. The aim of art, as we see it, is not to remove the familiar from its everyday setting, giving art a pseudo-accessibility that actually makes the everyday less accessible. Together with Okakura, we would locate art *in* life, manifest in our common practices and daily habits. What is truly paradoxical, perhaps, is the way in which modern culture—art, philosophy, and even our everyday practices—has made us less mindful of these practices as sources of beauty and meaning.

<p align="center">★ ★ ★</p>

Okakura furnishes a concise history of tea; yet, to appreciate the book for that reason alone would be quite mistaken. Certainly, there are better and more complete accounts of the beverage with its tremendous role not only in Asia and the European continent but in America, as well, where tea played no small part in our own history. Rather, Okakura's fleeting account is meant but to open our eyes, quickly and deftly, to tea's intimate ties with philosophy. His aim, in other words, is to help us see, in the drinking of tea, a place, or occasion, where the physical and the metaphysical are joined. For Okakura, the ideal of "Teaism," as he terms it, stems from Zen philosophy, with its emphasis on "the mundane as of equal importance with the spiritual."[7] Nonetheless, *The Book of Tea* does not presume to be a book about Zen Buddhism. Here again, Okakura's focus is more particularized. He saw Zen philosophy as originating the ethos in which everyday tasks offer the finest possibilities for living in a perfect and perfectly beautiful way:

> Thus many a weighty discussion ensued while weeding the garden, paring a turnip, or serving tea. The whole idea of Teaism is a result of this Zen conception of greatness in the smallest incidents of life . . . (P. 52)

For Okakura, the fundamental meaning of the practice of Teaism was founded on this idea of finding "greatness" in small things, in the most irksome of tasks, and in daily work. Teaism constituted "the simple and fundamental law of art and life" and that the truly beautiful must be in both (p. 20). What sort of beauty does he mean? And why is it fundamental to life?

To begin, let us be clear that drinking this beverage was not, in Okakura's view, simply a material necessity; drinking, and the entire range of activity that surrounds it, he considered meaningful as well as necessary. For Okakura, drinking tea is an occasion for participants to *drink in*, literally and

figuratively, what is beautiful. Two aspects of the ceremony are impressive—and essential, should we wish to make sense of the relevance to our lives of ritual, as Okakura understands it. First, that the tea ceremony, designed and executed by a tea master, is staged elaborately and as a performance of sorts. Second, that the details comprising the ritual become the locus of profound philosophical meaning in a way that essentially depends on the celebrant's heightened awareness of them.

Think for a moment, on the lowest scale of ritual, how travel disrupts the smallest but most usual of our habits like washing our hair or brushing our teeth. We become keenly aware, often uncomfortably so, of the daily routine precisely because details have been modified, altered, and hence disrupted, for they have been replaced by strange and unfamiliar ones. When it comes to festive or ceremonial ritual, this point—the constancy of props, costume, and spatial arrangement together with an equally constant shifting of the particular details through which the "universals" are expressed—is the most elusive, but also the most essential feature.

Both of these aspects have to do with form, but not form as a standard or principle to be adhered to, like an algorithm or set of rules governing a fixed sequence of actions. The formalities of the tea ceremony do not yield specific results the way putting a dollar in a vending machine yields a diet soft drink. This is form as it lives in nature, where, for example, consistent types of plants are modified by soil, sun, climate, and, of course, the gardener. The question, then, is: what could it mean to play a role in this performance, and how does the matter of variation and deviation of detail affect the participants?

As mentioned, the tea ceremony, for Okakura, is a performance, repeated daily in the same setting. Like a theatrical performance, the tea ritual has recurrent features—the tea-house, the equipment, the master, the costumes, even the gestures are "scripted." If we imagine a play, we can see the stage, the props, the director, and the performers. Some of these aspects are absolutely constant during the run of a show. The tea ceremony comprises similarly unchanging elements. There is always, for instance, the matter of the flower, as we shall soon see. Yet, these entities, stable and constant, are modulated by subtle and artful deviations and variations—a change of the flower, the passing and renewal of the seasons of the year, and even the selection of the kind of leaves to brew. Every aspect of the ceremony is deliberately and consciously considered for its *particular* effectiveness, at specific times of the year, and with due respect to certain kinds of tea and the manner of their preparation.

This sounds simpler than it is. For one thing, it is far more variable than a stage production. Each day, the master singles out or alters essential details, subtlely adjusting the formalities of the ceremony and thereby refining and varying the ritual. In this way, he animates the form itself. Only one who is intimately familiar with both the ceremony and a given master's individual style will be alert to the nuanced variations and to the meanings contained therein.

Our reductive and disposable economic mentality, in which one plastic foam cup is as good as another, can hardly be expected to grasp the consciously elaborate and constantly metamorphosing simplicity of the tea ceremony, let alone the rationale that would encourage the slow tempo of drinking and emphasize an appreciation of what seem to be items of mere convenience, such as napkins, or for how long or at what harmonic level the kettle whistles. Like reading the text itself, we are encouraged to modulate our tempo in order to hear "the pitch." Indeed, one of Okakura's aims throughout *The Book of Tea* is to demonstrate how the aesthetics of the tea ceremony both reveal and exert over the participants comparable aesthetics of living well and beautifully. "Tea with us becomes more than idealization of the form of drinking," he says, "it is a religion of the art of life." (p. 38)

Okakura's tea is something quite different from the foil-wrapped tea bag dunked in (often microwaved) water and belted down from a disposable cup while driving to the mall. Our tea bag is not "tea" any more than walking to the car after work is taking a walk in Thoreau's sense. The point here is that while, indeed, we may do these things—we do take walks and drink tea—we do not "perform" them in the way that Thoreau and Okakura meant us to, as rituals. Okakura believes the ritual of the tea ceremony is not only habitual and practiced but also leads, ultimately, to a nobler and more beautiful sense of reality. The end and the means, then, are identical in Okakura's ritual, the performer or celebrant, and the formalities of the ritual itself, merge in the ritual processes. Fundamentally, this—rather than what we usually see as its elaborate contrivances—is what distinguishes the tea ceremony from actions that are aimed mainly at consumption or the production of some generic result. It is not simply the external trappings that set the tea ceremony apart; it is the nature of the activity itself, in which inside and outside, ends and means are joined.

Not every aspect of the tea ritual is foreign to us. Most familiar to westerners is the architectural design and structure of the teahouse. Frank Lloyd Wright gave the beautifully austere aesthetic of the Japanese tea-house visibility and viability to suburban Americans at the turn of the last century. He incorporated its clean lines, screened vistas, and crisply ordered geometry into his own Americanized style. Curiously, this was at the same time that Okakura was battling against just this sort of appropriation of Asian forms, which he saw as draining Japan of its inimitable culture. The tea-house aesthetic, then, is not unfamiliar to Western eyes. This very fact, however, can make it more difficult for us to perceive the meaning of the ritual that takes place in and around it—of the intimate relationship between the structure and the things to which it gives order, the ceremony and those who celebrate it. We in the modern West, and especially in America, have a history—by now an accepted tradition—of putting whatever style from whatever context into whatever setting we want. We have Swiss chalets in malls, temple fronts on suburban residences, and pediments standing freely and absurdly over flat-roofed medical centers. Our Postmodern age has neutralized forms and styles by taking them as just

another batch of design choices like the logos and gifs that we now randomly insert into our texts from our computers. Wright's example stands at the beginning of this tradition, before such borrowing became arbitrary, ironic, disrespectful of and ungrateful toward its source. The problem now is that our current global age has almost totally lost the eye for—and any deep interest in—architectural context as a meaningful point of reference. Such current design practices make it difficult for us to see, let alone appreciate, the essential nature of the ritual as Okakura presents it: the wholeness of the architectural structure, the material things, and the ritual ceremony. For Okakura, and for the authors of this book, the recovery of this wholeness promises an insight into what is needed to restore our own wholeness and integrity.

For Okakura, these "things" that we tend to view as mere accessories or props are as indispensable to the ritual as is the setting. Everything—the ingredients, the storage cabinet, the brazier, the ceramic cups, bamboo dipper, and linen napkins—has an all-important role in the ceremony. No item is small or insignificant; all things are essential and, what is more, inseparable from the ritual. For most of us, any cup will suffice as well as another; tulips will decorate our table just fine if we cannot find holly in January; any serving dish is as usable as another, so long as it holds the food. And who among us would consider it crucial to transfer our coffee from its paper cup to a real ceramic mug once we get to work? For many, the significance of even the minutest detail is not easy to see, or to understand. This is where the master comes into play.

The tea master selects and arranges all these things, but he does so selectively. He is an artist, the ritual is his canvas, the celebrants both subject and object, participant and viewer. The tea-house is the stage, but one on which inside and outside are kept in close conversation. Okakura calls the ceremony "an improvised drama whose lot was woven about the tea, the flowers, and the paintings" (p. 33). Every detail is chosen as to how it could harmonize with the place and time, the particular season of the ceremony. The master sees to it that the walkway is swept clean with the vital exception of the few leaves that fall naturally in his wake. His "leaving" them is as artful a gesture as is the sweeping. Then the flowers (the renowned *ikebana*) are chosen, one or two at most, to adorn the interior. One painting only, not a multiple array, graces the walls. Even the water is boiled at such a temperature and rate that the sound, the "song" of the kettle, is gauged for its harmoniousness. In this way, the master arranges for the readying of one sense (hearing) for another (tasting). The master considers every detail for its impact on all the senses, for the ritual is expected to awaken the celebrants and stir them to participate wholly. The ceremony thus becomes a setting for a full-bodied sensory engagement that harmonizes the visual (walkway, vista, garb, color, flower), the aural (teakettle), the tactile (the ceramic, linens), the olfactory (the perfume of the tea), and the kinesthetic (walking, bowing, holding cups). In the tea master, then, reigns prodigious skills and exceptional creativity. How else could this sort of unified, sensory, and sacred

experience usher forth routinely? Listen to Okakura:

> Teaism is a cult founded on the adoration of the beautiful among the sordid facts of everyday existence. It inculcates purity and harmony, the mystery of mutual charity, the romanticism of the social order. It is essentially a worship of the Imperfect, as it is a tender attempt to accomplish something possible in this impossible thing we know as life . . . *The Philosophy of Tea is not mere aestheticism in the ordinary accept-ance of the term, for it expresses conjointly with ethics and religion our whole point of view about man and nature.* It is hygiene, for it enforces cleanliness; it is economics, for it shows comfort in simplicity rather than in the complex and costly; *it is moral geometry, inasmuch as it defines our sense of proportion to the universe* . . . (P. 3–4:emphasis added)

These lofty and not-so-lofty goals come to life, are "realized," in the details we described. Colors, sounds, gestures, movements, words, the arrangement of flowers, the setting of the table, are the actual forms in which beauty takes shape concretely. These are the choices and forms that the tea master sets before the participants for them to imbibe. Altogether, they embody what Plato would call the form, or *eidos*, of beauty itself. Experiencing the ceremony daily, appreciation becomes more than a matter of observance; participant and ritual become intertwined. The details of the ritual, the whole host of experiences that the master composes becomes so familiar to its participants that they assume its characteristics, the "qualities" of the implements they habitually use and of the structure they inhabit. We spoke of this earlier when we talked about daily hygiene. Yet, the tea things differ from toothbrushes and dishcloths, for those implements are not artis-tically conceived for the embellishing effect the way tea things are. Okakura explains:

> The tea-master held that real appreciation of art is only possible to those who make of it a living influence. Thus they sought to regulate their daily life by the high standard of refinement which obtained in the tea-room. In all circumstances serenity of mind should be main-tained, and conversation should be so conducted as never to mar the harmony of the surroundings. The cut and colour of the dress, the poise of the body, and the manner of walking could all be made expressions of artistic personality. These were matters not to be lightly ignored, for until one has made himself beautiful he has no right to approach beauty. (P. 110)

These are actual matters of character and conduct. The tea ceremony seeks to regulate conduct according to these ennobling values: refinement, serenity, harmony with one's surroundings. Now we begin to see the sort of life that Okakura wishes us to lead, the sort of life we lead by living artistically. That we become beautiful ourselves . . . that is the regulating effect of the tea

ceremony. This is how the ritual imparts its own values, so that the aesthetic is followed not only in tea but in life:

> We must remember that all this is the result of profound artistic fore-thought, and that the details have been worked out with care perhaps even greater than that expended on the building of the richest palaces and temples. A good tea-room is more costly than an ordinary man-sion, for the selection of its materials, as well as its workmanship, requires immense care and precision. (P. 56)

The tea-room is designed to accommodate not more than five persons. It consists of an anteroom, for washing and arranging the utensils, a portico where the guests wait, and the garden path connecting the waiting area with the tea-room. Although the tea-room itself is unimpressive in appearance, the materials within are arranged with "profound artistic forethought." The lighting inside the room is subtle and unobtrusive as are the garments the guests are asked to wear. All novelty is banished except for the bamboo dip-per and linen napkin, both immaculately white and new. Everything is spot-lessly clean. Here again, the tea master must be an artist in sweeping, cleaning, and dusting. Okakura makes much of this, that cleanliness is an art, but reminds us, at the same time, that cleanliness is not simply a matter of efficiency or the removal of what nature puts in our way. If not a particle of dust is allowed to remain, if everything must be spotlessly clean, if novelty is banished, it is to create an opening for what is beautiful and natural, and thus truly spontaneous and alive. Menial tasks like these constitute one of the most profound elements of the tea ceremony, and of the art.

The decoration of the tea-room could not be more different from the sort of embellishment we tend to lavish upon our homes. More is better these days, when a mass of pillows and tea lights, scores of photos, an assort-ment of shelves, a profusion of flowers (whatever the time of year) is the norm. The tea-room is nearly empty of display; there is neither multitude nor variety of things, the master choosing instead to ornament the space with just one flower or two. There is no symmetry, uniformity, or repetition. "Uniformity of design," Okakura warns us, "was considered fatal to the freshness of imagination. . . . If you have a living flower, a painting of flow-ers is not allowable. If you are using a round kettle, the water pitcher should be angular" (p. 71). This is a very different approach to ornamenting interior space from the usual one. Lest we are led to think, however, that it is but one approach among others, we must hold this firmly in view: that serenity and purity were prized in decoration because they were prized in living, that the former prepared for and ensured the latter. We tend not to think Ralph Lauren designs his ensembles to condition anything but the appearance of the surface of our lives.

The treatment of the exterior pathway from the waiting room to the tea-room also presents an occasion for heightened experience, indeed for self-awareness. How the stepping-stones are laid, the pine needles and moss, the

few leaves that whirled and scattered along the perfectly swept paths are permitted to settle there as play against human orderliness. This reminds us, yet again, that formality is not the same as mechanical perfection. The transition from outside to inside, from nature to artifice, into "another world," one of art and artistry, continues. The entry is carefully choreographed. Even the grand nineteenth-century tradition of building understood this potential of the dramatic entrance. Many public buildings of two centuries ago— museums, libraries, banks, schools, town halls, and so forth—made impressive use of space to instill in the visitor a sense of grandeur and awe, of the importance of the activities conducted within. The design of the tea-room, while sensitive to the same principles, engages them quite differently. The effect is not to make one feel grand but rather humble. Okakura describes it thus: ". . . [the guest] will bend low and creep into the room through a small door not more than three feet in height" (p. 62). This way of proceeding is incumbent on all guests, high and low alike, and is intended to inculcate humility. Everyone, from nobleman to peasant, passed through that small doorway to enter the tea-room. A more direct expression of the relation between physical activity and inner character indeed would be hard to imagine.

Now we turn to flowers. Flower arranging is esteemed as a high art in Asia. The tea master is trained in this field—the way other artists are trained in painting or pottery. The selection and placement of flowers in the tea-room, then, would be a sort of artistic signature of the master, an expression of his unique, individual talent. Flowers are carefully chosen and positioned, resting on the place of honor, the *tokonoma*, as Okakura describes it, ". . . like an enthroned prince, and the guests or disciples on entering the room will salute it with a profound bow before making their addresses to the host" (pp. 100–101). Again, for the second time, guests are made to bend low in an attitude of reverence, this time toward nature, itself vested and on stage.

The master places the flowers to harmonize with the surroundings, first according to their lines and proportions. Flowers are chosen for the grace and form of their petals and stems, as much as for the display of color. Their heads are adjusted to gesture this way or that. One flower becomes a soliloquy of sorts. Yet, every time, the flower is picked anew. Day in and day out, the master stands before nature as though before a palette of shapes, colors, and qualities. Both pure and varying, flowers are forms; but for the tea master, each form—with its distinctive shape and color—has its own meaning, its own story to tell. In their stately or aging bearings, in gaunt or fleshly body, ravishing or elegant leaves, themselves adorned by drops of dew, these flowers ensure that participants learn of the cycles of life and the dramatic differences of personality.

Okakura bemoaned the West for its gaudy and lavish displays of flowers. The tea master returns each single flower to the earth, when it dies. To the trash we give masses of perfectly gorgeous flowers, even when still radiantly living. How can we understand the treasures of a flower's fleetingness in our

present-day climate, when we live in the midst of the categorically disposable? As we shall see in Chapter Eight, *Thinking as Craft*, our lavish displays of flowers—how quickly we discard them, alas, with little thought for whence they came or where they go—is but another instance of our technological disposition. It is scarcely any wonder that we are bitterly ignorant of flowers' personae as narrators and guardians of the ethics of nature:

> Entering a tea-room in late winter, you may see a slender spray of wild cherries in combination with a budding camellia; it is an echo of departing winter coupled with the prophecy of spring. Again, if you go into a noon-tea on some irritatingly hot summer day, you may discover in the darkened coolness of the *tokonoma* a single lily in a hanging vase; dripping with dew, it seems to smile at the foolishness of life. (P. 105)

This recalls us to Thoreau's idea of borrowing from nature. The gathering of flowers recollects nature itself by giving back a sense of its own ephemerality. This ability to recollect is a gift we enjoy only with time, and much practice. The appreciation of this gift is something we acquire, by the habit of looking and experiencing, by learning to see in the way Thoreau saw nature, or the way Okakura receives it through the ceremony's artistry. Flowers are "used" in the tea ceremony neither for their practicality nor as servants of our prodigal demand for wasteful display. Rather, flowers are the art of nature, respected and worshiped as reminders of what "nature" means, and therefore, as we wonder about the stories they tell, of our own naturally fleeting and imperfect essence. Listen again to Okakura's words: that the tea-room is an "echo of departing winter coupled with the prophecy of spring." Flowers, glimpsed in that poetic depiction, are the incarnation of the cycles of the seasons, of the seasons of life.

In the way the tea masters work with them, as art and not simply as human artifice, flowers render one of the great lessons of mortality: that nature is beyond our control. We capture its heady essence, its ravishing beauty, indeed its very life, often by killing it. We all (most of us) pick flowers ordinarily, if not every day. The tea master sets a flower's essence, its freshness and singularity, literally on a pedestal, where the transiency, the momentariness, the fleeting are made most exquisitely and particularly visible. This is his art, one that is continuous with nature's own ("modeled upon it," as Thoreau might say). Flowers become, then, like dancers on a stage: now they're here, now they're gone. What is so creative and ultimately so philosophical about this is the way in which the temporal and the timely become the true artistic material. Making art from nature's ephemerality— this is what Okakura reveres in the tea ceremony. This is how the tea master can hasten (rather than harness) the complex sensory nature of dew and distinctive bouquet to issue forth as something rare and beautiful rather than merely accidental. Flowers, when they are not slaves to wedding and banquet tables, are consummate masters of mortality and thus, in the

tranquil setting of the tea-room, they become perfect lessons for those who wish to live not by denying, but by embracing that fundamental law of human nature that, we, too, are ephemeral.

★ ★ ★

Okakura's stories are filled with the heady aromas of teas and breathtaking flowers. When we set this beautiful little book down, we feel a sort of longing, a yearning to leave behind our day-to-day cares and woes, to give up internet shopping and malls and cell phones, and submit to these intoxicatingly elegant rituals. But it is not Okakura's purpose to exhort us to give in to the allure of the exotic, to turn away from what is here and now. As hard as it may be to grasp, *The Book of Tea* labors to call us forth to living fully, completely wide awake, and unsparingly present. Okakura learned to do this from his own engagement in the tea ceremony. He believed that the ritual elevated and taught its guests how to live more beautifully. The little book is a sharing of this belief, not a formula or device, a prescription or even a direct summons to construct tea-houses or attend tea ceremonies. For what it wants to tell us, the lesson it imparts, is more complex and mysterious than that. It does not explain or instruct. It "informs" us in a different way—the way Plato thought philosophy could inform us, as we shall see in the next two Chapters. It stirs us to wonder about a life of simplicity, humility, and ephemerality in which we daily strive to "drink in" those marvelously exquisite and fundamentally ethical abstractions in actual material and physical form. Through our bodily participation, our own characters take on the formal characteristics, the qualities that is, of the ritual itself. Not once, but every day that we celebrate it. Such a life must surely be a practice. This is what, and how, *The Book of Tea* teaches us.

★ ★ ★

We find ourselves asking, again and again: what is this beauty, this art that Okakura talks about, if it is not a "product"? How can we claim that such formalities ensure a better life? Ultimately, our experience of so-called aesthetic form, if we have listened carefully to Okakura, is marked by two intangible but actual characteristics: humility and mutuality. To live with art, we must be open to it. We have encountered this already, in Pieper's notion of loving acceptance and Thoreau's "intention of the eye." We shall encounter it again. It is essential to the idea, as well as the practice, of contemplative seeing that is developed in this book. For Okakura, such openness requires what he calls a "cultivation of the proper attitude," which we hold toward the world around us and which is held in place by humility. Okakura is convinced that great art, true masterpieces, provide a glimpse of eternity, of what is universal. "A master has always something to offer," he says, "while we go hungry solely because of our own lack of appreciation" (p. 79). For us really to see what the glimpse affords, not only must the

master have to "know to impart it," but the spectator must "cultivate the proper attitude for receiving the message" (p. 78). For Okakura, the mastery displayed by both the tea master and the artistic masterpiece is inseparable from the humility that underlies it, and it calls that forth in each of us. This humility is not just something that art commands. It is something that art teaches.

That we cannot be vain or think only of ourselves is Okakura's most strident word of caution: "We have an old saying in Japan that a woman cannot love a man who is truly vain, for there is no crevice in his heart for love to enter and fill up. In art vanity is equally fatal to sympathetic feeling, whether on the part of the artist or the public" (p. 81). Our call is to a deeper response, by leaving, or in Okakura's words, "transcending" ourselves: "At the moment of meeting, the art lover transcends himself. At once he is and is not" (p. 81). It is through contemplative seeing, in the experience itself that this "meeting" occurs. We move in and with the art, in its spirit, yielding to it, the way the lover yields to the beloved, experiencing reciprocity with the object of our love. This is what we hear in the title of Pieper's book: "Only the lover sings." This is how forms change us. We allow ourselves to enter into them, to leave the fetters of vanity and ego behind and, in fact, become the form. This way of formulating it, however, may imply a passivity that these authors would rather guard against. Such meetings, we insist, take practice. To see is to allow something to happen. But it takes work to see.

Now, of course, to one who believes this, it also matters what we become. Forms, and the things that embody them, matter as much as the way we experience them. Thoreau's walking put him directly in touch with the mysteries of nature, in their particular forms. It constitutes not just a means of exercise, but a source of life. For Okakura, it was the drinking of tea and the detailed activities surrounding it. For the rest of us, the essential thing is not that we live in England or in Japan, that we spend four hours a day in the fields and forests, or that we participate regularly in a tea ceremony. What is essential, however, is that contemplative seeing, whatever its setting, be *practiced* and that it be *particularized*. But then, its "setting" cannot be just anywhere or at any time, nor can what we see be just anything. This is no easy matter to grasp, but it is the crux of our thinking in this book. Daily activities are a source of our humanity, both by virtue of *what* they are and by virtue of *how* we perform them.

We might call this, as Okakura does, "a reverence for the useless." For Thoreau as well as for Okakura, what is great is inseparable from what is small; it is through the most seemingly insignificant and useless actions that we learn to experience and to express the qualities of what is great and noble. Humility is humility whether facing a filthy floor or an audience of likely voters. In different ways, Thoreau and Okakura discover virtue in small things and in how we connect with and participate in them.

Practiced, daily ritual makes such participation and connections possible. For, whether walking in Thoreau's sense or drinking tea in Okakura's, ritual

connects us to its object in such a way that we become inseparable from it, we merge with it, when it is performed every day. It is this connectedness that Okakura sees as the ground not only of artistic creation and art appreciation, but of living well and fully.

What matters is not simply how often we do the things we do. The nature of the activity also matters. Certainly we Americans have rituals, too: shopping, watching TV, clicking a computer mouse. These have affected us no less than tea drinking in Japan has, encouraging us to develop our own set of quite specific habits and attitudes. For instance, we expect information to be prompt, if not immediate and plentiful. Most of us spend more money than we have in order to purchase clothes, decorate our homes, and play with electronic toys and cars. We drive, almost never walk. The habit of good conversation has languished in the chatter-filled presence of the TV, which in many houses is always on, ever present. Machines answer our questions along with our phones; email and the ever-present cell phone is there to fill the empty hours. These are habits and daily actions, too, no less than walking or drinking tea are. Yet, they are actions whose consequences are hardly ennobling: we fall into debt; we become materially obsessed and competitive; we lose our desire, even our need, for society and conversation; we forget how to read and love books; we turn our backs on nature as a source of wonder; restlessness replaces passion and business replaces real work. Can we love what we see in the way Pieper would have us do? Ultimately, we may cease to celebrate humanity itself as a form of creation. These are perhaps the most fundamental of ways in which we have lost what we like to call our "civility."[8] We are, to put it bluntly, out of practice.

Okakura's book is a gentle lesson in resisting this, not a template or something to copy. It is, rather, an example of the kind of philosophy that strives to recover what is lost in the only terms in which it could really be recovered—not by instituting an idea but by recalling us to the practice, while knowing full well the difficulties we face in simply being alive:

> Those of us who know not the secret of properly regulating our own existence on this tumultuous sea of foolish troubles which we call life are constantly in a state of misery while vainly trying to appear happy and contented . . . He only who has lived with the beautiful can die beautifully.[9]

This is an attitude that one may only approach through learning humility—learning, that is, to approach a great masterpiece as we would "approach a great prince" (p. 79). We learn it by bending low at the entrance, by listening to the kettle, by savoring the bouquet of the tea and seeing it embodied in a flower. "Living with the beautiful" involves being open to the fine details, so that the meanings they afford may enter that "crevice" in our hearts and change us, urging us to become more like them: beautiful and complete, but fleeting. That ability to enter into a reciprocal relationship with small but great things is the very essence of making and

appreciating art. It is no different in life, Okakura says. Bend low to what is fine and beautiful, and let it in. Perhaps this is the connection between elitism and humility. That low door humbles us by raising the bar, after all, by elevating rather than lowering standards. Then, will we live more fully, and more contentedly. We are not born with this facility, but learn to do this.

One last story before we conclude. Ravishing in its imagery, it nonetheless embodies the most tangible incarnation of Okakura's philosophy of why we should expose ourselves to beautiful form and what such an attitude may bring about or create in us. It is about a wondrous harp, a prized instrument, which no musician could learn to play. Even the king, with all his power and might, could not find any one who was able to draw music from it. No one, that is, but Peiwoh. Here is how he did it:

> Once in the hoary ages in the Ravine of Lungmen stood a Kiri tree, a veritable king of the forest . . . And it came to pass that a mighty wizard made of this tree a wondrous harp, whose stubborn spirit should be tamed but by the greatest of musicians. For long the instrument was treasured by the Emperor of China, but all in vain were the efforts of those who in turn tried to draw melody from it strings. In response to their utmost strivings there came from the harp but harsh notes of disdain, ill-according with the songs they fain would sing. The harp refused to recognize a master.
>
> At last came Peiwoh, the prince of harpists. With tender hand he caressed the harp as one might seek to soothe an unruly horse, and softly touched the chords. He sang of nature and the seasons, of high mountains and flowing waters, and all the memories of the tree awoke. Once more the sweet breath of spring played amidst its branches . . . Anon were heard the dreamy voices of summer with its myriad insects, the gentle pattering of rain, the wail of the cuckoo . . . It is autumn; in the desert night, sharp like a sword gleams the moon upon the frosted grass. Now winter reigns, and through the snow-filled air swirl flocks of swans and rattling hailstones beat upon the boughs with fierce delight . . . In ecstasy the Celestial monarch asked Peiwoh wherein lay the secret of his victory. "Sire," he replied, "others have failed because they sang but of themselves. I left the harp to choose its theme, and knew not truly whether the harp had been Peiwoh or Peiwoh were the harp." (Pp. 75–78)

Is there any more evocative way to conclude these thoughts about habits and rituals and forms and how they shape our innermost character than this powerful story of intimate mutual respect, of love between artist and instrument? In the following pages, we pursue these ideas around the concept of craft, in which mutuality, reciprocity, respect, and love bring us close to the source of beauty and to living well. Okakura has opened a door by giving us a glimpse of things, activities, and settings in which beauty meets humility, love begets reciprocity, physical and material practice becomes

contemplation and ultimately begets character. We see a world in which art becomes life, thankfully, in which we are raised up by bowing low. How is it, C.S. Lewis wondered, that "when I read great literature, I become a thousand men but am never more myself?"[10] Okakura answers: "True art," he proclaims, "is Peiwoh, and we the harp of Lungmen. At the magic touch of the beautiful the secret chords of our being are awakened, we vibrate and thrill in response to its call. Mind speaks to mind . . . The masterpiece is of ourselves and we are of the masterpiece."[11]

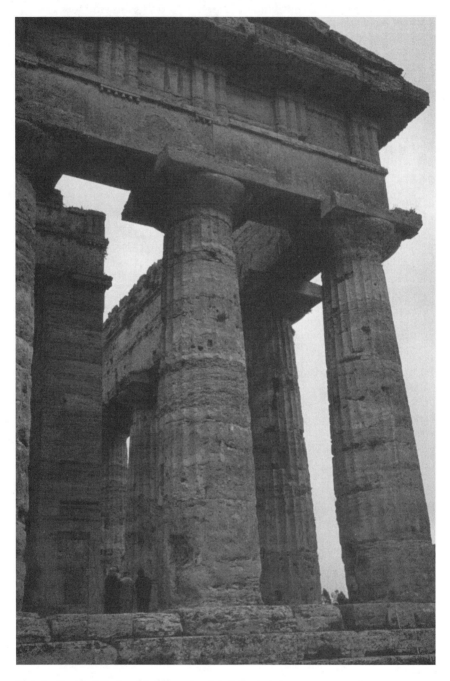

Plate 3 Temple at Paestum, late fifth century B.C. Author's photo

CHAPTER THREE

Turning the Soul Around

> Then education is the craft concerned with doing this very thing, this turning around, and with how the soul can most easily and effectively be made to do it. It isn't the craft of putting sight into the soul. Education takes for granted that sight is there but that it isn't turned the right way or looking where it ought to look, and it tries to redirect it appropriately.
>
> —Plato, *Republic*

Many of the things we noted about *The Book of Tea* could also be said about Plato's *Republic*. Although it is perhaps his best-known work, it, too, may strike us as rather foreign. Much of it is given over to some very abstract and technical philosophizing. In form as well as in content, it can seem entirely distant from *our* everyday reality.

Plato's main character, Socrates, also seems to stand apart from everyday life. Best known for "knowing that he did not know," Socrates had a reputation for being an outsider even in his own time. Of course, he did his work in the Athenian marketplace, "examining" people, asking them questions they could not answer without becoming hopelessly confused. He was not an outsider in this sense. But he was a relentless critic of the thoughts and attitudes of the way of life that most people tended to take for granted. His questioning was seen as such a threat to the everyday order of things that he was eventually tried and executed. Since he would not remove himself from society (he was unwilling to accept exile rather than death), society removed him from it. Okakura may be dismissed as an aesthetic elitist, but he got off easy compared to Socrates. Socrates spent most of his time in the city, conversing with other people and not in the countryside. But he still looks to us like a kind of John the Baptist, crying in the wilderness, even if he was doing it on the equivalent of Wall Street.

What about Socrates and Thoreau? While Thoreau also got off easier than Socrates, and was more engaged with society than we might realize, he too had trouble fitting in. We are told that Socrates often went barefoot. Thoreau

did not. Even if he did not entirely reject culture and custom, Thoreau never really gained the recognition and respect that he publicly sought. The scientific, literary, and philosophical "communities" are still uncomfortable with him, perhaps because he himself could not figure out what he was: an artist, a naturalist, or a philosopher. In any case, none of these departments welcomed him wholeheartedly; and though people did turn out to hear him speak (which was also true of Socrates), his contemporaries were uncertain what to make of him. He was, like Socrates, a misfit, and a complainer, and was viewed with the same kind of suspicion, even if it did not have the same fatal consequences.

So perhaps the *Republic* earns a place in this book through Socrates and his closeness to Thoreau. But once again, this is too simple. It is easy for us to assume that what Socrates says in Plato's dialogues is what Plato himself really thinks, that Plato's works are faithful portraits of his beloved teacher. But what Plato "himself" thinks is a difficult question to which scholars have devoted a great deal of attention. We do not intend to entangle our readers in the complexities of this debate. We would rather call attention to the artful quality of Plato's writing. There is more to a good and faithful portrait, after all, than simply an accurate representation. There is more to art than this, and there is more to faith than this. The trouble with assuming that Socrates words are meant to be Plato's words is that it ignores the fact that Plato wrote *every* word. And the words are carefully crafted. Plato was highly regarded, in his own time, as an accomplished literary stylist. Socrates remains an enigma to us because he did not write anything down. But then, Plato is an even greater enigma, given what his hero and mentor inspired him to do.

There is an irony here that we seldom recognize. We read Plato's dialogues, we see Socrates in heated conversation with his friends (and sometimes his enemies), and we say, "this is how philosophy was meant to be done, with people actively discussing important issues out in the world; it cannot be a lecture, it must involve real dialogue between real people, something everyone can engage in." But then, we forget what we are really looking at. Plato is doing all of the talking here. In fact, he is not talking, he is writing. And he is doing it all by himself, hidden away in his study. *He* is not out there, in the marketplace. He is more like the artist in his studio.

If this is what Plato is doing, what does it have to do with us? We might ask the same question about the tea ceremony: is this highly stylized, artful performance really something that everyone can engage in? It seems not to be, unless we were to replace Starbucks with an equally ubiquitous chain of tea houses. This is not what Okakura was proposing, of course. For him, the formalism of the tea ceremony was not meant to be easily accessible. It was meant to provide the occasion for a different sort of engagement, one that is far more vital than the sort that Starbucks provides. What kind of engagement does Plato's work invite? If Socrates is a little like Thoreau, in being connected with everyday life even as he questions it, Plato seems more removed than either of them. *The Book of Tea* raised the question of art for

art's sake and moved us to reflect on what this could mean. In the same way, we need to think twice about what Plato's text, experienced as a work of art, is *for*; about what its "value for life" might be. For all its abstractness, it can look as if the argument of the *Republic* is very practically oriented, as though the whole thing were an exercise in social engineering. This is what most people object to in reading this book: the arrogance of a philosopher who claims to know the truth about how we should live our lives (who claims to know the Good) and tries to apply this knowledge by creating a political state in which (surprise!) philosophers take control.

It certainly can look this way. That is, until one begins to look closely, "with one's own eyes," and with Thoreau's discerning attention to detail. We could start with the first few sentences. Here, and throughout the whole of the *Republic*, Plato has Socrates speak in the first person:

> I went down to the Pireaus yesterday with Glaucon, the son of Ariston. I wanted to say a prayer to the goddess, and to observe how they would conduct the festival, since they were holding it for the first time. I thought the procession of the local residents was a fine one; but the one the Thracians conducted was no less fitting a show . . . After we had said our prayer and seen the procession, we started back towards Athens . . .[1]

We drew a contrast between Socrates and Plato, who was not out there in the marketplace, actively confronting people, but was more like the artist in his studio, painting a picture, creating something (a spectacle in words) for the rest of us to behold.[2] How and where does Socrates appear in this picture? He is not in the Athenian marketplace, either. He is on the way back. From where? What did he set out to do?

To see and to pray. What kind of seeing, and what kind of praying is this? Even without the original Greek, if we think back to the Introduction to this book, we might guess at the language Plato uses here. Socrates wanted to pay his devotions to the goddess (*thea*) as well as to behold (*theasthasthai*) the festival. The procession he admired was a "fine" (*kalē*) or beautiful one— a real "show" (*ephaineto*). It was only after Socrates and his friend had seen these sights and said their prayers (*proseuxamenoi de kai theorēsantes*) that they started walking back to town. But their journey is interrupted. They are met by Polemarchus, Adeimantus, and several others who compel them to stop at Polemarchus's house ("You must either prove stronger than we are," Polemarchus says, "or you will have to stay here"). There they find Cephalus and Thracymachus (among others), who will join in the conversation that follows.

A combination of force and persuasion leads Socrates into the kind of philosophical discussion we are accustomed to see him engaging in—a discussion that focuses on the topic of justice. But Socrates had other plans. The *Republic* does not begin philosophically, if by philosophically we mean purely intellectually. It begins liturgically. Some readers may dismiss these

opening sentences as mere stage setting, disregarding the scenes Plato paints for us. Socrates himself does not disregard them, however. He takes them in. If these sentences are meaningful (and we have no reason to assume in advance that they are not), then we cannot fail to notice how full of "seeing" they are, the kind of seeing that is implied by the words Plato uses (*theasthasthai, theoresantes*). This is the kind of seeing that we associated in our Introduction with *theōria* (to which these words are clearly related). *Theōria*, we recall, was originally a form of participatory beholding—the kind of "going to look" that Thoreau practiced religiously. This is what Socrates originally set out to do: to witness and to participate in a religious spectacle, a festival or feast. But then, Socrates is not the detached thinker we often take him to be, or at least, this is not how Plato portrays him. He is not observing from a distance and explaining what he sees. Nor is he merely going through the motions. In this scene, seeing and praying are inseparable (they are twice coupled in the same sentence). Like Thoreau, Socrates is observing faithfully. He is a worshipper not just of the unseen but of the seen. He is not "out of it." He is getting into it. What he is "getting into" is *theōria* in the original sense—an embodied, experiential, festive and (as Pieper might put it) "grateful" act of beholding.

Perhaps this is what Plato is getting into, as well. In suggesting this, we are by no means speculating about the artist's intentions in creating his work. It is the work itself that raises the question. Is Plato drawing us into a theoretical spectacle in the original sense by inviting us in the opening paragraphs to picture the show that Socrates has seen?

Anyone who has read the rest of the *Republic* is aware that what follows tends to look a lot more like theory in the modern sense: a long-winded attempt to define justice, involving complex logical arguments, an analysis of the soul, and an abstract metaphysical theory, or theory of reality—all of which is supposed to prove that the best life for a human being is the life of the philosopher, who cares not at all (or not very much) for particular material things but only for universal truths, who cares not at all for the senses but only for the intellect, who cares not at all for desire or emotion but only for reason. That is, someone who is or aspires to be entirely "out of his senses" (as Thoreau puts it), and definitely not where his body is. If anything, Plato's picture seems to leave, not just everyday life, but life itself behind. All he wants us to do is to think, in a detached way, about things ("Forms" or "Ideas") that are themselves detached from the here and now. Rather than a "beatification of the mundane," his answer to the question how should I live my life points to an other-worldly existence. Rather than the attitude of mortality, the philosopher's attitude, as Plato describes it, would embrace a timeless eternity. Rather than seeing death as part of life, it seeks to transcend it entirely.

Or so it seems. But let us go back to the beginning. This kind of "theoretical" inquiry is not what Socrates had in mind. He wanted to see the show. As Plato presents it, the theoretical argument is what gets in the way of the real *theōria*, just as the demand that Socrates engage in a seemingly more "contemplative" discussion interrupts what might have been a more genuinely contemplative walk back to town. The *Republic* does go on to

portray the philosopher as someone who gazes at the truth. But it also portrays him as someone engaged in a characteristically Thoreauvian activity.[3] It is Socrates interlocutors, with their vaunted interest in philosophical inquiry, who force him into the abstract discussion that follows (they ultimately succeed in persuading him to stop and talk only by offering the prospect of another festival that will be "well worth seeing," promising that, after dinner, they will "go out to look at it").[4] Perhaps what Socrates is trying to show them—what Plato is trying to show us—is that one cannot *tell* the truth about the soul or about human life by means of logical arguments alone. If so, then the picture Plato is painting will look very different from the theoretical one we recognize when we read the *Republic*.

At the start of this book, we emphasized the active dimension of *theōria*, the idea of theory (of thinking and beholding) as a "happening." Perhaps Plato himself is trying to make something happen here. He is not trying to turn us into pure intellects, but is trying to move us toward the kind of vision Pieper describes: not an other-worldly point of view, but a way of seeing and of being in *this* world that promises to make our lives complete. We recall that the original meaning of *theōria* preserves the unity of seeing, thinking, wonder, and worship. So does the *Republic's* opening scene. There may well be forces at work, within Plato's text, that threaten to undo this unity, so that thinking becomes separated from the rest of life. *But this is part of Plato's artfulness*. It is why we should look to him for an insight into how this unity might be restored. Why turn (back) to Plato? Because the very activity of reading him might actually turn our souls around.

To see how this happens, we must first recognize how wedded we are to a more detached view of things, especially of philosophical texts like Plato's. We have to see this before we can be converted to the way of seeing Plato really has in mind for us. We must be made aware of what the *Republic* looks like when all we do is look for a summary of the main arguments, in the belief that these arguments are all that matter. This is what we shall provide for our readers here. Then, we shall point to the ways in which Plato himself helps us to see beyond this (how he brings philosophy back to life). We are not simply telling the reader that this is what happens in Plato's text; rather, we ask the reader to join in experiencing it. For this reason, much of what follows in this chapter may seem dry or overly abstract. The aim of this exercise (and it is an exercise) is, however, to prepare our vision by making ourselves aware of what we see when we do *not* look closely, the way we looked closely at the first few sentences. Perhaps then, when we *do* attend more closely to the particulars of Plato's text, as we shall in Chapter Four, their meaning will be experienced more fully. We shall have the experience of seeing what we could not see before. We shall experience Plato's art, and (hopefully) be moved by it.

<p style="text-align:center">★ ★ ★</p>

The argument begins in Book One when Socrates is drawn into a discussion of justice, and what it means to be just.[5] He elicits a definition of

justice from Cephalus: it is speaking the truth and repaying one's debts. This is refuted in a characteristically Socratic fashion. Through a process of cross-examination, Socrates tries to get his interlocutor to see that his definition harbors a contradiction. According to Cephalus's definition, some things will be both just and unjust. Returning what one has borrowed may seem like the right thing to do. But if the item in question is a weapon, and the person to whom it is owed has gone mad, it would not be the right thing. Actions that are by definition just turn out to be the opposite. Polemarchus, Cephalus's son, tries to help his father out, but his definition suffers the same fate. One cannot live by these definitions, not just because they are unworkable (Cephalus's idea seems to have worked for him) but because they are unthinkable.

Then Thracymachus enters the discussion. He objects to Socrates logical way of proceeding. It is purely negative (all Socrates does is refute others) and does not get us any closer to understanding what we are trying to understand. "If you truly want to know what justice is," he exclaims, "don't just ask questions and then refute the answers simply to satisfy your competitiveness or love of honor. You know very well that it is easier to ask questions than answer them. Give an answer yourself . . ."(336c). Thracymachus seems to suggest that there might be something *unjust* about Socrates method of inquiry. And even though Socrates accuses him of not taking the discussion seriously—"Or do you think it a small matter to determine which whole way of life would make living most worthwhile for each of us?" (344e)—Tracymachus himself seems to treat the matter with greater urgency than Socrates does. The answer he provides is not only a response to the question of how best to define justice. He is talking about how it is best to live. Analyzing and refuting definitions will not tell us the truth about this.

So what is the truth? Socrates says he doesn't know. Thracymachus is impatient. Try this, he says: "justice is nothing other than the advantage of the stronger" (338b). When Socrates asks him what he means by this, he elaborates: those who possess the power of rule always make up rules that are to their own advantage. This is, in reality, how justice comes to be defined. People who obey these rules are praised for their conduct; they are told that they are being "good" and are thereby led to think that they are living good lives. Those who do not obey them are punished, reinforcing the idea that it is good to be just. But the truth is just the opposite. What Thracymachus says to Socrates is meant to apply to anyone who believes that it is better to live justly:

> You are so far from understanding about justice and what's just, about injustice and what's unjust, that you don't realize that justice is really the good of another, the advantage of the stronger and ruler, and harmful to the one who obeys and serves. Injustice is the opposite, it rules the truly simple and just, and those it rules do what is to the

advantage of the other and stronger, and they make the one they serve happy, but themselves not at all.[6]

Justice, Thracymachus proposes, is a cultural product, a device invented by the strong to exploit the weak. We (most of us) are dupes, controlled by a ruling authority whose interests are served while we are made to believe that we are living good and happy lives. He alludes to the institution of taxes. Of course, it is good to pay one's taxes (we are told) and not to cheat in paying what we owe, since our taxes go to serve the common good, or "public purse," as Thracymachus puts it. But then we realize who is holding that purse, that our taxes work to support and strengthen (what do you know?) the same governing institutions that are telling us that we ought to pay our taxes. We are made to think that they benefit us, in some way. But in the meantime, they not only pay the rulers' salaries; they make those in power that much more powerful and strengthen those already strong enough to make the rules. According to Tracymachus, it is injustice, the desire to "outdo" everyone else and get more than one's fair share, that lies at the origin of justice as we know it. To see this, he says, we must consider the thoroughly unjust man—the person who is not only willing to do injustice but able to get away with it. This is the tyrant—the person who, because he makes the rules, stands above them. This is the person whom justice (obedience to the rules) truly makes happy while the rest of us suffer from it, all the more so in that we fail to realize that this is what justice is really all about: a means of control that works to the advantage of the unjust (those who take advantage of it).

Socrates is taken aback by this idea, though not for long. He manages to refute Thracymachus's definition in the way that he refuted those that came before. What Thracymachus has said implies that the very institution of justice is unjust. How can justice, a virtue, be a "bad" thing? Here again, such a contradiction seems unthinkable. But does this kind of argument really settle the issue? Even Socrates seems to realize that it does not. All he has come up with is a "banquet of words" that he admits, at the end of Book One, even he has not enjoyed.

Why isn't Socrates satisfied? Because, as Glaucon and Adeimantus remind him, the question we need to answer is not only what justice is, but why we should be just. What does this have to do with *me*? This is what Thracymachus was trying to make us see: according to his understanding of justice, none of us has any reason to be just. What we have most reason to do is to free ourselves from its constraints precisely because it is the opposite of what it pretends to be. This is why Socrates accomplishes nothing by showing that Thracymachus's definition is self-contradictory: this is exactly what Thracymachus wants to say about justice.

The state of things Thracymachus describes does seem rather extreme. Glaucon and Adeimantus try to make his basic point more plausible (while insisting they do not really believe it). In Book Two, Glaucon explains why

we (some of us) *do* (sort of) have a reason to be just, though none of us really wants to be. His speech is of crucial importance in setting the stakes for the rest of the argument. The account of justice that Glaucon proposes resembles Thracymachus's in several ways. Justice is something "made up" by human beings, and it is basically a matter of power and control. Rather than the strong exploiting the weak, however, Glaucon sees it as an invention of the weak to protect themselves against the strong. Justice is a kind of social contract based on a calculation of interests:

> They say that to do injustice is naturally good and to suffer injustice bad, but that the madness of suffering it so far exceeds the goodness of doing it that those who have done and suffered injustice and tasted both, but who lack the power to do it and avoid suffering it, decide that it is profitable to come to an agreement with each other neither to do injustice nor to suffer it. As a result, they begin to make laws . . . and what the law commands they call just. This, they say, is the origin and essence of justice. (358e–359a)

For most of us, the chances are greater that we shall be taken advantage of by others than that we shall be able to take advantage of them. We may gain more for ourselves if we cheat or steal. But if everyone agrees to refrain from such behavior, we are more likely to keep what we already have. It is, therefore, in our interest to be just, since it protects everyone's fair share. But this is the point Glaucon is trying to make: justice is *all about* serving your individual interests in the best way you can. This is what you have most reason to do. But what about someone who did *not* lack the power to do injustice and avoid suffering it? For this person, entering into such an agreement would be "madness"; it would be irrational. While it may be rational for the rest of us to live and act justly, it is not because we really think it is good, but because we are "too weak to do injustice with impunity." We simply cannot get away with it. But then, even if we are lacking in power and strength, if too many people start cheating, we should too. This would now be the rational thing to do. One gains nothing by clinging to justice in a community that is so corrupt that one is likely to be taken advantage of in any case.

Even though Glaucon defines justice in somewhat more positive terms than Thracymachus did, as "intermediate between the best and the worst," it is still the opposite of what it pretends to be. It is based entirely on what Thracymachus described as a desire to "get more and more" (the Greek word for this is *pleonexia*). Justice is still based on injustice (even if, in this case, the just people are the ones making up the rules). As Glaucon sees it, justice does not really involve a willingness to accept one's fair share, or the ability to be truly content with that. If we live justly, it is because we are forced to settle for as much as we can get. The selfish desire for "more," Glaucon insists, is what anyone "naturally pursues as good" (359c). The idea that our desires must be limited in some way, that there are limits not only to what we can have but to what we should want, is not natural but artificial.

It is imposed upon us by society and its conventions (the Greek *nomos*, which generally refers to sets of rules, laws, or customs which are made up by human beings). Wherever justice holds sway, Glaucon claims, "nature is forced by law into the perversion of treating fairness with respect" (359c).

In a further attempt to persuade Socrates that what he says about justice might actually be true, Glaucon offers a "great proof that one is never just willingly but only when compelled to be" (360c). This proof comes not in the form of an argument, but in the form of a story, or myth, about a shepherd who finds a ring that makes him invisible. When he discovers the magical power of the ring, and realizes that he can do whatever he wants, with no fear of being seen, he immediately arranges to become a messenger to the king, seduces the queen, kills the king, and takes over his kingdom. Glaucon thinks the moral of this story is clear. For all we knew, the shepherd was a thoroughly respectable and trustworthy person. As soon as he was given the opportunity to "do injustice with impunity," however, he did. The only thing that was keeping him honest, it seems, was his respect for the conventions of justice, a concern about what other people would think or how they would treat him if they caught him behaving this way. But if they cannot *see* him, he is free to disregard all that. Once the appearances are taken away (by the ring), the truth is revealed and justice gives way to injustice. Then, we can see what sort of person the shepherd really is. We also see what sort of thing justice really is, that the force of law is based entirely on how one appears to others—on reputations and opinions, rewards and consequences. But then, Glaucon contends, we also see something that is true about each and every one of us, what *anyone* naturally pursues as good. If we imagine two such rings, Glaucon says, one worn by a just and the other by an unjust person, the actions of the seemingly just person "would be in no way different from that of those of an unjust person" and we would catch both of them "following the same path"—except that we wouldn't catch them (360b–c).

Glaucon's story does not just invite us to think about what we would do if we were subject to temptation. It forces us to think about what it would mean to see things as they really are. Justice may regulate our outward actions, but, in Glaucon's view, any reason we have for being just depends entirely on how we are perceived by others (or by ourselves, since the same point applies to the conscience or superego).[7] It is not what anyone naturally pursues as good, even though most of us, judging from our words and actions, seem to believe that it is. This, the truth about how one should live, is revealed only when the appearances are stripped away. This is what the ring represents: not a science-fictional fantasy, but the power we are supposed to associate with philosophy—a certain conception of what it takes to arrive at the truth about people and things. It is only by getting past the appearances that we get down to reality. If we want to tell the truth, Glaucon insists, "we must take the seeming away" (361b).

This is Glaucon's view, and Adeimantus agrees. All the reasons we customarily recognize for living justly only prove that justice is a means and

not an end in itself. What they say about justice is what we might initially think about the tea ceremony: that it is simply a matter of "keeping up appearances." But then, the answer to the question "how is it best to live," must be that it is better to *appear* just while *being* unjust (and getting away with it).

This is the challenge Socrates is forced to accept. He must prove to his interlocutors that justice is not simply a means to an end (something valued only for the consequences it brings), but is more like health—something that has real benefits but is also its own reward ("the kind of good we like for its own sake and also for the sake of what comes of it"). Health is enjoyed in both these ways. It enables us to do all sorts of things we could not do if we were ill. In that sense, it is a means to an end. Of course, many of the things being healthy enables us to do are the sorts of things that help to preserve our health (physical activity, e.g.). The ends to which health is a means are themselves often the means to health. If we asked, "why are you doing those things?" the answer might be, "for the sake of my health." But it is also the case that doing these things is what it means to be healthy. To ask "why do you want to be healthy?" is a little like asking "why do you want to be happy?" or like asking Thoreau, "why are you walking?". It is something he does for its own sake (something he finds good in itself).

It is not terribly difficult to see how health might be valued in this way (its benefits are palpable, and it just feels good to healthy). But justice (like Thoreau's walking) is harder. If Socrates is going to show that being just is necessary for living well, in a way that will satisfy Glaucon; his "demonstration" cannot rely on anything we can see. As Glaucon puts it, he must strip away the reputations enjoyed by both the just and the unjust man, and replace them with the opposite ones. He must show that, even under the worst possible circumstances, it is better to be just than to be unjust. He will have to take a person who is truly just, but is believed by everyone to be unjust (and is punished severely), put him beside an unjust person who is believed to be just (and enjoys the rewards of both justice and injustice), and still prove that the just person is happier. Otherwise, Glaucon insists, we shall have no way of knowing whether he *is* truly just, or whether he is acting justly only for the sake of the consequences and rewards that it brings, rewards he could more easily enjoy by *seeming* just on the outside while being unjust on the inside, or in secret. If there is any lingering suspicion that the reasons for living justly depend on external circumstances, as the story of the shepherd suggests, the advantage will ultimately go to the unjust man (the one who either has the ring, or is clever enough not to get caught).

How can Socrates show that it is better to be just even under the worst possible external circumstances? By defining justice in terms of its internal circumstances. That is, by doing psychology. "Psychology" is a modern word that comes straight from the ancient Greek. Like *theōria*, however, its meaning has drifted from its origins. Psychology today is generally taken to be the study (or perhaps the science) of the mind (or the brain). The Greek

psyche originally referred to the *soul* (a different word was used to refer to the mind). The Greek *logos* (the source of our "-ology") can mean many things. It can refer to a "rational account" (it is sometimes translated as "argument" or even "theory"), but it can also mean "word." We hear only the "logic" in *logos*. But there is more to it than this. Psychology, for the Greeks, could involve, not just thinking logically, but also speaking a word about, or somehow describing, the soul. This is what Adeimentus calls on Socrates to do:

> [O]f all of you who claim to praise justice, from the original heroes of old whose words survive, to the men of the present day, not one has ever blamed injustice or praised justice except by mentioning the reputations, honors, and rewards that are their consequences. No one has ever adequately described what each itself does of its own power by its presence in the soul of the person who possesses it, even if it remains hidden from gods and humans . . . So don't merely give us a theoretical argument that justice is stronger than injustice, but tell us what each itself does, because of its own powers, to someone who possesses it, that makes injustice bad and justice good. Follow Glaucon's advice, and take away their reputations . . .[8]

How, then, do we tell the truth about the soul? The soul by itself is almost too small to see into, Socrates suggests ["The investigation we're undertaking is not an easy one but requires keen eyesight," (368c)]. So, he proposes that they start with a city (a whole made up of individual souls) and use this as a model. If we can see how justice comes to be in a city, what it is and what difference it makes, then perhaps we can tell the truth about justice in the soul. The city (which will become the ideal state of Plato's *Republic*) turns out to have three basic parts, or classes of people: the rulers (those who govern the city), the guardians (those who defend it), and what is best described as the ordinary citizenry (craftsmen, merchants, and consumers). Justice turns out to be a harmony among these parts. It consists, fundamentally, in "everyone's doing his own work" (433d). In Book Four, Socrates argues that the soul also has three parts, analogous to those of the city: the "rational" part (the part that thinks and exercises judgment), the "spirited" or emotional part, and the "irrational appetitive" part [the "part with which [the soul] lusts, hungers, thirsts, and gets excited" by other desires (439d)]. Here too, justice turns out to be a harmony, with each part doing its own work. Accordingly, "each one of us in whom each part is doing its own work will himself be just and do his own" (441d).

Justice, Socrates argues, is psychic health. The alternative to this inner harmony is inner conflict. This is injustice: "a meddling and doing of another's work," or worse, a "rebellion by some part against the whole soul in order to rule it inappropriately" (443b). To be unjust is to have a civil war going on within one's psyche. It is to be "enslaved" to or have one's life "overturned" by the insatiable pursuit of irrational appetites and emotions. It is to suffer

from the "turmoil and straying" of the different parts of one's soul. But then, something more is required to establish and maintain harmony among them. *The rational part must rule,* "since it is really wise and exercises foresight on behalf of the whole soul . . ." (441e).

Critically minded readers are often suspicious of this part of the argument (which is not to say that they are not suspicious of other parts as well). Is it really the case that all the parts of the soul are harmoniously ordered when, and only when, one part orders the others around? Why does justice require rule by reason? Because justice prevails when each part does its job and it is reason's job to rule, and the job of appetite and emotion to be ruled. But, of course, it is reason itself that presumes this. "The rebellious part is by nature suited to be a slave," Socrates says, referring to the appetites (444b). In saying this, he seems to assume that appetite is by nature rebellious (as are the emotions, unless they are tied to reason). The argument he gives for the necessity that reason rule the whole soul implies that, rather than harmonizing with the other parts, reason will treat them the way a master treats a slave. Rather than a state of "friendly and harmonious relations" (442c), justice is really just another form of enslavement, or tyranny . . . the kind that ensures that the trains run on time.

Is this what it means for the soul to be "ruled" or regulated by reason? The word Plato uses to designate this part of the soul is *logistikon* (which is related to *logos,* as well as to our "logistical"). Curiously enough, Socrates says very little in Book Four about what it means to be rational. Reason is the most important part of the soul, but it is the part about which the least is said. The real function of what Socrates refers to as "the part of the soul with which it calculates" (439d) is alluded to only abstractly.

We are given further insight into what it would mean for the soul to be ruled by reason in Book Five, in the wake of Socrates notorious claim that "until philosophers rules as kings . . . cities will have no rest from evils, nor . . . will the human race" (473d). The soul that is ruled by reason is the soul of the philosopher, the truth-lover as opposed to the honor-lover (whose soul is ruled by emotions like pride and shame) or the money-lover (whose soul is ruled by an insatiable appetite for material things and physical pleasures). Only these people know the truth about justice, and only these people are just (since only they are guided by reason). Without them, there will be no justice in the city or in the souls of any of its citizens. As things stand, Socrates suggests, there is very little justice in our cities, or our souls. What Glaucon and Adeimantus proposed is largely the case. Most people *would* behave the way the shepherd did when he found the ring (people in power often do, as the recent history of corporate America attests). How then, Socrates asks, can we "show the unbelievers" that what the philosopher says is true?

We must try to show them what it means to be a philosopher. Socrates defines philosophers as those "who love the sight of truth," as opposed to the "lovers of sights, lovers of crafts, and practical people" (476a). The lovers of sights and sounds, Socrates observes, "like beautiful sounds, colors, shapes,

and everything that is fashioned out of them, but their thought is unable to see and embrace the nature of the beautiful itself" (476b).

Someone who believes only in "beautiful things," but not "the beautiful itself," Socrates argues, is living in a dream rather than a wakened state. He mistakes what is essentially a likeness, or imitation, for the real thing. Someone who "believes in the beautiful itself," can see "both it and the things that are like it," and does not confuse the two, is not dreaming but "very much awake" (476c). Such a person *knows* what is beautiful, in contrast with those who are led on by the passing array of beautiful sights and sounds. The latter are like people who merely follow the fashion, as it changes from one season to the next. While they may consider themselves to be "in-the-know" about the most recent tastes and trends, in fact they have only fleeting "opinions" about what is beautiful.

The philosopher sees beyond all that. He has his sights set, not on things that might appear beautiful in one way and ugly in another, or beautiful at one time (or under certain circumstances) but ugly at another; he has eyes only for what "remains always the same," for something that, while it may appear "in association with actions and bodies," is in reality "one in form" (476a, 479a). This is what the philosophers "study" (480a). "Those who study the many beautiful things but do not see the beautiful itself and are incapable of following another who leads them to it, who see many just things but not the just itself, and so with everything"—such people have eyes only for what is changeable and shifting. Their beliefs, desires, and feelings are directed toward something that can never really be known but only "opined." In their thoughts and actions, throughout their lives, they are led on by something that is "rolling around . . . between what is not and what purely is" (479d). Like the person who spends his time "running around to all the Dionysiac festivals," they themselves are in a "wandering" state. Their opinions are as shifting as the fashion they seek to follow. They really have no choice, since they do not see what the philosophers see. Those "who are able to grasp what is always the same in all respects," those who "love and embrace . . . the thing itself" (480a), are philosophers, Socrates declares, "while those who are not able to do so and who wander among the many things that vary in every sort of way" are not philosophers (484b).

What Plato seems to be trying to prove, starting in Book Five and for the remaining five books of the *Republic,* is that the philosophical life is the best life for a human being. To be a philosopher is, literally, to love wisdom (this is what the Greek word, *philo-sophia* means). It is to "love and embrace" reality, to study or "see" the "things that are," "the thing itself," or "what is." And what is that? Not particular material things or the physical realities we think we know (and often love), but the "forms" or ideas of things. The word Plato uses here is *eidos.* This is what Socrates is referring to when he says that the philosopher cares, not about beautiful things but about beauty itself.

How could an *idea* be more real, or true, than (what we usually regard as) real things? What would it mean to *see* "beauty itself"? In trying to answer these questions, interpreters of Plato typically appeal to his so-called "theory

of Forms," generally considered to be Plato's central philosophical doctrine. Whether this is really the way Plato answers these questions, whether his insight ultimately takes the form of *any* doctrine or theory in the modern sense, remains to be seen. But what Plato has Socrates say, here and elsewhere, can lead us to think that underlying his division of the soul and his attempt to distinguish between the philosophical and the nonphilosophical life is a more fundamental metaphysical distinction. Socrates often refers to mathematics and geometry to illustrate his point. Setting beauty and beautiful things aside for the moment, we might consider the difference between circles and triangles, on the one hand, and circular or triangular things, on the other. The clock on the wall is a circular thing, but it is not perfectly circular. If we examined it closely enough, we would see that it has all sorts of rough edges, that its circumference "wanders" and is not always equally distant from its center, that we cannot precisely locate its center, and so on. This would be the case, however carefully crafted it was. There are lots of things we know about circles (and squares and triangles). Mathematics and geometry tell us the truth about these things. But none of this is really true about the things we see. The circular thing that we see on our wall is an approximation, or "likeness," of a circle. It is not square, nor is it a true or perfect (a "real") circle. It is circle-ish, so to speak. It is "rolling around" between "what is not" and "what purely is" a circle.

The same is true of triangular or straight things, even the most precise computer-generated figures. It is true that two lines intersect at only one point and that the square of the hypotenuse of a right triangle is equal to the sum of the squares of the other two sides. We know these things. They are essential to something's being a line or a right triangle. But no two lines that we can see (that are physically embodied and visibly manifest) will intersect at only one point. They will intersect at a place, a blob of ink perhaps, that contains many points. Nor will they be perfectly straight, however much they seem to us to be. However accurately we try to represent it, we shall never encounter a particular triangle whose sides and angles measure up to the ideal (the true, or perfect) form.

This is not just the result of our own shortcomings. It is materiality itself—the whole physical realm that falls short. We share in this to the extent that we trust physical things and our senses to reveal the truth or to "reach reality" (as Socrates puts it). The clock on the wall falls short of being perfectly circular not only in the static sense, as being flawed to begin with. As is the case with all material things, it is subject to change. With this, modern physics agrees: physical objects are never really in "being." They are always "becoming," coming-to-be and passing away. We may not see this happening, but even as we look upon these things, they are falling apart. With each passing moment, the clock is ceasing to be even as circular as it was. In this way, too, material things are rolling around between being and not being.

So are we, when we experience them physically. Because our senses are tied to our bodies, and our bodies (like all material things) are subject to the

vicissitudes of space as well as time, the kind of seeing to which the lovers of sights devote themselves will always be partial and perspectival. Whether the clock even *looks* circular depends on the particular point of view from which one sees it (from the side, it will appear elliptical). This was the problem with telling the truth about justice: whether something (a particular action, or even a particular person) appears just depends on the circumstances in which we see it. It is the problem Socrates talks about with regard to beauty. If all one does is pursue beautiful things, with no thought for beauty itself, one is bound to pursue things that are "beautiful in a way and also ugly in a way"—things that may appear beautiful under cover of darkness but may look very different in the light of day.

What, then, would it mean to see beauty itself? It must be a little like telling the truth about right triangles. One will never grasp this by calculating the sides of the triangles one sees; however many one looks at, they will never measure up. Such knowledge is gained, not by senses (or the emotions) but by thought alone. What one "sees," using only the mind's eye, is a true—a *real*—right triangle. This is the ideal Form. It is ideal in two senses. It is perfect, the standard, as it were, against which all triangular things are measured (think of the circle one *tries* to draw, but never really does). It is the universal Form to which the many particulars are compared, and which they are seen as being like but also inevitably unlike. But then, the Form is ideal in another sense. It is more fully real than the particular manifestations or "imitations" of it; and yet, it can only take the form of an "idea." To be sure, the Form is not just a thought in somebody's head (the Pythagorean theorem is hardly a subjective notion). It is the ideal pattern that particular things (sort of) emulate and that we ourselves emulate when we make things or try to understand them. We sometimes talk about ideas as needing to be realized. According to this theory, the ideal (Form) *is* reality. We talk about some ideals as being unrealizable. According to this theory, it is particular things that are never fully real.

The precise sense in which the Forms can be said to "exist," how we are to picture this is a problem Plato seems to have struggled with. We find it difficult *not* to picture them as lying entirely beyond the realm of physical embodiment. What *The Book of Tea* described in its material aspect (the "formalities" of the tea ceremony), Plato seems to value only in its transcendent, immaterial aspect. Material objects, our bodies, and our sense impressions are all changeable and fleeting. Just as seeing beauty itself would have to be utterly different from seeing a beautiful thing, the Forms must be separate from the particulars. They are eternal and unchanging, or "deathless" (as Socrates sometimes puts). And so must we be in some sense deathless in our striving to reach them. If we are to embrace the universal Forms, we must look beyond the ephemeral particulars (since there is little, if any, truth in them). We must leave behind the realm of becoming, the mortal realm, if we are to grasp the being of things. But then, we must also be separated from ourselves. Particulars are objects of the senses, and of our physical desires and appetites (these are the beautiful things we want so badly to possess).

The Forms are objects of thought. We embrace the particulars with that part of ourselves that is itself mortal (with our bodies). The Forms can only be embraced with that part of ourselves that is not led astray by appearances, the part that seems furthest removed from our own materiality. This would be the rational part of our soul.

Why does the philosopher care only about the Ideas or Forms of things, and not about the world around him, or the flesh-and-blood reality of material things? Because, he seeks knowledge, and these alone are the true objects of knowledge. Only these things "are." The particulars are rolling around between being and nonbeing, and so are we when we love and embrace them. If we give no thought to beauty itself in our heedless pursuit of what we take to be beautiful things, we shall not only be led on by our own (and others') opinions. We shall also be let down, when the light changes, or tomorrow comes, and what appeared beautiful now appears ugly. The philosopher's love for the Forms is, by contrast, a permanent and stable one—an attachment to something that will not let us down in this way, something that is itself permanent and stable, and truly lovable. Just as the Form of a triangle is the only thing that is truly triangular, it is only beauty itself that is really and truly beautiful. The same is true of everything, Socrates says: of justice, and ultimately of the Good.

When we put the pieces of the *Republic* together, this is the idea we end up with: the philosophical life (the best or happiest life for a human being) is as close to a purely intellectual, a purely rational, life as one can get. To love and embrace particular things (beautiful sights and sounds) is to live a wandering life (like the money or the honor-lover, who follows his appetites, or lives according to the opinions others have of him). Such a person "is living in a dream rather than a wakened state." Only the philosopher, whose attention is fixed on the Forms (of which particular things are pale images or reflections), who forsakes literal, bodily seeing for a disembodied, purely intellectual kind of seeing—only he lives a real life.

★ ★ ★

This is what most of us end up seeing when we read the *Republic* for its theoretical arguments. But is it really what Plato is trying to convert us to? To think that it is to assume that his text offers us nothing more than a purely rational justification for a purely rational life. How differently would this picture look to us if we were to turn back, and think again about what is really at stake here? This would involve looking more closely, and wondering about, passages like the one where Plato has Adeimantus say to Socrates: "don't merely give us a theoretical argument," but *describe*, as no one has yet been able to do, the presence of justice in the soul, using words (*logoi*) that are adequate to the task. Adeimantus wants to be shown something. What he is asking for is not just a logical demonstration (an argument or "proof"). He wants not only to see, but to be *moved* by a vision of justice. He wants Socrates to teach him how to see it "as it really is," in such a way

that he will truly come to love it. The way of seeing to which he wants to be converted is not a purely intellectual one. It is not the dispassionate vision we usually associate with the philosopher, one that is focused exclusively on pure abstractions. It is closer to the prepared vision realized by Thoreau.

It is for this change of vision that we have tried to prepare the way in this chapter. But it is in reality Plato's own work that effects it. It is *Plato* who has Adeimantus say "don't merely give us a theoretical argument . . ." Has he ignored his own advice? What we have seen so far (the reading we have just experienced) would suggest that he has. But then, perhaps we ourselves are the ones who have ignored Adeimantus's advice. As Thoreau says, "the gardened sees only the gardener's garden." Because we were looking for a theoretical argument, because that was what we expected to find in Plato, that was all we were able to see. The question remains: what haven't we seen in Plato's text? What does his work really make visible?

Plate 4 Chapel (*Saal*), the Cloister, Ephrata, Pennsylvania, eighteenth century. Author's photo

CHAPTER FOUR

Plato's Art

When all such sayings about the attitudes of gods and humans to virtue and vice are so often repeated, Socrates, what effect do you suppose they have on the souls of young people? I mean those who are clever and are able to flit from one of these sayings to another, so to speak, and gather from them an impression of what sort of person he should be and of how best to travel the road of life . . . The various sayings suggest that there is no advantage in my being just if I'm not also thought just, while the troubles and penalties of being just are apparent. But they tell me that an unjust person, who has secured for himself a reputation for justice, lives the life of a god. Since then, "opinion forcibly overwhelms truth" and "controls happiness," as the wise men say, I must surely turn entirely to it. I should create a façade of illusory virtue around me to deceive those who come near . . .

—Plato, *Republic*

Plato's text might look different—we ourselves might come to see it differently—if we were to pay greater attention to the "particulars," viewing them as Thoreau would, with wondering eyes. We could start with what Plato has Adeimantus say in this passage. Socrates challenge may appear to be purely theoretical: define justice and prove that, even under the worst possible circumstances, it is always better to be just. Like many philosophical problems, this may seem hypothetical and abstract, not a problem we really face in the course of our lives. Why would I need reasons for being just even under the worst possible circumstances if, like Cephalus, I am already happy being a good person and doing the right thing?

Because these *are* the worst possible circumstances. This is what Adeimantus's words may help us realize. Not that we see everyone running around killing the king and seducing the queen, but that truth *has* been almost entirely reduced to "opinion," and reality to mere appearance. Contemporary social science (and even philosophy and art history) tends to

agree: "truth," "reality," and "meaning" (which must now be placed in quotes) are human constructions and therefore relative. Thracymachus's view may sound like that of a belligerent thug (might makes right!), but is really not unlike that of most social theorists. What they call "belief-systems" are fabricated (albeit in more complex ways than Thracymachus imagined); what it means for these beliefs to be "true" is that they have become fashionable. This is how truth and reality are defined for us.

The suspicion that fashion, so-called popular opinion, "controls happiness" is confirmed by even a casual glance at contemporary culture. We head off to the store, or "flit" through catalogs, or search on-line, guided by what we take to be our own thoughts about what will make us happy. But where does this idea of happiness come from? From those very stores, catalogs, and websites (from the dictators of fashion, whoever they may be). It is from sources such as these that we typically "gather . . . an impression of the sort of person [we] should be and how best to travel the road of life." Thracymachus was right about this, too: for the most part, we are told what will make us happy, while those in control reap the profits.

By now it should be clear that the aim of this book is to restore our faith in appearances, not to criticize it. If we identify Plato's ideas with the Platonic doctrine (as we have summarized it), then there is reason to resist them. To let go of the senses, and take refuge in reason alone, does not make for a complete life. It would carry us away from what Thoreau and Okakura are trying to move us toward, a way being present to and with things—in humility, awareness, and awe—that essentially characterizes the attitude of mortality. But then we must ask ourselves how Plato's ideas would look to us if we were to experience his own text in this way. What Plato is trying to help us envision is not some other-worldly reality. The reason for looking outside the realm of opinion is to restore what is *inside*. Adeimantus is describing a situation in which the very distinction between inside and outside has all but collapsed. This is a world in which everything has become superficial and external—a world in which there *is* no inside. This is not just a question of how we judge others, or of how others judge us; it is a question of what we find within ourselves. Adeimantus's words suggest that there may be nothing left to the state of one's soul beyond the "impressions" one gathers—from oneself or from others.

That this is Plato's real concern becomes clearer if we look more closely at the conclusion of the argument of Book Four. Here again, what looked like a logical (or psychological) analysis is really a poetic description, or way of picturing what it means to be just:

> And in truth justice is, it seems, something of this sort. However, it isn't concerned with someone's doing his own externally, but with what is inside him, with what is truly himself and his own. One who is just . . . regulates well what is really his own and rules himself. He puts himself in order, is his own friend, and harmonizes the three parts of himself likes three notes in a musical scale . . . He binds together those parts

and any others there may be in between, and from having been many
things he becomes entirely one, moderate and harmonious. Only then
does he act. And when he does anything, whether acquiring wealth,
taking care of his body, engaging in politics, or in private contracts—
in all of these, he believes that the action is just and fine that preserves
this inner harmony and helps achieve it, and calls it so, and regards as
wisdom the knowledge that oversees such actions. And he believes that
the action that destroys this harmony is unjust, and calls it so, and
regards the belief that oversees it as ignorance.[1]

Much of what we can see in this passage, the way in which justice
"regulates" the soul, should remind us of what we were able to see in *The
Book of Tea*. Such regulation is not imposed from without (it does not
merely govern external action). It issues from within. And yet, what is inner
and what is outer are essentially related. To be truly "just and fine," our
actions cannot simply conform to the rules. They must flow from, and
reflect the inner form of, a well-ordered soul. This is how true justice is
made visible—when what appears on the outside is itself in harmony with
one's inner being. Such actions are not isolated productions. We may be
accustomed to thinking that justice is at issue for us only on those rare occa-
sions when duty calls, when specific obligations or prohibitions apply, or
when we face a "moral dilemma." Socrates sees justice as an *everyday per-
formance*, something that is exhibited in everything we do, publicly or pri-
vately, including the care of our bodies. But then, justice is not merely an
outward show. It is one's whole *way of life* that is (or is not) just, not the kind
of individual performances that might appear just under some circum-
stances but not under others, or the kind of good-looking deeds behind
which injustice might conceal itself. A way of life truly is just when it not
only flows from but establishes and preserves the harmony of one's inner
being. Justice is not separable, therefore, or something that exists by itself. It
does not come about as a result of harmony; it *is* this harmony.

Socrates speaks of actions that are just and fine. The word he uses here
is the same one he used to describe the "spectacular" festivals we beheld at
the outset—*kalon*—which can also be translated as "noble" or "beautiful"
("fine" in the sense of "finely made"). Here again is Okakura on the per-
formance of the tea ceremony:

The tea-master held that real appreciation of art is only possible
to those who make of it a living influence. Thus they sought to regu-
late their daily life by the high standard of refinement which obtained
in the tea-room. In all circumstances serenity of mind should be main-
tained, and conversation should be so conducted as never to mar the har-
mony of the surroundings. The cut and colour of the dress, the poise
of the body, and the manner of walking could all be made expressions
of artistic personality. These were matters not to be lightly ignored, for

until one has made oneself beautiful he had no right to approach beauty.[2]

What Plato means by being just is what Okakura means by being beautiful; as Socrates suggests, by likening the soul to a musical instrument and justice to the actual performance of a musical work (the proper tuning of a chord). But then, justice is not simply a condition or quality *of* one's inner being; it is a condition of one's really *having* an inner being. To ask whether someone is just is not simply to ask what is inside him; it is to ask whether he is "truly himself," whether what is inside him is really "his own." What Plato is trying to demonstrate (what he is literally trying to show us) is what it takes to be a complete human being, to be whole. It is to be attuned to oneself. We may pride ourselves on our ability to do, or even to be, "many things." The danger is that, in being many things, one is unable to be oneself . . . one is no longer one.

Being "entirely one" is what Socrates really meant when he defined justice as "doing one's own work." This is not just a job that has been assigned to us, fairly or unfairly, by nature or by convention. It is not simply a matter, as Socrates says, "of someone's doing one's own externally." It is the task of being a human being. This requires not that we be ordered about by others (philosopher–kings) or by only a part of ourselves (the rational part). It requires that we be ordered, or regulated, from the inside out. If we attend only to what lies on the surface, to the various impressions to which Adeimantus alerts us, we shall be led this way and that, both in our daily lives and within our souls (we are not people who are capable of doing many things; each of us is many things, often at odds with ourselves). What lies on the inside will be as hollow and superficial as our perceptions tend to be. But Socrates is not encouraging us to ignore what lies on the surface. Whether one is just depends on the condition of one's soul. The outside matters, insofar as it preserves (or corrupts) that inner state. To insist on the reality of what is inner is not simply to value opinion. We often equate the "personal" perspective with a "subjective" point of view. Plato does not (nor does Emerson, as we shall see in chapter ten). His point is that in cherishing opinion, we may actually *lose sight* of what is inner. To be real on the inside one must, as it were, "get real" on the outside. Plato saw what Adeimantus was getting at—that our opinions are rarely our own because we are rarely our own. It is not appearance as such that Plato would have us beware of, but the lifeless externalities—the easily digestible impressions, or outsides without insides—that our vision rarely penetrates beyond. This is what he describes as the substanceless substance, or wandering stuff, of opinion.[3]

How can we regain the ability to see, or restore the integrity of our inner being? If Adeimantus is right, there may be nothing there (just an accumulation of impressions), or what there is may be a mess, even if we do not realize it. For Plato, being whole is a task, something it takes work to achieve. The ability to *be*, on the inside, is related to the ability to see and

embrace what truly is; that is, the being of the Forms. The philosopher is someone who loves reality, not the superficial or made-up appearances that we ordinarily recognize as reality. By trying to help us to understand what it means to live philosophically, by offering us the kind of demonstration that can inspire and move us, Plato is actually trying to bring us back to life. If Plato's writing is so carefully crafted, it is because we need art to teach us how to see.

★ ★ ★

When Glaucon and Adeimantus challenge Socrates to show them that justice is better than injustice without taking appearances into account, he claims to be at a loss:"I don't see how I can be of help. Indeed, I believe I'm incapable of it . . ." (368b).Why is it so hard for them to see what they need to see? It is not just because the argument would be too complex. It is because of the kind of education it would involve. This is what Plato has Socrates discuss between the posing of the question of justice in Book One and the psychological argument of Book Four, the role of art and poetry in education. This is another part of the *Republic* that many readers find troubling. Here again, we need to ask ourselves what Plato is really saying. He says (or has Socrates say) some astonishing things:

> You know, don't you, that the beginning of any process is the most important, especially for anything young and tender? It's at that time that it is most malleable and takes on any pattern one wishes to impress on it . . . Then shall we carelessly allow children to hear any old stories, told by just anyone, and to take beliefs into their souls that are for the most part opposite to the ones we think they should hold when they are grown up?
>
> We certainly won't.
>
> Then we must first of all . . . supervise the storytellers. We'll select their stories whenever they are fine or beautiful and reject them when they aren't. And we'll persuade nurses and mothers to tell their children the ones we have selected, since they will shape their children's souls with stories much more than they shape their bodies by handling them. Many of the stories they tell now, however, must be thrown out.[4]

What do we find astonishing about this? The claim that most of the stories that are told now (the bulk of contemporary culture) must be thrown out has led many people to think that Plato himself is a kind of tyrant, or at least a conservative crank. But is this really the most astonishing thing he says here? Is he simply saying that a good education depends on the stories we tell our children, and that what makes a story good or bad is whether it gives children the morally right ideas? If so, how could we be teaching them to love reality? It looks instead as if we are hiding something from them, the

sort of thing that Glaucon was trying to help us to see with his own story about the shepherd and the ring (something that might be true of any or all of us). Rather than telling the truth, and teaching them to love it, we would be indoctrinating them. At the very least, we should tell them both sides of the story, show them the evil as well as the good, and allow them to see the truth for themselves.

But perhaps we should look again. Socrates does suggest that what makes a story good or bad has something to do with its truth and falsehood. But he is not just talking about a story's being "realistic," or true-to-life. We should note that Glaucon and Adeimantus have trouble understanding exactly what Socrates is getting at, and that he devotes a considerable amount of time to explaining and illustrating his point (the discussion of poetry and art occupies the rest of Book Two, all of Book Three, and even a portion of Book Four, only to be taken up again in Book Ten, where it has practically the last word). This suggests that what Plato is trying to show us about art and education is not as straightforward or as obviously objectionable as we take it to be. In the passage we looked at (where Socrates initially declares that if we are to educate our children well, we must be careful about which stories we expose them to), the emphasis is not so much on whether the stories we tell are morally correct, or literally true, but on whether they are "fine or beautiful." Here again, the word is *kalon* (the same word used to describe the just soul, as well as the festivals Socrates admired). A few lines later, Socrates says that "telling the greatest falsehood about the most important things doesn't make a fine story," adding that, *even if it were true*, "it should be passed over in silence." What we should beware of, in any story, is whether it "gives a bad image" of what gods and mortals are like, "the way a painter does whose picture is not like the things he's trying to paint." Of even greater concern, however, is if the falsehood *isn't well told* (377d–e). This should lead us to wonder: is it *what* the story says (the subject-matter or content), or *how it says it* that gets the message across? (We might ask the same question about the painting, and what it depicts.)

More astonishing than Plato's claim that some (if not most) poetry should be censored is his claim that music and poetry are the most important part of any education. The idea that education should consist primarily of "physical training for bodies and music and poetry for the soul" (376e)— that it should actually begin with music and poetry—may have seemed less astonishing to Plato's contemporaries than it does to us. But Plato goes further, perhaps than any philosopher then or now, in seeing what is at stake where art and education are concerned. It is because he takes music and poetry, because he takes all art more seriously than we ourselves do that he ends up saying things that shock us. To appreciate this, we need only compare Plato's curriculum to our own. If we are offended by Plato's claims (after all, how could he presume to judge which poems are right and which are wrong, which we are allowed to see and hear and which we are not?), it is because we ourselves have already thrown these stories out. We have marginalized art, as far as education is concerned, and relegated it to the sphere

of entertainment. What Plato sees as fundamental, we tend to see not as one of the basics, but as the stuff of which electives are made. What is central, for Plato, is peripheral for us. Of course, we teach poetry and music at almost every level of education. Colleges and universities may even have an arts requirement. But, it is hard to imagine a contemporary core curriculum where art itself is the core. When we do offer (and perhaps even require) an education in the arts, it is generally education *about* the arts. What we tend to regard as having genuine academic worth are those aspects of the curriculum that deal with history, theory, and analysis. In Plato's view, it is not what we learn *about* art that is most important, but what we learn *from* it. For him, education in art is education by art. This is not just one curricular area among others; it is the very foundation of the kind of education that leads to justice, the kind of education that can teach us to see and embrace "what is," and that makes us whole.

How can music and poetry educate us? If Plato really meant what he seemed to be saying in Books Four and Five, why is his curriculum not directed primarily toward the rational part of the soul (the way ours actually tends to be)? It looked as if what Plato wanted us to do, in Book Five, is shift our gaze away from beautiful sights and sounds (away from the particulars) and focus exclusively on the universal and purely intelligible Forms of things. But then, we have failed to see what is happening in Books Two and Three: that *whether we get there* (whether we "reach reality") *depends entirely on beautiful sights and sounds!* The solution to the problem Plato is struggling with throughout the *Republic* is arrived at not just theoretically, but practically through a process of education that is essentially based on our experience of *particular* poems.

Why is this not a contradiction? Perhaps, we have also overlooked something in Plato's description of the philosopher. In Book Five, it looked as if Socrates was going to define what a philosopher is in the same way that he tried to get Cephalus and Polemarchus to define justice; that is, as the opposite of a nonphilosopher. What he is really trying to do, however, is show us something about the philosophic character. The actual result of this "lengthy and difficult discussion" is not a logical analysis, but a revelation (as Socrates puts it at the beginning of Book Six). The nonphilosophers are portrayed as the wandering lovers of sights and sounds. As Glaucon observes, such people *do* seem to take pleasure in learning things (475d); they delight in seeing. In bringing to light the contrast between them and the "true philosophers," Socrates does not define the latter as those who love truth rather than the appearances of things (as we might expect him to). Instead, he says philosophers are "those who *love the sight of* truth" (475e), using the same word (*philotheamones*) that he uses to describe the nonphilosophers. A *philotheamonas* is, literally, a spectacle-lover. A stricter (albeit more awkward) rendering of Socrates characterization of the philosopher might be "those for whom truth is the spectacle that they love." When we read these words, our tendency is to place the accent on truth. By assuming that truth lies beyond the appearances, and that, if someone really cares about the

former, he must not care about the latter, we make the difference between the philosopher and the nonphilosopher look more like a logical opposition. But, this is not what Plato himself does in his text; nor is it what Socrates is shown to be. If we think back to the very beginning of the *Republic*, we see that Socrates himself is a spectacle-lover. He, too, delights in seeing.

How does he differ from the unphilosophical lovers of sights and sounds? Plato does not make this perfectly clear; at least not with the kind of logical clarity we ordinarily associate with philosophical understanding. In Book Five, there is no mention of the truth being separate, or utterly removed, from the appearances. If anything, Socrates suggests that the ideal Forms "manifest themselves everywhere in association with actions [and] bodies"; that is, in the "beautiful sounds, colors, shapes, and everything fashioned out of them" that captivate the nonphilosophers (476a–b).

In the previous chapter, we pictured the philosopher as looking away from beautiful things and toward something else entirely (beauty itself). The subtleties of Plato's text suggest a different picture. What we are shown is not someone who averts his eyes, but someone who is capable of seeing something *in* the particulars that others do not—someone whose vision is more like Thoreau's. When Thoreau looked at nature, he was not simply moved by his own pleasures and tastes. It was not just his personal inclinations and concerns that were aroused. He was able to see nature in a way that moved him to wonder. It was this experience of wonder that took him outside of himself, only to restore him to himself. What he saw, and how he saw, put him in touch both physically and intellectually with the fullness of life.

If Plato's philosopher has eyes not only for beautiful things—but for beauty itself (Socrates insists that he is able to see *both* the Form *and* the particular), it is because these things move him to wonder. His experience goes further than that of the person who, in seeing a particular painting for the first time, considers only whether it "does something" for him, and leaves it at that. The philosopher is open to where the experience leads, to its ultimate (and ultimately mysterious) source. The beauty that is manifest in particular things, like falling leaves, *is* fleeting and ephemeral. How might it also offer us a glimpse of something eternal ("They teach us how to die . . .")? If the sight of a beautiful thing can yield philosophical insights, it is not because our experience leads us away from or beyond what actually lies before our eyes. In Thoreau's case, it was because he was led more deeply into it. It is the astonishing particularity of natural phenomena that make things like the autumnal landscape or the single flower on the *Tokonoma*, an occasion for wonder, an object not just of understanding or enjoyment, but of mystery and awe.

If the philosopher loves what he does not know, the lover of sights and sounds, as Plato portrays him, is someone who loves merely what he loves. He may seek novelty in running around to all the festivals, but he is really looking for (and at) the same thing time after time. He embraces what he knows and likes and, like Thoreau's gardener, is interested only in what he

happens to find interesting. But then, he is not a true lover of sights and sounds; he is not seeing all of what there is to see in the sights he beholds. If he did (and if they were really beautiful and fine, and not simply produced for quick and easy consumption), he would be struck by something he does *not* know, something he could not "figure out," something that challenged his interests or thwarted his expectations in the same way that the particularities of Plato's text challenge us when we pay close attention to them.

Plato's philosopher is someone who really looks at what lies before his eyes. Scholars are often exercised by the fact that the word Plato uses to refer to the ideal, and supposedly invisible, Forms of things is *eidos*—a word that even in Plato's time was commonly used to refer not to abstract "ideas" (in our sense), but to something that is literally *seen*. To grasp the "idea" of something, in this sense, is to discern the characteristic shape and line, the visible form by which it is recognized as the kind of thing it is (as a Doric rather than an Ionic column, e.g.). As Rhys Carpenter observes, in his wonderful book on *The Esthetic Basis of Greek Art*, Plato's choice of words implies a "concrete . . . visible quality (and therefore a *concrete existence*), of which *eidē* [the ideal Forms] could not divest themselves."[5]

For many scholars, Plato's theory of Forms suffers logical shipwreck on this point. They do not know what to make of the idea that the Forms must be both visible and invisible, and are thereby led to assume that Plato is forcing a radical shift in the meaning of words by divorcing the seen from the unseen. Our modern association of ideas with "thoughts" or "concepts" has made us less sensitive to this tension (if we translate *eidos* as idea, then our idea of what an idea is makes the contradiction disappear). In severing a link that might actually have been preserved in Plato's thought, we find ourselves unable to see something in his text that should lead us to wonder. How might it not have seemed illogical, and hence irrational, to see an abstract idea embodied in a concrete visual image, or to discern the universal *in* the particular? In his writing, Plato did not differentiate between the common and the philosophical senses of *eidos* (he did not capitalize or place quotation marks around it when he meant Form rather than form). He just used the word. In so doing, he raised the question: *how are* the concrete, physical forms (the "shape and line") of things related to the true or perfect form? How do we ourselves relate to the one through the other?

On the few occasions that Plato has Socrates try to answer this question in an explicit way, he uses the language of participation.[6] Scholars tend to be far less comfortable with this than they are with the language of imitation, or likeness, which Plato also uses, and which it is easier to make theoretical sense of, especially if we assume that an imitation is a more-or-less accurate representation that is separate from the reality it depicts. Participation is more challenging, precisely because it does not entail this kind of separation. If anything, it invites us to picture the physical form, and the ideal form, as more intimately involved with one another, not just to conceptualize the forms in this way but to *see* them in this way. Perhaps that is why Plato's attempts to explain the connection between particulars and forms

are so few and far between. It may be that the relationship just cannot be grasped theoretically. Instead, what we find throughout Plato's texts are dramatic illustrations, or images, of what this participation might involve: not just the relationship of the ideal forms to the concrete particulars, but our own intellectual and physical relationship to both. This relationship is embodied in Plato's writing. It is not explained to us. It is there for us to see, and to participate in—to enact the text.[7]

A closer reading of Plato's text should make it less surprising that he would use a word that refers, first and foremost, to visible form, and that the philosophers' gazing at the ideas would involve the experience of really seeing something, fully and concretely, for what it is. Nor should we be quite so astonished to discover that it is only through our experience of particular things (especially works of art) that we become the sort of people who are capable of seeing and loving beauty itself, and of becoming beautiful and whole inside.

This is not to suggest that how we learn to see is easily understood, or accomplished. Why must we take the utmost care to insure that the first stories children hear about virtue are the best ones for them to hear? Because, Socrates says, "the young can't distinguish what is allegorical from what isn't, and the opinions they absorb at that age are hard to erase and apt to become unalterable" (378d). This seems to echo what Adeimantus said earlier, about the effect that our often-repeated sayings about the virtue and vice are likely to have on the souls of young people. But now Socrates is addressing the true depth of Adeimantus's concern. What are we really doing when we shape our children's souls with our stories? We are not teaching them the difference between right or wrong (especially if what we say suggests that the difference consists primarily in whether they will be punished or praised). Nor are we teaching them what is true or real. This would ignore a more fundamental question that remains unanswered not just in theory, but in our children's souls (and perhaps even in our own souls). The question is: how does one *tell* the difference between truth and falsehood, reality and fantasy? Our ability to do this is not psychologically guaranteed. Perceiving the visible reality "as it truly is," and recognizing our fantasies, projections, and other constructions for what they are, depends on the structure of our souls. Every soul has its appetitive, emotional, and rational parts (Socrates hints that there might be others in-between). But then, there is the question of how those parts are ordered or organized, how our souls are actually formed, just as the parts of temple, or a piece of music, must be made to fit together in a certain way. If they are *not* made to fit together, if the parts are not harmonized or well-proportioned so that appetite or emotion "overwhelm" the other parts, we shall end up seeing what we want to, not what is. Or we may end up seeing what we fear to be the case. Wish-fulfillment, paranoia, anxiety, anger, pride, or shame will not only cloud our judgment and make it difficult to think clearly and rationally, but will prevent us from seeing what actually lies before our eyes. In Thoreau's case, it was the calculating part of his soul that did this. But then,

to be calculating is not what it means to be rational—even for Plato. To be rational is to have one's soul function as a whole. It is *to be*, and thus *to see*, *in proportion*.[8]

Just as the parts of a young child's body are not yet proportioned to one another in such a way that its interactions with the world are well-coordinated, the parts of a child's psyche, or soul, need to develop in such a way that the child comes to recognize that there *is* a "real world" that does not magically conform to its wishes and desires, or reflect its darkest fears. This would not only be a reality with which the child would have to contend, by learning the difference between what feels good and what is good and making practical judgments on that basis. It would be a reality that the child could truly love (even if it is not always pleasant or pretty). Otherwise, the reality the child inhabits would be a fantasy world— a world in which "wishing makes it so."[9] When the child is *in utero*, it actually does inhabit such a world. It is one with its provider (the mother's body), both physically and psychologically. The gap between desire and fulfillment, or between frustration and its external source, is experienced only later through a process that continues long after birth.

Our own experiences as (and of) adults show that this process is never really over and done with. The process of realizing the difference between reality and fantasy is never final or complete. We can always regress. Plato sees this, too. Even after the parts of our souls have developed, even if we have acquired that sense of reality that Socrates associates with the rational part, there may still be a lack of proportion among them. In ways that we are not always able to recognize, our fantasies (including our negative fantasies) can overwhelm us and distort our vision. We have grown souls, as it were, but have not become whole. We cannot assume that we are able to see what is true, or what is false, for what it is.

How does one learn to do this? Not simply by being shown the truth. Something else has to happen first. "Fine words, harmony, grace, and rhythm" are the accompaniments, Socrates observes, of a "fine and good character." These are the qualities "our young people . . . must aim at, if they are to do their own work" (400e). How are such qualities developed in the soul? Through our experience of works of art:

> Now, surely painting is full of these qualities, as are all the crafts similar to it; weaving is full of them, and so are embroidery, architecture, and the crafts that produce all the other furnishings. Our bodily nature is full of them, as are the natures of all growing things, for in all of these there is grace and gracelessness. And gracelessness, bad rhythm, and disharmony are akin to bad words and bad character, while their opposites are akin to and are imitations of the opposite, a moderate and good character . . . Is it, then, only poets we have to supervise, compelling them to make an image of a good character in their poems or else not to compose them among us? Or are we also to give orders to other craftsmen, forbidding them to represent—whether in pictures,

buildings, or any other works—a character that is vicious, unrestrained, slavish and graceless? Are we to allow someone who cannot follow these instructions to work among us . . . or must we rather seek out craftsmen who are by nature able to pursue what is fine and graceful in their work, so that our young people will live in a healthy place . . . and something of those fine works will strike their eyes are ears like a breeze . . . leading them unwittingly, from childhood on, to resemblance, friendship, and harmony with the beauty of reason?

The latter would be by far the best education for them.[10]

There is a great deal to wonder about in this passage. If Plato is right, then art has a profound effect on our souls. We are peculiarly receptive to it, especially when we are young. This is how ideas are conveyed to a psyche like that of young child—a psyche that is acquisitive, prone to "taking in" (rather than "thinking about") what it sees or hears. What is expressed in poetic form is not filtered through rational thought, but is absorbed in a more basic and direct way. Once absorbed, it not only shapes our beliefs, or what we think but our whole character, how we think (and act), and, ultimately, the way we are.

How does it do this? Not by conveying ideas in the modern sense or by representing particular thoughts or images of people and things. What Socrates is talking about here are ideas in the original sense, the characteristic shape and line that a work of art embodies, and that we experience concretely. While the message communicated by the poem does matter, what matters most are the sorts of *formal* qualities—grace, harmony, and rhythm—that are exhibited in all the arts, and in nature as well. These are the forms that we literally see and hear, that "strike [our] eyes and ears like a breeze that brings health from a good place . . ."; that is, if we are fortunate enough to be exposed to, and capable of receiving their sanative influence. These formal qualities are abstract, but they are also materially embodied and made visible by (well-made) works of art. Rather than eschewing matter in favor of form, Plato would have us embrace both together. Form matters in art, because form matters in us.

Socrates says that poetry, painting, music, sculpture, architecture (all the crafts, including weaving and embroidery) are full of these qualities, as is "our bodily nature," and "all growing things." In "all of these there is grace and gracelessness." There is a "kinship" (not just a resemblance, but an isomorphism) between these qualities and our own qualities. If architectural structures—the very shape of a building—can educate us, it is because they shape our souls. How can that be, if buildings do not depict anything? In what sense could they "represent . . . a character that is vicious, unrestrained, slavish, and graceless"? The representation is not something we simply look at and thereby come to believe; nor is it a copy of something (a good or bad character) that we experience from a distance. We take it into our psyches, so that we ourselves imitate what it imitates. We embody the *eidos* that it embodies, in a physical (though not merely physical) way.

Although Plato does not refer to them directly, we might pause to con-
sider the formal arrangements that famously underlie the classical architec-
tural Orders. We tend to see these as regulating the structure in a superficial
way, as specifying how a column or capital is supposed to look. We see
volutes and we identify a column as Ionic; or we see something more plain
(just an abacus and echinus) and we recognize it as Doric. Or, perhaps (if we
are somewhat more attentive, or knowledgeable about these things), we
notice a difference in overall proportion, in the intercolumnar spacing, for
instance, and see one Order as allowing for greater freedom of movement
than the other. But then we may fail to see that the classical Orders are fun-
damentally a matter of proportion, of the way in which the structure as a
whole is "ordered." Each of these patterns is a visual realization of harmony,
rhythm, and grace—of health and of life. To see them merely as a set of
visual cues or cultural symbols for identifying or categorizing a particular
style of building is to construe our own relationship to them in a superficial
way. Plato helps us to see that what it means for a building to have a fine and
good character is what it means for us to have a fine and good character. The
Orders are meant to regulate the arrangement of the parts in the way that
justice is meant to regulate our lives. Architectural forms—the proportions
of a temple, for instance—do not merely facilitate worship or symbolize
reverence for the gods. They order the parts and govern the structure of
our souls. These are the reasons education in music and poetry is "most
important":

> First, because rhythm and harmony permeate the inner part of the soul
> more than anything else, affecting it most strongly and bringing it
> grace, so that if someone is properly educated in music and poetry, it
> makes him graceful, but if not, then the opposite. Second, because
> anyone who has been properly educated in music and poetry will
> sense it acutely when something has been omitted from a thing and
> when it hasn't been finely crafted or finely made by nature. And since
> he has the right distastes, he'll praise fine things, be pleased by them,
> receive them into his soul, and, being nurtured by them, become fine
> and good. He'll rightly object to what is shameful, hating it while he's
> still young and unable to grasp the reason, but, having been educated
> in this way, he will welcome the reason when it comes and recognize
> it easily because of its kinship with himself. (401d–402a)

Here again, we are reminded of *The Book of Tea*, and also of Thoreau's
hope not just for a nature that was preserved from culture, but for a culture
that would help to preserve our own nature. In Book Six of the *Republic*,
Socrates tells us that "anyone who sees only the outer covering and not
what's inside" will think that human person is a "single creature" (588c). But
the unity is only apparent. Genuine unity or individuality, being organized,
organic, and alive on the inside, depends on the integration and harmony of
the potentially conflicting parts of the soul. What is at stake where cultural

"information" is concerned are not just ideas about how to behave, beliefs that are right or wrong, true or false; nor is it simply a matter of providing suitable role models. It is something more fundamental. Our happiness depends on the overall constitution of our psyches, on our ability to see and to be in proportion. To "be one's own friend," as Socrates says, is to be led "to resemblance, friendship, and harmony with the beauty of reason." But all of this ultimately depends on art. It is through our experience of what is well-ordered (what is fine and beautiful) that we develop a rational order within ourselves. Art does not just appeal to our emotions and desires; nor does it go straight to our heads. Our ability to distinguish between truth and falsehood, fantasy and reality—to think, feel, and desire in harmony with that vision—must be constituted from the bottom up.

With regard to those poems that children ought not to hear, Socrates voices a concern that "from enjoying the imitation, they might come to enjoy the reality. Or haven't you noticed that *imitations practiced from youth become part of nature and settle into habits of gesture, voice, and thought?*" (395c–d). "It isn't that they aren't poetic and pleasing to the majority of hearers," he notes, "but that, the more poetic they are, the less they should be heard by children or men who are supposed to be free" (387b). If what matters about these particular poems is not just what they say but *how poetic they are*, it must be the form itself, and not just the content, that is good or bad for us. What poetic qualities "inform" is our own inner and outer form. Where art is concerned, what we see affects the way we see . . . the way we think, feel, and act. This is what makes us whole or not.

Now we can understand how works of art, even humble crafts like gardening, could educate us in the same way that Plato thinks gymnastics does. Physical activities, the kind of disciplined practice, or "exercise" that Plato has in mind, can embody and cultivate the same formal qualities as works of art. For Plato, physical education should not merely accompany music and poetry in the development of character. The "best education" is a meeting place of the material and transcendent aspects of form. It aims at the harmony not only of our souls with themselves, but of our inner and outer being. This harmony remains essentially incomplete, without its physical realization. "If someone's soul has a fine and beautiful character," Socrates asks, "and his body matches it in beauty and is thus in harmony with it, *so that both share in the same pattern*, wouldn't that be the most beautiful sight for anyone who has eyes to see?" (402d, emphasis added). As Socrates himself comes to realize, it is *not* the case that physical training takes care of the body while music and poetry take care of the soul. Glaucon is surprised to hear that both are "chiefly for the sake of the soul" (410c). We, too, might be surprised by this, that "habits of gesture" should matter as much as "habits of thought" to a philosopher like Plato. But then, it is entirely consistent with a vision of justice that looks to what is outer to preserve what is inner, and that sees wisdom as the kind of knowledge that oversees this harmony and works to achieve it. It is no less consistent with Plato's characterization of the philosopher as one who really does "have eyes to see" the most beautiful

sights, as a theorist, like Thoreau. Socrates would have felt very much at home at a tea ceremony.

We may regard art, and even architecture, as elite pastimes or peripheral amusements. We may regard them with indifference or even suspicion—a suspicion motivated by our own anti-materialism or even a strong sense of what justice demands (one that resists any suggestion of privilege). Or we may simply fail to see why it is so important that children be able to "sense it acutely when something . . . hasn't been finely crafted or finely made by nature." Why *must* we "seek out craftsmen who are . . . able to pursue what is fine and graceful in their work" if we are to become "fine and good" ourselves? Because, as Plato reminds us, there is an architecture of the soul. Our very individuality, our own unity as a person, and our ability to interact in a just manner with other persons depends on how our souls are structured. We may be indifferent to the architecture we see around us, to what is "out there." Shall we remain indifferent to what is within each of us? Perhaps not, and yet—this is the crucial insight—the two depend on each other. Justice, as Plato pictures it, *is* a cultural product; but, it is not merely a human invention, or a "device," as Thracymachus, Glaucon, and Adeimantus took it to be. The moral of the story Plato tells about justice is, in reality, the moral of the story of Peiwoh's harp. We recall the passage:

> The masterpiece is a symphony played upon our finest feelings . . . At the magic touch of the beautiful, the secret chords of our being are awakened, we vibrate and thrill in response to its call. Mind speaks to mind. We listen to the unspoken, we gaze upon the unseen. The master calls forth notes we know not of . . . Our mind is the canvas on which the artists lay their colour; their pigments are our emotions; their chiaroscuro the light of joy, the shadow of sadness. *The masterpiece is of ourselves, as we are of the masterpiece.*[11]

The *Republic*, we daresay, is such a masterpiece. Plato's own text is full of such colors and pigments, of the light of joy, and the shadow of sadness, though they often remain unseen. More often than not, they are "trampled down" by our interests and assumptions, about the philosophical theories Plato was supposed to have held, or about what it means to think philosophically. Aristotle (a student of Plato's) famously observed that "it is owing to their wonder that men both now begin and at first began to philosophize; they wondered originally at the obvious difficulties, then advanced little by little to . . . greater matters."[12] The "obvious difficulties" are the ones that lie closest to us—the sort that we might encounter on our daily walks. (Why *do* the leaves turn color in autumn? It is almost as thought they are showing off. But, then, why should they do us this favor . . . ?)

Of course, it may require a prepared eye to see even these things as wonderful, for it is often the *details*, the manifold variety, the minute differences, the subtle and indefinable hues, that give us pause. It is easy to overlook these things precisely because they are so close to us. The problem with the

nonphilosophers' fixation on the particulars is not so much that their per-
ceptions remain singular rather than universal, but that they tend to be
undiscriminating and generic (this is why Socrates characterizes the appet-
itive person as a money-lover: money is simply a means for acquiring what-
ever material goods one happens to want). The trouble with the "lovers of
sights and sounds," we recall, is that they run around to *all* the festivals, lis-
tening indiscriminately to *every* chorus, without considering what it is that
makes any one of them beautiful, or worth seeing. Their perceptions are
superficial and scattered. The problem is not just that they do not have eyes
for beauty itself. It is that they do not really have eyes for the particularity
of the particulars, for what distinguishes each from the other. They see trees
turning color where Thoreau sees the characteristic shape and line of the
Scarlet Oak at the very moment that its leaves deepen to that russet hue that
bespeaks fruitfulness even as it announces their imminent fall. This is why,
though the nonphilosophers are moved by what they see, they are not
moved to wonder. They are moved too easily, and therefore move too
quickly. They are not given pause, by what they see, to marvel at just what
it is. This is the difference between them and the philosophers. The ideal
Forms may be universal, in some sense; but, they are not generic. They are,
in another sense, utterly unique (Plato often reminds us that each of the
forms is "one," like the just person).

Plato's *Republic* is a philosophical text. It conveys universal insight. What
makes it unique? Perhaps it is moments like these that color the text in the
way that Thoreau's autumnal tints color the landscape. In Thracymachus's
confrontation with Socrates, for instance, habits of gesture and voice seem
to matter as much as the words and arguments (the *logoi*) he delivers. Plato
is as painstaking (and as poetic) in his attempt to describe them as Thoreau
is in his attempt to describe his own encounters with people and things:

> While we were speaking, Thracymachus had tried many times to take
> over the discussion but was restrained by those sitting near him, who
> wanted to hear our argument to the end. When we paused after what
> I'd just said, however, he couldn't keep quiet any longer. He coiled
> himself up like a wild beast about to spring, and he hurled himself at
> us as if to tear us to pieces. (336b)
>
> Thracymachus agreed to all this, not as easily as I'm telling it, but
> reluctantly, with toil, trouble, and—since it was summer—a quantity of
> sweat that was a wonder to behold. And then I saw something I'd never
> seen before—Thracymachus blushing. (350d)

Here is a dramatic moment. It comes at a crucial point in the argument
(the point at which Socrates is about to "refute" Thracymachus), but is
described in strikingly physical terms. And yet, there is something in the
physical observation that points beyond itself. What is it about
Thracymachus's sweating, in its very profusion (understandable, given the
heat of summer), that should move us to philosophize? If wonder is the

point at which philosophy truly begins, it is at this point in the text that Plato first presents us with something that is "a wonder to behold." One wonders why he did not have Socrates say that about justice at the very start of the conversation. That the nature of justice is something to be wondered at may be implied. But here, Plato is not just *saying* that something is to be wondered at. He is placing it literally (if poetically) before our eyes.

In Plato—in both his writing and his thought—art and philosophy meet. The *Republic* is not the only place in which we can see this. In the *Phaedrus*, he portrays Socrates as someone who has eyes not only for the universality of the Ideas, but for the particularity of the particulars. Plato does not simply describe Socrates in this way. He shows him to us in a passage that could have been written by Thoreau. Socrates and Phaedrus are searching for just the right place to have their conversation (about writing and about love). They come upon it, and Socrates sees (and feels) what makes it right:

> By Hera, it really is a beautiful resting place. The plane tree is tall and very broad; the chaste-tree, high as it is, is wonderfully shady, and since it is in full bloom, the whole place is filled with its fragrance. From under the plane-tree the loveliest spring runs with very cool water— our feet can testify to that. The place appears to be dedicated to Achelous and some of the Nymphs, if we can judge from the statues and votive offerings. Feel the freshness of the air; how pretty and pleasant it is; how it echoes with the summery, sweet song of the cicadas' chorus! The most exquisite thing of all, of course, is the grassy slope: it rises so gently that you can rest your head perfectly when you lie down on it . . .[13]

What does it really mean to follow reason? Plato gives us pause. In Book Six of the *Republic*, Socrates "supposes" that "when someone's desires flow toward learning . . . he will be concerned with the pleasures of the soul . . . by itself, and . . . abandon those pleasures that come through the body" (485d). *Does* the "true philosopher" abandon the body? Does he leave the particulars (the material world) behind, forsaking desire and emotion for pure reason? In Book Five, we were told that philosophers love the spectacle of truth. Elsewhere (on several occasions), Socrates compares them to painters. He ultimately describes the philosopher's contemplative vision of the ideal forms in the same way that he describes our experience of works of art:

> [A]s he looks at and studies things that are organized and always the same, that neither do injustice to one another nor suffer it, being all in a rational order, he imitates them and tries to become as like them as he can. Or do you think that someone can consort with things he admires without imitating them? [. . .] Then the philosopher, by consorting with what is ordered and divine . . . himself becomes as ordered and divine as a human being can.[14]

The kind of experience Plato associates with philosophy is very much like what he thinks esthetic experience involves. Such an experience makes us, not just fully human, but most nearly divine. In Book Ten, Socrates speculates that if particular things are fashioned by human beings who are trying to imitate an ideal form (he is thinking about crafts), then the form itself must have been fashioned by a god. The philosopher does not simply "know" the form (he may not know it at all). He "admires and consorts" with, and tries to emulate it within himself. He is not just informed by what he sees. He is formed by it. His experience shapes him, both inside and out, in the same way that art or justice can shape us. He does not "look at and study" these things from a detached or dispassionate point of view. The word, here again, is *theasthasthai*. The philosopher's vision of the forms is participatory, just as *theōria* was participatory. He "models" himself on the forms. In this, Plato joins Thoreau who looked to the ideal yet materially embodied and concretely visible forms of nature as "models for man's art" (where this art includes the shaping of our physical as well as our spiritual existence). And he joins Pieper, whose own words are worth reciting at this time:

> Whenever in reflective and receptive contemplation we touch, even remotely, the core of all things, the hidden, ultimate reason of the living universe, the divine foundation of all that is, the purest form of all archetypes (and the act of perception, immersed in contemplation, is the most intensive form of grasping and owning), whenever and wherever we thus behold the very essence of reality—there is an activity that is meaningful in itself taking place.[15]

From the very beginning of this book, we have suggested that a life well-lived is one that is in some sense complete, or meaningful in itself. The question is: in what sense? While this may seem like an abstract philosophical question, we have been led to search for answer, to articulate a "sense" that is quite concrete. Unexpectedly, perhaps, we have found such an answer (or part of the answer) in Plato. To live philosophically, to be whole, in Plato's sense, is to be capable of a certain kind of beholding. *This is a beholding in which the senses themselves are concretely engaged* (as they are in Plato's own text, in what he himself puts before our eyes). When Pieper suggests that through contemplation we may actually "touch" the ideal Forms, we might assume that he means this in a purely metaphorical sense. Thracymachus's sweat, and Socrates feet, should help us to see that Plato does not mean it this way. The English word "behold" owes nothing to the Greek. But its original meaning is rooted in the act of holding (*halten*). Just as our "theory" has become detached from the full-blooded experience of *theōria*, so has our idea of what it means really to behold something become detached. Plato's art may yet provide a corrective for this. If, in our minds, we hold the Forms apart from the particulars, and reason apart from the senses, then our souls

shall be held apart from themselves. In so doing, we are failing to see what there is to see in Plato's text. This is a pity, since what is happening there should also be happening in us. This is what Socrates is trying to teach Glaucon:

> Then, by the gods, am I not right in saying that neither we, nor the guardians we are raising, will be educated in music and poetry until we know the different forms [*eidē*] of moderation, courage . . . and all their kindred, and their opposites too, which are moving around everywhere, and see them in the things in which they are, both themselves and their images, and do not disregard them, whether they are written on small things or large, but accept that the knowledge of both large and small letters is part of the same craft and discipline?[16]

* * *

That the kind of beholding (and wholeness) of which the philosopher is capable should be understood, and undertaken, as a *practice* was already suggested by the passage in which Socrates describes what it means to be just. That it involves a "discipline," that it must be regular and habitual, was underscored by the role art and gymnastics play in teaching the soul to follow reason. The sense that there remains something profoundly mysterious about this process comes to light in what is perhaps the best known of all the images Plato, the artist, ever composed; that is, the famous allegory of the cave. It is really a visual parable, though precisely what it is intended to illustrate remains obscure. The cave is one of three images that Plato has Socrates use to describe "the most important subject" for the philosopher to learn, that is, the form of the Good. "*Every* soul pursues the Good," Socrates claims, "and does whatever it does for its sake. It divines that the Good is something, but it is perplexed and cannot adequately grasp what it is . . ." (505e). In what sense does the philosopher grasp what it is? In characteristic fashion, Socrates suggests that he himself does not possess this knowledge. He is unable, or unwilling, to define the Good in the way that he defined justice. He frustrates Glaucon and Adeimantus, who crave such a definition, and plead with Socrates not to "desert" them "with the end almost in sight."

If it was Adeimantus and company who initially thwarted Socrates in his walk from the Piraeus back to Athens, now it is Socrates who seems to thwart their efforts to arrive at some definitive knowledge of the Good. Instead of telling them what the Good is, Socrates offers to show them "what is apparently an offspring of the Good and most like it" (506e). Instead of an idea, he offers them an image. Rather than a theoretical account, he provides a *thea* (a spectacle) for them to "look at and study." If the *Republic* begins with their turning Socrates around from festive sights and sounds to a certain way of thinking about justice, it is Socrates who ultimately turns them around. Perhaps Plato can do the same for us.

The cave is not a static image. What we are meant to see is not a fixed and unchangeable idea. It is what is *happening* here that this particular image sets into relief. This is why we should beware of viewing it as an allegory, each element of which can or ought to be associated with some codified meaning. Allegories can be visually complex in that they can sometimes be quite detailed. The symbolic references may be esoteric. But the point of any allegory is, ultimately, to be figured out. Countless interpreters have tried to figure out the cave (in the same way that Glaucon and Adeimantus want to figure out the Good). We do not presume to judge the success or failure of these attempts. We would rather point to the features of Plato's art that challenge our expectations that might actually turn us *away* from figuring it out. Our claim is not that the cave defies interpretation in allegorical terms (there is almost nothing in heaven or earth that cannot be trampled down by the desire to codify). Our claim is that any such interpretation is likely to overlook the artful qualities of the story Plato tells.

The cave functions as both a painting and a poem (it would not be a stretch to describe its qualities as painterly as well as poetic). The story begins with Socrates inviting Glaucon to *imagine* human beings "living in an underground, cavelike dwelling . . ."

. . . with an entrance a long way up, which is both open to the light and wide as the cave itself. They've been there since childhood, fixed in the same place, with their necks and legs fettered, able to see only in front of them, because their bonds prevent them from turning their heads around. Light is provided by a fire burning far above and behind them. Also behind them, but on higher ground, there is a path stretching between them and the fire. Imagine that along this path a low wall has been built, like the screen in front of puppeteers above which they show their puppets . . . Then also imagine that there are people along the wall, carrying all kinds of artifacts that project above it—statues of people, and other animals, made out of stone, wood, and every material. And, as you'd expect, some of the carriers are talking, and some are silent.

It's a strange image you're describing, and strange prisoners.

They're like us. Do you suppose . . . that these prisoners see anything of themselves and one another besides the shadows that the fire casts on the wall in front of them?

How could they, if they have to keep their heads motionless throughout life?

What about the things being carried along the wall? Isn't the same true of them?

Of course. (514a–515b)

A strange image indeed, if only on account of the peculiar details that color it (it is unclear how we are even to imagine, let alone interpret, the

entrance of the cave being "as wide as the cave itself").[17] And talk about chiaroscuro! But, perhaps, we should not find it strange after all, given what we have already seen. These "prisoners" (we are supposed to picture ourselves in their place) have spent their entire lives watching shadowy impressions flit across the wall in front of them. These appearances are not even skin deep. They are utterly superficial, providing only the vaguest outline (not even so much as an image or reflection) of the artifacts that project them. Because the prisoners are unable to move their heads, there may be great variety in what they see, but really they are looking at the same thing all the time—they can see nothing but shadow (even the shadows of themselves). But then, they are unable to see them as what they are. Given what they are able to see, there can be no occasion for them to think that there might be anything more real than this (they "would in every way believe that the truth is nothing other than the shadows of those artifacts" (515c)). They are unable to perceive even the visible reality as it truly is.

These, we may suppose, are the lovers of sights and sounds with whom the philosophers were contrasted in Book Five. The shadows they behold point to nothing beyond themselves. But then, they do not really behold them. Their vision does not touch, or participate in, these spectacles (how could it, given that they are almost entirely without substance?). This is not Thoreau, who "takes in" the sights and sounds of the winter landscape in a way that is anything but motionless. It might look to us as if all these prisoners do is look. We might even see them as caricatures of the philosopher who "contemplates" things without interacting with them (or with other human beings), whose vision remains hopelessly detached from material reality.

The prisoner's way of seeing *is* detached. We see them being led on by the wandering stuff of opinion. But then, we can also see them as "objective" thinkers, in the modern sense. The prisoners have no choice but to follow the fashion (fashioned for them by the puppeteers). But the fashion, changeable as it is, displays a superficial consistency with which the prisoners busy themselves, by calculating the frequency with which certain kinds of shadows appear, predicting which ones will come next, and developing what amount to statistical theories. Socrates even invites us to imagine that there would be "honors, praises, or prizes among them for the one who was sharpest at identifying the shadows as they passed by and who best remembered which usually came earlier, which later, and which simultaneously, and who could thus best divine the future . . ." (516c–d). It is not hard to detect an uncanny resemblance between the cave and contemporary academia. The prisoners, as Socrates would have us imagine them, are in fact displaying the skills of any competent social scientist or art historian, for that matter! What is remarkable about the shadows on the wall of the cave is not that they are dark and mysterious in a way that might move us to wonder. It is that they are so easily figured out. The prisoners' real plight is that their way of seeing makes them *unable* to wonder not just because they are bound, but because what they see is so superficial and "clear." It is this way of seeing that they are really fettered by.

This is not the philosopher's way of seeing. We are told that the philosopher "looks at and studies"—he takes in the spectacle of truth. It is noteworthy that Socrates never describes the shadows on the wall of the cave as a "spectacle." When the philosopher looks at things (when Socrates admires the festival), the word Plato uses is *theasthastai*. He does not use this, or any related word, to describe what the prisoners do. The point is not that all the prisoners do is look, but that their passive (and passing) perceptions fall short of real seeing. It is not that they fail to "study" the appearances (they sort of do). What they fail to do is to gaze at or truly behold them.

Who can blame them? Not Socrates. He does not invite us to see the nonphilosophers as the inferiors they are. On the contrary, he insists that they are "like us" (like Cephalus and Polemarchius, Tracymachus, Glaucon, and Adeimantus, even Socrates himself). And so the question becomes: what would it take for their (or rather our) way of seeing to change? They must, in some sense, be "released from their bonds." But in what sense? What would this be like? Here again, we tend to assume that the physical chains that bind them, like the overwhelmingly physical character of the cave itself, must be construed in a purely metaphorical sense—as standing for something that is more like a state of mind than a material condition. But while we may assume that this is the moral of Plato's story, that the aim of a philosophical education is to leave the material world and concrete appearances behind, the story itself does not permit us to take that leap. There is no point at which our imagination, or understanding, is allowed to shift from the physical to the purely intellectual. Instead, Plato has composed his story in such a way that, in our attempt to figure out what such a change would involve, we confront something that is fundamentally mysterious. This is how the reader is moved to wonder, as she finds herself moving, not away from concrete appearances, but more deeply into them:

> Consider, then, what being released from their bonds and cured of their ignorance would be like, if something like this came to pass. When one of them was freed and suddenly compelled to stand up, turn his head, walk, and look up toward the light, he'd be pained and dazzled and unable to see the things whose shadows he'd seen before. What do you think he'd say, if we told him that what he'd seen before was inconsequential, but that now—because he is a bit closer to the things that are and is turned towards things that are more—he sees more correctly? Or, to put it another way, if we pointed to each of the things passing by, asked him what each of them is, and compelled him to answer, don't you think he'd be at a loss and that he'd believe that the things he saw earlier were truer than the ones he was now being shown?[18]

One thing, at least, is clear: this is a description of *bodily* seeing. Like someone emerging from a darkened room into a brilliant winter landscape,

the prisoners would be literally pained by the sights they beheld. Only now do they find the spectacle "dazzling" precisely because they cannot see it clearly, or figure it out. Plato's story reminds us that "the eyes may be confused in two ways and from two causes, namely, when they've come from the light into the darkness and when they've come from the darkness into the light" (518a). If the prisoners initially mistook falsehood for truth, now they mistake truth for falsehood. They are bound to, for reasons that are every bit as physical as the chains that formerly bound them. They are uncomfortable, disoriented, and confused not only because what they see is unfamiliar or a sight to which they are unaccustomed, but because it is *hard to see*. The fact that we ourselves must be able to understand the physical experience that is involved in making this ascent (and to understand it, we actually have to experience it) is reinforced by the increasing intensity of the sensuous elements that Plato weaves into his story. The prisoners are "compelled to stand up," (their limbs must ache as much as their eyes) to turn their heads, and *walk*:

> And if someone compelled him to look at the light itself, wouldn't his eyes hurt, and wouldn't he turn around and flee towards the things he's able to see, believing that they're really clearer than the ones he's being shown? [. . .] And if someone dragged him away from there by force, up the rough, steep path, and didn't let him go until he had dragged him into the sunlight, wouldn't he be pained and irritated at being treated that way? And when he came into the light, with the sun filling his eyes, wouldn't he be unable to see a single one of the things now said to be true? (515e)

What would have to happen for us to be able to see these things? Our eyes would have to adjust, naturally. But does this happen naturally? If Thoreau is right, a person (his naturalist, let us say) might venture out into the stark clarity of a winter morning and, even after adjusting to the light, still not see what there really is to see. Even as he walks across the snow-covered fields, his eyes would "flee towards the things he's able to see" (the things he is able to make sense of or explain using the ready-made concepts at his disposal). Plato's prisoners may come to see things "with their own eyes," in Pieper's sense. But they do not do this on their own. They must be "dragged . . . by force," and are "pained and irritated" by the treatment they receive. Are they simply being bullied into seeing what the philosopher sees, or "conditioned" to see things in a certain way (as Thracymachus suggested we all are)? Is there no sense in which they might be led on by the very thing they are trying to see—the vision they are struggling to make out?

After all, this is supposed to be a vision of the Good. If the prisoners' experience leads them to see it for what it is (and if it is truly the Good), then it cannot just be a matter of conditioning. They cannot just come to believe certain things that they did not believe before, or exchange one reality

for another. Nor is it enough for them simply to acquire a body of knowledge that they previously lacked. What we see happening, as the prisoner emerges from the cave, is not just that he comes to *know* more than he did before. It is that he only now becomes not just a spectator of the truth, but a true beholder of spectacles:

> At first, he'd see shadows more easily, then images of men and other things in water, then the things themselves. Of these, he'd be able to contemplate [*theasaitoi*] the things in the sky and the sky itself more easily at night, looking at the light of the stars and the moon, than during the day, looking at the sun and the light of the sun. (516a)

The point is not so much that the prisoner's eyes have to adjust, but that his way of seeing has to become *habituated* ("There would be need of habituation," Socrates says, "to enable him to see the things higher up"). Nor is it just his eyes—if we are to take the whole image seriously—in its full richness and concrete particularity. Once they have seen the light, Socrates assures us, the prisoners' *souls* will be "always pressing upwards" (517c). Whether this image "is true or not," Socrates says, "only the god knows. But this is how I see it: In the knowable realm, the form of the Good is the last thing to be seen, and it is reached only with difficulty. Once one has seen it, however, one must conclude that it is the cause of all that is correct and beautiful in anything . . ." (517b).

<p align="center">★ ★ ★</p>

What is the moral of this story? That the philosopher's disembodied point of view provides sole access to the truth, while the materially encumbered perspective of the cave dwellers leads only to falsehood? At what point, exactly, does one become a philosopher if, as Socrates says, the prisoners are indeed "like us" (Socrates included)? If we are to see ourselves as being faithfully portrayed by such an image, it cannot look familiar to us. We must first appreciate and contend with its very strangeness. The implication is that we are all potentially philosophers. To realize this, however, we must be turned away from our shadowy conception of what it means to be, or become, philosophical. As Socrates invites us to picture it, the prisoners' ascent does not lead them away from concrete things and toward abstract ideas. By freeing them from their detachment, and bringing them closer to particular realities (in their bodies as well as their souls), it ultimately enables them to see the beauty *"in anything."*

But then, there is something more to the moral of this story—a crucial ingredient. In making their ascent, the prisoners need guidance. They need actual guides (real human beings). They resist this guidance for reasons that the story itself makes clear. But in reality, the guides are their friends in

the way that the soul of the just person—by virtue of the harmony of its parts—becomes its own friend. This, too, is something the prisoners can only come to see once their way of seeing has become properly habituated. These guides are not just telling the prisoners the truth (this is not what they find painful and irritating). They are compelling them to negotiate, making them aware of the rough physical terrain not only of the cave but of the outside world. They guide the prisoners on their walk in the way that we might imagine Thoreau guiding us on one of his four hour walks (or the way that Plato himself guides us through the difficult terrain of his very long text). In this way, they are teaching them how to see.

This is the moral of the story as Socrates sees it:

> Education isn't what some people declare it to be, namely, putting knowledge into souls that lack it, like putting sight into blind eyes. Our present discussion . . . shows that the power to learn is present in everyone's soul and that the instrument with which each learns is like an eye that cannot be turned around from darkness to light without turning the whole body. This instrument cannot be turned around . . . without turning the whole soul until it is able to study that which is and the brightest thing that is . . . Then education is the craft concerned with doing this very thing, this turning around, and with how the soul can most easily and effectively be made to do it . . . (518c–d)

What Plato has done is show us how very difficult this "turning around" might be and how very important it is. But then, his *art* shows us how it might actually be accomplished not by explaining or analyzing the process by which it happens, but by providing an occasion for it to happen to us. It is only by experiencing the disorientation, the "strangeness" of the image, that we can be turned, or converted, from one way of seeing to another. This is how we know that we are not just being exposed to different sights and sounds, but are seeing more and in a deeper manner than we were before.

And it is here that the difficulty lies. Imagine your attention being drawn to something—something "birdlike" that lands outside your window. You are hard at work at your computer and the window is off to the side, perhaps even a little bit behind you. You turn only your head, crane your neck, and peer over your shoulder, while the rest of your body remains focused on the computer screen. The bird will not only be hard to see, but you probably won't get a very good look at it. What you see will be a distorted image of what is. To really see, you would have to abandon your work and, in true Thoreauvian fashion, turn your whole body toward it. But, of course, if Thoreau is right, you might not really see it even then. It would depend on where your mind was focused, not just the reasoning part but

your interests and concerns, your anxieties and preoccupations, your desires and emotions as well.

In describing what the craft of education involves, Socrates is not simply drawing an analogy between the body and the soul. What it involves is nothing more, and nothing less, than learning how to see. Not only do we need bodies to see things like the beautiful sights and sounds that make up Plato's text, our whole body (not just our heads) must be turned in the right direction. So must our whole soul. To see what is requires not just the reasoning part but an investment of all the parts of the soul. It is not just thought that is brought to bear on reality. You need to take desire and emotion along with you, turn the whole soul around, or you will not really see what lies before your eyes. If Thoreau warns us against the reduction of vision to mere perception, Plato warns us against the reduction of reason and thought to detached cognition. What Socrates emphasizes again and again (perhaps because Glaucon and Adeimantus have such difficulty really hearing it) is that the philosopher *loves* the Forms with a passion that surpasses that of the lovers of sights and sounds. His vision delights in and embraces "the things that are." He studies the Forms in the way that one might gaze—with wonder and awe—at the stars, admiring them in the original sense of the word (from the Latin *mirari*, to wonder). He does not just think philosophically, he lives philosophically, from the inside out. He takes the Forms (the *eidē*) into his soul. What he takes in does not become him (like something we eat). He becomes it. By patterning himself after what he sees, he gives shape to all the parts of his soul. His soul is structured the way a classical temple is structured. He is made whole.

"The eyes see better when guided by love," Pieper wrote. If it is indeed that case that "a new dimension of 'seeing' is opened up by love alone"—if *only the lover sees*—then to learn to see is to learn to love. This brings us back to the question raised by Thoreau: do we first fall in love, and then see? Or do we first see, and then fall in love? What Plato helps us to see is that loving and seeing are both "part of the same craft and discipline." He also helps us to see that while it is reality itself that ultimately motivates this loving acceptance, this is a vision we may be unable to arrive at without proper guidance. In being taught how to see, we are also being taught how to love. It is only by loving what is that we can see it as it is, and it is only by seeing as it is that we can see what makes it truly lovable. Only then can we truly love it. If this seems paradoxical, it is because it is ultimately mysterious. That it cannot be figured out the way the shadows on the wall of the cave can be figured out, that it cannot be calculated, or manipulated, or controlled, *does not mean that it cannot be practiced*. This practice *is* philosophy, as Plato would have us envision it. It is a vision, like the "sights and sounds" of Plato's text, in which we are welcome to participate.

In being philosophical, it is also inescapably concrete. In all of the writers we have discussed, we encounter the idea that one needs to look outside oneself (to venture beyond one's opinions) in order to come to life on the inside. Being a complete person, in Plato's sense, does not mean being

a pure reasoner. It means being fully alive. As an image of the soul's journey from darkness to light, the prisoners' ascent from the cave can also be seen as an image of a plant growing from seed. If form matters, for Plato, it is because he himself sees that the impulse to form lies in life itself.

Anyone who has worked with wood should also be able to see this . . .

Plate 5 Eric Sloane, "The Old Barn," from *A Reverence for Wood*, 1965. Courtesy of Mrs. Eric Sloane

CHAPTER FIVE

A Reverence for Wood

. . . but I enjoy musing over worn old wood and trying to decipher the story it so often has to tell.

—Eric Sloane, *A Reverence for Wood*

There is no place for nostalgia in a progressive world.

—Eric Sloane, *American Yesterday*

Taking up Eric Sloane's *A Reverence for Wood* after a reading of Plato's *Republic* is no simple task. The last chapter taught us to see the *Republic* anew as a philosophical work of art. Indeed, it was Plato's own text that effected this "turning around." Whether we read the *Republic* as philosophy or as art, however, *A Reverence for Wood* still looks very different. So do the apparent aims of their authors. Sloane's mission was more restrained, more humble, we dare say, than Plato's. Yet, Sloane is more similar to Plato than he first appears. He wrote from a passion for wood—with a marvelous focus on small objects. And he was a real working artist. He did not write explicitly about Justice and the Good, or about the nature of truth and reality. But he, too, set about to question how we live and offered some practical insights that turn out to be fundamentally Platonic. Both are calling (or recalling) us to a way of life that is at once extraordinary and every day. Both visions also differ from what we might otherwise take them to be. Plato is not a rationalist, after all; Sloane (as we shall see) is no mere antiquarian.

A Reverence for Wood stands at an extreme from the *Republic;* yet, it also differs from the other texts we discuss in this book. Perhaps we ought to stop and wonder about this. How does a book like Sloane's find us, and how does it fit, like a jewel in its setting, among the others we have chosen? Books are living ideas; how they move from shelf to shelf, and the company they keep seems entirely a matter of our own making. But is it? Are we solely responsible for the common voice among these authors? What is a grouping of authors—such as the ones presented here—but a particular

bookshelf, the active section, where the books are taken in and out with wondrous rapidity, day in and day out? All writers and thinkers have such books at their fingertips, either as they walk about their study turning pages, or as they pick up the pen to write turning the pages over in memory. Yet, while common themes may become visible to us they certainly did not originate from us as our own creation.

Our bookshelf, the one that shapes *Practicing Mortality,* needs a bit of explanation, because we bring together writers who ordinarily never share the same shelf space. Indeed, any library would catalog these books in very different locations—a sure sign of a kind of permanent, if artificially imposed, estrangement among them. For while Thoreau, and certainly Plato, need little justification for their presence in a book about living philosophically or artistically, Sloane's contribution to such a project is far less self-explanatory. Yet, here he is, Eric Sloane, painter and illustrator, writer on weather and barns and craft, holding court alongside Plato and Thoreau, Pieper, and Okakura. In such company, he seems quaint and vaguely New England-y— like cranberry chutney or a brisk amble through the village green—except perhaps to people who specialize in American life and craft.

To reckon with Sloane's contribution to such a worldly and cosmopolitan conversation as this, with his down-to-earth prose and matter-of-fact way of telling a story, takes careful preparation and, of course, a willingness to hearken to this unassuming voice quite carefully. How, after all, is it that we find a New England artist following on western civilization's noble thinker, Plato?

Sloane is ordinarily associated with books on Americana—the collecting of antiques (especially pre–Civil War period tools and woodenware), architectural restoration, and other such antiquarian interests. We do not know of any study of Plato or Thoreau that brings Sloane into dialog with them or with Pieper who, like Sloane, was also a twentieth-century writer. Thus, part of our task in this chapter is to develop a sensitive ear for listening, and we do so by taking the time right now to think about how *A Reverence for Wood* comes to be worthy of the extraordinary company it keeps between the covers of our book.

★ ★ ★

A Reverence for Wood consists of four chapters arranged in reverse chronology, beginning at the time of writing (1965) and moving backward precisely 100 years with each succeeding chapter: *1965: The Old Barn; 1865: The Cleared Land; 1765: The Warehouse;* and *1665: The New World.* The final chapter is a "random selection of trees," that is "not alphabetically listed or at all complete."[1] The text is interspersed with exquisite illustrations and graphics drawn in Sloane's own hand. What is most striking, especially to academicians, is his narrative style; it is personal, folksy, and even friendly (with the occasional Thoreauvian barb). The first chapter, *The Old Barn,*

begins this way:

> "They don't build them like that now," said Harley as he tapped his wrecking bar against one of the old pegged joints.
>
> I was above on a ladder, ready to tackle the roof. It seemed wrong to destroy such symmetry. The ancient shingles lay haphazardly like matted grass on a hill, but from my vantage point, the wooden roof pattern stretched away with a mathematical grace that first became part of the local landscape, then of the distant horizon. Sighting along the peak I could see wavy contours that indicated the position of each rafter underneath. (P. 13)

This passage is prescient, giving us the writing style and the aesthetic values Sloane means to communicate in the pages that follow. There is no question but that Sloane is the narrator here—the person through whose eyes we see. And what eyes they are! For the most experienced art historian among us could ask whether we are prepared to see ". . . the wooden roof pattern stretched away with a mathematical grace . . ." even if we were to climb onto Sloane's very same ladder. As improbable as it seems, that sentence, "I was above on a ladder . . ." and the paragraph that follows, might even be compared with the opening of Plato's *Republic* in style and in significance. It also bears comparison with the passage from Thoreau's "Autumnal Tints" where he raises the question of what we, as individual human beings, are truly prepared to see from where we stand.

Sloane's "vantage point," as he calls it, is not the point he reaches by mounting the ladder. Rather, it is a result of his ability to see a particular formal beauty in the roof, and the specific landscape with which it interacts—things most of us are admittedly not (yet) prepared to see. There is reciprocity here, in the way that each makes the other visible. And lest we miss the beauty in Sloane's written description, he furnishes a lively and delicate, fine pen-and-ink drawing as the heading of the chapter. There, in pen-and-ink, is that old barn roof itself. We see it moving from foreground to background along a strong diagonal, swiftly receding toward the horizon, which meets the roof peak at the barn's far end. Like waves of an ocean, each rafter rises slightly and then declines, pushing the shingles up, like the creases in an evenly folded piece of paper. Those "ancient shingles" trace a steady but imperfect line, more organic than mechanical, like a handwoven fabric. They move along the horizontal, while the rafters punctuate the vertical. Mathematical grace, indeed.

"The world," Pieper writes, "is unfathomable. Who could ever perceive the countless shapes and shades of just one wave swelling and ebbing in the ocean!"[2] What there is to see, in these waves, is an inexhaustible variety of particular forms. Each is utterly unique, none precisely identical to any other . . . and yet, as one contemplates this ceaseless ebb and flow, one also sees a movement that is eternal, a form that is universal, that returns again and

again but is manifest only in what is ephemeral and fleeting. One could say, about ocean waves, that they are never identical but always the same. There are many individuals, each distinct from the other, but also "one in form" (as Plato might say it). We find such forms—in which the universal is made visible only in the particular, while the particular is seen only against the background of eternity—throughout nature, throughout art, and throughout our lives.

How did this artful and meticulous seeing come about? Where did Sloane learn to see not only the antiquity of barns, but also their grace and beauty? And why should this matter to anyone who does not share Sloane's particular interest in and familiarity with old wooden structures? Answering these questions, we shall come to learn something of what he has to teach us about living. Learning to see the "form" of wood, the story he tells of it, and the way it engages our attention—this is how Sloane's work embodies, in remarkably faithful ways, the sort of education Plato hoped for.

<p align="center">★ ★ ★</p>

Students love reading Sloane. In this, they are good indicators of his audience—a general but interested readership. The prose is accessible, even easy, but the plentiful drawings that illustrate the text are the real protagonists of this story. They are occasions for slow, thoughtful, and participatory reading. Here, we should also say participatory viewing, for one of the most remarkable features of Sloane's work is the incorporation of the text into the illustrations and vice versa. The illustrations do not merely illustrate, in the usual sense of the term, the ideas that the text conveys. They are not just visual examples supporting a conceptual point. Many of the illustrations include text that is drawn, while others are interwoven with the printed type. The drawings (the visible forms, or *eidē*) are of a piece with the ideas that are communicated by the writing. This is the way Plato's images work. It is also the way the illustrations for this book are meant to function—not just to "accompany" the words of the text, but to exhibit the interpenetration of the ideal Form and the concrete particular, so that one becomes visible in the other.

This is important because it offers a model of the sort of learning experience we hope to realize—a model that is as particular to Sloane as walking was to Thoreau. The artful seeing that he displays in the passage above is embodied in the relationship between text and drawing. Indeed, Sloane provides the reader the occasion to learn to see artfully, too. Impressive pedagogy is at work here, and the drawings are the real teachers. Sloane's text is a miniature world, a *kosmos* (as we shall call it in the next chapter), where we learn how to see, what to see, and how to internalize the craft, the art, as part of our character. It is education as Plato envisioned it— an education "in" art that is truly an education by art.

There is, in other words, a single lesson being taught in *A Reverence for Wood,* that is given in two distinct but coexistent forms: the subject itself (trees and wood), and the way the subject is narrated. The lesson has to do

with learning to be content with our lives, and with life as such. For Sloane, we can learn to do this by learning to be sensitive to wood. Sloane would have us learn to "join" with wood by allowing ourselves the time to develop a reciprocal relationship with the nature of this material. Sloane's teaching is a *particular* response to the general search explored in *Practicing Mortality,* for an awareness of life, for that sense of blessedness that makes us whole and gives our souls a beautiful harmony. Sloane's book gives particular shape to that theme, which holds all our authors together.

You will recall from the previous chapter that the form of the stories we tell children matters. Sloane is a wonderful modern example of the way that the form of the story—the "how"—enables us to engage the content—the "what." In this case, it is the drawings, done with the most meticulous and threadlike touch. Nearly every page and each different topic has at least one drawing, if not several, to accompany it. They are small and delicate, and at the same time strong and confident. Sloane works with a thin pen and ink. The drawings are such that we envision him in our mind's eye looking something like a Swiss watchmaker, bent low over the drawing board, moving the pen about in deft and steady movements, the scale demanding great precision and agility. The drawings, then, oblige us to meet them one-on-one, as a single reader to a single image. Perhaps we should rather say as a single beholder of the image, for indeed we become beholders making our way as readers through the text. Once again, we gain a lesson in humility as Sloane's work sheds light on what such virtues of character might mean, and how we acquire them.

Sloane's way of engaging the reader is deeply and genuinely contemplative even as the emphasis of his book is on something active and eminently practical (matters of craft). Yet, how delightful that he accomplishes this without ponderousness or pretension. There is nothing stuffy or smugly grave about Sloane's method, nor is there any whiff of New Age gimmickry about it. We are made to slow down and really look, to participate in the story about wood by looking long and hard, that is, we learn to contemplate *by seeing* and *in seeing.*

The first page of the first chapter is a good case in point. Only after many readings and many hours of looking did it finally strike us that Sloane himself and Harley are represented in the drawing working on that barn! What is more, with careful looking, the drawing comes to life, as part of the life of the author. The once-baffling quote at the top of that same page, from Emerson (how many days have we wondered what it meant), is also animated. It reads: "Perpetual modernness is the measure of merit in every work of art." We often puzzled over how a book on Early American life and craft can have anything to do with "modernness?" And where in *A Reverence for Wood* are the "works of art" Emerson speaks of? Isn't this a book about wood, not museum practices? Indeed, but then, its title is not "a reverence for the antique." With time, and getting to know Sloane's way of working from that one single barn, to barns, to wood itself, Emerson's notion is realized, called into a particular existence by Sloane's little drawing. The old

barn is torn down by Sloane and Harley, but finally becomes the subject of a written work in 1965—a date boldly inscribed on the page and in the field where the barn sits. These rural wood structures speak to Sloane while he speaks to us through them. These together—antique barns, twentieth-century illustrator, and a continually renewed readership—bespeak what Emerson may have meant by the paradoxical juxtaposition of "perpetual" with "modernness." How like Thoreau this seems! Sloane leaves the hard physical labor of his daily chores for his study, to transform his experience of wood into reflections expressed through pen on paper.

This pictorialized occasion for contemplation is another way (and no small matter at that!) in which Sloane differs from the other authors in this book. But, we can still place Sloane in line with Plato (as Sloane himself saw the barn in line with the landscape) even though the *Republic* is not an illustrated text. For in another sense, it is; it includes images and is itself an image (made up not only of concepts but of words that form beautiful sights and sounds). Both these writers craft, artfully and consciously, a work of art that readers are obliged to participate in and behold should they wish to plumb the deepest level of the content. Such repeated confrontation with a work of art will enable it to enter your soul and shape your character—slowly and quietly. This is Sloane's approach to wood and, in turn, his approach to the narration and illustration of wood, which is as much a call to shape us *in the process* as Plato's writing is. What Sloane sees in wood is nothing less than "a substance with a soul . . . a kindred spirit to live with and to know."[3]

Of course, we ourselves must see this realized. Here, we face a challenge that we have not, as yet, acknowledged. For, in presenting us with these artfully contemplative practices, both Plato and Sloane also tend to cast them into shadow—Plato by keeping his readers (as well as Socrates's interlocutors) continually perplexed, Sloane by working so frankly and directly as to seem flatly self-explanatory. How can obscuring something make it more visible? Our goal here is to bring this wisdom to light, that our readers might appreciate the insight that Plato and Sloane bring to each other when we place them together on the same shelf.

★ ★ ★

Teaching us to contemplate by looking at drawings, Sloane also teaches us how to engage the subject matter, wood. Why? What does wood have to teach us? One answer from Sloane is that we should slow down and look at wood, carefully and closely, the way we do when looking at his drawings. Then, we may learn to convert the attitude of receptivity we developed through studying the illustrations into a "reverence" for wood itself.

Wood is Sloane's teacher. And although he is not a card-carrying philosopher, Sloane is not fainthearted about setting his subject in motion with plainly philosophical terms: "What impact, I thought, could a book about trees and wood have on people living in this world of concrete and glass and steel?" We may think we have the answer. We probably take for granted

what a book like Sloane's is trying to offer. The title, the location in the bookstore or library, the subject matter, not to mention the diminutive and easygoing physical format, would seem to suggest any number of perfectly plausible and anticipated answers: that it is urging a return to handcrafted wood objects made by artisans; that it encourages us to collect antiques (especially items made from wood in eighteenth- and early-nineteenth-century New England) and to buy and restore old houses and barns; that it is promoting "natural" over "synthetic" materials; or perhaps it is prompting us to make everything ourselves. Finally, it may look as though Sloane is advocating a return to country living as the best way of life. Indeed, it may appear that a sort of nostalgia is the driving force—one that advances an antimodern, antiurban, and anti-industrial attitude toward living. But to see Sloane this way would entirely miss the point. If we left it at that we would be guilty of skimming, of the worst form of superficial reading, for we would not have lingered over the puzzling epigram of Emerson.

Wood has something much more important to teach us than how to decorate our homes, or what styles of furniture we should choose from, or whether we should abandon city life for living in the country. Those things are certainly reflective of our values, and Sloane would be among the first to maintain that. But there lies the point. It's not the things or places that matter most, but rather what calls them into being. Behind and beneath the early American response to wood is a character of existence, an "attitude of mortality," to be precise. That attitude is what Sloane cherishes about handcrafted wood—a specific form corresponding to nature (its nature as well as nature *per se*) as well as to maker. Wood, for Sloane, is at once intangible and tangible, a type of Arcanum where the greatest wisdom about nature materializes (and that is really the proper word) for the one who contemplates it.

As friendly as his writing sounds, Sloane thinks our modern existence is fundamentally barren and impoverished despite the riches that are available to us. How could this be? Sloane answers:

> In 1765 everything a man owned was made more valuable by the fact that he had made it himself or knew exactly from where it had come. This is not so remarkable as it sounds; it is less strange that the eighteenth-century man should have a richer and keener enjoyment of life through knowledge than that the twentieth-century man should lead an *arid and empty existence in the midst of wealth and extraordinary materials benefits*. (P. 72: Emphasis added)

Our initial response is to shout, no! My life is full and active (if stressful). How dare he call it "arid and empty?" Of course, students are quite offended by Sloane's decrial of (not to say contempt for) our lives and times. This leads them, rather harshly and quickly, to presume that Sloane is advocating a return to "the way things were." And, of course, merely skimming the book and glancing at the illustrations might not change

that type of thinking. Sloane, however, is not nostalgic. We find no traces of turn-the-clock-back mentality and living in imitation of eighteenth-century ways. What appeals to him is the underlying thinking and feeling made visible by wood and woodcraft. For Sloane, wood (barns, trees, bowls, and tools) is a manifestation of belief, attitudes, and values—those intangibles that constitute Plato's notion of "character." Wood is not a product, for Sloane; rather, it is a form, literally, of thought.

The title is telling in this, referring to an attitude we hold toward something or someone. *A Reverence for Wood* would mean a profound respect mingled with love and awe, such as for a holy or exalted being. In dance, a "reverence" is a deep bow, like a low languid curtsy. It is considered a gesture of sincere respect, as when the pupil bows to the ballet master on parting the dance floor, or the performer to her audience. Closer to the heart of this book is the way that reverence expresses humility. Okakura, it may be recalled, discussed it earlier as a gesture to be performed on entering the tea-room, that is, bowing low at the threshold. That, too, is a form of reverence. Sloane, then, is talking about the relationship of a person to the life he or she lives. Reverence for wood is not about brute matter. Nor is it about pure Form (in the traditional Platonic sense). It is closer to the philosopher's reverence for the forms as Plato actually describes it. Fundamentally, Sloane is talking about how ethical dispositions are made visible in form and matter:

> The antiquarian might argue that his interest in antiques is an appreciation of historic atmosphere, a love of the beauty of pleasing decay. More often, however, his interest in antique art boils down to a reverence for the individuality of the past, what man once stood for, *the way he lived* and the thoughts he thought. (P. 26: Emphasis added)

This is a lesson all the authors who are explored in our book are striving to help us learn. We shape things but, more importantly still, things shape us. There is reciprocity, a flowing back and forth, between person and object. This is not an easy thing to grasp. After all, in our culture, *we* seem to be in control; *we* shape matter, not the other way around.

Sloane is very good at giving particular definition to the idea of reciprocity. He uses tools to do this, for they demonstrate a change in attitude toward things that happened around the time of the Civil War—a change that signaled a change in the attitude toward mortality as well:

> Anything which hitherto had been made of wood was quickly duplicated and mass-produced in iron. . . . Carpenter's tools, house architecture, and even farm machinery got the treatment. It was an era of doodads and decoration. The American reverence for wood had become old-fashioned and obsolete almost overnight, and the individual makers of wooden things became rare artisans. (P. 46)

Sloane thus differentiates ancient from modern tools. Why? A tool is a tool, at any point, isn't it? Is it not true that all tools lead to production, increase and vary human power, economize human time, and convert raw substance into valuable and useful products? Is one tool not like another in the sense of getting the job done well and efficiently? For Sloane, the answer is decisively and firmly negative.

Before the Civil War, users made their own tool handles. Take a hammer, for instance, one for which the user crafts the wooden handle. The handle is an extension of the user's hand. Sloane offers the analogy with the nails of a beast's claw, which extend from the body as the most important implement. Today's worker goes to the hardware store (now that probably means super-hardware store, like Home Depot) and picks something off the rack, keeping in mind, of course, certain specifics having to do with function, weight, cost, durability, and so on. Certainly, how the hammer "swings" is important. But missing from even the most expensive or thoughtfully chosen hammer that money can buy today is the intimate interrelation between *hand* and *handle* that emerges when the user crafts the handle for himself. Even the crafting reveals an extension of the self as the artisan handles the material *through* the artifact, absorbing its character and feeling how it "behaves," using a hand-made, wooden-handled axe, for example, to split wood. As Sloane describes it, ". . . the resulting workmanship seemed to flow directly from the body of the maker and to carry something of himself into the work" (pp. 26–27). This gives the tool its particular feel or "heft."

This interdependence, or reciprocity, between tool and user is not dependent on our making our tools ourselves, even if the notion of hand-craft has furnished us with the paradigm. Recall the passage we visited earlier, where Sloane suggests that what is essential for "a richer and keener enjoyment of life" is not just making everything we own. It can also, and perhaps more importantly, depend on our knowing where it comes from, that is, on an intimate and lived familiarity with its originary source. This is what Sloane would have us dwell on, and dwell with, where wood is concerned. But then, we may encounter it in other materials as well. It is what is *given* in and through the material, what is felt in the object, and is thus given back to us, that we are not just cognitively aware of but actually model ourselves upon. Sloane's contrast would then point to something far more profound than an aesthetic preference for the natural or the artisinal. It would imply that through our exclusive interaction with machine-made things, we risk becoming machines ourselves.[4]

Take musical instruments, like violins or cellos. We not only want them to "fit" our bodies but need them to, should we wish make the instrument capable of expressing our innermost musical and emotional feelings. If my chin is long and angular, I need to place it on a different kind of curve than a violist with a short, fleshy chin. A cello has to rest comfortably within the players' form, but poised for action; a particular cello must be at home, then, enfolded in the particular body. The player must "feel" the instrument as

belonging to the body, dovetailing with it, echoing and revealing it in a most direct, physical way. Or consider the dancer's costume—the tutu, leotard, what have you. The costume renders the dancer's physical movements more visible by extending her body outward into space, drawing contrasting or parallel lines like the flutes on Grecian columns, or by hugging the body, echoing, quoting, and underscoring its movement. The costume not only adorns the dancer's body but restates those movements, thus insisting on their greater visibility to us. Finally, to use a more mundane example of the way instruments play us as much as we play them, consider golf clubs: height, weight, heft, all affect the "swing." Golfer and golf club become extensions of one another with the physics of one flowing into, indeed governing, that of the other. Anyone who has seen Martha Graham's arms arc through the air to the ground or watched Tiger Woods finish a hit will be all the more prepared to consider how blurred it is—that boundary between artist/player and costume/instrument. These examples all are about reciprocity, which, for Sloane, is most perfectly embodied in our interaction with wood and that of wood with us.

This reciprocity, or connectedness, between things and users stands at the very heart of *Practicing Mortality*. Wood is a superb example of the breadth of response, and the significance of the interaction, because wood has *its own nature,* which the craftsman, first of all, must respect. Take wood grain, for instance. To try and work against the grain is futile; worse, it is to be ignorant of wood's nature or properties. Yet, grain is not something of our own doing or making; we cannot will the grain to change or suddenly shift its direction. A craftsman works *with* the grain, as someone who not only "knows" about it but also respects it—someone who, in a word, reveres it.

We tend to conceive of matter as the opposite of form, as shapeless "stuff." We regard the craftsman's material, what something is made out of, in the same way. But then, it is interesting (and revealing) that the Greek word *hylē,* the word philosophers used for and still translate as "matter," originally meant forest or woodland, and more specifically, wood or timber. It referred not to a lifeless substance that was entirely up to the craftsman to shape. It referred to something that already had its own shape—a substance with its own distinctive character or form. This is what is given to us in the material. But then, it is not just the form of a boat, for instance, that is realized in the wood when it is cut and shaped; it is also the form of the wood that is realized in the boat, in the same way that the wood's grain is brought out by the shape of a well-made bowl. This is a point that champions of "embodiment" do not always seem to acknowledge. The debate is not a contest between matter and form. It is form that matters in the material, because it is instinct in it. This is what calls for respect or reverence: not just what is superficially imposed (it is not veneer that Sloane reveres) but its inherent characteristics or, more to the point, its character. Anyone who has gained practical experience with this will have less trouble with Sloane's describing wood as "a substance with a soul."

The craftsman loves and honors the substance that is wood with a kind of self-abnegation. That reverence is, at the same time and paradoxically, the

source of his connectedness with it, for the craftsman responds to its nature with an eye to creating a tool that is responsive to the maker. This reciprocity is what genuine craft is all about. Connectedness like this, stemming from awareness and receptivity, is realized in Thoreau's interactions with nature. It is also realized in Plato's idea of justice, when what is inside is brought into harmony with what is outside and, thus, into harmony with itself.

★ ★ ★

Sloane's reflection on wood is ultimately philosophical, because it is ultimately about living. *A Reverence for Wood* is not a book about the things in our attic. Nor is it promoting one style over another, for instance, the "primitive" style of decoration or the period reproductions so popular in New England these days. Never once does Sloane urge us to buy early Americana or decorate our homes with colonial-style furnishings. Those are the superficial elements of design, that while they may reflect our values, nonetheless have lost touch with that which originally brought them into being—the connectedness and awareness of life that early American people had. For Sloane, the issue has to do with how our *living* differs from our predecessors', not our styles of furnishing or building. In *American Yesterday* (1956), Sloane put it this way, and minced no words about it:

> I am sure that I would prefer that my descendants find in my life a graciousness worthy of perpetuation than simply to decorate their houses with the obsolete implements of my everyday life and regard them only as quaint curiosities.[5]

But how can this be? Are we not better off than our predecessors? Are our lives not more comfortable? Do we not live longer with far greater benefits of many sorts? We have central heating (not to mention air conditioning) and indoor plumbing; our cities are clean of coal fuel; infant mortality rates have dropped since the last century; technology enables early detection and cure of many illnesses; boundless information is at our fingertips, as are the goods of the world's marketplace; travel takes us quickly from one continent to the other; our food supply seems endless, and is available day and night; we can even eat strawberries year round, should we wish! How can it be that early American folk were better off, splitting and hauling wood to keep themselves warm, transporting themselves in extreme weather conditions, dying young, turning in when the sun went down? Yet for Sloane, all our recent "material benefits" signal a loss—a loss Thoreau recognized a century earlier as being a loss of our connectedness with things, a loss of the "consciousness" of our actions. As Sloane saw it:

> Those days [1765 and the time of Independence], when the nation was struggling to be born, were perhaps our most poignant times, for

it was an era when each man was forced to live with piercing intensity and perception. Two centuries later, when an American turns on the water and the lights in his apartment, he has little awareness of where these things come from; the greatest pity, however, is that he says, "Who cares where it comes from, as long as it keeps on coming?"[6] (72)

Why should our knowledge of the source, this consciousness and awareness, matter? After all, Sloane is not advocating that we homestead, return to the land, grow all our food, and make our clothes. What is to be gained, then, if knowing where our conveniences come from is impossible given the current world marketplace in which they originate? What we stand to gain is not more things, but rather what Sloane sees resulting from the familiarity of knowing where things came from: creativeness and satisfaction, or what Sloane in his later writings will come to call *contentment*. In *Practicing Mortality*, awareness is a key concept. Thoreau and Okakura strove to find ways to teach awareness—from the formalized habitual ritual of tea, to the daily walking. For, from awareness comes virtue. Sloane thought so, too:

It you were to define briefly the difference between the man of today and the man of the past you might find the word "awareness" very descriptive. Fiorello LaGuardia, in praising air transportation, said that he dozed into slumber in a plane at Chicago and landed in New York without being aware of having left the ground. A century ago you would have been conscious of every mile of travel, counted by the bumps and turns and stops and starts. Uncomfortable, indeed, but you would have been awake to the experience of the trip. One of the wonders of jet-plane travel lies in the fact that there is no sensation of movement and the passenger remains unaware of speed. We have relegated the inconvenience of travel to the past, but we have also lost our wonderful awareness of the experience.[7]

Without awareness, we live without what Sloane calls "a full consciousness of life." Sloane views this as a distinct form of creativity, one that discovers beauty in what is well-done, in fashioning (like the fashioning of parts to which Plato alludes) rather than in fashion. It is something we might discover in our own living rooms, regardless of the age of our homes, when we "build" a fire in the fireplace and enjoy the sweet scent of pine kindling that encircles it (or in the backyard, when we stack the wood). This fashioning, Sloane believes, is artful; it is even art.

A lack of this kind of awareness cuts deeply into our human nature. It robs us of the opportunity to find satisfaction and contentment—two virtues that manifest a whole person, a well-ordered soul. Indeed, if we hope to find a key to Plato's search for justice and reason, we need look no further

than learning how to achieve satisfaction and contentment—Sloane's goals precisely.

How can we hope to follow Sloane when our current culture exerts great pressure in just the opposite direction? If anything, dissatisfaction these days is a virtue. We change the very essence of our facial structure with botox; we starve ourselves beyond recognition in pursuit of the cult of thinness; we quest for change for the sake of change—in our cars, home decor, clothing, and now, sadly, even in our "life partners." A culture of disposability is the product of this dissatisfaction: cups, clothes, books, cars, and spouses, all of it easily and thoughtlessly discarded in search of the new. The entertainment industry promotes a culture of dissatisfaction; it is an industry that feeds on change—out with the old, in with the new. Sadly, our aging population suffers from this culture. All too often the elderly are forsaken, abandoned, tossed away along with everything else that has lost the gloss of novelty and newfangledness. Along with this mania for discard goes rampant and nearly uncontrollable consumerism—more food, more virtual reality, more choice (hundreds of TV stations and cereals), and more fun. How is it possible to obtain—let alone freely desire—even the slightest degree of satisfaction and contentment, in a culture that glorifies senseless discard and rank consumerism?

Yet, as we are striving to lay open in this book, satisfaction and contentment are the portals to our fulfillment. Sloane reminds us that when we were guaranteed the American right to life, liberty, and "the pursuit of happiness," that guarantee meant something very different from today's version, which amounts to a sort of entitlement to do whatever one wishes, at any volume. But when independence was literally fought for, happiness meant something more like blessedness—a state of satisfaction and contentment. Why else would Benjamin Franklin describe it thus, as, "Contentment is the philosopher's stone that turns all it touches to gold?"

When Sloane wants to perpetuate something from the past, when he calls us to remember the goodness and quality of wood, it is not to put antiques and antiquated tools at our disposal, as our servants. Sloane does not want us to buy antiques and old homes as decoration to fill a void. As all his books encourage, we are meant to use woodcrafts as moral stories and moral beings, as forms that give us a way of life to emulate. Wood connects us to nature and ultimately to the divine source of it all (as we shall see more clearly in the next chapter). It does this by teaching awareness. We shape wood and it shapes us; we are well fitted to the activity *and* the end result. Together, wood and crafter are harmonious and unified, and thus their relationship, we may say interdependence, is a keen and reliable source of contentment. How Plato would have enjoyed this lesson!

★　★　★

What is the moral lesson that wood teaches us? Remember that in describing the "craft" of education, Socrates offered that it involved nothing more, and

nothing less, than learning how to see. We cannot, however, reduce "seeing" to mere perception as Thoreau warns us. We need proper guidance to learn how to see, guidance of the sort embodied in those formal qualities to which Plato was committed. Form itself matters, for *there* is the "best education," there is a meeting place of the material and transcendent aspects of form.

Having explored some of the formal qualities of Sloane's storytelling in his drawing style, what are the formal qualities of wood? If, indeed, we enter into a reciprocal relationship with wood, what does this teach us, and what values does it embody? How fortunate to have Eric Sloane who made a commitment to the *particular* story of wood, and of particular kinds of wood. It is through these particularized forms that we are able to take into ourselves certain aesthetic and ethical qualities. Sloane puts it this way:

> I derive a certain pleasure from an awareness of our gift of wood. Besides giving me its chemical and utilitarian benefits, like the fireplace that "warms the soul as well as the body," the tree and its wood are a most necessary part of my life's aesthetic enjoyment.[8]

Tearing down the barn, with its "ancient shingled roof," gives Sloane the chance to talk about what Harley (his co-dissembler on the roof) called those "miserable old weathered boards" full of "knots and decay" (p. 17). Sloane rescued those boards for picture framing. Writing first of his old barn, Sloane moves on to talk about Independence Hall in Philadelphia as well as historic American homes. He wonders why the nails on the roof have "pushed outward from the shingles like quills on a porcupine" (p. 16):

> The reason for this is interesting, for it demonstrates how softwoods tend to breathe with every atmospheric change. Each wetting and drying, heating and cooling, each pressure change of new weather, will bring about some tiny expansion or contraction. (P. 16)

Breathing sustains human life, and from Sloane we learn of the role of breath in wood as well. This has to do with the grain, not in the generic sense in which all wood has a grain, but in the particularities of the grain itself. With advanced age, wooden bowls, for instance, become more oval, shrinking across the grain—an example of "how woods (like human beings) shrink in old age" (p. 19).

A full page of drawings illustrates the point with a tabletop, wooden-pegged furniture, wooden bowls, and the spacing in floorboards and in panels. Here is Sloane's pedagogy in full swing. We lean close into the drawings to see little arrows pointing to summer swell and winter shrink, the bowl becoming oval between 1765 and 1965, the little lines of pressure shrinking across the grain, the floorboard spacing in between. Wood—like human beings who change from the midsummer to the midwinter of their lives—changes in response to the remarkable processes of nature. Sloane conveys these natural processes as aesthetic events: "But the beauty of

naturally aged wood," he confesses, "has a strong appeal to the human mind." He loves the "abstract pattern of natural decay" (p. 18). He admires the "athletic" quality, how wood gets accustomed to the "strong breathing caused by atmospheric changes." These formal qualities of wood (and there is no other way to describe them) make the effects of the seasons, of sun and wind, indeed of nature herself, *visible* to us. What a precise analogy for human life itself! Thus, *if* we learn to see wood as closely and as finely as Sloane does, we, too, can learn to absorb, and hopefully adopt, a similar attitude of mortality: that we may see how the aged body is beautiful, like wood, in its patterns of wear, absorbed by living through the many seasons of life and nature.

Sloane kept the big chestnut siding from that old barn of his for picture frames. He became fascinated with the natural wood cracks—the split in the timber—which he learned are known as a "shake" or a "check," coming from the mispronunciation of the old word shake, meaning to split (p. 32). He made a detailed drawing defining the shakes or checks in timber. Again, however, Sloane is not satisfied with merely understanding the history or knowing the use of these building parts. He sees farther, taking from them very human lessons:

> Builders today wouldn't think of using a ten-inch square beam for framing a small house; in fact, lumber yards don't carry that kind of wood. But the early builder used animal anatomy as his model and he thought of framework as being the bones of his house and the sheathing or clapboards as being its outer skin. Today's house has bones only as strong as its skin. At one time a house's bones were big and much stronger than necessary, but they really furnished the weight to keep the house from blowing away. I have slept in an old barn when a gale was blowing and *there was some peculiar comfort and sense of solidity in being aware of the tons of oak and chestnut that made up the framing.* (P. 35: Emphasis added)

We may be reminded here of Gaston Bachelard's masterful study, *The Poetics of Space,* in which he paints a convincing picture, often poetically framed (not surprisingly), of how our homes become safe precisely when we are made aware of how they comfort and protect us.[9] In other words, a ten-inch square beam is no longer considered efficient and economical, but efficient for what? Indeed, today our houses will not usually blow away with strong winds (though even that becomes questionable these days in the face of nature's raging), but what we have saved in money we have lost in wisdom, in the experience of safety and security as a tangible property of home. Now, of course, it is unreasonable to think that we can return to using ten-inch square beams for building homes. But, what is not unreasonable to hope for is that the lessons of wood can still be learned. Our awareness of the *source* of safety and strength, which lies outside and beyond human beings—beyond our control or will—is one of them.

Sloane furnishes many more examples than we have space to cover here. One last story, though, should bring some closure to these points: the Seek-no-further apple tree. Sloane meets up with this tree while listening to Harley talk about harness hooks made from the crotches of tree limbs. Harley tells Sloane about apples planted by a fellow from Westfield, Massachusetts, in the 1700s. They are still producing, but not from the same tree. The story, the last we share from Sloane, is a good one to quote at length, for reminding us of the reciprocity of the story and the form:

> Harley continued, "The old folks called them Seek-no-furthers. Never did know why." . . . "Oh, in a way it's not the same tree," said Harley. "It just kept growing and falling down and growing up again. Some day I'll look for it. If it's still there, I'll show it to you."
>
> That night I thought about Harley's story of the seek-no-further apple tree that "kept falling and growing up again." It seemed more interesting than working on the barn. And so before noon of the next day, we were shoulder-deep in thickets of a forest slope searching for the old tree.
>
> "There she is!" Harley said suddenly. "She's done it again! That's the old tree I carved my initials on when I was about ten years old."
>
> He sliced away some forest brush so I could get a better look. Resting on a bed of leaves and young shoots was the hulk of an old apple tree well over three feet in diameter. It had fallen from old age, yet some of the branches which were still living when the old tree fell had struck into the ground and miraculously taken root to become offspring of the parent tree. As the fallen trunk decayed, new apple saplings had rooted all around it, giving the appearance of a family gather around a dead giant on his bier. The old tree had dug its branches like fingers into the earth, a strange and striking sequence of resurrection.[10]

This is no mere anthropomorphizing of trees into families and human digits, any more than Thoreau's vision of falling leaves going beautifully to their graves was an anthropomorphizing. It is, rather, a process of seeing and reading how they are intertwined, and the moral lessons they can teach us. In Sloane's book, there are three sequences of drawings that illustrate this. The first is chronologically the most recent: the bucket hooks made from the crotches of tree limbs. Turn the page and we see an illustration of a fallen tree, a couple of small saplings to its right, dated 1865 and 1965, respectively. Then, finally, in fine stippled ink, Sloane draws for us—evokes for us is really the better term—what he imagines the first "Seek-no-further" apple tree looked like. The story told in words is marvelous alone, but the images are the best teachers here, for we are made to see in them what Sloane sees.

How many times we may wonder—and wonder certainly is the word to use!—what, really, is the resurrection? How is it possible to come to terms

with the resurrection as a physical rather than theological reality? Yet, right before our eyes is nature offering up such manifestations as tulip bulbs and "Seek-no-further" apples trees, plunging their life deep into the earth, hidden, buried, invisible, only to appear again, young, fertile, and bearing fruit.[11]

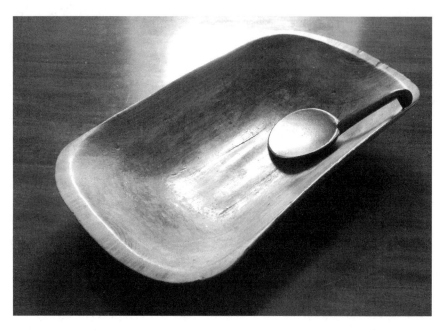

Plate 6 *Trencher and Paddle*, Wood, Blackstone Valley, Massachusetts, date unknown (Collection of the author). Author's photo

CHAPTER SIX

Making Kosmos *Visible*

Then the release from bonds and the turning around from shadows to statues and the light of the fire, and, then, the way up out of the cave to the sunlight and, there, the continuing inability to look at the animals, the plants, and the light of the sun, but the newly acquired ability to look at divine images in water and the shadows of things that are, rather than, as before, merely at shadows of statues thrown by another source of light that is itself a shadow in relation to the sun—all this business of the crafts we've mentioned has the power to awaken the best part of the soul and lead it upward to the study of the best among the things that are . . .

I accept that this is so, even though it seems very hard to accept in one way and hard not to accept in another.

—Plato, *Republic*

At first glance, it looked as if Sloane might help us bring Plato down to earth. Both are deeply concerned with a way of seeing and thinking about things. Each is attempting, through his writing (or drawing), to "convert" us to this way of seeing. As the last three chapters have demonstrated, this is not so much a matter of their preaching to us, and our subsequently deciding to practice what they preach. The conversion takes place in the practice of reading itself. To understand what Plato and Sloane are saying is already to experience their texts in a certain way. It is to experience a change in our way of seeing. What this change involves is very simple, in one way, but complex, in another. As Glaucon suggests, it is both hard to accept and hard not to accept. It may seem obvious that if we are to see and understand what is really happening in these texts, we must look closely. But this takes work on the part of the reader (who must negotiate the difficult terrain), on the part of the guide (whose job it is to point things out), and, lest we forget, on the part of the artist whose work is meant to serve as an occasion for this very experience.

Chapter five did for Sloane what chapters 3 and 4 did for Plato. We tried to bring these texts to light in a way that might reveal the power of the texts themselves to change us. The idea that this change is physical and sensory as well intellectual (an idea that was foreshadowed in Plato's allegory of the cave) was brought to life through our attention to Sloane's drawings. The way in which these drawings relate to the substance of Sloane's text, and the way in which we relate to them, might seem superficial at first. They are humble illustrations, after all—the sort of thing that we might expect a philosopher like Plato to banish from his more "theoretical" text in the same way that he seems to banish the poets from his ideal state. When we really examine these texts with wondering eyes, rather than viewing them through the lens of our preconceptions, we see something very different. We see what is really there.

It seemed at first that the way of seeing that Plato was espousing was purely intellectual, as if the things with which he wanted us to engage were themselves pure abstractions (like the idea of beauty itself). Turning from Plato to Sloane, we might have expected to see the kind of contrast between the philosopher and the nonphilosopher that Glaucon expected Socrates to draw. Where Plato's concerns seemed theoretical and abstract, Sloane's seem practical and "hands on." Where Plato seemed to have eyes only for universal truths, Sloane seems content with the particulars. Plato is telling us what we need to do to "become fine and good." Sloane is telling us how to tell the difference between one kind of tree and another, and about how to do things with wood. If Plato seemed to love only what is invisible, Sloane is very much in love with the material world.

Just as Glaucon came to see things differently, so have we. Now, it is worth pausing to consider just how unexpectedly Sloane's thinking joins with Plato's. To call Sloane a thinker may still run counter to some people's expectations, even after they have read him, and what we have written about him. While it is clear that Sloane is a knowledgeable and thoughtful writer, to regard him as a companion of Plato's might still seem like a stretch. Even a sensitive reader of this book may have the impression that it is the very fact that Sloane does more than "just think," that he is an admirer not of Platonic ideas but of handcrafted items (tools), and is himself a craftsman first and foremost, that we consider important about his work. But the reason Sloane appears in this book is not to provide a practical corrective to Plato's philosophical vision; nor is it merely to illustrate, in concrete terms, something that Plato only hints at (that what it means to be a philosopher is to see the universal in the particular). In our view, Sloane is a thinker in the fullest and richest sense, as is Plato. To appreciate this, one must consider what it really means to think.

One must also consider what it really means to practice a craft. This is the point at which our discussions of Plato and Sloane seemed to converge; and it is the question this chapter discusses.

★ ★ ★

When Plato presents his vision of philosophy, he invites us to picture it *as a craft*. This should strike us as odd, since he also portrays the philosopher as an

"impractical" person (who, among other things, must be forced to involve himself in politics). Thoreau was an impractical person, in one sense; and yet, his contemplative way of being was realized only through a disciplined practice. What kind of craftsman does Plato's philosopher turn out to be? It may seem difficult, at first, to picture him alongside Sloane's friend Harley, carefully dismantling a barn or fashioning a wooden bowl. Why would he care whether it will shrink with or against the grain? And yet, Socrates insists that he should care, or learn to care, if he is to become fine and good. We recall Socrates saying that if one is to be led to "resemblance . . . and harmony with the beauty of reason," one must be able to "sense it acutely when something has been omitted from a thing and when it hasn't been finely crafted . . ." Those who conceive of craft as the practical application of a body of knowledge will tend to picture the craftsman's work as depending on the philosopher's (or more likely, the scientist's). Plato encourages us to picture it differently: it is philosophy that is somehow dependent on craft. The philosopher's ability to see the Good depends on his ability to appreciate what is well or "finely" made—to see and feel what makes it good. It depends on good craftsmanship. This does not make craft subservient to philosophy, any more than philosophy is subservient to it. If Plato pictures the philosopher as a beholder of beautiful things (including beauty itself), he also pictures him as a shaper of beautiful things (including, first and foremost, his own soul). The philosopher is himself a craftsman, a maker as well as a seer. It is, as we saw, "by consorting with what is ordered and divine" that the philosopher "becomes as ordered and divine as a human being can." If, Socrates asks:

> he should come to be compelled to put what he sees there into [other] people's characters . . . instead of shaping only his own, do you think he will be a poor craftsman of moderation, justice, and the whole of virtue . . . ?[1]

Philosophers, Socrates goes on to suggest, are like "painters who use [a] divine model" (500e). The connection between philosophy and craft is not simply metaphorical, as if the philosopher's seeing and shaping were purified of the material elements to which Sloane is so attentive. It is as real as the well-made things that the philosopher must learn to see.

But then, it is a mistake to think that all Sloane does is to bring Plato down to earth. For Plato has already brought himself down to earth, in and through his own writings, with their carefully crafted sights and sounds. Plato's philosopher may seem to have his head in the clouds, while Sloane has his feet on the ground (and his hand on a hammer). But, it is not just in the workshop that they come together. Plato has us picture the philosopher as consorting with something "ordered and divine." What Sloane sees from the top of that old barn is "a mathematical grace." He is not just telling us how to do things with wood, or urging us to appreciate it, but is teaching us to revere it. Sloane's references to the divine may be as infrequent and as indirect, as elusive and enigmatic, as Plato's. But what he is

teaching us may actually bring us closer to God. In bringing us down to earth, he is helping to realize a connection with what Plato alludes to as a divine source.

Some readers may balk at this. Just as it may seem like a stretch to call Sloane a thinker (in the sense in which Plato, and even Thoreau, are thinkers), it must surely seem like a stretch to view his thinking as religious. Can we really take it seriously when he talks about a "reverence" for wood (or about wood itself as "a substance with a soul")? Here again, Glaucon's words apply. It *can* seem very hard to accept. And yet, it may be hard not to accept if our humanity truly depends on it. It may be hard to accept in the sense in which the things Sloane admires are hard to make. It can and should require a certain effort to take Sloane seriously, not only to see what he means when he talks about a reverence for wood, but to see it in practice. Asking whether he really means it when he suggests that in beholding (in seeing and using) something that is made by hand we may be connected with something divine, is like asking whether Thoreau really meant it when he said that falling leaves could teach us how to die, or that we might be "saved" by living in closer proximity to forests and swamps.

How *could* they have meant it? In the little book to which we have returned again and again, Pieper emphatically declares,

> [T]he ultimate fulfillment, the absolutely meaningful activity, the most perfect expression of being alive, the deepest satisfaction, and the fullest achievement of human existence must needs happen in an instance of beholding, namely in the contemplating awareness of the world's ultimate and intrinsic foundations.[2]

With this, we imagine, Plato would just as emphatically agree (in fact, Pieper goes on to quote Plato in the very next sentence). For Pieper, the answer to the question—How may the ultimate fulfillment of human existence come about?—comes primarily from philosophy, religious meditation, and the creation of "fine" works of art. Pieper does not think that such an answer has to lead us away from the realm of concrete things. But even he tends to oppose the kind of leisure that Aristotle associates with philosophical contemplation to the "work" that we would ordinarily associate with craft. The former is an activity that is meaningful in itself. The latter may be meaningful, Pieper says, but is not meaningful in itself, since "it has a practical purpose, [and] produces utilitarian goods" (p. 19).

Our own claim is that this "contemplating awareness" can and must bring us closer to the realm of concrete things. In saying this, we mean not just that philosophical contemplation can be more concrete, or practical, than it is often taken to be. What we are saying is that it allows for a deeper engagement with things, for a richer and more meaningful everyday life, than we would experience otherwise. By enabling us to "perceive the visible reality as it truly is," it connects us in a vital way to the very source of

reality itself. "The most perfect expression of being alive" is not just something we realize in ourselves. It is something we discover outside of us; something that is not merely human, or even natural, but divine. Thoreau, Okakura, Plato, and Sloane have all helped to support this vision, not with evidence or arguments, but in the way each of them helps to realize it. It is their inspiration, and not their authority, that we recognize.

If our own references to the divine are to amount to anything more than rhetorical gestures, however, we too will have to go further to realize what we are talking about. But the question cannot simply be whether, and in what sense, philosophy depends on craft, or craft on philosophy; nor is it enough to have shown that contemplation is indeed an activity, that it is not just looking or just thinking, but is something one does with the whole of one's being. There is more that we have to see to understand what it could mean to talk not only about "the practice of contemplation" (lots of people talk about this), but about contemplation itself as something practical. This is what it would mean to practice our mortality: it would be to live life as a craft. But then, we shall have to look further than Pieper did. If he sees the answer as coming from philosophy and art, we have to ask where philosophy and art come from. The question Sloane leaves us with is whether we can conceive of philosophy and art as sharing the same origin, and as ultimately drawing on the same divine source.

Here again, Glaucon's words ring true. This will not be easy to see. What stands in the way are all the preconceptions this book is attempting to challenge. These are not just preconceptions about writers like Plato. They are the preconceptions Glaucon himself is blinded by, in the *Republic*, about theory and practice, wonder and worship, and how truth is revealed; these are our preconceptions too. This is one of the remarkable features of Plato's text—that its characters are indeed "like us." It is also something that is remarkable about Sloane. It is not just heaven and earth that are connected in and through his craft. Ancient and modern are connected as well. Sloane is not showing us how ancient ideas might apply to our modern situation, the way many contemporary philosophers have tried to do. What he does, by drawing and talking about wood, is recall us to the source of these ideas. Sloane's work is tapping into what may be the deepest roots of Plato's thinking. His way of seeing is neither anachronistic nor nostalgic. It is very much of our own age. His being modern does not stand in the way of his recalling the original meaning of things, however. If he can recall it in a way that brings him closer to it, so can we. This recollection—literally, a gathering together again—is what is happening in his work, not in the past but in the present tense. In this chapter, we step back, even further than Plato. But in recollecting, we also look forward.

<p style="text-align:center">★ ★ ★</p>

We recall from our introduction that contemplation has its etymological and experiential roots in *theōria*, in what was originally a participatory act of

seeing. The spectacles *theōroi* beheld were religious not just as a matter of historical fact (taking the form of a religious festival), but in the deeper sense that Heidegger was trying to recover when he translated *theōria* as the "reverent paying heed to the unconcealment of what presences." This seemingly cumbersome formula is not intended merely as an etymological gloss (though there is etymological support for it). As an instance of what might be described as poetic philology (and by poetic we do not mean something that is made-up, but rather something that is artfully revealing), it attempts to recall the experience that underlies the original meaning of the word—the experience from which its meaning originates.

What does Heidegger mean by invoking (or evoking) reverence here? It is the same thing that Pieper meant when he said that "to contemplate means first of all *to see* . . ." He means that all genuine theorizing is, originally, an experiencing of the divine. In what sense? Not just by virtue of the historical facts (the cultural context, or humanly constructed meanings) that surround it. It is a matter of how this seeing itself originates, of the source not only of an experience, but of the spectacle that gives rise to it. We may think this is obvious, that the origin of most spectacles, be they natural or man-made, is easily identified. After all, human beings "produced" the festival that Socrates admired, just as chemical reactions and other natural processes cause the leaves to turn color. But, the nature of a theoretical spectacle (in the original sense) is such that its source is experienced as, in some way, fundamentally mysterious—a question whose answer is not so readily available, or so easily identified in terms of human or natural causes. It is in this way, by harboring mystery, that such spectacles move us to wonder, and it is this experience of wonder that is essential to contemplative seeing.

This is the experience that is brought to light by the fact we noted in Introduction—that ancient sources often use the word *theōros* to refer to a person who travels to a sacred place to consult an oracle. Such a person was not just a sight-seer (like Plato's lovers of sights and sounds). If he is a true *theōros* (like Plato's philosopher, or like Thoreau), then his seeing and hearing go deeper than this. He is not just looking for information or aesthetic entertainment. His experience is revelatory in the way that oracular sayings are; that is, in a way that remains fundamentally obscure. It is not just that part of the message is clear while the rest remains to be figured out. The message itself is an enigma. It is in this way, by disorienting us, that we are moved to see the world, and to make sense of our lives in a different light. The wonder to which such spectacles give rise is (as we said) inseparable from the illumination they promise. "Theoretical" beholding does not involve the kind of wonder that demands, and eventually arrives at, a satisfying explanation. To see contemplatively, in our sense, is to experience a wonder that is itself illuminating.

Perhaps, this makes contemplation seem even less practical than we initially thought. Someone who travels to a sacred place, or visits an oracle, may have to undertake an arduous journey, just as Socrates had first to go down to and then make his ascent back up from the Piraeus (perhaps

singing and dancing in the meantime). But, where is the *craft* in all this? It might help to recall a word that appears frequently in Homer, the verb *theaomai*, which shares a root with *theōria*, and means "to gaze upon with wonder" or to see with wondering eyes. How, when, and where does this seeing happen? What provides the occasion for it? In her fine book, *Socrates' Ancestor: An Essay in Architectural Beginnings*, Indra McEwen reminds us that in Homer's art, one "sees with wondering eyes" when a spectacle reveals a divine presence or "when the sight beheld is of something particularly well made."[3] A phrase that appears often in the *Iliad* and the *Odyssey* is *thauma idesthai*—"a wonder to behold" (the same phrase that Plato used to describe Thracymachus's sweating). As McEwen points out, on every occasion this phrase is used, it describes a beautifully or divinely crafted piece of work.

The Greek word for craft is *technē*. It is the root of our "technology." The contemplative and the technological seem very much at odds in the modern world, just as theory and practice are taken to be. But here again, the recollection of origins—reflecting on what *technē* originally means in the way that we have tried to recover the original meaning of *theōria*—may enable us to appreciate how deeply intertwined contemplation and practical skill really are.[4] If *theōria* takes root in the "reverent" seeing of, and wondering at, a beautifully made thing that is in some way an intimation of the divine, *technē* was, as McEwen puts it, "the very revelation of the divine in experience."[5] While the technological has come to be understood in purely instrumental or utilitarian terms, as (in Heidegger's words) "a man-made means to an end established by man," *technē* was originally understood, and experienced, as a *making visible*.[6] The craftsman's activity (according to this archaic understanding) does not simply involve the imposition of form on matter, or the practical application of a body of knowledge. What the craftsman does is let *kosmos* (order, form, arrangement) *appear* through the making of the artifact. Craft is a revelation of *kosmos*, which is simultaneously discovered (known or seen) and allowed to appear in and through the craftsman's work.[7]

The way in which *technē* made *kosmos* visible was not by representing or symbolizing the order or arrangement of things. Like Thoreau's walking, the craftsman's activity could be seen as a "realization" of something—as both a recognition or discovery and an actualization or making real. As McEwen observes,

> The discovery of a pattern seems . . . to be an inherent feature of the human experience of making. Whether he or she thinks about it or not . . . a person who makes something implicitly assumes the existence of an order or standard of rightness that transcends all recipes and rules of composition . . . This pattern can be thought of as a single, immutable template to be traced or copied . . . or it can be thought of as a mutable rhythm governing a pattern of movement, like the figure of a dance: a rhythm or order (*kosmos*) that is rediscovered with each new tracing of the figure. (Pp. 41–42)

We hear the word "cosmos" and we think of the universe, the starry heavens, or the orbiting planets. Or we think of something that is so metaphysically far out (so "cosmic") that it cannot be grasped in thought or pictured except in the most abstract terms. *Kosmos* does refer to something universal and abstract. But it is not an abstraction in the modern sense. Nor is it "far out" in the way that we usually think of Plato's Forms as being. Like the classical architectural Orders, *kosmos* was realized concretely in particular things.

McEwen reminds us that Anaximander, a Greek philosopher who lived two centuries before Plato, was supposed to have created (really to have *crafted*) the first map of the world. Now, if we were to think of anything as making *kosmos* visible, it would be a map, especially one that attempted to represent the world as a whole (Anaximander is also supposed to have fashioned a celestial globe, a three-dimensional image that, included both the earth and the heavens). We might assume that for such a thing to succeed in making kosmos visible, it would have to be as accurate as possible, that this is what it would mean for a map to be well-made. But, there is, or was, a different way of seeing it: not as a representation of objective reality (the sort of thing that might reliably guide the *theōros* on his journeys), but as a theoretical spectacle in its own right. Such a thing might actually be more revealing than the kind of maps we usually rely on today. It would bring us closer to, and better enable us to behold, what the *theōros* himself was able to see. The *theōros* would encounter many wonders on his way. By presenting itself as a wonder to behold, such a map would itself become an occasion for, and enable us to participate in, this kind of experience. Legend has it that Anaximander's map was improved upon (or "upgraded, as we might say"). McEwen recalls us to a different way of thinking about what this would mean. To make it better was not to make it more accurate, but to make it more beautiful . . . that is, better made:

> When Hecataeus brought Anaximander's map to perfection, he did not necessarily make a more exact representation, a more accurately scaled copy, of an earth viewed objectively on his travels. Whether on foot, under sail, or on horseback, the rigors of sixth-century B.C. travel would, one must imagine, have made a *theōria* of [this] kind highly participatory. And never, in the terms the ancient sources actually used, was a map simply a representation of *ge* [earth]. What is today called a map . . . was spoken of as a *gēs periodis*, a circuit of, or journey around the earth . . . [These] terms reveal mapmaking as an attempt to . . . make visible the traveling itself; an effort to capture in an artifact the relationship between an earth still perceived as divine and alive and the human experience of journeying over her surface. It is generally assumed that Hecataeus' perfecting of Anaxiomander's map entailed the drawing of another, more accurate map . . . However, if Anaximander's map was an assembly, constructed along the lines of a hoplite shield, of bronze plates fixed to a wooden backing, then . . . the perfecting of the

earlier map may very well have been just that: the removal of certain plates, the making of shinier, newer ones, and the more perfect adjustment of the entire assembly so that, as Agathemerus attests, "it became a thing to be wondered at." (Pp. 30–31)

We can imagine Sloane telling a similar story about an eighteenth-century tool or artifact that was made by hand. The "new and improved" version is not *another* map—something that one might find on the shelf at the Superstore. This is the mentality of mass-production (as Sloane understands it): the attitude not of mortality, but of disposability, according to which things are just substitutable instances of some generic type (like hammers or trees). Anaximander's map may have been improved upon by others. It may not only look different; it may be different (parts may be replaced, or differently put together). But, while the craftsmen may be different, it is *the same craft*—the same fitting together of parts—that both improved upon it and initially produced it. It is in this way, through this very "fitting together," that *kosmos* is revealed. Throughout its improvements, Anaximander's map remains one-of-a-kind—unique, utterly particular. This is what enables us to see something universal in it: an order or arrangement that which we experience in a participatory way even if we "use" it only as something to behold. It functions in the way that Sloane's hammer functions, not just as a utilitarian object, or a merely aesthetic one, but as an extension of ourselves. The same reciprocity between the order that we see and the order that we experience in ourselves is realized by Anaximander's map. The way in which the artifact "makes manifest . . . the relationship between an earth still perceived as divine and alive and the human experience of journeying over her surface" does not just represent the experience of an individual traveler. It includes our own spectatorial relationship to the artifact itself as our eyes journey actively over its surface following the arrangement (the hills and valleys, if you will) of its intricately crafted parts, of its colors and textures. It makes *kosmos* visible in the same way that Thoreau's essays do.

One might object that Thoreau's references to the divine are even less frequent, and more elusive, than Plato's or Sloane's, that what he makes visible is just the beauty of the landscape. To this we would respond that the elusiveness of the divine may be precisely what these visionaries are trying to help us see. The connection between Thoreau's craft and Anaximander's may seem less of a stretch if we remind ourselves that *kosmos* can also mean "adornment" or "ornament," as in "cosmetic," which for us has assumed the connotation of mere superficiality. In Homeric Greek, *chrōs* (meaning skin or color) was the word used to refer to the living body. For the ancient Greeks, the living body was understood and experienced as a visible surface, not in the sense in which we regard skin as mere surface, but as the radiance of an inner being (pp. 43–44). The Greek word *epiphaneia* meant both "surface" and "appearance," but did not carry the meaning that "epiphenomenal" carries for us. What showed on the surface was not unreal, nor did

it necessarily cover up. As McEwen observes, "when a woman adorned her-self [the Greek is *kosmēse*], she wrapped her *chrōs* in a second skin or body, in order to bring the living surface-body . . . to light; to make it appear." When, in Homer, female divinities adorn or literally wrap themselves in *kosmos* in order to go dancing, the *kosmos* of the dance was seen as a reflec-tion of their own *kosmos, and vice versa* (p. 45). This order, or *kosmos*, is not something that is imposed on brute matter. It is something that emerges reciprocally, as the dancer traces the patterns of the dance.

Here again, *kosmos* is discovered not through abstract speculation or objective inquiry, but through a making that differs from a making-up. The dancers follow the patters (the form) of the dance, even as they produce it by executing their movements. Their *technē* (skill) is a "letting appear" through which *kosmos* is revealed. It embodies a knowledge, or wisdom, that cannot be separated from the experience of the knower. McEwen's philological insight captures it perfectly: "The feet of the dancers in Ariadne's dance are *epista-menoisi*, knowing feet, and one cannot claim to have knowledge of dancing, until one can, in fact, dance"(p. 126). "Knowledge of dancing" is practical knowledge. But, this embodied knowing is, at the same time, a contempla-tive seeing. The seeing and the making, knowing and letting appear, happen together as practitioners and spectators both participate in the spectacle that is the dance.

Dance is a craft. So is weaving. In Homer, something that is well-crafted, put together or assembled (carefully wrought), is called *daidalon*. In the *Odyssey*, this word is applied frequently to textiles. Textiles are *daidala* when they are tightly woven or well-fitted, and display an especially luminous quality—when they "shimmer with dancing light and seem to have a life of their own" (*Socrates' Ancestor*, p. 53). Scholars have argued that the iridescent patterns that made a woven cloth *daidala* were not embroidered on or applied to a material surface that was simply there (like formless matter). They were woven into the surface itself, in such a way that, as the weaver practiced her weaving, the pattern (*kosmos*) would have appeared *along with* the surface of the cloth, the making of which, in McEwen's words, "would have been an activity that entailed great skill and a highly complex pattern of movement of shuttle over loom" (p. 54). This physical movement would incorporate its own *kosmos*, whose display was not experienced as a merely human production, but as the revelation of an order that was not entirely subject to the human will. If anything, it was the *pattern* (rather than the sur-face of the cloth) that was experienced as "already there"—unseen and waiting to be discovered. The word for weaving, or the actual practice of plying the loom, was *hyphainein*, which literally means "bring to light." *Hyphainein* is related to *epiphaneia*. Weaving was an epiphany, or unveiling.[8]

★ ★ ★

It is difficult for us to conceive of craft in anything but aesthetic or utilitar-ian terms, or some awkward combination of both. This may be part of the

reason why we have so much trouble acknowledging any inherent connection between craft (what is man-made) and the divine (or what is God-made). Such a connection may be purchased only at the cost of yet another distinction, which we discussed in chapter two, between craft and what we call fine art. Even Pieper, who writes so passionately about painting, sculpture, and music as occasions for contemplative awareness, sees a contrast between the "receptive openness" of the artist and the "concentrated exertion" of the craftsman. We may be prepared to think that art can bring us closer to God;[9] but, we seem to find craft too burdened by practical purposes and utilitarian aims, too human or everyday, to allow us access to "the hidden, ultimate reason of the living universe."

The authors of this book do not believe that much progress will be made by continuing to argue about the distinction between art and craft. If we have been using the terms almost interchangeably, it is not because we are forgetful of this distinction. It is because the distinction itself is already forgetful of something—something we are trying to recall. Here again, it is by looking back (we believe) that we can actually move forward and see more than we otherwise could. The Greeks needed only one word, *technē*, to refer both to crafts (like weaving or woodworking) and to arts (like painting, music, and poetry). The question is what they heard in this one word. What did they see, or experience, that we no longer do?

They saw that the order that *technē* makes visible is neither merely aesthetic, nor merely functional. *Areros* is a very old Greek word meaning well-adjusted or perfectly fitted together. It is the archaic root of *harmonia*, which in Homer is often applied to the craft of ship-building.[10] In ship-building, *harmonia* "works," not just in the way that the proper fit or attunement of the joints allows the ship to stay afloat and to trace an orderly course through the water, but also in the way that it makes an otherwise unseen harmony visible. A well-made ship is in visual and functional harmony both with itself and with its surrounding element, whose own *kosmos*, or patterns, are revealed in its wake. These elemental patterns are made visible in and by the ship's form even when it is not afloat or literally functioning. Just as the shipbuilder's activity involves working with rather than simply working on his material, the artifact itself stands in a similar relationship to its natural environment. It serves not only as an instrument of conveyance (for *theōroi*, perhaps), but as an occasion for revelation and discovery (for *theōria*). It functions as a revelation of *kosmos*.

In Homer, the spectacles that are described as *thauma idesthai* (wonders to behold) are all *daidala*—beautifully wrought artifacts. What makes them so "marvelous" is the otherwise unseen order they bring to light. This was experienced as the source not only of the creative process, but of life itself. Things that are *thauma idesthai* are often so described because they seem to have a life of their own. This is not a life that the craftsman alone bestows. Art or craft is related to giving birth (as *technē* is related to the Greek word *tiktein*, to give birth), but is, as Heidegger suggests, an "occasion" rather than a cause. The craftsman is not the source of the order that lives in the artifact,

but rather, "lets it come forth into presencing."[11] Anaximander was a philosopher (a theorist as well as a craftsman). In addition to his map and globe, he was credited with inventing the sundial. Scholars now tend to pay far more attention to Anaximander's thought than to his craft. McEwen would have us conceive of Anaximander's "theorizing" as encompassing both his cosmological speculations and his practical inventions, rather than viewing the latter as mere applications or illustrations of the former. His thinking, she maintains, would be as incomplete without the work of his hands as it would be without the work of his eyes and mind. The sundial reveals something about what this whole process of thinking most fundamentally involves. If, in fashioning a sundial, the craftsman succeeds in making a temporal order visible, he owes his success to something he does not make—the light of the sun, which is made to tell the time only by being concealed. What the craftsman does is provide the occasion for the sun to cast the shadow that allows *kosmos*, the periodic cycle of hours of the day and seasons of the year, to appear. What the craftsman makes, in fashioning the sundial, is not all of what is made visible. He gives form (*kosmos*) to the artifact, arranging its parts in a certain way. This is not an arbitrary choice, though it is a creative one. The craftsman can only create order by acknowledging its ultimate source. The *kosmos* that is made visible through craft is one that is not of any human being's making. What Heidegger calls the "bringing forth into appearance" of *technē*, and the "reverent paying heed" of *theōria*, the beautiful and the divine, are thus joined.

★ ★ ★

If *theōria* involves an attentive seeing, with wondering eyes, of a divine or beautifully made thing, *technē* involves the making visible, in a thoroughly materialized way, of something that is seen as divinely made, even if it is man-made. The skilled craftsman was himself a *theōros*. His making is grounded in and provides an occasion for contemplative seeing.

The convergence of these sources (*theōria* and *technē*, theory and craft) can help us to understand the deeper sense in which contemplation is and involves practice. *Theōria* is rooted in wonder, and we are unaccustomed to thinking about wonder as something that is "practiced," either as an activity that is performed regularly or as one that requires preparation. A craft or skill is practical in both of these senses in addition to being "useful." It is routinely practiced and it takes practice. If we fail to understand the practicality of contemplative seeing, it is because we fail to understand how it is originally related to craft: not in the way that it produces a useful result, but in the way that *technē* itself was originally understood as both a revelation and a realization of the divine.

Just as the *theōros* beholds a spectacle, but is not a detached spectator or mere thinker, the artist or craftsman (the technician in the original sense of *technē*) is not a mere "doer." The Greek word that was used to refer to a craftsman's function was *ergon* (meaning task, work, or deed). *Ergon* did not

simply refer to the actions performed by someone who builds a ship, weaves cloth, dances, or makes music (to the means to production); nor did it refer merely to the finished product (to the end result). Like *kosmon*, which can mean not only order or arrangement but ordering or arranging, *ergon* comprises both the "working" and "the work" (the means and the end) and holds them together in the way that the English word still does, when we use it to refer to an artist's work.[12] *Ergon* refers to an activity from which process and product cannot be separated out—a process whose end is contained within it. It reminds us of the sense in which *technē* can be considered an activity that is meaningful in itself.

In allowing *kosmos* to appear, the craftsman's work involves both an ordering and a revelation of order. Order is not simply brought about by the craftsman. It is what his making makes visible. A dance, or a musical performance, is both a technical making and a theoretical spectacle. The order that is revealed is not simply produced by the musician's playing or the dancer's dancing. Order and ordering are reciprocal, as we can see if we remind ourselves that the craftsman's activity (the ordering) is itself ordered. The bodily movements of the weaver at the loom, or the musician at her instrument, can be as beautiful to see as the music is to hear or the cloth is to look at and touch. They are, they have to be, as ordered, as carefully arranged, or intricately patterned (as "harmonious") as the finished product. They are not *ordered by* the craftsman or artist, but by the work. They, too, are an epiphany of *kosmos*. If we take seriously the dual sense of *kosmon* as both order and ordering, and of *ergon* as both process and product, we do better to say, not just that music is a revelation of *kosmos*, but that the making of music *is kosmos* "presencing."

This is why it takes practice, both in the sense of regular engagement or participation, "doing" it over and over, as the shuttle moves over the loom, and in the sense of preparation, the repeated performance, or rehearsal, through which certain capacities or skills are developed or actualized. If the craftsman's activity is not a mere means, nor is the preparation it requires. Rather than aiming at a separate result, or product, it only draws one more deeply into that for which one is preparing oneself. One becomes a musician by, as Aristotle would say, performing musical actions, by playing repeatedly. The goal of this practice is to make oneself musical so that one not only produces the right notes but plays them musically.[13] Philosophical contemplation, for Aristotle, was not only the study of divine things (the first principles of metaphysics); it was itself a divine activity or way of life.[14] What Aristotle said about philosophical contemplation could also be said about the making of music: that it is a form of human work that connects us, both as spectators and as practicing participants, with God's work.

If the "end" of *technē* is the realization of *kosmos*, then the practice for and of such work is practice for and of a kind of seeing that is at once contemplative and productive (to play musically, one must hear musically). The requirement that its performance be regular and repetitive is not a matter of efficiency. *It is the regularity of ritual. Technē* involves the formation not only

of an object or artifact, but of the participant or performer. Just as the patterns that the weaver weaves emerge along with the surface of the cloth, there is an emergence of order in the craftsman, as motions are repeated, become habitual, or come together harmoniously (like the threads of the woven cloth). The formation that brings order to light in the craftsman is not merely physical. It can be seen as having the same divine source as the patterns that the weaver brings to light in the cloth, or the harmonies the musician brings to light in her playing. We recall that the *kosmos* (adornment) in which dancers wrapped themselves was seen as reflecting, and as reflected by, the order of their dance. As *kosmos* clothes the body to bring it to appearance, the *kosmos* of the dance was seen to clothe the ground so that it too was made visible. The dancer's movements function in the way that Anaximander's sundial functioned. They bring the ultimate source of their own order to light.

If the ancient craftsman was himself a *theōros* (a seer or spectator), then, perhaps, we can understand the sense in which *theōria* might be a *technē*—the sense in which contemplative seeing could originally have been understood as an art or skill. Just as *technē* involves more than mere productive labor, *theōria* involves more than mere cognition or detached observation. Both involve a realization—a making visible—that allows for active participation in the emergence of *kosmos*. Both are rooted in the seeing, with wondering eyes, of an order that transcends human making. The making that joins craft and contemplation is the presencing of the divine.

It is in this sense that the work of craft and of contemplation is meaningful in itself. It is in this sense, too, that *theōria* is (or was) fundamentally liturgical. Our "liturgy" comes from the Greek, *leitourgia*, which literally meant "public service" or work (*leitos-ergon*) of a sort that was customarily associated with religious festivals. We now associate liturgy almost exclusively with the service of divine worship. But our forgetfulness of liturgy's origins can lead to a purely external conception of what it means for a certain activity to be liturgical—one that makes it difficult for us to conceive of how a ritual seeing, or making, could be truly reverential. *Leitourgia* is public *ergon*. Its public nature consists in its being a spectacle in which both performers and spectators, artists and audience, participate. Its work is not a means to an end, or a separate product, but the performance itself. Liturgy, in the original sense, is a making visible that provides for a realization of the divine. Those who "serve" do so in the way that the craftsman realizes his or her own function.

Just as *technē* does not force us to distinguish between art and craft, it does not force us to distinguish between crafts that are utilitarian and those that are not. The skill involved in the production of artifacts that are useful (like that of carpentry or weaving) is fundamentally the same kind of skill that is involved in the production of those that are not (like dancing or making music). Both could be seen as engaged in the same kind of work. *Ergon* is productive, not just of future results, but of present actualities. It is by holding art and craft together that *technē* unites the human and the divine. This

should prompt a different conception, very old and yet for many of us entirely new, of the role art or music plays in worship.

By making something that is "a wonder to behold," the musician's work lets *kosmos* appear and thus furnishes the occasion for a kind of seeing that connects us, in a vital way, with God's work.[15] This is its inherently liturgical function. It could be the function of any craft that embodies the work— not of production, but of presencing.

We needn't be craftsman to take this work upon ourselves, although, as Plato suggests, we do need craftsmen if we are to develop the kind of a skill that contemplative seeing involves. The *theōros*, we recall, was both a spectator and a participant. If theoretical observation was originally participatory, there must also be a sense in which we can participate through observing— a sense in which "seeing" can itself be a form of worship, a way of serving God. A superficial understanding of the usefulness of craft makes it difficult for us to appreciate the fruitfulness of contemplative seeing. Contemplation serves not in the production of future results, but in the original sense of *leitourgia*, through active participation in a spectacle that is itself the realization of a divine order.

The kinds of experience in which the meaning of *theōria* originated should remind us of the difference between passive looking and participatory beholding. The craftsman's work presents a spectacle in which the divine is itself present. As an epiphany of *kosmos*, such spectacles allow the spectator to participate in this divine "presencing," just as the *theōros* was actively and experientially engaged in the realization or making visible of a divine order. A spectacle provides the occasion for this kind of participation when it is "seen with wondering eyes" (*theaomai*) or presents itself as "a wonder to behold" (*thauma idesthai*); that is, when it is beautifully wrought, or well-made. It is by virtue of its harmonious composition that any work of art serves as a realization of the divine. While the spectator may not possess the skill necessary to make such a thing, the skill necessary to create *harmonia*, the possibility of participating in anything more than an entertaining show depends on the craftsman's ability to do so.

Now we must ask ourselves: is this possibility still available to us, or does the fact that we have had to undertake such a philologically arduous journey to uncover its archaic roots in the historically distant past testify, instead, to its remoteness?

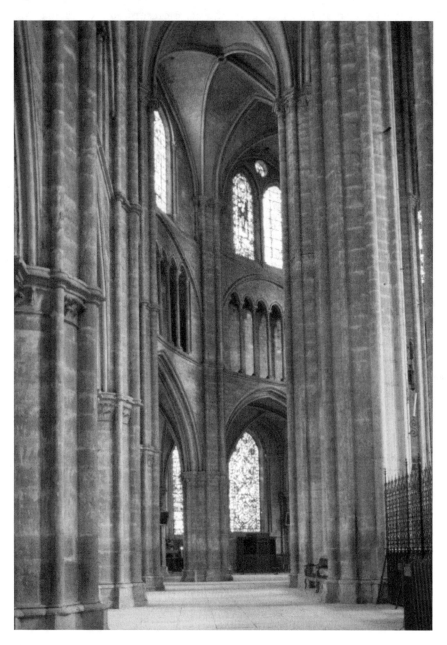

Plate 7 Cathedral of Saint-Etienne, Bourges, France, 1195–1214. Author's Photo

Having Different Things to See

We have talked a lot in the preceding pages about the connection between philosophy and craft, and how that connection is not simply metaphorical but is as real as the well-made things that the philosopher must learn to see. We have insisted that this activity holds forth the promise of shaping character. We looked to the ancient Greeks, whom we think had it right when they envisioned craft as a revelation of a higher, divine order. This part of our exploration has not been easy going, the tacking back and forth between genuine abstraction and the piercing intensity, as Sloane would have it, of material things. Certainly, with his love and attention to wood, Sloane furnished a tangible example of what it means to "see contemplatively" and with wonder.

Now, we take up the practice ourselves. We set about doing the hard work of thinking about the things in our lives, not just the things that actually surround us, but the things that ought to.

But what are we saying now? That we must not only see things differently, but must also find different things to see? To say the least, this brings a whole new range of ethical implications to the fore. But, the problem we now confront is not a new one. It was with us from the beginning. "Man's ability to see is in decline," Pieper warned, and our humanity is thereby threatened. This way of putting it—indeed, much of the foregoing discussion—makes it seem as if the problem has mainly to do with us and whether we can learn to see, and to love, what is actually before our eyes. But, there is another dimension to the problem, which was barely broached in our discussion of Thoreau. Can we live like him, we asked, if there is less landscape of this sort to behold or if we choose to ignore it? Perhaps, but it is still the case that we need certain kinds of things to provide the occasion for this way of seeing, the kinds of natural or well-made things that invite or call for it. If Plato is right, such things play an essential role in our learning how to see. But then, the problem becomes even more acute. For our inability to see and appreciate these sorts of things—to "expect" them, in Thoreau's sense—may well lead to their actual disappearance.

We shall consider the full depth of this problem in Chapter Eight, *Thinking as Craft*. But this needn't prevent us from applying ourselves, here and now, to the hard work of seeing. What we described as Thoreau's "visionary activity" *is* one that we can take upon ourselves. Indeed, we have been anticipating this all along by calling attention to the craft of writing. But now, we ask our readers to do more than read quietly; we ask you to try to see, to hear, and to feel some particular forms. This task will not result in either a workbook or a workout. What follows is rather an occasion to see with us some of the things that we believe really matter; things that provide the occasion for the sort of seeing toward which all the authors discussed here have been trying to move us.

When Pieper lamented our inability to "see," he meant seeing in a special sense. He was not referring to the "physiological sensitivity of the human eye." We still possess that; we are not physiologically blind. If anything, we have advanced instruments that enable us to see more things than we ever could before. What Pieper meant was that we have lost "the spiritual capacity to perceive the visible reality as it truly is."[1] For Pieper this capacity is "an essential constituent of human nature," and as such it is a source of our "ultimate fulfillment," as he calls it. The matter is deeply urgent for him. With our "inability to see," we are losing our capacity for fulfillment as human beings. What is at stake, Pieper contends, is our integrity as spiritual beings, and, along with it, our ability to live well and fully.

This is a difficult formulation to come to grips with, in one sitting, or on a first reading. We cite Pieper again because he is a thinker to whom we have turned many times ourselves. It is not just his text that we have come back to. He has motivated us to look at *things* again—with new eyes—seeing in the way he would have us do. It has taken us many years of reading and teaching to internalize Pieper's idea, to know it well, to commit it to memory where it has taken up residence in much the way our names or our dates of birth do. Many times we point back to that phrase ("seeing the visible reality as it truly is") and invoke it as a way of gathering momentum toward the problem of seeing as we understand it. What we have especially loved about Pieper is the courageous way in which he names the problem as one of our having *too much* to see, and, just as importantly, the depth of his own response to the question: so what do we do?

We must be willing, Pieper boldly claims, to "exclude from [our] realm of life all those inane and contrived but titillating illusions incessantly generated by the entertainment industry" (p. 33). These days, about a half-century after Pieper wrote *Only the Lover Sings*, the entertainment industry offers up far worse matters than "contrived but titillating illusions." Who would contest the fact that it condones, even celebrates, senseless violence—both in actions and words—and demeans human relationships? And yet, we hardly stop to consider that we patronize abusive language and violent content every time we rent a DVD or go to the movies. This form of entertainment is taken for granted by *all* segments of society as an important part of contemporary culture—the centerpiece of today's world.

While explicit depictions of violence are not all that gets in the way of real seeing, Pieper—and we—maintains that fasting from this sort of visual material is necessary to "restore our eyes" (p. 33). What does it mean to restore our eyes, and why should we undertake the discomfort and apparent cultural snobbery involved in doing such a thing? Why would intelligent people want to divorce themselves from the pulse of popular culture—indeed, sever their relationship from it? Because without doing so, we cannot hope, in Pieper's terms, to contemplate or behold the very essence of reality. Contemplation constitutes for Pieper an activity that is the most "perfect expression of being alive" (p. 22). This is because when we contemplate, we accept reality to the point of loving it for what it is, in living as much as in suffering and dying. Hard things to accept, these are. But receptivity and openness to the very core of our human nature, in its fullness, is what Pieper is talking about when he claims that contemplation and beholding are the most meaningful and perfect expressions of being alive. In contemplation, we sing praise and worship for, in Sloane's words, "life and all that goes with it."

If, as Pieper believes, the culture of entertainment makes it impossible for us to see in this way, then turn it off, he says. Should you wish to celebrate life, to love, to worship and praise, to live in full awareness of your nature as a human being, you have no choice but to learn to perceive "the visible reality as it truly is." This challenges us to change the things we see—literally. Pieper offers a wonderful example he experienced during a boat trip he took to America. One morning, his fellow passengers remarked that there had been "nothing to see" the night before. Pieper was aghast, for he had spent a lot of time that previous night marveling at the whirling sea creatures coming up against the boat, making colors and patterns in the nighttime waters. He wondered how there could be nothing to see, when there was so very much to see. And indeed, it is because we have too much to look at of the sort of things that deaden our ability to *see* the essential realities before us, like the fluorescence of the sea creatures at night. If this were true 50 years ago, how much truer it must be today.

What about when we are not on board ship or, like Sloane, working with old barns? We absorb whatever visual matter exists before us. We are not devoid of things to see. Quite the contrary. The matter has to do with the fact that what there is to see is mostly savage, rude, shallow and disposable, and intentionally uncivil. It is, however, the shallowness that is the key element. We laugh contemptuously when we see mistreatment of one person by another; we are quickly and deeply absorbed by savagery of person to person to the point that what we do to one another has become rather inconsequential—not to mention funny—in film and now, sadly, in life. The things we see matter, then, and whatever they may be, we internalize that visual material. Our culture is so very visual, at that. This was Pieper's lament—that there is too much to see, of such a superficial nature, that we cannot possibly see what is profound and essential, let alone divine.

Pieper's little book, then, is fraught with wisdom and courage about these things—the wisdom to grasp the problem and the courage to articulate it as unequivocally as he did. Moreover, he explicitly sets out three activities we can undertake to restore our eyes: religious meditation, philosophical reflection, and the creation of the artist. In this chapter, we take up artistic creation by extending, refining, and transforming the idea in light of the ancient Greek understanding of art and craft discussed earlier. In the preceding pages we have learned that the well-made thing is an occasion for contemplation—for the kind of participatory seeing that was so important to both Plato and Sloane. The well-made thing, when we have the occasion to see it in the sense that these authors intend us to, shapes our character as we take in the formal characteristics of finely crafted material, notably grace, harmony, and proportion. We absorb those of junk, spam, and rap, too, but the contents differ from the well-made because the form differs.[2] The content does matter, but we have lost our awareness that the form matters, too. There is, therefore, a great deal of recent cultural criticism that we, the authors of this book, are ourselves critical of not because it is narrowly conservative or because it is too liberal, but because it focuses too narrowly on cultural subject-matter and is forgetful of form.

Our reflections on *technē* have shown why things matter, with their particular formal constitution. Shortly, we shall turn to look at some of these sorts of well-made things. Before doing so, we take time to familiarize ourselves more concretely with the sort of seeing that involves practice and participation.

★ ★ ★

Seeing is like a "sense" that has to be acquired, or at least brought to the fore. The ancient Greeks had an admirable way of conceiving this idea. For them, forms—the real forms on earth brought into being by *technē*—rekindle in us a memory of their ultimate source. Through their beauty, brought about by craft, forms recall us to the origin of all things. Forms shape us as much as we shape them. That is the central idea. How this comes about is a matter of learning and exposure. It takes experience, seeing a lot of things and forms, to recognize things that are well-made and then to be moved by them. We have likened this experience to a performance in which the beholder does the performing. In other words, the artist is not the only one who needs skill and talent; the beholder does, as well.

To see contemplatively as Pieper would have us, we must *learn* to use our eyes. There are ways that we can develop this sort of seeing. These are pedagogically akin to teaching a skill, like learning languages or playing a sport. As Plato suggests, the goal is to become spectators who are themselves well-crafted. As an example, we offer two ways to sharpen the ability to see well: either seeing a single great work of art many times, or seeing many things of the same type. (We realize this may be difficult to envision but it does happen and it does work.) With students we often use an imaginary exercise

in which they would be shown a Peruvian textile, something they're seeing for the first time. Imagining this textile, students will be struck by its vivid color and wild patterning, finding it "wonderful," or "great," or "really interesting." Then, we tell them that an entire year will be devoted to looking at every Peruvian textile that we can lay our hands (and eyes) upon, visiting each one in person, traveling hither and yon to see extant examples. At the end of that year, we revisit that first textile. What now do we see? Is it as vivid and wild, wonderful, great, and interesting? Or perhaps have we seen another that henceforth sets the standard for those qualities? The answer—almost invariably—will be yes. This approach, seeing as many examples as possible of one type of work of art or craft, develops the visual sensitivity that sustains contemplative seeing.

Listening and reading also offer helpful analogies to the activity. If we consider even the most mundane example, for instance, singing "happy birthday," we promptly will realize that most of us have experienced the connection between knowing something well, our memory, and the execution. We do not have to 'think about' how to sing happy birthday. It is so familiar that we can do it probably without any thought at all. This familiarity is precisely what lies at the heart of learning to see well, and being able to perceive the vital characteristics of form. Familiarity, borne of practice, brings into awareness the particulars of *technē*, craft, and beauty. Intimate familiarity is the core of learning to see contemplatively.

To take this notion onto another plane of experience, we, the authors of *Practicing Mortality*, have our college students look at a single work of art for the entire semester. Week by week, the students return to the Worcester Art Museum and set themselves in front of one painting, the same painting for the entire semester. We ask them to describe in writing exactly "what they see." They perform this activity for 13 weeks. Students who are committed to the assignment are transformed by the end of term. They feel a shift in their experience—from themselves as sole generator of meaning *toward* the work of art or, as we prefer to describe what happens, from opinion (I like or I don't like, or it makes me happy or it makes me feel sad) to genuine objectivity. Let us be unequivocal about this. By "objectivity" we mean that the work of art, by the end of the semester, speaks on its terms; no longer is it merely a record of an imposed opinion. But, while the painting has finally come to exist in its own right, the student who has experienced that transformation has simultaneously shifted from a subjective to an objective perspective. Yet—and this is a key point to grasping these concepts—she is hardly detached from the work; she is anything but neutral. Objectivity, then, true objectivity, means in our sense that the work is "seen" in its material fullness and reality by the intensely intimate participation of beholder with the work. True objectivity arises when the beholder merges with the work of art, so as to engage the formal characteristics in their own right. To be objective, in other words, is to be responsive to an object. After 13 weeks, students feel personally connected to the work of art, as though they have learned to live in its light and according to its precepts. This sort of

objectivity occurs, then, when we participate fully in the external reality of things, in the essence of craft. This sort of objectivity is what Pieper meant by "seeing the visible reality as it really is." The nature of this activity has convinced us that Plato was right, that form interacts with our innermost character: it must enter us in order for us to perceive it "objectively." Philosophy is borne out by practice.

Music offers a similar occasion for the practice of contemplative beholding. Again, an ordinary example will help to introduce the situation. Recall a favorite tune or song, but think about knowing it well and how this functions. Our familiarity with certain songs often is the source of their solace. Why else would we return time and again to listen to familiar music is times of joy or woe? We do not have to *think*, as it were, about listening and yet, paradoxically, we are listening with deep attentiveness. We know the song so well that we register its every nuance, without needing to analyze or "think about it" rationally. We need only change the performer of a much-loved piece to realize how different, indeed how conscious, listening becomes.

Practice of this sort—familiarization, routine, every day—lies at the heart of contemplating great music, too. Commit a single Bach prelude to memory. Listen to one performer over and over again until, like that favorite song, you become intimate with every note played in a particular way. Learn it by heart, as it were, so that listening no longer involves "thought" in the way that we ordinarily define thinking, that is, as analysis or self-conscious reasoning. Imagine hearing that same, now familiar, prelude played by another performer. The experience would be compelling, so engaging, because all our expectations have been reshaped and rephrased. The particular form of the Bach prelude, therefore, changes with particular performances. These changes, however, are only perceptible to one who knows the details amazingly well. That sort of "knowing"—once again a knowing borne of practice—is the root of contemplative beholding.

This approach to learning has not been a stranger to academia. English professors will ask students to copy lines of Shakespeare by hand, to copy the same line repeatedly. What is going on there? To follow the line of text closely—in and with your own body—is to take in its figuration, its character—literally, physically, kinesthetically. This assignment acknowledges that meaning can be experienced in frankly and straightforwardly physical ways. By the movement of the hand in mimicry, we absorb something of the great wisdom of Shakespeare's wise and beautiful words. It as though by copying we enact, through the hand, the words. This is embodied learning—memorizing, copying, rehearsing, and so forth—and it can develop sensitivities that were not there before. We become able to see things, hear things, and feel things with greater intensity and with genuine objectivity—things that would never be apparent were we not to participate contemplatively.

Now, we can begin to grasp why sensitivity to the nuances of form must be developed. The formal attributes of craft have their source in more than one place—in one sense in the artist, in another sense in those of us able to perceive the attributes, and in yet another, the form itself and its source,

which is neither the artist nor the spectator. Think, for a moment, of pitch in music, proportion in building and design, or color in painting. People with an "ear" for music are able to sense immediately when an instrument is out of tune. For the musician, pitch is necessary to music; for the listener, pitch can complete the musical experience. And yet, pitch is not the making of the musician, any more than it is the making of the listener. Pitch is a function of proportion.

Proportion is certainly one of the most important conditions of beauty and power in architectural design. How do we know when something is in proportion, the way we "know" when something is out of tune? We know partly by training, partly by experience and repeated exposure to superior manifestations of sound and beautiful proportion, and partly by the presence of proportion itself. We do not know it by calculating it. For proportion, as any musician or architect knows, is not generated by human will or desire. Artists may make proportion visible or summon its presence, but we do not create proportion anymore than we create pitch. We arrange the forms—bring about the occasion—to reveal proportion or pitch but the geometrical properties of proportion and pitch are not invented by either artist or beholder.

It is not that we no longer use our minds when we contemplate form—it is that thinking has taken on another mode of being. A great mistake is made when we presume that listening to familiar music or seeing a painting we know intimately is a "thoughtless" activity, for quite on the contrary, it is thinking in an ultimate and final way—the way that Pieper and Thoreau propose: *thinking with and through awareness.* We engage things in our bodies, senses, and memories, and that in and of itself puts us in touch with the deepest layer of meaning, of the essential content of art and craft. We are talking here of poetics and not a type of analysis.

The "meaning" of objects experienced this way differs from standard art historical approaches. It rests not on the accumulation of data or the compilation of factual connections, but on the intimate coupling of beholder and object. When I am not the artist but the spectator or listener, I can, indeed I must, follow the path or reenact the artistic process, should I hope to gain entry into the realms of nuance contained therein. The best analogy to offer is this: when a listener recognizes all the instruments of the orchestra, listening is more than physiological. When I can identify the specific source of the bird calls, I can really hear them. Our culture, as well as our current pedagogy, has relegated this sort of experience to the lowest level of knowledge. But, our sensitivity to the ancient Greeks is teaching us that participatory beholding is the source of the highest and greatest meaning. Moreover, it acknowledges that contemplative beholding yields meaning through many points of access—the mind, which is made to work in non-analytical ways, the emotions, which are aroused not spontaneously but through discipline and practice, and the senses, which have been trained to respond to nuance. We are whole and full and rich when this sort of response can take place.

It is worth recalling at this point that Okakura's passion for Teaism had to do with its connection with "the beautiful." "Teaism," he wrote, "is a cult founded on the adoration of the beautiful among the sordid facts of every-day existence."[3] As we saw in Chapter Two, Okakura derived this notion of beauty from his routine participation in the tea ceremony. In the writing of *The Book of Tea,* he abstracted principles from this ritual, such as hygiene, cleanliness, simplicity, and moral geometry. He believed that these, in his words, "inculcated purity and harmony, the mystery of mutual charity, the romanticism of the social order" (p. 44). The notion that virtues like these are shaped by what is beautiful should no longer be foreign to readers of this book. This chapter is interested in not so much in the general philoso-phy as it is in the particulars, in how we attain specific virtues in specific things. This is why it is worth turning to Okakura once again.

For Okakura, the forms were very specific, very particular. They were embodied in the metal of the teakettle, which variously conditioned the song of boiling water, much the way one human voice sings differently from another. How the individual master swept the path mattered, too. The way the master sweeps the path is a predictable aspect of the ritual of the ceremony generally; each individual master does it as he does it. No two masters could possibly sweep the leaves into identical patterns, even if every master sweeps the leaves into patterns. Like Pieper's ocean waves, no two are identical, but the universal form is the same, the eternal made visible in the temporal, in what is fleeting.

The principle of simplicity also governs the ritual of the tea ceremony, generally, but the precise way in which the master comprehends and com-municates this principle and gives it life—this is the particularity of form of which we speak. Recall the single flower in the tea-room. What flower to choose, at which time of year, and where to place it, these are individual choices in which the universal principle is given life:

> Entering a tea-room in late winter, you may see a slender spray of wild cherries in combination with a budding camellia; it is an echo of departing winter coupled with the prophecy of spring. Again, if you go into a noon-tea on some irritatingly hot summer day, you may discover in the darkened coolness of the tokonoma a single lily in a hanging vase; dripping with dew, it seems to smile at the foolishness of life. (p. 105)

It is important for us to understand that these choices are not the result of mere whimsy or narcissistic fancy. All too easily, and all too often, we mis-take individual choice for egotistical opinion. If anything, what Okakura has shown is that the craft of preparing the tea and the tea-room presupposes a high degree of training, skill, and experience. Only a sensitive and skilled tea-master would know to couple the slenderness of cherries, as making visible the passing of winter, with the bursting, profligate fleshiness of the camellia, as embodying spring. This is one of the fundamental lessons to

hold in view: that such particular formal choices, when they arise from practiced contemplative beholding and have been "religiously" undertaken and learned, are not mere subjective opinion any longer, but the "bringing forth into appearance"—as Heidegger puts it—of larger and more profound abstractions.

We recall Plato here, and Socrates's contention that in order to see the universal form, we must become sensitive to the subtleties of the well-made thing, to be able "to sense it acutely when something has been omitted" or is out of place. It is not just detail and proportion that matter, however; slight deviations (think of the classical temple) can also contribute to something's being finely crafted, and so we must be sensitive to these as well. For Plato, it is by praising "fine things," being pleased by them and receiving them into our souls that we are led to resemblance and harmony with the beauty of reason. It is a question, therefore, not merely of taste but of knowledge; but then, we are also reminded of Anaximander and his sundial. Responsiveness to particular form involves a sort of knowing that is mysterious; indeed, a knowing that is about mystery itself. This is why we argue that the knowledge gained in contemplative seeing involves more than analytical thinking. It is not something we perform detached from objects or things, as neutral inquirers, but quite the contrary, we are engaged deeply in what is truly a practiced accomplishment. We are "following reason" in the way that Plato envisioned. Thus, the notion that when we arrive at the deepest engagement with the craft or ritual, what we find there is mystery. Okakura put it this way:

> For Teaism is the art of concealing beauty that you may discover it, of suggesting what you dare not reveal. It is the noble secret of laughing at yourself, calmly yet thoroughly, and is thus humour itself,—the smile of philosophy. All genuine humourists may in this sense be called tea-philosophers,—Thackeray, for instance, and, of course, Shakespeare. (P. 15).

The idea of concealing as revealing is one of the principles of contemplative seeing that we believe is worth exploring further. It comes from experience, but also touches on faith—a faith that is both aesthetic and philosophical, and ultimately, we believe, religious. Recall how Anaximander's sundial made the cyclical motion of the sun visible only by obstructing, by casting it literally into shadow. For a time such as ours, which demands that truth be clear and calculable, the notion of concealment is a difficult, if not nebulous, one. Anaximander's sundial bears witness to a very different way in which "seeing is believing," for here we find ourselves believing in concealment as revelation.

To learn to see this way takes practice. The roof of Sloane's old barn with its "mathematical grace," as he describes it, is an object of this sort of contemplative awareness. That barn roof no longer consists solely of a batch of shingles on a wooden framework, although certainly those comprise the

basic ingredients. The form is something the seer (Sloane, in this case) brings into view. Sloane has "eyes" to see the patterns in the roof, to perceive evenness, a balance and poise, akin to the rhythm of the dance. He sees what is revealed by the shingles concealing the beams below. He sees it *in the shingles* but not by removing them. And what about grace? How can chestnut and cedar have or communicate grace? By their proportion, by their mathematical regularity, which like the beating of a drum or the prancing of hooves, conveys a regularity that is *in time;* and hence, not perfectly regular. They move not with the precision of a mechanical apparatus, but the way the weaver moves at her loom, or the musician at her instrument. In other words, Sloane saw a temporal and geometrical quality revealed by the shingles rising and falling, striding in even consistent waves across the skin of the roof. Are these qualities not really there? Doesn't Sloane perceive the visible reality, as it truly is? We answer with Pieper that what Sloane sees and describes is a reality that comes to awareness only through an act of beholding. Sloane's ability to see contemplatively enables his readers to see along with him a more poetic truth, but a truth grounded definitively in the material, in the thing itself.

This sort of seeing is what we are asking our own readers to begin to do: to look to *the form.* We can learn to do this by looking at the things around us. Clapboards come to mind—a concealing, if ever there were one! The wooden clapboards on the Ephrata Cloister are laid down just as any other clapboard from the same period is or from other periods, for that matter. We find this marriage of matter and form on eighteenth-century New England houses as well as contemporary neocolonial ones. Such clapboards are laid one over the other by overlapping them. There is a mechanical principle at work, then, which is consistent with the practical function of siding: to shed the rain and keep it from finding its way up underneath and into the walls. What is it that really constitutes the practical function? Is it brutely physical, mere protection from the elements or is there not also a more psychological aspect to "being protected"? In other words, the practical function of protection has both a material and a spiritual source. Neither is any less real or vital than the other.

The noteworthy thing about wooden clapboards—especially older handwrought clapboards—is their irregularity, not necessarily their functionality. The feathering is often uneven as the lower edges are worn by the extremes of weather. Vinyl siding achieves good practical results, and is a far less costly means. Vinyl satisfies the practical function admirably and does so with consistency and regularity. But the regularity of vinyl—its perfection, if you will—can never give life to the psychological function of sheathing in the way wooden clapboards do. The clapboard, like the sundial, interrupts the movement of the sun; it casts irregular shadows that achieve regularity not by the imposition of perfect lines or ruler-straight plumbs, but by repetition. One clapboard above the other; one wave-like line ascends across the surface to another—another that is like it in type (a line of wood) but different from the others by its individual expression of the wave. Like the

waves of the ocean, there is at once a sameness and a difference. Each wave is a unique manifestation of "wave." Clapboards do this, too. But they do more. They draw patterns on the surface of the wall, patterns that come from cast shadows; patterns that in their imperfect repetitions remind us of ("imitate" in Plato's sense) the presence and absence of sun and the clouds. They interrupt the sun's beam. Thus, it is not simply the case that clapboards are worn down by the weather, and thereby exhibit its effects. They are, as Thoreau would say, "living poetry," like the leaves of a tree. The marriage, the visual reciprocity, between feathering and weathering is more intimate, more immediate than the relation of cause and effect. It is more like—it even looks like—the wave-like patterns that ocean waves often leave behind on the sand. The architectural form does not, therefore, simply protect against external conditions; it lives with them, mirroring the regular irregularities, the recurring extremes, of the seasons themselves.

Most importantly, the clapboards lend movement to the wall—movement that our eyes, if they are keen to become so engaged, follow, the way we follow the waves of the ocean. This movement, wave-like, particularized but patterned, repeated differently each time . . . this movement is dynamic. And in its being dynamic, it is life itself we see there. Clapboards are mortal, if anything is (anyone who must care for an old house is keenly aware of this). But, in the way that they make visible what this means, teaching us how to die, as Thoreau suggests, they offer intimations of immortality, teaching us how to live as mortals in a way that philosophical or theological treatises may be unable to do.

The "formalist" (as he was not surprisingly called), Wilhelm Worringer, argued this same point about a century ago is his enigmatic text, *Formprobleme der Gotik* (translated into English as *Form in Gothic*).[4] He was passionately engaged in the study of Gothic architecture, not as a religious, economic, or social phenomenon but as a "spiritual" one. He believed that the vast spaces of the Gothic cathedrals articulated by Gothic ribs and vaults had an "organic" form—that is, a dynamic one. Not because they bear a visual resemblance to trees and forests, but because they express motion, movement, dynamism—life! The eye is never allowed to rest, but is encouraged to follow the teeming lines of the ribs and vaults, ceaselessly. It finds no stopping place, no resting-place; there is no long low horizontal line such as Italian Renaissance builders will use. The structural members, ribs and vaults, are designed rather to produce a restless movement of the eye.

Worringer believed that the form—the structural design understood as ceaseless movement—was the source of the unique spiritual event that was occasioned by the Gothic cathedrals. His word for this experience was "transcendental." He arrived at this notion by delving into the form, which, like our clapboards, was at once functional and psychological. This is what he meant when he called his book, the "problem of form." Like Sloane's barn roof, the Gothic ribs, piers, and vaults provided him with an outstanding occasion for contemplative seeing. Worringer was very good at this—able to see and then to articulate what the particular forms most profoundly

expressed. He did not *explain* the cathedrals but rather gave voice to the form they embody, a form he saw as taut, rhythmic, and restless. These, like the mathematical grace of Sloane's barn, are particular formal qualities, ones that, for Worringer, were also a source of truth and meaning. He sees what Plato saw: not just what the architecture looked like (that is mere description), but what its visual qualities really mean for us, what they have to offer, and what we have to "take in."[5] That he described this effect as "psychological" can make him sound more modern (and even more scientific perhaps than Plato). But it will only sound that way if we allow ourselves to forget what the word psychological really means and where it originally came from—from the Greek *psyche*, meaning soul. Worringer, we daresay, was not so forgetful of this. In describing the function of Gothic architecture as psychological, he was helping to see it for how it moves our souls.

As we look—and that is the crucial point here—as we see or behold the forms, we embody the particular qualities of the restive, the excited, and the anxious. We do so in the very act of beholding them. All the "explanations" of Gothic architecture—the funding and patronage sources, the economy of the towns, and so forth—have contributed much to our stock of knowledge, but have not managed to reveal, as Worringer has, why centuries of beholders feel such heightened emotion inside the great Gothic churches.

<p align="center">★ ★ ★</p>

We can learn to see with Sloane and Worringer, through them, should we wish to. They offer actual instances of what it means to "behold"—to see contemplatively. To both, form mattered, not just for an appreciation of art (as an aesthetic category) but as the source of a way of living, of being human. In their views, the unique forms of early American and High Gothic architecture not only reflected the times (or our current way of thinking about those times) but shaped them. That is to say, for Sloane as well as for Worringer, ways of life live on embodied in the forms. The "content of past" (of a particular historical period as it was lived) can still be experienced by spectators today in whom that keen sense of contemplative awareness has been developed. It is widely accepted that in order to understand cultural phenomena, we must understand the way of life that produced them. We must see them "in context." But, how is this context ultimately understood? If there is more to a way of life than a collection of objectively observable and documentable facts, then we must either admit that we can arrive at no fundamental understanding of such a thing (if objective understanding is all there is), or we must look to its vital expression in the forms that reflect and shape it.

The mathematical grace of the old barn roof lived, and Sloane felt and saw it. Worringer experienced something of "the transcendent" in the ribs and vaults of Amiens Cathedral, the same source of heightened spirituality that the devout felt and responded to so many years ago. For Sloane and

Worringer, form, then, is not fixed in time; form is not petrified or fossilized; form is a living substance, made visible by *technē*. But then, if we are willing to participate in it fully and with all our senses alert, we shall have the potential to be transformed by it, as well.

Our lives today, so very different from early America or medieval France, can be the occasion for contemplative beholding—indeed for shaping ourselves, dare we say, more beautifully. Taking Pieper's advice, fasting from the overabundance of what there is to see and hear in order to feast on form, we may rediscover the things around us that can really matter. Take this so-called cereal bowl made by potter Ann Newbury. Thrown on the wheel, this curve of the bowl is steep. The sides are long, barely arched. The rim is thin and fine—a sort of delicate piece of drawing that sits atop the clay. Is this *any* bowl, for *any* purpose? Well, of course, in one sense the answer is yes. Use it however you wish, for that's how most of us think about freedom. Stack them, eat your oatmeal, lay some herbs inside, or decorate a hutch. Yet, the shape of the bowl and the finely drawn rim call out for us to respond in specific ways—to hold it with both hands and drink. It is a chalice of sorts, offering, should we be sensitive enough to grasp it, to call us back to the very elementary act of drinking, of taking in the liquid of life. This bowl is made for us to feel, through our hands, the warmth of the tea or broth or cocoa. It slides gently across our lips, reminding us of the living connection between vessel and mouth. It can warm us three times, if we are open to its doing so—once in holding, once in drinking, once by inhaling the vapors that arise from the broad expansive surface of the liquid.

This is not a priceless work of fine art; it something that can and should be used every day. We do not discard it after use, however, but must tend it lovingly, washing it by hand and putting it away safely till the next time. This vessel invites us to be conscious of our doings. In a larger sense, it invites us to reflect on how much of what we do, of what we make or produce, is really our own doing (we shall pursue this further in the following chapter). The potter, her *technē,* did not create the space the bowl surrounds (that emptiness that allows it to perform its function), nor has she made the clay, nor, in fact, has she created the hands and lips that hold and drink from it. What she has done is to provide the occasion for us to become aware of these things; she has made them visible. Thus, the very act of drinking becomes more sacred, closer to ritual as we understand it here. This little piece of simple pottery speaks volumes about the possibility of living more fully in our everyday acts, the way Okakura would have us do.

There are other ways to observe form in our lives today. We can be reminded in our houses and eating utensils of how objects help us "see the visible reality," as Pieper meant it, the source that is not of our own making, like the earth that gives us the clay. Form thus "presences," providing an occasion for praise and for living in full awareness of what creativity can and cannot bring about (we shall look more deeply into this when we turn to Heidegger). But, there other ways that form matters to our living well and fully. Recall Plato's discussion of gymnastics and music, how grace, rhythm,

and harmony are embodied and, thus, taken into the soul. Even for us today, listening to great music can be an act of "being in proportion," in the way that pitch and rhythm make proportion audible. Textiles can also provide a wonderful source for experiencing rhythm and proportion—in the very ancient way we described earlier—as well as for experiencing the reciprocal emergence of matter and form through making. We spoke, in connection with weaving and dance, about how the physical movement that produces form incorporates its own form or *kosmos,* how the pattern appears along with the making. Young people who dance or make pottery or prints or fabrics know this marvelous aspect of *technē* implicitly.

Although we may be unaware of it, weaving and dancing entail great skill not only on the part of the maker, but on the part of the beholder. Indeed, in this book, we are developing the capacity to do just that—to become skilled beholders. Here, too, as with listening to music, we are called to practice, even to commit to memory what we see. We mean this in specific and decidedly concrete ways. There is no avoiding the fact that while it sounds very nice to talk about rhythm "in the abstract," particular people give it particular life, and thus particular meaning. That incomparable paradigm of modern dance, Martha Graham, works, as they say in the dance, "close to the center." Her movements are tense, constrained, angular, and tight. When she unravels her body into full arc, it is like a coiled spring unwinding slowly, carefully enough not to burst its tense circularity. Such a conception of rhythm is unique, and Graham was well aware of just how unique it was:

> I am a dancer. My experience has been with dance as an art. Each art has an instrument and a medium. The instrument of the dance is the human body; the medium is movement. The body has always been to me a thrilling wonder, a dynamo of energy, exciting, courageous, powerful; a delicately balanced logic and proportion. It has not been my aim to evolve or discover a new method of dance training, . . . I did not want to be a tree, a flower, or a wave. In a dancer's body, we as audience must see ourselves, not the imitated behavior of everyday actions, not the phenomena of nature, not exotic creatures from another planet, but something of the miracle that is a human being, motivated, discipline, concentrated. . . . Training, technique, is important; . . . Its importance is that it frees the body to become its ultimate self.[6]

How different Graham's formal conception of the body is from Twyla Tharp's, although both women believe that the physical body is the source of meaning. As Tharp puts it, "Every body—every literal body—makes a different truth of all that for themselves. It's your composite and it's your vocabulary that you've made of the elements of locomotion of the human body."[7] Yet, her high speed and incorporation of jazz elements with classical form is utterly unique. We experience, then, the form of dance not in the

abstract but by *watching it*—by seeing closely, by comparing technique and execution, and ultimately by being open to embodying the dance form. As there are beautiful and very different conceptions of wooden boats, so, too, there are beautiful and very different manifestations of the human body and its potential for particularized expressions of grace, harmony, and rhythm. Should the human body be our "wood" (Sloane) or our "woods" (Thoreau), we are called to know the instrument intimately in its concrete specificity. Only then can the dancer and the dance call us forth into a genuine beholding.

To engage the art and craft this way takes extraordinary amounts of practice, and hence, time. We are becoming ever more forgetful of this. Yet, we are ready and willing to take time in the stands for football or baseball, where, rhythm, too, and certain patterns also emerge in the doing. What we fail to ask ourselves is why? Through dancing, as Graham says, the body is freed to become "its ultimate self." What is that self? It is a self that knows that movement makes the inner life visible; that movement, when it is *technē*, when it lets *kosmos* appear, can teach us how form, the body in beautiful and powerful movement, both mirrors and shapes meaning. It does so, not as a product but as a process, as both the working and the work. There is perhaps no clearer example of the importance of gesture and bodily movement as the instance of inseparability of process and product than dance. The dancer becomes more graceful by dancing gracefully, and by practicing it as such. To "practice" means to be concretely engaged. As we learn to "hear" pitch, so we learn to feel grace, but only in the real forms borne of individuals.

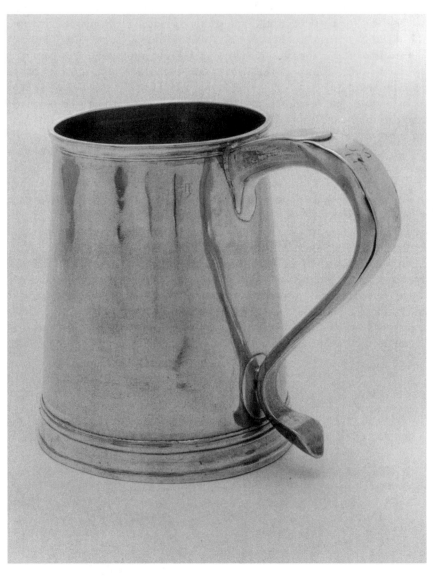

Plate 8 George Hanners, *Mug*, silver, ca. 1720 (Worcester Art Museum). Courtesy of the Worcester Art Museum

CHAPTER EIGHT

Thinking as Craft: Heidegger and the Challenge of Modern Technology

> Wherever man opens his eyes and ears, unlocks his heart, and gives himself over to meditating and striving, shaping and working, entreating and thanking, he finds himself everywhere already brought into the unconcealed.
>
> —Heidegger, "The Question Concerning Technology"

Technique is something we generally associate with art or craft, with the way in which something is made, or how it is done. Painting a house, splitting wood, preparing a stew, even brushing one's teeth—all of these activities involve a technique of one kind or another. Music differs from meringue, of course, just as portraiture differs from house painting. But, proper technique is as essential to one as to the other. Any good musician must master the necessary skills, or develop the proper technique, to ensure that the right notes are played or sung. Only then can he or she go on to play or sing musically. The same is true of the sculptor, who must know how to fashion the material—how to work the wood, clay, or marble—in order to realize her artistic aims. This knowledge cannot just be in her head. It must be in her fingers.

By now, we realize that the same may be true of the spectator, that the beholder must, as Thoreau puts it, have a kind of knowledge in his eye. Each of the preceding chapters has advanced the notion that seeing might also involve a technique. Sloane calls our attention, not just to things that are antique or old-fashioned, but to things that once did, and still could, foster a certain kind of awareness. But then, he also realizes that being surrounded by well-made or finely crafted things will not foster this kind of awareness all by itself. Our vision needs to be crafted as well. We must practice it as a skill. Only then can we really connect with what is in front of us; only then can it move us to wonder.

In our view, contemplative seeing is not just something one does. It is essentially practical. It is also a realization of freedom, of the sort that Pieper

associates with "an activity that is meaningful in itself." This is not the kind of freedom we usually associate with the contemplative attitude of the philosopher, the kind of quasi-mystical detachment we typically envision when we think of Plato or Thoreau; nor is it the kind of freedom we usually associate with the artist. Thoreau's prepared vision, like that of the philosopher who has worked his way up out of the cave, is as inspired as that of the weaver or the woodworker, the mapmaker or the musician. As we saw in the previous chapter, these activities are not partly practical and partly contemplative. They are contemplative through-and-through. But they are also, like the tea ceremony, thoroughly "regulated."

The creation of the artist, Pieper tells us, is aimed at ". . . making visible and tangible in speech, sound, color, and stone, the archetypal essences of all things as he was privileged to see them."[1] If the artist's way of seeing is truly spontaneous, if it is free and open in a way that others are not, this is because the artist is a practiced seer. "How meticulously . . . must a sculptor have gazed on the human face," Pieper notes, "before being able to render a portrait, as if by magic" (pp. 73–74). This kind of seeing does not just happen, any more than the rendering does. As Thoreau reminds us, the person who really sees with his own eyes is not the person who stays at home or takes refuge in his own preconceptions. The person who really sees for himself is the one who walks religiously, whose sensory engagement with the world has become a ritual. The "practical" side of art is therefore not just a means, as if all the artist needed to do was prepare his materials and master their use. He must also prepare his eyes. Regularity, habit, and discipline are as essential to this process as they are to those others.

"Practiced" seeing is not just a prelude to artistic expression, any more than Thoreau's walking was; it is something the artist's work makes possible. A fully engaged, participatory way of seeing is a necessary condition for true creativity, but it is also the end, or goal, of the creative process. "The true artist," Pieper goes on to say,

> . . . is not someone who simply and in any way whatever "sees" things.
> So that he can create form and image (not only in bronze and stone
> but through word and speech as well), he must be endowed with the
> ability to see in an exceptionally intensive manner. The concept of
> contemplation also contains this special intensified way of seeing . . . Art
> flowing from contemplation does not so much attempt to copy reality
> as rather to capture the archetypes of all that is. Such art does not want
> to depict what everybody already sees but to make visible what not
> everybody sees. (Pp. 73–74)

The ability to see in this way is indeed a privilege. But, we must be careful here. This ability owes it exceptional status not just to some personal endowment of the artist or the spectator, but also to the nature of what is seen. Such visions are a gift. We cannot make them happen. The ability, in Okakura's words, "to gaze upon the unseen" is dependent on skill, but it is

not just the artist or craftsman who makes this visible. If Thoreau is right, if one does not simply open one's eyes and see, then the beholder also has work to do. The wonders Thoreau beholds on his walks—like the order made visible by Anaximander's sundial—are not of our own making. But, they do not simply come to us; we must come to them. The technique that is involved in making *kosmos* visible is cultivated in the same way as the attitude of openness and receptivity that is required for seeing it. They are, as Plato might say, "part of the same craft and discipline."

<p style="text-align:center">★ ★ ★</p>

By now, we should have begun to realize that all of this might also be true of *thinking*, that philosophical thinking (Pieper's "reflective and receptive contemplation") might be more like working with wood than we ever imagined. Martin Heidegger is a philosopher who believes that this is so. Anyone who reads him, especially the essays from the middle decades of the last century, may balk at this. Heidegger's style can seem inaccessible to the point of impenetrability (especially in translation). The lines of thought are often tortuous, the language nearly opaque. How can a way of thinking that is expressed in such seemingly abstract and convoluted terms be compared to something as simple and direct, as "accessible," as woodworking?

Reading Heidegger is not easy. The source of the difficulty lies not in the technicality of his writing (in the sense in which we usually use that term), but in the technique of his thinking. Here too, the spectator "must cultivate the proper attitude," as Okakura would say. We ourselves must develop the proper technique for reading him if we are to understand how, and what, he thinks.

In truth, Heidegger is not more (and no less) difficult to read than wood is to work with. The kind of difficulty we encounter in his writing actually is rooted in a certain kind of experience—the kind of experience of practicing a craft. Readers unfamiliar with that sort of experience may simply assume that if Heidegger is hard to get through, it is because he is overly abstract, logically convoluted, or simply unclear. The irony is that most of us (especially those of us who read and write academic books) have more experience with abstract technicalities than we do with the genuinely technical difficulties of art or craft. Impenetrability, opacity, even tortuousness are what we *should* experience when we read Heidegger. These terms are typically used as metaphors for the faulty expression of ideas. But, their meaning is originally derived from experiences that have little to do with purely logical thinking. We talk about arguments as being impenetrable, or hard to get through. But, the real meaning of such phrases may be better understood by anyone who spent time in the woods or actually built a barn. It is in experiences such as these that Heidegger's thinking takes root. His own writing is shaped by his understanding of what philosophical thinking originally involves.

Heidegger uses two metaphors to characterize the activity of philosophical reflection. The first is the experience of following a path, not just in the

figuratively loose sense in which this phrase is sometimes invoked, but in the physically concrete sense of following a trail through the forest (it was the Black Forest that Heidegger would have had in mind, and where he actually walked). The other is the activity of crafting an object or of working the land. In an essay written in the 1940s, we find the following passage where Heidegger describes what he calls "preparatory thinking." This is not the kind of thinking that claims, or even attempts, to solve a problem. It is the kind of thinking that helps us to become aware of what the problem really is that works at allowing the truly fundamental questions to present themselves to us. Before we can set about answering these questions, we have to come upon them. This is a matter not of assembling arguments with premises and conclusions, but of doing what needs to be done so that what remains mysterious in the midst of all our problem-solving can be seen for what it is. Such thinking is modest in its pretensions, but laborious nonetheless:

> [It] proves to be an unobtrusive sowing—a sowing that cannot be authenticated through the prestige or utility attaching to it—by sowers who may perhaps never see blade and fruit and may never know a harvest. They serve the sowing, and even before that they serve its preparation. Before the sowing comes the plowing. It is a matter of making the field capable of cultivation, the field that . . . has had to remain in the unknown. It is a matter first of having a presentiment of, then of finding, and then of cultivating, that field. It is a matter of first taking a walk to that field. Many are the ways, still unknown, that lead there. Yet always to each thinker there is assigned but one way, his own, upon whose traces he must again and again go back and forth that finally he may hold to it as the one that is his own—although it never belongs to him—and may tell what can be experienced along that one way.[2]

It is not to say that it is easy to see what Heidegger has in mind when he pictures the thinker in this way. But, we should hesitate to say that the difficulty stems from its being overly abstract. The idea that "before the sowing comes the plowing"—that before we can reap we must cultivate, that before we can cultivate we must prepare the ground, that this requires finding our way to the field and having a "presentiment" of what might grow there— such an idea is *not at all* abstract, though it may seem foreign to anyone who has not experienced it. As the final words of the passage suggest, part of what the thinker has to do, what he "may" do, is tell us what this experience involves so that we may share in it (as Thoreau's essays invite us to share in his experience). This, too, is part of the cultivation that philosophical thinking entails. The thinker's task is not so much to prove something as to show us, to teach us to see, what he is talking about.

This should help us to picture our own role in reading what Heidegger wrote. The real challenge is to take him more literally than philosophers

generally do. If we should hesitate to say that what makes him so difficult is his being logically opaque, then we should also hesitate to think that our task as readers is to make his ideas accessible and clear. It is "only what already has become more meaningful to us," Heidegger says, "that becomes clearer to us"(p. 54). We need to approach his writing in the same way that the preparatory thinker approaches the field, if our reading is to bear fruit. Like Plato's allegory of the cave, the implications of Heidegger's image of following a path—as a model for thinking—need to be interpreted in a physical sense. Only then, when it becomes meaningful to us, can we begin to discern the truth in it. To divest these images of their physical aura does not make their meaning clear. If anything, it makes it disappear.

As we have seen, we tend to picture thinking in terms of detachment, a point of view that is really no point of view, that considers things in an unprejudiced or undistorted way rather than from one side only. Our every-day, earth-bound experience is of the sun rising and setting. An objective point of view, like the view from outer space, reveals something different: not a sun orbiting the earth but an earth orbiting the sun. To think, according to this picture, is to overcome—literally to rise above—the limitations of our perspective or of our particular location in space and time.

If objective thinking hovers over things so as to fully comprehend them, following a path through the forest offers a very different kind of experience. To be following a path means that we are able to see only so much at any given point along the way. We have a limited view of where we are, of the surrounding forest, and some portion of the path itself. The path extends behind and before us. To some extent, then, we can see where we have come from and where we are headed. There is also a great deal that we cannot see from where we are. What lies ahead, or is hidden by the trees and shadows (what is concealed in the depths of the forest) remains uncertain, or questionable. But then, there is only so much that we can *ask*, at any given point. The fact that we cannot see everything clearly does not just mean that we cannot see all the answers. It means that we cannot see even the questions.

Questions such as "what is that bird that flew across the path" must arise for us before we can think about them. We must wait for them to show themselves. We must wait as we must walk, quietly (or else we might frighten the birds away), but not passively. Such questions, like the sightings that give rise to them, occur to us only as we proceed along our way. But then, there is this further implication—that as we walk, things disclose themselves to us. We may draw nearer to things, to gain a better view of them. But we would never be moved to do this if they did not first appear to us. The same is true, Heidegger suggests, of the "matter" of our thought. What is supposed to be revealed *by* our thinking must, on a more fundamental level, be revealed *to* our thinking. Here again, such revelations do not simply come to us. We must come to them. That bird would not have appeared to us at all, we would never have wondered about it, if the path had not led us to the place where it emerged from the forest, or offered a

vantage-point from which to see it. But it is not our walking, or our think-ing, that reveals things. It is by making our way that they come to reveal themselves to us.

As we make our way through the forest, we are reminded that this "way" is one that we do not make by ourselves. It is one that we follow (or "trace"). The trail has been blazed by others following the contour of the land, and while it may be narrow, it is rarely straight. It may well prove tortuous, or convoluted. We may have judgments to make in determining which way we shall go, and there is certainly an exercise of will involved. But in finding our way, in going where we want to go or seeing what we want to see, we have the inescapable sense of being guided by the path itself or the landmarks it discloses, if not by an actual guide.

But then, there is this final implication. As the path twists and turns, more and more is revealed. But there is no less that remains concealed. We have the experience of making progress, of "getting somewhere" in our walking or our thinking, or of seeing more than we would have if we had turned back sooner. But the very nature of this experience entails that each of our sightings will be momentary. A slight rise in elevation opens onto a prospect that disappears from view as we round the next turn. Of course, we may remember what we have seen (if it was memorable), and all of these perspectives do contribute to a greater sense of the landscape as a whole. What is seen from the top of the ridge is not identical to what is seen from alongside the stream, nor is it separate. Each is an experience of what Heidegger calls "the Same." But the progress we make in gaining this experience is not cumulative, as if we were adding pieces of knowledge as we went along. However much our view takes in, it is always partial. There is not an increase of clarity, of things seen or known, and a corresponding decrease of hiddeness. As we advance, even when we arrive at the summit or the open field, there is always something that retreats into the darkness from which it emerged and where, we might say, it belongs.

All of this may sound esoteric, but should be obvious to anyone who has taken such walks again and again. While the implications of the craft image as an alternative model for thinking may be less obvious (even to a craftsman), we have reached a point in this book where these may also stand out more clearly.

Heidegger's way of thinking is indispensable, we believe, not only for understanding the attitude of mortality, but for actually practicing it. Where modern thinking detaches us from things, this way of thinking brings us closer to them. It also brings us closer to being human. But how, one may ask, can a way of *thinking* constitute a way of *being*? Here again, our modern preconceptions about the nature of thinking, and about the nature of life will tend to hold these apart. This holding apart is, in fact, the fundamental situation this book is trying to address. We occupy many different compart-ments in our lives. Not all of these involve thinking. Those that do require that we think in different ways. We think in one way when we study art or philosophy, another when we buy a house or fix a furnace, another when

we tend our gardens, and yet another when we tend to a sick child. If we are fortunate enough to have time for a walk in the woods, we may not think at all. If one is an ornithologist, and a walk in the woods means business, one will do some thinking, of course. But how one thinks when one's mind is on one's business has little, if anything, to do with how one *is* as a human being. If anything, it is a separable part of that, just as thinking, seeing, and feeling are supposed to be separate.

From the outset, this book has tried to question this separation. But, we cannot simply oppose it with the idea of contemplative seeing that (we think) lies at the heart of the attitude of mortality. The danger is that we might end up with just another compartment, one more thing to do over the weekend, like practicing the piano. How are we to practice seeing as a way of being, if Pieper is right and we are unable to see what we are missing?

This brings us back to Heidegger, and what is potentially fruitful about his way of thinking. The truth is that we do *not* have an unobstructed view of where we must go from here, or of how we will get there. Neither the end nor the means are clear in advance. To think that they are would be an indication that we are not proceeding in the right way; that in our very determination to "fix" the problem, we have abandoned the task of preparatory thinking. It would mean that we had *stopped* thinking, in Heidegger's sense. This is a constant danger, in Heidegger's eyes. It is a threat that philosophical reflection may help to avert, but can not definitively avoid. For the openness to things, which Heidegger associates with genuine thinking, is as much an openness to darkness as it is to light. Heidegger alerts us to this in a passage that weaves both of his metaphors together and offers a glimpse of what it could mean to practice living as if it, too were a craft:

> Everything here is the path of a responding that examines as it listens. Any path always risks going astray, leading astray. To follow such paths takes practice in going. Practice needs craft. Stay on the path, in genuine need, and learn the craft of thinking, unswerving, yet erring.[3]

<p style="text-align:center">★ ★ ★</p>

Like Pieper, Thoreau, Okakura, and Sloane, Heidegger finds that there is something deeply problematic about our contemporary way of life. We approach him with a set of questions that have been with us all along. How *can* we change the way we live? What would it take to live like Thoreau, and in what sense is this really an option for us? What is the solution to the problem of technological or mass production? Are there viable alternatives that we can make available to enough people? If we cannot simply "go back" to the eighteenth century, what can we do? Why should we even want to go back given the advantages that contemporary life provides?

Heidegger can help us address these questions, though not in the way we might expect. Heidegger, like many of the authors we have discussed, is

often accused of being "anti-modern." But, there is a fundamental differ-
ence between his view of modern life and that of other philosophers and
critics who believe that Western culture is in decline, and that we need to
return to more ancient (or less Western) ideas if we are to save ourselves.
Heidegger does not just think critically "about" our modern situation; he
thinks through it. What he can ultimately help us to see is why the problem
we face *might not have* a solution, at least not is the sense in which we can
first identify what is wrong and then figure out how to fix it. If we are still
thinking about it in this way, Heidegger would say, then we have not really
understood (we have not really thought through) the nature of the problem.
If it would only occur to us to ask the right question, then we might see that
the question itself contains the answer.

This is an insight we have to arrive at. We may be unable to see the
problem from where we stand, but this does not mean that we have to step
outside of our modern situation in order to examine it critically. It is not the
way of thinking he would have us undertake. So how would he have us
think about this?

If we are to remain true to the spirit of Heidegger's thought, we must
approach his writing in the way he himself pictures the preparatory thinker as
he approaches his "field." Heidegger's essays, like Thoreau's, are places of this
sort. To read them thoughtfully we have to participate in them (as we partici-
pated in Thoreau's), joining in his own "essay," or attempt at thinking. Here,
we remind our own readers of something that Heidegger is also mindful of,
that to participate in a way of thinking is not simply to think what someone
else thinks or to presuppose that what the author says is true; our task, like that
of the ancient *theōros,* is to "tell what can be experienced along that . . . way."[4]

The essay we shall attempt to plough through here is entitled, appropriately
enough, "The Question Concerning Technology" (it was first given as a
lecture in 1955). What makes this essay appropriate, however, is not what it
promises by way of an answer to this question. What the essay tries to do,
from the outset, is move us to wonder: what *is* "the question" concerning
technology? After all, even those of us who embrace technology (and all of us
do, to some extent) even we are able to see that there might be something
wrong here. Our lives are becoming more and more dependent on machines.
Devices are supposed to make our lives easier, and save us time. But then, it
takes time to assemble and learn to use them. They create tasks we did not
have to perform before. Technology does a great deal for us, but then there is
the question of what it has done to the world around us. We can point to our
new computers, and the flood of email they unleash upon us, and say "that's
the problem!" Or, we can point to a nuclear reactor, a hydroelectric dam, or
the ever-increasing crop of microwave antennas that seem to sprout overnight
on what were once scenic hillsides, and say "*that's* the problem!"

Is that the problem? This is what Heidegger is asking us to do, in his essay:

> We shall be questioning concerning technology, and in so doing we
> should like to prepare a free relationship to it. The relationship will be

free if it opens our human existence to the essence of technology. When we can respond to this essence, we shall be able to experience the technological within its own bounds.[5]

One wonders what Heidegger might be getting at here. Isn't our relationship to technology *already* free? Yes, we sometimes feel like we are slaves to our machines; but, they are still our machines. We built them. We run them. Even when they run themselves, we still push the buttons. We can turn them on and off. Even if the switch does not always work, we can fix that problem (we can always just pull the plug). And even if we do feel enslaved, in some broader or deeper sense, can't we still stand back and freely question our dependence on these machines, why we use them, and what they really do for us? Can't we at least occasionally take off for the mountains, or limit the time we (or our children) spend on line? Heidegger refers to technology's "own bounds." Is he talking about putting technology in its place? Its place now seems to be virtually everywhere. It also seems, in some form or another, almost always to have been with us. Is Heidegger trying to help us to acknowledge or accept that?

He is trying to help us to question, to wonder about something. Is this something we are supposed to *do* anything about? It is something we are supposed to "experience," and respond to. We may think that we already experience technology, everyday. But then, it is not just technology that Heidegger wants us to experience. It is not particular machines that we are supposed to be pointing at and complaining about. It is the *essence* of technology that is supposed to concern us. What *is* the essence of technology? How and where do we encounter it? Not in the ways we might ordinarily think:

> The essence of technology is by no means anything technological. Thus we shall never experience our relationship to the essence of technology so long as we merely conceive and push forward the technological, put up with it, or evade it. Everywhere we remain unfree and chained to technology, whether we passionately affirm or deny it. But we are delivered over to it in the worst possible way when we regard it as something neutral; for this conception of it, to which today we particularly like to do homage, makes us utterly blind to the essence of technology. (P. 4)

We "remain unfree and enchained to technology" whether we put up with *or evade it*, whether we passionately affirm *or deny it*. What else can we conceivably do? We cannot dispense with technology entirely, any more than we would want to rely on it every moment of our lives. Shall we pick and choose, saying yes to electric lights, no to bread machines, yes to modern medicine, no to interactive video games? Cellular telephones are useful devices, but perhaps we should keep them out of the mountains or limit their use except for emergencies. Perhaps, this would gain us some

freedom (at least from the chatter of those strangely one-sided, seemingly psychotic conversations we see and hear so many people having). Or perhaps, it would not. We are delivered over to technology "in the *worst* possible way," Heidegger says, "when we regard it as something neutral." But *isn't* it something neutral? Isn't this what people often say in defense of technology—that it is "only a tool," invented by us to suit our needs?

Heidegger recognizes the unavoidability of this way of thinking. The current conception of technology "according to which it is a means and a human activity" is what he calls the "instrumental" conception:

> Who would deny that is it correct? It is in obvious conformity with what we are envisioning when we talk about technology. The instrumental definition is indeed so uncannily correct that it even holds for modern technology, of which, in other respects, we maintain with some justification that it is, in contrast to the older handwork technology, something completely different and therefore new. Even the power plant with its turbines and generators is a man-made means to an end established by man. Even the jet aircraft and the high-frequency apparatus are means to ends. A radar station is of course less simple than a weather vane. To be sure, the construction of a high-frequency apparatus requires the interlocking of various processes of technical-industrial production. And certainly a sawmill in a secluded valley of the Black Forest is a primitive means compared with the hydroelectric plant in the Rhine River. But this much remains correct: modern technology too is a means to an end. That is why the instrumental conception of technology conditions every attempt to bring man into the right relationship to technology. Everything depends on our manipulating technology in the proper manner as a means. We will, as we say, "get" technology "spiritually in hand." We will master it. The will to mastery becomes all the more urgent the more technology threatens to slip from human control.
>
> But suppose now that technology were no mere means, how would it stand with the will to master it? (P. 5)

The same contrast could be drawn between Anaximander's sundial and an atomic clock, or his primitive map and a GPS device. The beauty of the instrumental conception is that it seems to capture what these different technologies have in common. But then, there is something else that is attractive about this way of thinking. The idea that technology is only a "means" suggests that, like any tool, it is entirely at our disposal; that how, why, and when it is used is up to us. Like a pair of pruning shears, it enables us to manipulate and control things. The same kind of "instrumental" thinking suggests that it is up to *us* to *control it*. If technology has made us what modern thinkers, like Descartes, thought we ought to be—namely, "masters and possessors of nature"—then are we not also masters and possessors of the instruments that enable us to do this?

Yes, if technology *were* a "mere means," if it were just a tool. But if it *weren't,* what then? Technology itself seems to support the kind of thinking that would define it in these terms. In the way we use it, it practically confirms the notion that we are in control. We might even be led to wonder which came first, whether the instrumental way of thinking that seems to be the driving force behind technological development is not, in reality, a product of that very development. This is why Heidegger thinks that the instrumental conception is indeed "correct." It corresponds to what is actually the case. But, Heidegger insists that it still does not show us technology's essence. While the instrumental conception does bring something to light, what technology is really all about remains hidden. What, then, *is* technology, if it is not just a tool? If it is conceivable that technology is not just something we use, what would it mean to enter into a "free relationship" to it?

This is the next question Heidegger asks (the next question to arise along the path). How could technology be anything *but* "a man-made means," a tool we make, an instrument we employ to accomplish certain ends "established by man"? Without any guidance from Heidegger, one could say that, of course, technology is not just a means. This has always been true. Long before information technology became a "priority" at institutions of higher education, before the development of new and better technologies became a goal in its own right, craftsmen were making tools and using tools to make those tools. That these tools were made by hand, and made to be used by hand, did not make them any less technological. We already know that this is where "technology" came from—from *technē,* or craft. But if technology is rooted in craft, then it must be more than just a means for getting things done. The tool is not just what philosophers call an "efficient" cause, something that is effective in bringing about something else or causing it to happen. The tool is also what the Greeks called a *telos* or "final" cause, an end, purpose, or goal. The *telos* of the builder's craft, the final cause of a builder building a house, is the house itself—a "machine for living in." What more is there to see or wonder at? Perhaps, it has something to do with the very notion of what it means to make something:

> For a long time we have been accustomed to representing cause as that which brings something about. In this connection, to bring about means to obtain results, effects. The *causa efficiens* . . . sets the standard for all causality. This goes so far that we no longer even count the *causa finalis,* telic causality, as causality . . . The doctrine of the four causes goes back to Aristotle. But everything that later ages seek in Greek thought under the conception and rubric "causality," in the realm of Greek thought and for Greek thought per se has simply *nothing at all to do* with bringing about and effecting. What we call cause . . . is called *aition* by the Greeks, that to which something else is indebted. The four causes are the ways, all belonging at once to each other, of being responsible for something else. (P. 7: emphasis added)

Heidegger is trying, as we have been throughout this book, to enter into a way of thinking that lies at the origins of our own modern one, but that we ourselves have forgotten or lost touch with. What Heidegger would have us wonder about is what this "indebtedness" or this "being responsible" might have meant, "thought as the Greeks thought it," and what it might still mean for us.

Heidegger points to a chalice—a sacrificial vessel—crafted of silver. (No doubt Heidegger has something very ancient in mind; taking our cue from Sloane, we might substitute an example of Paul Revere's work, or any one of a number of Early American silversmiths.) The most obvious cause of the chalice's being made is, of course, the person who crafts it. In what sense is he responsible for the finished product? *Doesn't* he "bring it about"? It would seem to owe its production entirely to him. Is there a sense in which he remains indebted to it?

Heidegger wants us to see this as questionable; to think again about whether the chalice is really just an effect that the craftsman produces. At the same time, he wants us to question whether the finished product is itself just an efficient instrument—something that serves our needs. Here again, we may think that we can already see what Heidegger is getting at. Of course, the production of the chalice does not just depend on the craftsman. It depends on the matter (the silver of which it is made), the form (the shape that is given to it), and the purpose it is meant to serve. What the chalice is meant to do (its final cause) plays a large role in determining what it is meant to be. The chalice owes its being to each of these four causes of which the craftsman counts only as one. At the same time, each of the four causes owes something to the others. The form of a chalice is, in one sense, what makes it what it is (a chalice rather than a bowl or a wash basin). This is its characteristic shape or *eidos*. But, the form cannot be realized without the craftsman's *giving* shape to the matter. The shape that is given to it depends on the purpose it is meant to serve. This purpose cannot be served without the chalice's actually being produced. The craftsman also depends on this in order to realize his own purpose. In order to "be" a craftsman, he must actually make something. He, too, owes his being to each of the other causes. To make the chalice, he must have the matter in hand, the form in mind, and the purpose in view.

This is not difficult to see. But, it may still look as if all of this is really the craftsman's doing. He decides to make a chalice, to give it a certain form, and to make it out of silver. The matter and the form do not do this all by themselves. The craftsman does not create the chalice in the way that God is sometimes thought to have created the world—out of nothing but Himself. The craftsman depends on other people and things. But, even then, the production of the chalice remains a "human activity." Even if the craftsman did not actually mine the silver, draw it from the earth and refine it, someone did. Even if he did not decide what the form of the chalice would be, since this is largely determined by the purpose it is meant to serve (and perhaps by the wishes of those for whom it is made), is the purpose it serves not a

"product" of human decisions? The same could be said for the patterns of the dance or of the woven cloth. Call it *kosmos* if you wish, but it is still up to us (to the designer or the choreographer, if not the weaver or the dancer). What the chalice, or any made thing, is "meant to be": isn't that our own doing? Isn't all of this ultimately determined by human purposes and needs?

So it seems. But here the path takes another turn:

> The four ways of being responsible bring something into appearance. They *let it come forth* into presencing. They set it free to that place and so start it on its way, namely, into its complete arrival. The principal characteristic of being responsible is this starting something on its way into arrival. It is in [this] sense . . . that being responsible is an occasioning or an inducing to go forward. On the basis of a look at what the Greeks experienced in being responsible, in [the word] *aitia*, we now give this verb "to occasion" a more inclusive meaning, so that it now is the name for the essence of causality thought as the Greeks thought it. (Pp. 9–10: emphasis added)

Here, the forest (of Heidegger's language) has grown admittedly obscure. But, perhaps, the truth we are trying to discern *is* obscure. Such obscure places may sometimes admit a new and clarifying light so that we notice things we would not have noticed if all the shadows were banished and everything were made as plain as day (look again at those clapboards). The "more inclusive meaning" that Heidegger would give to this word is not a philosophical obfuscation. In suggesting that making is really an "occasioning," he is not reaching far beyond what our own language says (or once said). To redefine causality in this way may seem foreign to our thinking. But, it is not so very foreign to our speaking. If this usage seems strange, it is because it is forgotten, or overlooked. Here again, it is not just a meaning that has fallen into disuse. It is an experience from which we have become detached even as we engage in it.

The truth, Heidegger suggests, is that craft (*technē*) is not just a "bringing about." It is a making of something, but it is not just a "making happen." On a more fundamental level, it is a matter of *letting* something *come forth*, of *bringing* it *into appearance*, of *setting it free*. How could that be, if what is made and how it is made, is ultimately determined by human purposes and needs—if it is made to serve, or to suit, us? In what sense is the craftsman setting anything free when he creates the chalice? In making the chalice, the silversmith gives the matter a certain form. Is there a deeper sense in which the form the craftsman gives to the silver is itself already *given to* the craftsman? The form is determined by the purpose the chalice is meant to serve. *Is* that a product of human decisions?

What is its purpose, after all? Heidegger tells us: this is a sacrificial vessel, to be used (we might imagine) as part of a religious observance or in the service of worship. Is divine worship the product of a human decision? It may be something we choose to do. But is it something we simply decided

that we needed to do, or is it something we are ultimately *called* to do? It is not just our own needs that worship serves. Social scientists may object, of course, and insist that it is. The modern theoretical view, at least the dominant one, does see religious observance (ritualized worship) as a fundamentally human activity—as a "construction" that serves, in complex ways, to create or reinforce the identity of the worshippers. But, the view of the observers themselves (of those who participate in the practice) must be different, or else there would be nothing to distinguish the function of worship from any other social function (from a political convention, for instance). To worship is to be observant of something other than ourselves. If worship were answerable only to human needs, if we saw it as something we did simply to suit ourselves, it would not be the purpose we take it to be. This is the purpose the chalice is meant to serve. But, if this is why it is made the way it is (or why it is made at all), then *is* it simply "brought about" through human activity, as a "man-made means to an end established by man"? If it is not something the craftsman simply decides to make, but is something he is somehow called to make, is there not a corresponding sense in which it is called for, or brought forth, and not just brought about?

Surely not everything that is made is intended for religious sacrifice, in the way that the chalice seems obviously to be. Perhaps we are making too much of Heidegger's example (or perhaps it is too cleverly designed to suit his own theoretical needs). Let us say that the chalice is not meant for divine worship. In the same way that the function of a house is supposed to differ from that of a church, perhaps the chalice is meant to serve simply as a vessel for drinking. This is what it used for, what it is meant to be. This is what determines its form, why and how it is made. In this case, the making of the chalice would be entirely answerable to human purposes and needs, would it not? There is nothing "divine" about its production or use. It is just an instrument, the making of which is entirely our own doing, the imposition of a suitable form on a suitable matter (be it silver, wood, pewter, clay, plastic, or the ubiquitous styrofoam).

But then, we ask ourselves: what makes the form suitable? We begin to see this in the previous chapter. Any drinking vessel needs to hold a sufficient amount of liquid (at least a sip). It will have to be shaped in such a way as to function effectively (if not efficiently) as something from which we can actually drink. At the very least, it will have to fit our hand and fit comfortably into our mouths. It would have to be something that we could balance, whose contents would not spill as we brought it near our face, but would flow evenly as we tipped it toward us. Its proportions would have to be such that we could hold it and drink from it at the same time. In all of these ways, its form would have to suit our form, if it is to satisfy our need for drink. There is something any such vessel is meant to be, given what drinking involves.

Is this really our own doing? Drinking is. But, there is more to "what drinking involves" than meets the eye—more than simply meeting our need for drink. There is also what meets the hand and the lip. Cups have lips

because we have lips. Why is that? If the cup is meant to be a certain way because we are a certain way—our hands are shaped a certain way, our mouths are positioned a certain way, our arms work a certain way, our bodies are (in general) proportioned a certain way—is all of that, *human* form, our own doing? What do we see in the cup, after all? If it is full, we see what it contains—the object of our desire. We look at the cup itself and we see an instrument for the satisfaction of our needs. But, if we look more closely and attentively, we see ourselves. We see something that is man-made, to be sure; but then, we also see something that we ourselves do not make. When we handle the cup, or place it in our mouths, it does not simply conform to us. We conform to it (if it is well-made). What we see, in the suitability of its form, is not just our needs and productions, but our own form. We see something that has been given to us.

The cup is meant to have a certain form because we have a certain form. It, too, is not simply brought about by human decisions but is in some way called for. By what? Even if there is no obvious occasion for worship here, there is an occasion for observance. In fashioning the cup, the craftsman is not just imposing a form of his own choosing on matter of his own choosing. He, too, is bringing something into appearance, or letting it come forth. Here again, we are reminded that human making is, originally, a making visible, and that what is made visible is not just a product of our own hands.

★ ★ ★

Heidegger would have us conceive of the craftsman's "being responsible," not in the ordinary sense of causing something to happen, but as occasioning (rather then controlling) something, "inducing" (not forcing) it to go forward. Now, we can see that this way of thinking is not as historically remote as it initially seemed. We can picture it happening in our own backyards. Our own experiences with making things, whether it is baking bread or tying trout flies, should remind us that craft is not just the imposition of form on matter. It allows form and matter to appear, lets them come forth, in the same way we allow them to appear when we garden. Any practiced gardener knows that while she does make the garden, she does not "make it grow."[6] There a great deal to be done, to make the garden: clearing the plot, preparing and enriching the soil, sowing the seeds or placing seedlings in the ground, watering, weeding, and so on. The garden would not come to fruition were it not for the gardener's work. But, its growth is not her own doing. She is "responsible" for it, but she does not cause it to happen in the way that flicking a switch makes the lights go on. Not only is the gardener's responsibility for the garden ongoing, unlike the flicking of the switch, the nature of the responsibility is different. It is more like moral than causal responsibility, a matter of caring or tending, of overseeing (or seeing to) the growth of the plants rather than effecting it. Gardens do not simply come to be by nature; they come to be by craft (gardening is a *technē*). But even when the gardener "intervenes" in natural processes, which she does at almost

every step of the way by removing the weeds that would hinder the development of her seedlings or even directing their growth by pruning or staking them up, she is reminded (again, at every step of the way) that all of this work is only providing an occasion for something that is not under her control. The plants would not flourish without the work of her hands; but, the germination of the seeds, their emergence, growth, flowering, and fruition are all out of her hands.

We still say about gardens what the ancient Greeks said about beautifully crafted things—that they have a life of their own. What is strange, however, is that this is something we are often forced to admit or acknowledge in frustration when things do not go according to plan, as if, when things *do* go according to plan, it did not seem to be the case! ("Why are the cucumbers growing this way rather than that? Well, they have a life of their own, you know!") If we seem less aware of what is living in a garden when all goes well, it is because we have only our own plan in mind. But, a good gardener (like a good craftsman) never has only her own plan in mind. She must not only contend with the vicissitudes of weather, pests, and diseases. To garden is to work with the vicissitudes—the fundamental contingencies— of life itself. Because the spring was unusually cold, the yellow rose may not bloom together with the purple iris; the stunning contrast that the gardener hoped to see is not realized. But other, equally stunning combinations may emerge coincidentally, as the blue delphinium keeps company with the white clematis. Every gardener is looking for (or looking forward to) something in planning a garden and directing its growth. But, the possibilities that reside in the soil and in the seed are what make gardening a creative rather than just a mechanical process. It is not just the uncontrollability of weather and of weeds that should remind us that gardens have a life of their own, as if the recalcitrance of nature were what "life" is all about. Gardens have a life of their own because the soil and the seed have a life of their own. Without this, there could be no plan at all. There would be no growth, and no garden.

One could say that what the gardener is "plotting" is, after all, something that will suit herself. She is at least hoping for the results she works to achieve—an attractive display of foliage and flowers, or an abundant crop of tasty and nourishing fruit. This is why she must give form to the garden, setting her plants in rows or arranging them in some other way. But the order one sees in a garden is not just the order that the gardener puts there when she makes it. If it is well-designed (not just to allow for the efficient removal of weeds and easy access to the plants, but to promote strong and healthy growth), what the "plot" will allow for is the emergence of the plants themselves. The gardener will place certain plants behind or in front of others so that they can be seen in the order in which they bloom. She does not make them appear, any more than the erection of a trellis causes the vine to climb. Her aim, the real point of the garden "plan," is to allow the plants to show themselves. This is what makes any garden successful, whether it is designed to provide a beautiful spectacle or a rich harvest,

a wonder to behold. What is happening in a garden, however formal (and every garden is "formal" in some sense), is not just the realization of human designs, as if the gardener supplied the form and nature provided only the matter. There would be nothing for the gardener to tend, nothing that her arrangements would serve to reveal if the impulse to form were not already there in the soil and in the seed. This, the life that the gardener and garden share, is what is "brought into appearance," or allowed to come forth through the gardener's art. All gardens are artificial; but, the gardener's plot, all those stakes and twine, are also setting something free (it is precisely this that makes gardening so difficult, and so wonderful).

Heidegger suggests that experiences such as this can bring us closer to understanding what is involved in making or crafting anything. They might also help us to see why Heidegger would picture *thinking* as a craft, as a "bringing forth into appearance," and what this could mean:

> Through bringing forth, the growing things of nature as well as whatever is completed though the crafts and the arts come at any given time into their appearance. But how does bringing-forth happen, be it in nature or in handwork and art? [. . .] Bringing-forth brings hither out of concealment forth into unconcealment. This coming rests and moves freely within what we call revealing. The Greeks have the word *alētheia* for revealing . . . We say "truth" and usually understand it as the correctness of an idea.[7]

"Bringing forth" (as opposed to "bringing about") is what Heidegger thinks *technē* originally consists in. It is an occasion for the kind of revealing he refers to here. This is not something that is produced by clear or accurate thought, as if reason itself were a tool for getting at the truth (which is correctly represented by our methods of thought). Revealing is not the thinker's own doing any more than the chalice is the silversmith's own doing.

But surely, one might say, the craftsman has to manipulate the matter (just as the gardener has to manipulate the soil) if anything at all is to come forth. Silver does not behave like a seed; nor, it seems, does the object (or "matter") of thought. It is true that if the chalice is to be made of silver, it too (the matter as well as the form) must be suitable for use. This itself seems to involve an imposition of human purposes and of human will—forcing the matter to yield itself up to us. The "raw" material must be extracted and converted, turned into (or made to become) "pure" silver. Or, could this also be pictured differently? In being drawn from the earth and refined, could it be that the matter itself is being allowed to come forth, brought into appearance, and (in some sense) "set free"?

When the silversmith uses silver to make the chalice, he does not simply force it to become something it is not. Heidegger helps us to see a distinction that might not have occurred to us until now. The silversmith "uses" matter, Heidegger would say, but he does not "use it up." This may be

clearer in the case of the fine arts. The architect uses stone, but he can do more than just put it to use. He can allow it to appear so that we appreciate its material qualities—we see and feel its patterns and textures, its substance and weight—in ways that we might not if it were buried in the ground or even lying in a field. The painter uses pigment, but in such a way (as Heidegger says) "that color is not used up but rather only now comes to shine forth."[8] A poet uses words, but how? Not as material resource to be used up, or as a means of communication, but as ends in themselves. The poet uses words in a way that calls our attention to them *as words* that speak and sound a certain way (the same is true of the way a musician uses his instrument, or a singer her voice). A work of art, Heidegger suggests,

> . . . does not cause the material to disappear, but rather causes it to come forth for the very first time . . . The rock comes to bear and rest and so first becomes rock; metals come to glitter and shimmer, colors to glow, tones to sing, the word to speak. All this comes forth as the work sets itself back into the massiveness and heaviness of stone, into the firmness and pliancy of wood, into the hardness and luster of metal, into the lighting and darkening of color, into the clang of tone, and into the naming power of the word. (P. 46)

What happens in the work of the fine artist also happens in craft.[9] The person who brings stones from the field and uses them to build a wall is not just using them up; he does with them what the poet does with words. The stone wall, like a temple or a chalice, is something that serves a purpose— something we use. But we do not just "utilize" it as means to an end. It too can be experienced as an end in itself. What Heidegger would call the "stoniness" of the stone—all of the qualities that serve to remind us that it too has a life of its own—does not disappear behind its utilitarian function. The formation of the wall, the placement of stone upon stone, makes visible the form that is instinct in the matter itself—in the same way that the shaping of the bowl brings out the grain of the wood. The life that is revealed is ongoing, as the light changes from hour to hour or season to season, and as the material itself ages from year to year. In this way, stone walls also function like Anaximander's sundial.

When we look at a stone wall, we *may* see only a device for keeping people or animals in or out, for screening something from view, or for marking the extent of our own property. But, there is something about a stone wall that encourages us to view it differently, something that invites us simply to look at and admire its construction. This is part of what we "use" them *for*—to contemplate. What makes stone walls such "wonders to behold" is not just the precise fit, the stability or smoothness that the mason has achieved (as if he were able to make stone behave like plastic or poured concrete); like the clapboards we discussed in the previous chapter, it is the irregularity of such walls that makes their "harmonious" composition seem almost miraculous. This is something that the mason's hammer and chisel can help to reveal, and not just to obliterate. Regarding the construction of stone walls, it is said that the

genuinely skilled craftsman is not the one who can always find a stone and make it fit the place where he needs it. It is the one who can find a place for the stone—the one who has not just a strong arm, but a proper sense of what is "fitting."[10] If the craftsman has a good eye, he will see how the stones themselves want to be placed, where they are meant to be. He is not just *letting* them be. But, we can still see him as setting them free.

As these examples suggest, what Heidegger sees in craft brings it much closer to nature than we usually think of it as being. Heidegger goes so far as to suggest that nature itself is poetry (*poiēsis*) in the highest sense; that nature does not need a poet to bring it forth, that it unfolds out of itself, does not make it less like poetry. On the contrary, this is what Heidegger thinks all art (and craft) aspires to. The painting or the poem (any well-made thing) is all the more wonderful when it seems to have come forth by itself. The craftsman's aim is to create something that has a life of its own. But then, it is the craftsman, and not the matter, who wants to disappear. The beautiful wall is the one whose stones seem to fit together by themselves. The craftsman's presence is revealed by their being out of place, or being forced into place. It is the same with music where what we hope to see (or hear) realized are the creative possibilities inherent in the composition itself, and not just the individuality of the performer. This is what the artist's unique talents work to achieve. True genius, Heidegger suggests, is anonymous.

<p style="text-align:center">★ ★ ★</p>

Now that we have traced technology back to its root, have we found the solution to our problem? It looks instead as if there may be less to worry about than we might have thought. When Heidegger talks about opening our existence to the essence of technology, could this be what he has in mind: that we should learn not just to live with, but to admire modern technology in the way that we admire silver chalices and stone walls? While it may be true to say that technology, in some form or another, has always been with us (that the development of *technē* coincides with our becoming human),[11] there is also something about modern technology, especially its relationship to nature that seems, if anything, to be at odds with what Heidegger sees in the work of the craftsman.

At this point, it might seem as if Heidegger sees no essential difference between the ancient Greek (or the eighteenth century) world and our own. But then, he might also see something in our modern situation that we ourselves do not.

> What is modern technology? It too is a revealing. Only when we allow our attention to rest on this fundamental characteristic does that which is new in modern technology show itself to us. And yet the revealing that holds sway throughout modern technology does not unfold into a bringing-forth . . . The revealing that rules in modern technology is a challenging, which puts to nature the . . . demand that it supply energy that can be extracted and stored as such. But does this not hold true for

the old windmill as well? No. Its sails do indeed turn in the wind; they are left entirely to the wind's blowing. But the windmill does not unlock energy from the air current in order to store it.

In contrast, a tract of land is challenged into the putting out of coal and ore. The earth now reveals itself as a coal mining district, the soil as a mineral deposit. The field that the peasant formerly cultivated and set in order appears differently than it did when to set in order still meant to take care of and to maintain. The work of the peasant does not challenge the soil of the field. In the sowing of the grain it places the seed in the keeping of the forces of growth and watches over its increase. But meanwhile even the cultivation of the field has come under the grip of another kind of setting-in-order, which *sets upon* nature . . . The coal that has been hauled out in some mining district has not been supplied in order that it may simply be present somewhere or other. It is stockpiled; that is, it is on call, ready to deliver the sun's warmth that is stored in it.[12]

Technology is no longer a matter of bringing forth, but of "challenging" (Heidegger says). The cultivation of the field has "come under the grip of another kind of setting-in-order," which "demands" something of it. Where does this demand come from, and what is it a demand for? It is not just a demand for efficiency (or "the maximum yield at the minimum expense," as Heidegger puts it). We take it for granted that this is what technology is all about, but there is a more fundamental demand that underlies it. What is the difference between this "setting upon" and the way the silversmith uses silver to make his chalice, the way the farmer uses the earth to grow crops, the way the old windmill uses the wind, or a waterwheel uses the river's current?

Perhaps it would help to recall Sloane's view of eighteenth-century American life. This, he claimed, was an era in which each person "was forced to live with piercing intensity and perception." Today, by contrast, when someone turns on the water or the lights, "he has little awareness of where these things come from; the greatest pity, however, is that he says, 'Who cares where it comes from, as long as it keeps on coming?' " Sloane found it "less strange that the eighteenth-century man should have a richer and keener enjoyment of life through knowledge than that the twentieth-century man should lead an arid and empty existence in the midst of wealth and extraordinary material benefits."[13] Regarding our modern habits of life, Heidegger would agree that there is a strangeness lurking in the flick of a switch, or the turn of a faucet. If the eighteenth-century person is "forced" to live with greater awareness, it is because the satisfaction of his wants is not guaranteed. He does not live with the assurance that by flicking a switch his needs will be met. If such a person is provided with "a richer and keener enjoyment of life," it is not because his technological abilities are superior to our own. On the contrary, modern scientific and technological knowledge is what, we would rightly say, he lacks. What kind of knowledge does he possess, then, that is supposed to make his life so rich and ours so empty?

For Sloane, as well as for Heidegger, the source of this emptiness and aridity lies in our very expectation that by flicking the switch or turning the faucet, everything will be made clear, night will be turned to day, and water will flow like springs in the desert. It makes no difference that these expectations are met and encouraged by our technological abilities, that what we (now) know makes it reasonable to assume that we can make these things happen. It is not our practical expectations that come up empty. But then, this very fact does make a profound difference, for it is precisely this knowledge that prevents us from caring about "where it comes from." It is not just that we *needn't* wonder about this. There is a sense in which we are cut off from wondering about it, by the very answers that our technological way of thinking provides. Where does it come from? From the factory, of course, or the power plant, or from whatever powers these, from the coal, oil, or gas that we extract, the atom we split, or the current we divert. We assume that what ends with us (the light that our lights provide) also begins with us. We may not create these sources of energy. But we do make the energy by converting these materials into a kind of power that can be used for almost anything, just as the lumber industry takes various kinds of wood, each with its own individual characteristics (its own substance, as Sloane would say), grinds them up, and recombines them into press board or some other composite substance that can be put to use in more ways than any particular kind of wood ever could.

This way of processing material is very different from the way a wood-worker makes use of a piece of maple to fashion a bowl. In the latter case, it is precisely because the material has not been converted into neutral stuff to be manipulated at will, that the craftsman can (and must) work *with* it. This is not true of material that has already been "set upon" in its very nature. The difference between using linoleum to make a wood-cut and using wood is that, in the former case, one can make one's cut in whatever direction one wants. There is no grain with which to contend, to avoid working against or cutting across. In one sense, this gives the artist more to work with. It opens more possibilities. But in another sense, it gives him far less to work with, far less for the artist to follow, or for the woodworker's carving to reveal. The craftsman may curse the grain at times. But he is also thankful for (or "indebted" to) his material in a way that we cannot be thankful for linoleum, plastic, or pressboard. The latter are already our own doing. We may appreciate their convenience, efficiency, or greater usefulness. But, if we feel grateful for them, it is because our gratitude is really directed toward those who invented or produced them. We have ourselves to thank for these things. We owe these very materials to our own technological prowess. The craftsman's working with wood is, by contrast, more like the windmill's turning in the wind, or the use the sundial makes of the light the sun provides.

This idea of what it means to work with something brings with it an idea of what it could mean to live with something. It would mean not just to tolerate or put up with it or to accept it in a spirit of resignation (in the way that some gardeners are resolved to "live with" weeds). Along with a piercing perception and a richer enjoyment of life, Sloane attributes to his

eighteenth-century person a *gratitude* for life "and all that goes with it." It is this that provides him with an "inner satisfaction." His gratitude extends to the stormy as well as the fair weather (however life-threatening the former may be), to decay as well as to growth, to corruption as well as fruition—for they all issue from the same source. He may not welcome the early or the late frost, just as the carpenter may not welcome every knot that lies buried in the wood. Such things can and do thwart us, and defeat our purposes. But they, too, are part of what the craftsman has to work with.

Such work reveals more than just our own purposes. What we saw in the bowl, in our previous chapter, can also be seen in the earthen jug Heidegger reflects on in his chapter, "The Thing":

> When we fill the jug with wine, do we pour the wine into the sides and bottom? At most, we pour the wine between the sides and over bottom. Sides and bottom are, to be sure, what is impermeable in the vessel. But what is impermeable is not yet what does the holding . . . The emptiness, the void, is what does the vessel's holding. The empty space, this nothing of the jug, is what the jug *is* as a holding vessel . . . But if the holding is done by the jug's void, then the potter who forms sides and bottom on his wheel does not, strictly speaking, make the jug. He only shapes the clayFrom start to finish the potter takes hold of the impalpable void and brings it forth . . . in the shape of a containing vessel.[14]

This "impalpable void" is not sheer negativity or absence, but is all around us, like the soil out of whose darkness the garden emerges. It is because we no longer see that this is what makes the jug, because we no longer see this as the source of its being that we ourselves are given over to a different kind of emptiness in our own way of being. The fecundity of this "nothing," which is otherwise concealed in its abundant presence, is what the potter's work brings forth. But even then we may not see it. For this is precisely what modern technology (in its essence and not just through its devices) has worked to eclipse: the way the jug functions as a "containing vessel" will look to us like the way in which the hydroelectric dam holds back the water for our use. Heidegger invites us to picture it thus:

> The hydroelectric plant is set into the current of the Rhine. It sets the Rhine to supplying its hydraulic pressure, which then sets the turbines turning. This turning sets those machines in motion whose thrust sets going the electric current for which the long-distance power station and its network of cables are set to dispatch electricity. In the context of the interlocking processes pertaining to the orderly disposition of electrical energy, even the Rhine itself appears as something at our command. The hydroelectric plant is not built into the . . . river as was the old wooden bridge that joined bank with bank for hundreds of years. Rather the river is *dammed up into* the power plant. What the

river is now, namely, a water power supplier, derives from out of the essence of the power station . . . But, it will be replied, the Rhine is still a river in the landscape, is it not? Perhaps. But how? In no other way than as an object on call for inspection by a tour group ordered there by the vacation industry.[15]

Heidegger's reference to "the old wooden bridge" may lead us to think that his critique of modern technology is nothing but a nostalgic gesture born of a metaphysical romanticism. But Heidegger's philosophical vision is not romantic (in this sense). He is not simply rejecting modern technologies in favor of old-fashioned ones, any more than Sloane was. It is by wondering about the very essence of technology—pursuing it as a question rather than as something that is clear to us in advance—that we may come to see that there *is* a difference between the water-powered mill that turns grain into meal, and the hydroelectric dam that turns water into energy. Both use the river's current. But, in what way? The hydroelectric dam arrests it entirely, keeping it back for future use. But then, the mill pond appears to accomplish the same thing, does it not? Both hold back the river's current only to release it, or "set it free," even as they use it. Or so it would seem. But, if we look (and think) harder, we may see the difference between them.

The hydroelectric dam is not just larger or more efficient in the use it makes of the river's current. It uses it up, Heidegger suggests, by "stockpiling" it. When we picture the dam as "set into" the river, in contrast with the old mill which is set beside it, the river itself is more radically transformed. The river's current is "on call" as a "standing reserve"—not as a source but as a resource. This is what the hydroelectric dam really accomplishes, a deeper and more troubling (though less obvious) accomplishment than the generation of electricity. The hydroelectric dam does not borrow from the river's flow, and return the debt, in the way that the old mill does when the current is diverted through its narrow sluice. Its real work is accomplished even before its turbines begin to function. It consists, not just in the production of energy, but in the securing of its constant availability. The hydroelectric plant does not simply "make use" of the water that comes its way, or of the power it provides (a power that, like the other forces of nature, is as threatening as it is beneficial). Before it diverts the current's own energy to other uses, it has already made it into something else. It owes nothing, it *wants* to owe nothing, to the sky or the natural cycles of rainfall. It does not work *with* nature, with periods of plenty and of want, as the operator of the old mill was forced to do. Thanks to the hydroelectric dam, the rain and the river it supplies are entirely subjected to our purposes and needs; both become "supplies" in a different sense. We no longer think of them as being supplied *for* us, and need not be concerned about whether the supply will last, since we think of them now as something that is supplied by us (by the construction of the dam). Although we cannot make the rain fall (at least not yet), we can convert it into something that we can effectively harness—something that is "at our disposal" and that we can dispose of at will. Why?

Not for any particular purpose, but to ensure that we will *always* have electricity "on order," so that we are not at all dependent on the wind, the rain, or the seasons (or on whatever that order itself depends on).

The hydroelectric dam works to relieve us of our debt to something other than ourselves, of the sense that we as makers still owe our productions, our very lives, to something we do not make. What is true of the hydroelectric dam and the energy it provides is also true of us and the lives with which we are provided.

It is the same with the "mechanized food industry," and the system of travel (or efficient transport) that goes with it. While it promises to provide a greater supply of basic necessities, of the nourishment all human beings need to survive, it also makes it possible for us to enjoy any and all of the fruits of the earth, even out of season. Eating strawberries in the middle of winter may seem innocent enough, even to those who care deeply about feeding more of the world's people. But, there is something more that Heidegger wants us to see in the unlimited availability of things—that is, the profound difference that our *in*difference to the particularities of time and of place has made in our way of living.

"The field that the peasant formerly cultivated and set in order appears differently than it did when to set in order still meant to *take care of . . .*" What *is* the difference between the "maintenance" that Heidegger would associate with the craft of living, and the kind of "management" that he seems to associate with modern technology?[16] If what comes to appear through the cultivation of a garden is an order of things (of growth, flowering, and fruition, as well as death and decay), what kind of ordering is accomplished through modern technology? Not just a more efficient (or effective) way of ordering things, but one in which *everything* is "made to order," for use whenever, wherever, and however we want.

Heidegger speaks of coal that is "stockpiled." We might compare this to firewood that is collected and stacked. Both are "on call" for heat, are they not? To be sure (Heidegger would say), but firewood cannot be stockpiled indefinitely, not just because we may eventually run out (if natural production does not keep pace with the harvest) but because, if wood is to be made use of in this way it has to be seasoned properly, harvested at a certain time and kept (or "cured") for no more than two years. Beyond that time, it will be unfit for burning. The same is true of the storing of grain over the winter, or of the stock of vegetables kept in the root cellar. It will last only a certain amount of time—until the following spring, when that portion that has been kept in reserve for seed is planted for that season's harvest. It may not last, of course, if the previous season's harvest did not provide enough. But, neither will it last if we have provided ourselves with more than enough. It will go bad, if it goes unused.

The practice of Sloane's early Americans was to store meats and other perishable items in the eaves of their houses, where they would remain frozen through the winter; unless, of course, there was a thaw, which for them was akin to a power outage. Thanks to refrigeration and central

heating, we no longer have to live under these conditions. We cannot control the seasons, but we can control the heat and the cold. We can turn winter into summer and summer into winter (in our homes, at least). With the flick of a switch, we can turn night into day (not just in our homes but in the sky itself, as satellite images have helped us to see). What, then, is left for us to life *with*, if everything is at our disposal and we no longer see even the light of day as something that is provided to us?

It may look as if Heidegger is making too much of these differences; in fact, it is bound to look that way. From an instrumental point of view, horses and automobiles belong to the same order of things. Coal or oil is as "natural" a product as firewood, or hay and oats. They are all converted into raw energy, after all, whether it is the power plant producing kilowatts to run the refrigerator or the animal's metabolism burning calories to drive the farmer's plow. But, there is at least one social historian who sees what Heidegger sees—how profoundly this point of view has conditioned the way we see and understand almost everything. In *Reflections in Bollough's Pond: Economy and Ecosystem in New England*, Diana Muir argues that horses and automobiles do *not* reflect the same order of things. There is a difference in the way the sun's warmth is stored or "challenged forth" by each:

> Industrial revolution was a departure from old patterns of energy use. It marked a transition from the use of the product of *this year's* sunlight to the use of the product of fossil sunlight—from the use of wood and hay to the use of coal and petroleum as fuel and industrial feedstock. Industrial revolution was also a departure from old patterns of thought. The world before . . . was a world wherein wealth was understood to exist in constant volume. Wealth was a bag of gold, a field, a flock of sheep. If the rains failed in Cornwall forcing people living there to send gold or cattle to Essex to buy grain, then men in Essex were richer and men in Cornwall were poorer . . . Fossil fuels meant that wealth, like the energy supply, was susceptible to unlimited growth . . . From the dawn of history, the material basis of civilization had been immutable. Wood, clay, iron, flax: there might be innovations in their use, clever craftsmanship, such new techniques as pottery glaze or the combination of linen warp and woolen woof that produces linsey-woolsey, a fabric more durable than either parent. There might even be the discovery of a new thing—like the Chinese discovery of the technique of making fabric from the cocoon of the silk worm—but no craftsman could alter the nature of things. Alchemists and magicians might attempt to transform a base metal into gold, but no sane customer carried a barrel of mineral oil to an alchemist in the hope that it would be turned into silk or ivory. . . . [We now] routinely carry oil to the chemist and expect him to turn it into ivory or silk or their functional equivalent . . . Omnipotence, long an attribute of the divine, had become an attribute of humanity.[17]

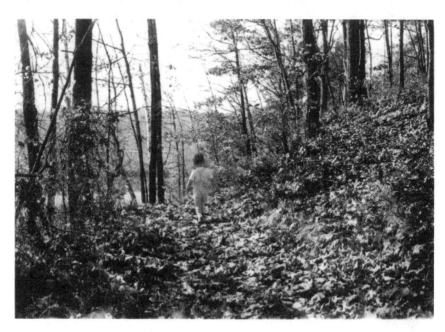

Plate 9 Woods near Concord, Massachusetts. Author's photo

CHAPTER NINE

Dwelling

[M]editative thinking does not just happen by itself any more than does calculative thinking. At times it requires a greater effort. It demands more practice. It is in need of even more delicate care than any other genuine craft. But it must also be able to bide its time, to await as does the farmer, whether the seed will come up and ripen.

—Martin Heidegger, "Memorial Address"

The "setting in order" Heidegger sees in the cultivation of the field reflects the order of a certain way of life—what he calls "dwelling." What Heidegger is invoking with this word is not a romantically fixed image of a life lived in historical costume or superficially defined by outward conformity to old-fashioned customs. It is what we have called the attitude of mortality. He does not just take us back in time, or encourage us to take leave of our historical situation, any more than Sloane does. Dwelling is not something that can be reproduced, like a piece of antique furniture, or restored in the way people often restore old houses. These activities *could* be performed in the service of dwelling, but not as a *means* to it. Even if the work were done by hand, it would still be a mechanical production—the "bringing about" of a more meaningful life. But dwelling is precisely that which cannot be brought about by us. Try as we might, it cannot be made to happen. Preservation, restoration, and recollection are essential for dwelling, just as they are essential for gardening. Gardening is a restoring, but the life that returns to the garden every spring is not something that we ourselves restored to it. As we have seen, the gardener does not bring the garden to life, or even keep it alive; she preserves and cultivates what comes to life in it—the life that emerges around and through her but not because of her. Gardening is a preserving, but it is not like keeping something in a jar. It is a recollecting, in the original sense of "gathering together again." Practiced in this way, it brings us back to life, such that, in the act of restoration, we ourselves are restored. In the same way, dwelling is not just an object of

remembrance (something we, or Heidegger, are trying to bring back). The restoring, preserving, and recollecting—all go on within it.

Dwelling, as Heidegger understands it, is a way of being *in time* and *among things*. Like Thoreau's walking, or the tea ceremony, or the woodworker's art, it is governed by, and exhibits, a certain form—a form whose impulse originally lies within life itself. The "order" it reflects is seasonal as well as regional. Like the grain of the wood, or the fall of the leaf, or the harmonies preserved in a musical chord, it permits of manifold variations. Dwelling is not just a passive "letting be" (as Heidegger is sometimes interpreted). Like craft, it is something we do, though it is not simply our own doing. In an essay entitled "Building, Dwelling, Thinking," Heidegger offers a sketch of what he calls the fourfold structure of dwelling:

Mortals dwell in that they save the earth . . . Saving does not only snatch something from a danger. To save really means to set something free into its presencing . . .

Mortals dwell in that they receive the sky as sky. They leave to the sun and moon their journey, to the stars their courses, to the seasons their blessing and their inclemency; they do not turn night into day nor day into a harassed unrest.

Mortals dwell in that they await the divinities as divinities . . . They wait for intimations of their coming and do not mistake the signs of their absence. They do not make their gods for themselves and do not worship idols. In the very depth of misfortune they wait for the weal that has been withdrawn.

Mortals dwell in that they initiate their own nature—their being capable of death as death—into the use and practice of this capacity, so that there may be a good death. To initiate mortals into the nature of death in no way means to make death, as empty Nothing, the goal. Nor does it mean to darken dwelling by blindly staring toward the end.

In saving the earth, in receiving the sky, in awaiting the divinities, in initiating mortals, dwelling occurs as the fourfold preservation of the fourfold. To spare and preserve means: to take under our care, to look after the fourfold in its presencing.[1]

What do we see when we compare the order of dwelling with the "ordering" that shapes our modern way of life? Rather than focus on the (apparent) simplicity of the past or the potentially harmful effect of modern technology, Heidegger would have us ask ourselves: *what has become* of clarity and darkness, of day and night, or the seasons of the year? Turning night into day, and summer into winter—this is precisely what electricity and air conditioning are good for. Or is there something more deeply disturbing about the kind of experience we now commonly enjoy: that *it really doesn't matter* whether it is night or day, summer or winter?

Perhaps it does matter that we now have more time at our disposal, that time itself has been brought under technological control. The way a sundial measures time is imprecise, to say the least, and utterly useless when it turns cloudy or after the sun has set. Clocks (themselves a very old, if not ancient, form of technology) allow for more accurate measurement of days, hours, minutes, and seconds regardless of the weather. Thanks to these and other devices, we no longer "mind" the weather in the way we once did. We no longer "receive the sky as sky" because we needn't rely on it. Apart from the severest conditions, it no longer makes much of a difference in and for our lives.

While we have become indifferent to the sky, one might still insist that time itself, and our ability to measure it, are hardly matters of indifference to us. If anything, we seem more concerned about it, more interested in keeping track of every second than ever. But, there is a profound indifference in the way that we now take the measure of time. It is not just that we care about accuracy, where the ancient Greeks marveled at the beauty of *kosmos* revealed. Related to this is the way in which time itself has been redefined. Counted among our modern technological discoveries is this: that the oscillations of a celsium–133 atom when subjected to microwave radiation, can be manipulated to allow for time calculations with an error of one second every 1.4 million years. We may be entirely unaware, when we set our watches, that while quartz vibrations can be affected by age and temperature, the oscillation frequency of a celsium atom remains unchanged forever. So why does this matter? What, after all, is a second, that we would not want to lose track of even one over the course of a million-and-a-half years?

A second is not what it used to be. With the invention of the atomic clock, the second was reinvented. In 1967, the inherent frequency of celsium atoms became the international unit of time (what is now called Universal Coordinated Time). But then, the atomic clock and the period of time it now defines is not just a more accurate, or efficient, version of Anaximander's sundial; it is not just a more precise instrument for recording what the sundial recorded. The atomic clock not only tells us how many seconds have elapsed, but it determines what a second *is*. By providing us with an absolute and universal grasp of "when" we are, it has *changed the meaning* of being in time. When a second becomes the period during which a manipulated atom oscillates precisely 9, 192, 631, 770 times, time itself ceases to be something that is given to us—in the way that it was when time was measured according to the movements of the earth, when a second was a fraction of a day. It is not just that we no longer look to the sky to tell the time. We have stolen it away. If we no longer leave to the sun and moon their journey, or to the stars their courses, it is not because we simply ignore them. If we no longer journey with them, it is because we have set them adrift by taking time unto ourselves.

In Heidegger's eyes, the replacement of "earth time" by atomic time is like the building of the hydroelectric dam. In taking the measure of time,

the sundial allows for the revelation of an order that is not made by us—an order that we can never measure precisely, but which, for that very reason, might better regulate our lives. The atomic clock takes the measure of time in the way that the hydroelectric dam takes the flowing current from the river and the sky. It takes it over. The order it takes is an order it makes.

This is what Heidegger sees in the ordering that shapes our modern way of life. Implicit in our desire and ability to keep track of time is the sense that it does *not* matter precisely because it is at our disposal. Time no longer matters in the same sense that the wood's grain or the river's current no longer matter, when matter itself is converted into something that can be manipulated at will or used for whatever purpose we choose. If day and night, and the seasons of the year, no longer provide the measure of our lives, it is not because we have replaced one measure with another. The reordering that is accomplished though modern technology is such that there *is* no "measure." There is only our own measuring. There are no limits that we have to work within, or live with. What we see, instead, are infinite possibilities.

The opening up of unlimited possibilities is what Heidegger sees as the essence of modern technology. This is something more fundamental, and more ominous, than the "instrumental" way of thinking with which we began. The price we pay for the depth of Heidegger's insight, however, is the difficulty involved in fully grasping his point. If modern technology is no longer a "bringing forth" (as *technē* was originally experienced), neither is it simply a "bringing about." It may look to us as if we are making things happen in a way that the ancient craftsman (or the peasant farmer) did not. Heidegger agrees—it *does* look this way. Modern technology is essentially different, but also the same as *technē*, in that it too is a way in which something reveals itself.

What is revealed in and through modern technology? Our absolute faith in science, one might say, or the sense of omnipotence to which Muir refers. The thought that, thanks to technology, we have become like gods—intended either as a warning or as a boast—is no longer the privileged insight of a few philosophers. It has become fairly commonplace. We seem not only to make our gods for ourselves, worshipping our own idols as we gaze at our computer screens, but to have made gods *of* ourselves, bowing to what we see as our own accomplishments.

Heidegger acknowledges this, but he also sees something more. In the way that we "use" it, he says, "the earth now reveals itself *as* a coal mining district," and nothing more; the soil *as* a mineral deposit, or a receptacle for whatever chemicals we choose to add to it, and nothing more. The field the peasant cultivated, and cared for, "appears differently" as (nothing but), what Heidegger calls, a "standing reserve." We no longer plant what will grow where it will grow and enjoy it in the fullness of time (to use a wonderfully old-fashioned expression), or when *its* time has come. When time itself ceases to be qualitatively measured—when "times" no longer carry any meaning, as they do when we speak of wintertime or summertime,

planting- or harvest-time—it becomes something purely quantitative. So, it is that we see ourselves as being able (or as needing) to manage time in the way that we manage money, or crops. The difference, as Heidegger sees it, between "agriculture" and "the mechanized food industry" is not that the latter uses mechanical devices or machines, while the former does not. If the modern farmer makes more than his pre-modern counterpart—if he *does* make the garden grow—it is because what he is making it out of has already been remade. The work of the peasant, Heidegger says, ". . . places the seed in the keeping of the forces of growth and watches over its increase." We alter the soil to yield more of what we want when we want it. We alter the genetic makeup of the crops we grow. Instead of "saving the earth," or "receiving the sky as sky," we build highways for trucks, and use airplanes to make everything we want available whenever and wherever we might want it.

The modern food industry is not the modern entertainment industry, of course. When it comes to food, much of what is (or could be) made available are things that people throughout the world desperately need. This is important work, and efficient systems of travel and communication help to support it. Without overlooking this morally significant point, one can still see a fundamental similarity between these two arenas in which modern technology holds sway. From Heidegger's point of view, the same thing is happening in all the areas of our lives where technology has made a difference—which is all the areas of our lives. The difference consists in this, that what we are making are not particular "things" (that we need or want). What we are "making" are possibilities. It is in this way, Heidegger thinks, that modern technology is also a revealing:

> The revealing that rules throughout modern technology has the character of a setting-upon, in the sense of a challenging-forth. That challenging happens in that the energy concealed in nature is unlocked, what is unlocked is transformed, what is transformed is stored up, what is stored up is, in turn, distributed, and what is distributed is switched about ever anew . . . Unlocking, transforming, storing, distributing, and switching about are ways of revealing.[2]

It is not just strawberries in winter that modern technology makes available to us. It is "availability" as such—the availability of . . . anything. We may look to technology to provide the necessities as well as the "good things" of life; but technology as such does not make for a *better* life. What Heidegger sees in the development of modern technology—what it essentially provides—is *more* of *whatever* we might need or want, faster and more efficiently. Not only can we live longer and do more, have more things and go more places, even listen to more music and see more works of art than we could when our possibilities were more limited, like the peasant farmer whose dwelling is locally and seasonally circumscribed. Technology makes it possible to have and do things that we are not yet aware of

ourselves as needing or wanting (the latest computer "upgrade" is a telling indication of this). By securing a standing reserve, technology does not just provide us with enough; it does not make for a satisfying life even in an ordinary sense. To provide a standing reserve is to ensure that there will *always* be *more* than enough. To live with this kind of security is to think that only more than enough is enough.

The result, Heidegger thinks, is that *nature as a whole*—reality itself—*now reveals itself as something that is "made to order,"* available on demand.[3] What we see, when we look at the world around us is not what the Greeks saw in the well-made thing or what Thoreau sees in the woods. What we see is an infinite array of possibilities as wood, water, and sunlight are converted into energy, which can then be converted into virtually anything or "switched about ever anew." This transformation is exhibited not only by nature (as modern physics envisions it), but by life itself. Even when we think that we are opting out of our technological way of life—when we take a vacation, looking to nature, or art, as an opportunity for recreation—this becomes just another resource, like energy, which we expect to have "on demand." Whether or not we employ technological means to accomplish it (by traveling to some remote wilderness, installing the latest composting toilet, or downloading art off the web)—whether we resort to some humble village on the weekends or choose to retire there permanently—it presents itself as one of an unlimited range of options at our disposal. In ridding our life of switches, we have really just flicked another switch—one we could always switch back. This is what Heidegger is trying to help us to see, when he observes,

> Everywhere everything is ordered to stand by, to be immediately at hand, indeed to stand there just so that it may be on call for a further ordering. Whatever is ordered about in this way has its own standing. We call it the standing-reserve. The word . . . designates nothing less than the way in which everything presences that is wrought upon by the challenging revealing. Whatever stands by in the sense of standing-reserve no longer stands over against us as object. Yet an airliner that stands on the runway is surely an object. Certainly. We can represent the machine so. But then it conceals itself as to what and how it is. Revealed, it stands on the taxi strip only as standing reserve, inasmuch as it is ordered to ensure the possibility of transportation. For this it must be in its whole structure and in every one of its constituent parts, on call . . . ready for takeoff.[4]

What is true of airplanes might also be true of paintings, Heidegger suggests, and even of the most pristine forest. However well-made or beautiful they may be, they no longer stand before us as *particular* beings we can engage with or as occasions for the kind of connected experience we have been discussing throughout this book. The important difference between Ann Newbury's bowl and a styrofoam cup is not just that the former is made of

natural materials and is handcrafted, while the latter is composed of synthetic stuff and is mass-produced. There is a more fundamental difference. Drawn from the standing reserve, the styrofoam cup is essentially at our disposal; as such, it is also essentially disposable. One will do just as well as another, which is why we find it so easy to crumple them up and throw them away. Our tendency to litter the world with such things is not just thoughtlessness on our part, or environmental irresponsibility. The thoughtlessness and irresponsibility are already there, Heidegger would say, in the "presencing" of these things.

What Heidegger sees on the runway, as well as in museums and forests, is not even an "object." Reduced to the status of standing reserve, it stands before us, not as a particular being (something that *is*) but as a pure possibility (something that *might be*). The styrofoam cup is nothing but a reservoir for drink; the being of any one is entirely on a par with, and can be substituted for, the being of any other. The same is true of nature and of art—when the river's current is converted into energy or the work of art is reduced to a free-floating image (like the shadows on the wall of Plato's cave) that can be stored in a database, made available for research, in the same way that the river becomes a resource for recreation. As Heidegger sees it, this is not just a difference in the way we treat these things. In the way that they are allowed to present themselves, it makes a difference in their very being.

★ ★ ★

If this is the way reality reveals itself to us, why is it a "danger," as Heidegger suggests? Not simply because it is threatening to the environment, or because atomic energy can be put to destructive as well as peaceful use. If even the natural environment allows itself to be seen in this way, as Heidegger seems to admit, in what sense is it a threat? The craftsman may allow the "stoniness" of the stone to appear, but doesn't the geologist tell us what the stone really is? And if the geologist's analyses allow the stone to be used in various ways for various purposes, doesn't this *also* set nature free by unlocking its secrets, even as it sets us free?

Perhaps, but there is a question that remains to be asked (a question it never occurs to us to ask, because the answer seems so obvious):

Who accomplishes the challenging setting-upon through which what we call the real is revealed as standing-reserve? Obviously, man . . . But man does not have control over unconcealment itself, in which at any given time the real shows itself or withdraws . . . Only to the extent that man . . . is already challenged to exploit the energies of nature can this ordering revealing happen. If man is challenged, ordered, to do this, then does not man himself belong even more originally than nature within the standing-reserve? The current talk about "human resources," about the "supply" of patients for a clinic, gives evidence of this. The forester

who, in the wood, measures the felled timber and to all appearances
walks the same forest path in the same way as did his grandfather is
today commanded by profit-making in the lumber industry, whether
he knows it or not. He is made subordinate to the orderability of
cellulose, which for its part is challenged forth by the need for paper,
which is then delivered to newspapers and illustrated magazines. The lat-
ter, in their turn, set public opinion to swallowing what is printed, so that
a set configuration of opinion becomes available on demand . . . Since
man drives technology forward, he takes part in ordering as a way of
revealing. But the unconcealment itself, within which ordering
unfolds, is never a human handiwork, any more than is the realm
through which man is already passing every time he as a subject relates
to an object . . . Modern technology as an ordering revealing is, then,
no merely human doing. (Pp. 18–19)

How could all of this ordering and securing be anything but our own
doing? If nature is on call as a resource, who but us could be doing the call-
ing? If we choose to see things in this way, are we not equally free to choose
another way of seeing? Or are *we* on call—*ordered into* the standing reserve?

Heidegger's examples should make us think twice. If the Rhine now
appears differently, how has being human come to reveal itself? There is
more than one sense in which we ourselves are made to order. What
Heidegger says about newspapers and magazines should remind us of the
many catalogs that are sent to us, advertising the clothing and equipment
that we supposedly need for our wilderness excursions, and that we can so
easily order-up. But then, even as we embark on those excursions, aren't we
"commanded by profit-making," supplying an industry every bit as much as
the trees out of which those catalogs are made? Even as we flick our
switches on and off, we ourselves are switched. We might still want to make
an exception of ourselves and insist that, unlike the trees we are the ones
making the choice. We are still in control. And if all that clothing and equip-
ment *does* help to bring us closer to nature—in the same way that possibil-
ities for travel can bring us closer to art—what is wrong with thinking that
all of this "ordering" is setting us free?

Gestell, or "enframing," is the word Heidegger uses to describe the kind
of ordering that characterizes our modern way of life. *Gestell* is a perfectly
ordinary (German) word. It has a variety of meanings, but generally refers
to any sort of mechanical framework, or system, like a bicycle or ski rack, or
a system of shelving (it is also the word for "skeleton"). What is Heidegger
getting at, when he uses a word like this to describe our modern way of life?
What he is getting at is what we see all around us—all of the systems, or
"networks," that we depend on, or (more and more often) find ourselves
entangled in. The examples are innumerable: the energy grid, networks for
travel and communication, our system of highways or of routes and
schedules for air and train travel, the internet and other "operating systems,"
voice mail, systems for storing, retrieving, and channeling information,

administrative systems for processing decisions, registering for courses, or registering one's car, and so on. Even a simple form (like those students use to evaluate their professors, or professors use to apply for grants), or a not-so-simple form (like a tax form), or any other "format" for preparing a document, constitutes a framework of the sort Heidegger has in mind.

What Heidegger really has in mind, however, is not any one of these systems or networks, or even all of them put together, but the overall system—the framework of life and thought—of which they themselves are "constituent parts." Heidegger's concern lies not just with how many of these systems we now have to contend with, or the extent to which they affect our lives; he is trying to help us to see how our *overall conception of reality*—of nature as a network of forces whose functioning we can predict and control—is itself an instance of enframing. It is not just the way we work the land that has become mechanized; it is the way we think. The operating system that drives our computers is but a reflection of the way we ourselves operate.

We may be the operators of each of these systems; but, the overall system of life and thought is something none of us runs. It is something of which we ourselves are "constituent parts." Everything we do (even going to the mountains for a vacation) takes place within the enframing of which Heidegger speaks.[5] We talk about how important it is to be networked. Why *is* that? Because it enables us to get things done, all the things that are supposed to make modern life so much better. But, what we are only beginning to realize is that our entire way of life is itself *already* networked. Enframing is not a human accomplishment. Our modern way of thinking—not only about nature, but what it means to be human—is trapped within the frameworks it sets up. Now we can see why this might also be true about our modern way of *being*:

> Where do we find ourselves brought to, if we now think one step further regarding what Enframing itself actually is? It is nothing technological, nothing on the order of a [particular] machine. It is the way in which the real reveals itself as standing-reserve. Again we ask: Does this revealing happen somewhere beyond all human doing? No. But neither does it happen exclusively *in* man, or decisively *through* man . . . As the one who is challenged forth in this way, man stands *within* the essential realm of Enframing. He can never take up a relationship to it only subsequently. Thus the question as to how we are to *arrive* at a relationship to the essence of technology, asked in this way, always comes too late. But never too late comes the question as to whether we actually experience ourselves as the ones whose activities everywhere, public and private, are challenged forth by Enframing.[6]

What does Heidegger mean when he says that the question of how we are to arrive at a relationship to technology "always comes too late?" Was this not the *point* of his essay, after all (of this tortuous walk in the woods)?

Or have we come to see something that we could not have foreseen at the outset? Heidegger could mean that technology is "here to stay." But in what sense? In such a way that it is too late to ask what we can do about it, how we are going to control it or put it in its place. That would not be "saying no" to technology. It could only be a further technological gesture, a reassertion of our technological way of thinking—of the idea that everything can be controlled by us, including technology itself. There is no question of our freeing ourselves from this. But if it is too late to ask *that* question, Heidegger says, it is not too late to ask whether we actually *experience* ourselves as standing within this realm. Answering a question, Heidegger suggests, is not necessarily the same as solving a problem. It may come as a form of response.

What would this experience involve, and what kind of response might it allow for? It is tempting to think that our way of life is freer than that of the peasant farmer, so free that we can enjoy the benefits of technology to the extent that we choose to, maybe even choosing to return to his way of life (after work, on weekends, or altogether). But *is* that freedom, having unlimited possibilities at our disposal (even the possibility of renouncing the possibilities technology opens up)? "The essence of freedom," Heidegger suggests, "is originally not connected with the will or . . . the causality of human willing," but rather:

> Freedom governs the open in the sense of the cleared and lighted up, i.e., of the revealed. It is to the happening of revealing, i.e., of truth, that freedom stands in the closest and most intimate kinship. All revealing belongs with a harboring and a concealing. But that which frees—the mystery—is concealed and always concealing itself. All revealing comes out of the open, goes into the open, and brings into the open. The freedom of the open consists neither in unfettered arbitrariness nor in the constraint of mere laws. Freedom is that which conceals in a way that opens to light, in whose clearing there shimmers that veil that covers what comes to presence . . . and lets the veil appear as what veils. (P. 25)

If we tried to "explicate" this passage, to analyze or conceptualize what Heidegger was getting at, we would find it difficult to say the least. But, this is not how one arrives at the meaning of Heidegger's text in any case. His language resists our efforts to gain access to it in this way. Such writing wants not to be explicated, but to be contemplated. The meaning of these words has to be "seen" in the sense in which we have been discussing it throughout this book—theoretically, but not in an analytic or purely conceptual way. To see what Heidegger is talking about, one must picture his thought, interpret it experientially and concretely. The kind of work that Heidegger's language invites, or perhaps even forces us to do is part of the experience through which the meaning of his words becomes clear. When we take this into account, we may find that what he is getting at is actually

quite simple—though it may not be easy. We may find that "that which conceals in a way that opens to light" is, and always has been, more present to us than we realized.

Freedom cannot be the opening up of unlimited possibilities—total control, unrestrained choice, or the complete technological mastery of nature and of ourselves; nor is it the same as having unrestricted access to things (like truth, or the meanings of words). Why not? Not because we cannot achieve this (we have already come dangerously close), or because choice must always be tempered by responsibility. Reading this passage, we should picture ourselves as having arrived at a forest clearing, as having found our way there, guided by the path (of thinking) that we have been following for so long. *This*—the clearing created by the "shimmering veil" of the surrounding forest—is what conceals in a way that opens to light. It is not our own doing. We have not just located it on a map; nor are we looking down at, or examining, it from the detached point of view we usually associate with objective thought. We do not simply find ourselves at it. We find ourselves *within* it, drawn there by a walking that is also a thinking, or a thinking that is also a walking.

And what do we find? What is there to see? That openness presupposes concealment, and that revelation presupposes hiddenness. Not in the merely logical sense that to have (an idea of) light one must also have (an idea of) darkness. This is not what Heidegger has in mind when he stands in his clearing. What he has in mind is what we ourselves might experience on our walks in the woods—that what is open or revealed presupposes mystery, or that which conceals, *as its source*. Whatever is made visible to us must have emerged from out of the forest. It is thanks to the darkness, then, that we are now able to see it. The mystery, "that which conceals," is not an obstacle to truth, functioning like barrier that seals it from view. As a concealing, it is also a harboring or a sheltering. It allows for the emergence of whatever comes to stand within it. The same is true of the light and the darkness themselves. It is not just the former that allows us to see or move freely. The light that enters the clearing is a light that the forest lets in. It in turn illuminates the surrounding forest, not by making visible all that remains hidden in and by it, but by the depths of the shadows it casts. This is how what is concealed is also always concealing itself. This concealment is not simply the opposite of a revealing, any more than the forest that encompasses the clearing is the opposite of the clearing itself. It opens in such a way that in seeing what is clear we also experience what is not. What comes to presence, in the clearing, *lets* the veil *appear* "as what veils."

This is what we saw in Plato's cave. The sun, Socrates suggests, is the source of all that is visible. It is the source of visibility itself, of truth. The sunlight does not come from within the cave, to be sure, anymore than the light that enters the clearing (and is filtered through the surrounding trees) comes from the forest. But neither does it come from the clearing. The clearing *opens* to light. What stands within this light is made visible and clear. This making visible is not just our own doing, nor are we simply witness to it. It

is our walking that brought us here. But then, it is not just simply the light's doing, any more than it is ours. The sunlight enters the clearing as we do when we emerge from the forest. Both issue from a further source—what Heidegger calls "the mystery." The sun itself, after all, is not illuminated by the light that comes from it. While the sun makes other things clear, it itself is not one of those things. As Socrates reminds us, the sun itself is the hardest of all things to see clearly. It remains concealed in its absolute brightness. As the source of all that comes to presence, it too is always concealing itself.

It is the clearing that allows for the emergence of whatever comes to stand within it. But then, we must also appreciate the sense in which we ourselves come to stand within it. If truth happens only in the clearing, "that which conceals in a way that opens to light," then freedom presupposes not open space, but a sense of place, not infinite possibilities and choices but meaningful possibilities from which to choose. We pictured the peasant farmer as dwelling in a certain region by which his way of life is defined or circumscribed (planting what will grow where and when the soil and the seasons permit). To say about a way of life that it is defined is not to say that it is predetermined, that its richness can be reduced to a simple formula, like a job description, or that one's role in life is assigned in the way that homework is assigned. It is to say something that would seem to be true of any human life even if we tend (or want) to forget it: that it is finite. To live a life that is defined in this way is to be mortal.

Heidegger wants us to picture ourselves following a path through a dense forest. We tend to think, however, that complete freedom would be not having to follow any path. It would consist in our being able to go anywhere by whatever route, to do anything in whatever way, to take any direction we chose to take, to be able to reach any and all places with a minimum of time and effort and with unlimited speed. It would be to *pave over* the forest, to remove all obstacles to progress, in the same way that cutting down the trees would remove all obstacles to knowledge and thought by "making it all clear."

Would that be freedom? What would it be like? To be able to go anywhere and everywhere is really to *be* nowhere. In a world that was completely paved over, a world in which there were no paths we had to follow, in which all points were immediately accessible, a world of equally available space and potentially unlimited time—there would no "where" or "when," no place in particular to go, and no particular time for doing so. With no paths from which to choose, there could be no sense of direction at all. There are no "points" in an open expanse of pavement, just as there could be no point in choosing one course rather than another. A world of infinite possibilities, a world in which anything *can* be, is a world devoid of actuality—a world in which nothing really *is*.

To pave over the forest . . . this is something we are perfectly capable of doing. In fact, we have largely succeeded in doing it. Ours has become a world of "virtual" realities in more or less obvious ways. The success of these efforts has reinforced the idea that this is what freedom consists in. But is

freedom really the opposite of having limits? There is a kind of limit, Heidegger suggests, that "gives bounds." These bounds are not obstacles or constraints, nor are they mere limitations:

> With [these] bounds the thing does not stop; rather from out of them it begins to be what . . . it will be. That which gives bounds, that which completes, in this sense is called in Greek *telos*, which is all too often translated as "aim" or "purpose," and so misinterpreted. (P. 8)

We should think, here, of the mature form—the fully "enmattered" form—of a plant. Reaching the natural limits of its growth, its foliage is dense and its abundant bloom stands ready to yield fruit. This is what its growth seems to have been aiming at (what the garden as well as the gardener look forward to). To achieve this is not to arrive at a stopping place, however. In completing itself, the plant has just begun to *be* what it is. Its life has not come to halt at the point of fullest flowering. It is still growing, even if it is not getting any bigger. In reproducing, even in withering and dying, it continues, as Heidegger might say, "on its way into arrival."

<p style="text-align:center">★　★　★</p>

Now, we should be thinking about our own lives. What Heidegger helps us to see is not that our freedom must always be limited in the sense of having limits placed upon it. The point is not that, if we want to live longer and healthier lives, we must eat less and give up smoking (though that may be true). Heidegger's point is that there is a kind of limit without which freedom is impossible—the kind of bounds that "open the space" for a finite range of meaningful possibilities, in the way that the clearing does. These are like the bounds within which the craftsman must work when he works with the grain of the wood to create something that is beautiful as well as useful, the kind of tool or implement that functions not only as a means to an end but as a revelatory and transformative extension of ourselves. Only within such bounds can a truly creative life be lived.

Then, there is the kind of freedom that technology is supposed to offer us—the seemingly infinite possibilities that our networks and operating systems open up. Included among these is the idea that we are free to enjoy the benefits of technology to the extent that we choose to, that even this possibility—of renouncing the possibilities technology creates—is at our disposal, maintained as standing reserve. What Heidegger helps us to see is that in giving us total control over our own destiny, the unlimited possibilities that our modern way of thinking opens up have given rise to a way of *being* that is *not at all free.*[7] And yet . . .

> These sentences express something different from the talk we hear more frequently, to the effect that technology is the fate of our age, where "fate" means the inevitableness of an unalterable course . . . [W]hen

we consider the essence of technology, then we experience enframing as a destining . . . a destining that in no way confines us to a stultified compulsion to push on blindly with technology or, what comes to the same thing, to rebel helplessly against it as the work of the devil. Quite to the contrary, when we once open ourselves expressly to the essence of technology, we find ourselves unexpectedly taken into a freeing claim.[8]

Once we have experienced what modern technology is all about, that it is not just the vast collection of technological devices by which our every-day lives have come to be shaped, we will understand why there can be no question of our freeing ourselves from an essentially technological way of thinking. Then, and *only* then, can we see that a liberating response might still be possible. To "open ourselves to the essence of technology" is to acknowledge not just the extent, but also the depth of our enslavement. Heidegger has been saying repeatedly that we ourselves are "claimed" not just by our machines, but by our technological way of thinking—that our whole way of life is ordered by it. So what is this "freeing claim" that we are now "unexpectedly taken into?"

Technology is a danger, Heidegger says, of the profoundest sort. The danger consists not just in the very real possibility that we could destroy ourselves; it is all the more dangerous in that it threatens our ability to see beyond ourselves:

The threat to man does not come in the first instance from the poten-tially lethal machines and apparatus of technology. The actual threat has already affected man in his essence. The rule of enframing threatens man with the possibility that it could be denied to him to enter into a more original revealing and hence to experience the call of a more primal truth. (P. 28)

Here, at this point, is where philosophy must turn to poetry. Heidegger quotes Hölderlin:

But where the danger is, grows
The saving power also. (P. 28)

What is the "saving power" that takes root in the danger itself? It is not something we can help ourselves to, Heidegger insists, or that we can make happen. It is not a solution in that sense. It is something we must be "taken into." That will only happen if we allow ourselves to experience the danger for what it is. The real crisis, Heidegger suggests, is that in our unquestion-ing preoccupation with technology, we *don't* yet experience it. But then, the kind of questioning that is called for is not a matter of problem-solving. It is more a matter of salvation—of being saved than of calculating or solving.

How *can* the problem itself save us if the only liberating response to our current situation seems to be blocked, as Heidegger also suggests? There would seem to be no room within our modern way of thinking for the idea that reality must, on some level, reveal itself to us—the idea that originally lies behind all art and craft, all science and philosophy. We can no longer see how truth might have its source in what remains concealed, just as we can no longer conceive of freedom as having its source in a certain kind of limit. If nature is to be known by us, it must be forced to give up its secrets. What is concealed has to be "challenged" to be made clear. Even if we do become insecure about technology, and the hold it has over us, we can only see one way to respond—by making ourselves safe from it. Either way, we assume that it must be up to us, that it has to be our own doing. This makes us blind to the possibility that something might be granted to us.

But then, there is this hope, as Heidegger expresses it:

> Challenging is anything but a granting. So it seems, so long as we do not notice that the challenging-forth into the ordering of the real as standing-reserve still remains a destining that starts man upon a way of revealing. As this destining, the coming to presence of technology gives man entry into That which, of himself, he can neither invent nor in any way make. (P. 31)

What *is* "That" (*Solches*)? (What moves Heidegger himself to capitalize it, but also to refrain from giving it a name?) Here, in what remains concealed, is where the saving power takes root. If there is no question of our freeing ourselves from an essentially technological way of thinking and being, we might still be set free. By what? What kind of experience could open our eyes to the "primal truth" that not everything is under our control? In what way could nature, including our own human nature, still reveal itself as something other than standing reserve? *Only when we experience the kind of control that technology has over us, only then might we see that not everything is under our control.* This is the liberating claim, but is not a claim we make. It is a claim that is made upon us. What could possibly remind us that the work of being human is not entirely our own doing? Is there anything left that we cannot be masters and possessors of? Nothing, perhaps, except technology itself. The very thing to which we owe thanks, for the control we think we have over our lives, is the only thing we might now have to thank for reminding us that not everything is under our control.

★ ★ ★

Where would this realization, which is more like a revelation than a discovery we make or a conclusion we arrive at, leave us? How could we live with it?

Consider how we might live without it. Faced with an uncertain world, we can try to be sure of ourselves. We can try to lay hold of that which is certain. We can develop a scientific method that makes us masters and

possessors of nature. This makes us even more sure of ourselves, not just theoretically but practically. We can make sense of things in such a way that we are both philosophically and materially secure. If we were once moved to wonder, now we can make it all clear. We can make ourselves safe and comfortable. We can even make . . . ourselves, now that we have arrived at the point where human form may *be* a product of human decisions, something that is, or can be, "our own doing." [9]

So far, so good (we might think). But then, Heidegger moves us, once again, to wonder:

> As soon as what is unconcealed no longer concerns man even as object, but does so, rather, exclusively as standing-reserve, and man in the midst of objectlessness is nothing but the orderer of the standing-reserve, then he comes to the very brink of a precipitous fall; that is, he comes to the point where he himself will have to be taken as standing-reserve. Meanwhile man, precisely as the one so threatened, exalts himself to the posture of lord of the earth. In this way the impression comes to prevail that everything man encounters exists only insofar as it is his construct. This illusion gives rise in turn to one final delusion: It seems as though man everywhere and always encounters only himself . . . *In truth, however, precisely nowhere does man today any longer encounter himself, i.e., his essence.* Man . . . does not apprehend enframing as a claim . . . he fails to see himself as the one spoken to, and hence also fails to hear in what respect he exists, from out of his essence, in the realm of exhortation or address, and thus can *never* encounter only himself.[10]

In what way do we exist from out of our essence? In what sense are we "called forth," and not just brought about? Could it be that the only thing that might really make us sure of ourselves is the same thing that prevents us from ever being absolutely sure of ourselves?

We are born and we die. The fact that we must die is what reminds us that our life (that life itself) is not our own doing—not something we own, or is owed to us, or even that we have a right to—but something that is granted to us. It may look as if death is what robs us of life. But, in truth, it does the opposite. Your own death, like your own birth, is what ultimately makes your life *your life*—what ultimately makes it your own, or makes you . . . you. But neither your birth nor your death is your own doing.

This is what Heidegger means when he talks about *us* as becoming part of the standing reserve. Nature is a resource—something that is at our disposal. But then, we ourselves become resources, human resources, in that we too are disposable, replaceable, or interchangeable. Many things seem to distinguish us as individuals. We each have our distinct talents and abilities, our separate backgrounds or callings, our personal style (as we sometimes like to call it). But, none of that ultimately distinguishes one life from another. You are not the only person who can do your job. You are certainly not the only person who can wear your clothes. Almost anyone could do most of what you do. But no one else can die your death. Only you can do that.

If anything makes us "insecure," it is the prospect of death. How do we respond to this—to our own mortality or finitude, the fundamental uncertainty or sheer contingency of human (indeed, of all) existence? We try to defeat it. In the face of the insecurity that makes us human, we try to make our lives as secure as possible.[11] There are obvious ways in which we try to make ourselves live forever (stem cell research is just one outstanding example). But, our attempts to overcome our mortality and to live "indefinitely," or without limit, also assume less obvious forms. The fact that one is finite and embodied means that one is *here*, in this place (which, in the authors' case, happens to be Worcester, Massachusetts) and at this time (late winter), and not someplace else—in Paris, let us say. The domain of one's existence is limited, like the farmer's. But now, we can extend that domain without limit. All we need to do is log on and, for all intents and purposes— the only ones that really seem to matter—we *are* in Paris. Our advances in travel and communication are but so many ways in which we try to conquer time and space, overcome our finitude, and defeat death (while forgetting that we have bodies).

What are we doing? We are defeating the very prospect that, by reminding us of our fundamental insecurity, can also reassure us that our life is our own. It is our mortality, after all, that makes us sure of ourselves as *human* beings, where this means being creatures as well as creators. But then, when we attempt to make our lives secure in the way that modern technology makes possible, so that what Heidegger calls "the mystery" is effectively (and efficiently) eclipsed, we end up doing the opposite. Perhaps, this is why technology has not made us any less anxious than we seem to have been when we enjoyed fewer of the benefits it now provides (thought certain diseases are less common, depression seem to be more so). The anxiety that drives technology is, in reality, an anxiety to which it gives rise. By ridding us of death, it threatens to rob us of life. It is no accident that despite the power and freedom technology seems to offer each of us (everyone has his or her own webpage, after all), it invariably threatens both genuine community and true individuality. To have an unlimited range of choices under one's control is to live a life that is ultimately just another possibility, while a community that knows no bounds is like an empty parking lot.

When we experience this, another possibility opens itself up to us—a different way of responding to the uncertainty of life. If a need for greater security than life itself affords is all that is really keeping us from "going back," a way of living that accepted our fundamental insecurity might actually constitute a way of moving forward. It would be a moving forward into dwelling, a restoring of the bounds that make a "complete" life possible. Our inability to dwell—to view reality with loving acceptance and with gratitude—is rooted in the difficulty we have accepting ourselves as the mortals that we are. The problem is that we are unwilling to die. Our mortality is something we have—really all that we have—to work with. We may yet be able to do this, but only if we are willing to practice it as a craft.

Plate 10 Robert Motherwell, *Beside the Sea #34*, oil on paper, 1962 (The Art Institute of Chicago). Courtesy of The Art Institute of Chicago

"Not diverse from things": Emersonian Materialism

He is the truest artist whose life is his material—every stroke of the chisel must enter his own flesh and bone, and not grate dully on marble.

—Thoreau, *Journals*, June 1840

The true poem is not that which the public read. There is always a poem not printed on paper, coincident with the production of this, stereotyped in the poet's life. It is *what he has become through his work.* Not how is the idea expressed in stone, or on canvass or paper, is the question, but how far it has obtained form and expression in the life of the artist.

—Thoreau, *A Week on the Concord and Merrimack Rivers*

What you ultimately hope for is that you will end up with a canvas that is no less beautiful than the empty canvas was to begin with.

—Robert Motherwell, *Storming the Citadel*

It is often said that the problem with our culture is that it is too materialistic. We may be surprised, then, to hear a philosopher like Heidegger emphasize the importance of "things" when he talks about what it means to dwell. From Socrates onward, we are accustomed to picturing philosophers (and even philosophy itself) as keeping their distance from material things. Platonists are notorious for treating the particulars with disrespect. But Plato, the writer of dialogues, is not a Platonist; nor is Heidegger. Dwelling is not an abstract idea that we somehow inhabit. It is something we inhabit in the full sense of the word—*habitually,* through our actual engagement with the world and with each other. By receiving the sky and initiating mortals, dwelling brings us closer to God, but not by separating us from the earth.

Dwelling is a contemplative activity—a way of seeing that is also a way of being. To live contemplatively, in this sense, is to live philosophically. But it is not a withdrawal from material reality, or a notional retreat into what is essentially a state-of-mind. What distinguishes dwelling, as a preserving, from a technological way of life is that it is not indifferent to things. It is not just intimately related to craft, as Heidegger pictures it; it is itself a craft:

> How do mortals makes their dwelling such a preserving? Mortals would never be capable of it if dwelling were merely a staying on earth under the sky, before the divinities, among mortals. Rather, dwelling itself is always a *staying with things*. Dwelling, as preserving, keeps the fourfold in that with which mortals stay: in things. Staying with things, however, is not merely something attached to this fourfold preserving as a fifth something. On the contrary: staying with things is the *only* way in which the . . . stay within the fourfold is accomplished at any time in simple unity. Dwelling preserves the fourfold by bringing the presencing of the fourfold into things. But things themselves secure the fourfold only when they themselves *as* things are let be in their presencing. How is this done? In this way, that mortals nurse and nurture the things that grow, and specially construct things that do not grow.[1] (Emphasis added)

How *is* this done? "That mortals nurse and nurture the things that grow, and . . . construct things that do not grow." It would seem that dwelling might be accomplished in either of these ways. What we have come to realize, however, is that these are not two separate ways, but are fundamentally the same. Of course, we can and generally do conceive of them as different. In Heidegger's view, while both are essentially human activities, kinds of making that make us human, neither is entirely our own doing.

Dwelling, we said, is a way of seeing that is also a way of being, one that is "complete" in a sense that we only began to discuss in the last chapter. What does it take to live a complete life? According to Pieper, it requires leisure, where leisure is seen, not as "free time"—the kind which, precisely because it is filled with an unlimited range of possibilities, is actually filled with nothing—but as the occasion for activities that are meaningful in themselves. To engage in such activities, we need, not just open time, but open eyes. But, there is something more that we need—something to draw on as a source. To see leisure as an "occasion" for something, to practice it in this way, is not just to see it as a date on the calendar, however regularly we observe it. To look at or observe things seasonally, one needs actual seasons. In the same way, leisure requires something that provides the occasion not for instrumental thinking or action, where we wonder what we might use it for, but rather something that invites us to wonder about . . . *it*. To engage in an activity that is meaningful in itself, we need something that we can regard as an end in itself, something that is worthy of contemplation, that enables us to stop demanding more than enough and to say "enough is enough." That is,

something that offers us the one possibility that a technological way of life might actually deny us—contentment, or human fulfillment.

What could this "something" be? Nature, Heidegger suggests—and art. But then, the question remains: can nature or art still show us what it means to live a fully human life? Can they help us to realize this? Or is there nothing that it really means to be human?

Some would argue that what seemed so natural to the Greeks (what Heidegger claims to see, when looks to the source) is really just another construction, that it was made-up, even for them. Heidegger would question why *that* thought seems so "natural" *to us*. The idea that there is nothing that it really means to live a fully human life—how is it that such an idea has become so readily available, that we can so easily call it up almost as if it were now part of the standing reserve of thought? Is this something we have discovered, or is it just another product of the way of seeing and thinking by which we are consumed?

This is the danger Heidegger spoke of: that all things, works of art as well as nature, now belong to the standing reserve. Only thus do we find or experience them: as instruments of representation, vehicles for the expression of political opinion, carriers of cultural information, or (more and more frequently) as converted into digital images, audio as well as visual, that can be stored in a database and "switched about ever anew." Whether they are viewed as material for historical research, or as a matter of enjoyment, the very things to which Heidegger points as a source of our salvation have been relegated to the status of a resource. But then, they take us along with them. What we see at the very end of Heidegger's essay is a possibility we have to take seriously; namely, that the promise of the saving power may be irreversibly eclipsed:

> The coming to presence of technology threatens [us] with the possibility that all revealing will be consumed in ordering and that everything will present itself only in the unconcealedness of standing reserve. Human activity can never directly counter this danger. Human achievement alone can never banish it . . . But might there not perhaps be a more primally granted revealing that could bring the saving power into its first shining forth in the midst of the danger, a revealing that in the techno-logical age rather conceals than shows itself? There was a time when it was not technology alone that bore the name *technē* . . . Once there was a time when the bringing-forth of the true into the beautiful was called *technē*. And the *poiēsis* of the fine arts also was called *technē* . . . Could it be that the [fine arts] may expressly foster the growth of the saving power, may awaken and found anew our look into that which grants and our trust in it? Whether art may be granted this highest possibility of its essence in the midst of the extreme danger, no one can tell.[2]

Art may yet save us. But who will save art? The particular way in which the arts may "foster the growth of the saving power" is essential; that is, by

awakening our *look into that which grants*, and our *trust* in it. What art may or may not awaken us to is a revealing in which we participate, even if it is not our accomplishment. And yet, this is a revealing that, in the modern age, "rather conceals than shows itself." How, then, are we to respond to it, if it is destined to remain so deeply hidden? Have we just missed our chance to see?

<div align="center">★ ★ ★</div>

The idea that modern culture is too materialistic is also correct, in Heidegger's sense. The truth, however, is not that we care too much about things. It is that we do not care enough about them; or rather, that we do not really *care* about them at all. It is certainly the case that we expect, and are able, to own more (and more kinds) of things than, say, Thoreau or his contemporaries. Industrialization, mass production, more efficient transportation (not to mention mass marketing) have both fueled this desire and provided for its satisfaction. Even if we cannot afford everything we want, more and more things are placed at our disposal every day. But, the materialism from which we suffer cannot simply be identified with our rampant consumerism, or the way we deal with things on this superficial level. It comes into play on a much deeper level. Heidegger suggests that when we see things as part of the standing reserve, when everything is reduced to possibilities for use, then we no longer see them *as things* (in their concrete particularity) but as the interchangeable beings they have essentially become. He suggests that even before we open the catalog, turn on the television, go online, or head off to the store, this has already happened. Our reductive materialism shows up in our very conception of matter as neutral "stuff"—something with which one can do almost anything one chooses. It shows up in our forgetfulness of the original meaning of the Greek word *hylē*, which philosophers have always translated as "matter" but which originally referred to what Sloane describes as a "substance with a soul." That is, to wood, not in the generic sense, but wood of a particular kind with its particular characteristics (with a particular "character," or grain). Seen in this way, wood is not just something that can be used in different ways. It is something that *allows* itself to be used in *particular* ways, something that already has a form of its own, something one can (and must) work *with*. To make something of wood, to craft it, is not simply to impose a form upon it, or make of it whatever one will. The finished product, a material thing, is not just a product of human decisions. It is a revelation, not just something to have and to hold, but a wonder to behold.

To say that our culture is too materialistic is to say that we have forgotten how to see things, to see material reality, in this way. Given the way in which matter is now revealed to us, it should come as no surprise that neither our theoretical nor our practical attitude toward things takes the form of a "reverent paying heed." It tends, rather, to be an ordering and

a demanding, whether our desire is to make use of them or simply to make their secrets known.

Perhaps, then, it is true to say that we are too materialistic, but also that we are not materialistic enough. Could it be that our want of spirituality might actually stem from our inability to revere material things? We can no longer see God in the wood, or in the woods, in something we make or do but is not entirely our own doing. This is why our lives are not complete. Paradoxical as it seems, the more we see as our own doing, the less our lives are truly our own.

Many readers may object to this statement as being too extreme. Others may find it objectionable in another way. The question—what does it mean for one's life to be one's own?—has such an individualistic ring to it that some may think it the wrong question to ask. After all, individualism seems to be as great a problem with modern culture as materialism. These two problems are usually seen as going together. Perhaps, then, we are only contributing to the problem by framing it in the way that we have, that is, by ignoring the value of community.

Dwelling, as Heidegger pictures it, is hardly individualistic. And yet, fundamental to his thinking is a value that is misrepresented by pitting the individual against the community (or the social). We encountered this mistake in our reading of Thoreau. The person whose solitary walks lead him back to nature is not necessarily leaving culture behind. Not only does Thoreau rediscover culture on his walks, the writings that come from them *are* culture (they themselves are walks in which we are invited to join). Our tendency to break things down (the way we break wood, water, or even the sun's rays down into units of energy) is partly responsible for this misrepresentation. We see societies as made up of individuals, and thus, as being broken down into or broken up by them. But then, we fail to wonder about the sources either of culture or of individual lives, not in the historical or biological sense, but in the way that Thoreau, Plato, and Heidegger wondered about this. The result is that the personal is reduced to the "subjective," while solitude is reduced to selfishness. These are all placed on the side of the "individual." Meanwhile, the social, seen as a human construction, assumes an importance that can only be taken for granted. It becomes an ideology.

To wonder about what it could mean to make one's life one's own, in the sense in which we are posing that question, is to ask what it could mean to live *a life* (as distinct from just being alive). This chapter began with a pair of quotations from Thoreau, and some words spoken by the Abstract Expressionist painter Robert Motherwell. These can be woven together with some other words that we have heard before. First, from *The Book of Tea*:

> Until one has made himself beautiful, he has no right to approach beauty . . . Our mind is the canvas on which artists lay their

color . . . The masterpiece is of ourselves, as we are of the master-
piece.[3]

And again, from "Autumnal Tints:"

There is just as much beauty in the landscape as we are prepared to
appreciate—not a grain more. The actual objects which one man will
see from a particular hilltop are just as different as the beholders are
different.[4]

And from Heidegger:

As soon as what is unconcealed . . . concerns man . . . exclusively a
standing-reserve, and man in the midst of objectlessness is nothing but
the orderer of the standing-reserve, then he comes to the brink of a
precipitous fall; that is, he comes to the point where he himself will be
taken as standing reserve. Meanwhile man, precisely as the one so
threatened, exalts himself to the posture of lord of the earth. In this
way the impression comes to prevail that everything man encounters
exists only insofar as it is his construct. This illusion gives rise in turn
to one final delusion: It seems as though man everywhere and always
encounters only himself . . . *In truth, however, precisely nowhere does man
today any longer encounter himself,* i.e., his essence . . . [H]e fails to see
himself as the one spoken to, and hence also fails in every way to hear
in what respect he ek-sists, from out of his essence, in the realm of
exhortation or address, and this *can never* encounter only himself.[5]

The mere fact that we have heard these words before, that they sound
familiar, does not guarantee that their meaning has become familiar (even to
the authors of this book, who have heard them dozens of times).
Repetition, we have suggested, is an indispensable part of the technique of
seeing, whether we are looking at scarlet oaks, silver chalices, Gothic
churches, or philosophical texts. And yet, we contend that such things
should always look strange to us, just as the words we have quoted again and
again should always sound strange to us. By revisiting them, we do not make
them less strange. On the contrary, this is what Thoreau, Heidegger, and
Plato have all taught us. A "prepared" vision is one that respects and
preserves the strangeness of things in the very act of revisiting them. The
prepared seer not only sees more (in the way that the experienced listener
hears more in the music than the inexperienced one), but, like the philoso-
pher who emerges from the cave, he sees the mystery in the midst of what
is revealed. Even after his eyes have adjusted, the clarity he enjoys is not like
that of the cave-dwellers. He sees "the things that are." But he does not cease
to be dazzled by them.

Thoreau, Okakura, Plato, and Heidegger all suggest that such a person
will not just see differently. Such a person will *be* differently. It should be

clear by now that everything we have said about philosophy, art, and con-
templative seeing must be taken personally. We understand that there may
be some resistance to this, just as we anticipated resistance to the elitism of
The Book of Tea. The authors have often encountered this kind of resistance
in the classroom. To be taught how to see is one thing, but to be told how
to be?! How can we presume to do that?

One way of responding to this resistance would be to try to diffuse it, to
reassure our readers that neither we nor the thinkers on whom we have
drawn are telling anyone how to live their lives or what kind of person they
ought to be. In saying this, we would be telling the truth. But, a different
kind of response is suggested by yet another quotation, in this case, a
reported conversation between Motherwell and a skeptical viewer of one of
his paintings.[6] To the viewer who asked, "What does your painting repre-
sent?," Motherwell himself replied with another question: "What do *you*
represent?"

★ ★ ★

Motherwell's was a simple, and yet not so simple, response. It is essentially
Emerson's response. This connection will seem far from obvious. What is to
be gained, what can be seen, by pairing a nineteenth-century American
Transcendentalist with a twentieth-century Abstract Expressionist? We have
seen other unlikely pairings in this book, but would it not make much more
sense to place Emerson beside Sloane? Between Emerson and Sloane there
is, of course, the "American" connection not in the superficial sense (that
they are both American), but in the deeper sense in which they were both
interested in things American. Sloane saw something in early American life
that he thought was worth emulating even if we could not return to it, and
so he wrote books with titles like *Our Vanishing American Landscape.*

What is remarkable about Emerson is that he could have written a book
with just that title even though he lived more than a century earlier. His
concern was not just that, by 1830, we were already "exalting ourselves" as
"lords of the earth," as Heidegger puts it. We *were* doing that, and Emerson
was aware of it. But Emerson's concern was more profound. It was shared
by Thoreau. Both were concerned about nature, but also about culture, and
what it could possibly mean to be American.[7] In their eyes, this had been a
vexing question from the very beginning: could there really be such a thing
as American culture, or is it all derivative, borrowed from Europe? America
was a different place, and Americans were different people. The problem was
that, in trying to express that difference, to define what it meant to be us,
we had no history or tradition of our own to fall back on. We had no past
to define us as the Europeans did. All we had was a new and very different
landscape. Were we bound to imitate, then, or could we find our own sense
of direction?

This idea of a break from the past, which can also be seen as the definitive
tendency of Abstract Expressionism, was not simply a matter of asserting

ourselves or affirming our independence. It was an awareness of our inse-
curity, an expression of anxiety, stemming from the realization that there
were no ready-made answers to the question of who we are or what we
stood for (since we did not have a cultural inheritance of our own to stand
upon).

What connects Emerson and Motherwell (the thinker and the artist) is
the question: what do you represent? On the surface, this seems entirely the
wrong question to ask an Abstract Expressionist. After all, isn't this the point
of abstraction—the "taking away" of any recognizable subject-matter, any
representational content, so that all that remains is pure form? After 1950,
"What does this painting represent?" must have seemed like a very old-
fashioned, a thoroughly outmoded, question to ask.

Motherwell's response to the question was not a flippant one. It was the
response of a philosopher (Motherwell's intention, as a young man, was in
fact to pursue graduate studies in philosophy). He saw that the question was
not outmoded, but was more relevant, and more urgent, than ever because
it got to the heart of what art was all about. That is, not just what it depicts
or represents in the superficial sense. What art is really all about is what you
and I—being human—is all about. Motherwell did not dismiss this ques-
tion. He reminded the questioner of what he was really asking—of what
was at stake—not only in the painting of the picture, but in the viewing of
it as well. "What *is* that?" What does it mean? "Well, what are you?" "A
human being." "Yes, but what does *that* mean?"

Motherwell realized that the answers to these two questions—"What is
there to see in this painting?" and "What am I?"—are intimately related.
Thoreau and Okakura saw it too. But the idea is even older than that. It
goes back at least to Plato. What you are able to see, not only in a painting
but in the world around you, depends on what you are able to see in your-
self. Does that make seeing "subjective"? In a sense, it does. But, it also
works the other way around. For Plato, what you are able to see in your-
self—the order of your soul—depends on what you are able to see in the
world around you. Seeing requires "an intention of the eye," as Thoreau puts
it, and is in that sense subjective. What you see is a reflection of who you are.
But, it is also objective, in that some people see better than others, where
"seeing well" involves a responsiveness to objects. This is a matter, not just
of physiological function (seeing what is there simply as a matter of fact),
but of reverence.

When Thoreau invites us to reflect on what we are prepared to see, this
is what he means. The idea that seeing might require the kind of prepara-
tion one might associate with religious observance, or with contemplative
practice, does not make it any less objective. If anything, it becomes objective
in a deeper sense. If what you see is a reflection of who you are, it is also
true that what you are is shaped by what you see. This is what Plato saw,
in the third book of the *Republic*: that our way of being is something we owe
to the objects of our experience. For Plato, as for the authors of this book,

our way of being is something that is very much in question. So is our way of seeing. For Plato, too, these questions are inseparable: what does this painting represent? What do you represent? What kind of work of art are you?

But let us return to Emerson. "What do you represent?" is a question whose seriousness he would insist upon. This should be clear enough from even a cursory reading of "Self-Reliance." It is also clear from the title of another of his works—"Representative Men." The meaning of this phrase is ambiguous. This is the sort of ambiguity Emerson tends to relish. In one sense, a "representative man" is an outstanding personality—an exceptional or heroic individual—set apart by the historical importance of his (or her) accomplishments. Representative men are the elect (or the elite) of humanity. But, the category of representative men could also include anyone who is representative of humanity in a different sense—your average person. What we find in Emerson is the possibility of bringing these two definitions together. It is not just publicly recognized "celebrities" who "celebrate" what it means to be human. At the same time, anyone who *does* represent humanity in this celebratory sense is by no means average. A life that realizes the fullness of human reality is not an ordinary life. It is extraordinary, but it can (and in some sense, must) be "everyday." The desire to bring the celebratory and the everyday together—in the promise that you too can be Shakespeare in the way that you practice your humanity— is very much at work in "Self-Reliance." We turn to this essay for guidance in the way that we turned to Thoreau's and Heidegger's essays for guidance; not for explicit instructions, or merely for inspiration, but as occasions both to see and to practice what we have been talking about all along.

★ ★ ★

What do you represent? Where would Emerson have us look for an answer to this question? If we read "Self-Reliance" in the way we usually read Plato's *Republic*, it will seem as if what he is calling upon us to do is not to allow who we are to be determined by what we see or hear or read, but only by our own conscience. "Trust only yourself!" is what Emerson appears to be saying. Truth is authenticity, truthfulness to oneself, even when that amounts to mere "whim." This can look and sound a lot like what the Abstract Expressionists were saying and doing. Or is it? Is it what Emerson himself is saying?

Like Heidegger's, Emerson's text is winding and at times even tortuous— a true "essay" or trial for the reader as well as the writer. There are clearings, to be sure, but there is a lot of surrounding forest. Of course, we usually cut through that. "Self-Reliance" is generally read as a manifesto of American individualism. "I must be myself!" To be one's self is to be a nonconformist, whatever that might mean.

Here, we shall devote the same kind of attention to the particularities of Emerson's text as we did to Plato's *Republic,* in the hope that we may be turned around from one way of reading it to another. We shall approach his writing in the way that we approached Heidegger's. Reading Emerson is work in the way that following a path is work. The meaning is never clear in advance, if it becomes clear at all. It is something that opens up for us in glimpses, illuminated not so much by the rays of the sun as by momentary flashes of lightening. This may be part of the reason why Nietzsche, an exceptional philosopher, liked Emerson as much as he did. It is part of the reason why the authors of this book like Emerson as much as they do, and why they find him so frightening to teach.

What, then, do we see and hear in this text? Perhaps, we should visit some passages:

> Trust thyself . . . Accept the place the divine providence has found for you, the society of your contemporaries, the connection of events. Great men have always done so, and confided themselves childlike to the genius of their age, betraying their perception that the absolutely trustworthy was seated at their heart, working through their hands, predominating in all their being.[8]

> Whoso would be a man must be a nonconformist . . . Nothing is at last sacred but the integrity of your own mind. (Pp. 134–35)

> I will stand here for humanity, and though I would make it kind, I would make it true. . . . [There is] a great responsible Thinker and Actor working wherever man works . . . a true man belongs to no other time and place, but is the centre of things. Where he is, there is nature. (Pp. 139–40)

> But now we are a mob. Man does not stand in awe of man, nor is his genius admonished to stay at home, to put itself in communication with the internal ocean, but it goes abroad to beg a cup of water of the urns of other men. We must go alone (p. 145).

> We imitate, and what is imitation but the traveling of the mind? Our houses are built with foreign taste; our shelves are garnished with foreign ornaments; our opinions, our tastes, our faculties, lean, and follow the Past and the Distant. The soul created the arts wherever they have flourished. It was in his own mind that the artist sought his model . . . Insist on yourself; never imitate. (P. 150)

At best, this sounds like a somewhat more eloquent echo of Immanuel Kant's well-known call to enlightenment as "man's release from his self-incurred tutelage."[9] To have "the courage to use one's own reason," to become independent thinkers, was Kant's way of characterizing what it means to be modern. It seems to have stuck. "Every man's vocation," Kant insisted, is to "think for himself." This is what it means to grow up, or to

come of age; that is, to become a truly modern individual. This, rather than "imitation," should be the real goal of education and of art.

But what is "this"? Is it as clear as we take it to be? Before we assume that we have understood what we are called upon to do, or to be, we should pay closer attention to what Emerson himself has written:

> Shakespeare will never be made by the study of Shakespeare. Do that which is assigned you, and you cannot hope too much or dare too much. There is at this moment for you an utterance brave and grand as that of the colossal chisel of Phidias, or trowel of the Egyptians, or the pen of Moses, or Dante, but different from all these. Not possibly will the soul all rich, all eloquent, with thousand-cloven tongue, deign to repeat itself; but if you can hear what these patriarchs say, surely you can reply to them in the same pitch of voice.[10]

One does not become another Shakespeare simply by studying Shakespeare any more than one becomes a philosopher simply by learning what other philosophers have said. In the same way, it is not through the knowledge and imitation of past styles that art flourishes. It is the soul, Emerson writes, and not just a set of social or historical conditions, that created the arts. Is artistic freedom unconditional, then? Is closing the book, ignoring what is outside of oneself and consulting only what is in one's own mind, all it takes to enable one to reply to Phidias, Moses, or Dante in the same pitch of voice? Or is there more to see here? Real creativity, truthfulness and integrity, are not unfettered. There *is* a condition in virtue of which it deserves to be called sacred. We catch a glimpse of it in the last sentence of the paragraph quoted above: *"if you can hear what these patriarchs say . . ."* then, and only then, can you reply to them.

What is *this* patriarch saying? That we should rely solely on ourselves and our own thoughts? Why read him, then, or anybody for that matter? Why should we take our cue from or imitate Emerson, even to the point of taking the "duty" of self-reliance upon ourselves? If one were truly independent, couldn't the refusal to assert one's independence, or to realize what one is, be an assertion of one's independence?

Much of what Emerson says does sound like an assertion of selfhood, as if he were saying that who you are depends only on you. It can look as if Emerson is calling upon us to lay claim to our own (individual) nature, our own (individual) freedom, and to dispense with any and all constraints. But, there is at least one constraint with which Emerson thinks we cannot dispense. This comes, not in the form of an assertion, but in the form of a question. "What do I represent?" is not a question we lay claim to as our own. As Heidegger would say, such a question always lays claim to us. It is not ours to ask if and when we choose. The question itself chooses us. But then, in what sense are we free to answer it?

Emerson's essay has no thesis because what it poses is, fundamentally, a question. This is what self-reliance turns out to be, not self-assertion, but

rather the acknowledgement that being human is a task. Realizing one's nature is itself an essay, in the original sense of the word.

One sees this already in the passages we have quoted. The "true man" is "the centre of all things," but he is not just a self-centered individual. He does not stand alone with his thoughts and opinions. He has work to do. He is not the self-assured ego who, secure in the logic that because he thinks he, therefore, undeniably exists, takes himself to be the absolute locus of all reality. This was the self on which Descartes thought we could all rely—the self whose being was unquestionable. As such, it was supposed to provide the foundation for all truth and knowledge. But, the theoretically self-reliant individual who trusts only his own reason is not the man before whom Emerson would have us stand in awe. In standing for humanity, Emerson would not have me simply discover the truth that "I am." He would *make* it true. The true man does not simply take himself to be the measure of all things. "Where he is, there is nature" could signal the reduction of nature to the ego and its thoughts, or it could signal the expansion of that ego through a process in which the self is actively and not just passively transformed.

What Descartes arrived at through a purely logical movement, Emerson describes as a substantial undertaking. The self that truly "is" is not a starting point, or a foundation laid in thought. It is an edifice that each of must strive to construct. The "perception" that Emerson sees even great men as having betrayed is not the self-certainty of the Cartesian ego. What is "absolutely trustworthy" is not just what is in their heads; it is what is "*working through their hands*" and predominates "in all their being." The "great fact" on which this enterprise is based is not a logical claim ("I think, therefore I am"), but an ethical one: that "there is a great responsible Thinker *and Actor* working wherever a man works . . ." It is in this sense that we are each called upon to be responsible for ourselves. The self who truly is, is the self who truly works. "It was in his own mind that the artist sought his model . . ." But then, Emerson's own model suggests that the self who truly is (the artist), must be related, through his work, to something beyond himself. There is something *to* which he is called to be responsible. "There is at this moment for you an utterance brave and grand as that of the colossal chisel of Phidias . . ." Phidias was a craftsman—an Ancient Greek architect and sculptor—whose utterances were realized in and through the material with which he worked.

We have encountered other such models over the course of this book—Anaximander, Sloane, and (now) Motherwell. Such models suggest a very different way of interpreting Emerson's call to self-reliance. "He is the truest artist," Thoreau wrote, "whose life is his material . . ." The "true poem . . . is what he has become through his work." To which Motherwell adds the hope that one may "end up with a canvas that is no less beautiful than the empty canvas was to begin with." Such artists do not see only themselves in their work. "If you can hear what these patriarchs say," Emerson insists, then "surely you can reply to them in the same pitch of voice." What is called for

is not the self-assertion of the isolated individual. It is a response. "Response" is, after all, the root of "responsibility," though here again the source easily fades from memory.

If Descartes thought that the self on whom we can rely is the self whose being is unquestionable, Emerson thinks otherwise. Pieper wants us to see "with our own eyes." Heidegger regrets that, because our way of seeing is so thoroughly enframed, we can no longer see how we exist "from out of our essence." He would agree with Emerson's observation that "ordinarily, every body in society reminds us of somewhat else, or of some other person" (p. 140). With the relegation of humanity to the standing reserve, the differences between us have become superficial, as has the sense of community that we think holds us together. For none of these thinkers, however, is self-reliance the answer. The problem is that we have forgotten how fundamentally questionable a human being—indeed, all being—truly is. The need to see our own existence as a question that calls for a certain kind of response—this is something that emerges only as Emerson's essay unfolds (only as he "finds his voice"). To be true to oneself, one must first truly be. But what does that involve? *Is* it one's own doing?

> The magnetism which all original action exerts is explained when we inquire the reason of self-trust. Who is the Trustee? What is the aboriginal Self, on which a universal reliance may be grounded? What is the nature and power of that science-baffling star, without parallax, without calculable elements, which shoots a ray of beauty even into trivial and impure actions . . . ? The inquiry leads us to that source, at once the essence of genius, of virtue, and of life, which we call Spontaneity or Instinct. We denote this primary wisdom as Intuition, whilst all later teachings are tuitions. In that deep force, the last fact behind which analysis cannot go, all things find their common origin. For, the sense of being which in calm hours rises, we know not how, in the soul, is not diverse from things, from space, from light, from time, from man, but one with them, and proceeds obviously from the same source from which their life and being also proceed. We first share the life by which things exist, and afterwards see them as appearances in nature, and forget that we have shared their cause. Here is the fountain of action and of thought. . . . If we ask whence this comes, if we seek to pry into the soul that causes, all philosophy is at fault. Its presence or absence is all we can affirm. (Pp. 141–42)

What are we really doing when we rely on or trust ourselves? We are doing the trusting, but in what or whom are we placing our trust? Trust, Emerson reminds us, requires a trustee. What, then, is the truly self-reliant person relying upon? What makes it trust*worthy*?

Consider the question Motherwell put to his skeptical viewer. This question could not really be answered in the sense in which one might say, to another person, that one represents a certain organization. When one

speaks at a meeting, for example, as a "representative" of one's department, what one has to say is something one stands for in the sense of standing in, or substituting for someone else, or for the organization as a whole. Is there anything we do not simply stand in for, but genuinely stand for? If not an organizational identity, perhaps one might stand for certain religious, moral, or political convictions. If one has chosen to identify with those things, who was the self who chose them, and on what basis?

We are often told, in moments of pressure or when we are overly concerned about what might be expected of us, that we should not worry, but "just be ourselves." Does this make us more, or less secure? If what you are is not entirely your own doing, what could it mean really to be yourself?

> We are like children who repeat by rote the sentences of granddames and tutors, and, as they grow older, of the men of talents and character they chance to see,—painfully recollecting the exact words they spoke; afterwards, when they come into the point of view of those who uttered these sayings, they understand them, and are willing to let the words go . . . When we live truly, we shall see truly . . . When we have new perception, we shall gladly disburden the memory of its hoarded treasures as old rubbish. When a man lives with God, his voice shall be as sweet as the murmur of the brook, and the rustle of the corn. (P. 143)

To live truly, for Emerson, one must not simply dispense with these "sayings." It is only when we *understand* them that we should "let the words go." Art, literature, and poetry, like nature, constitute an indispensable source for living. To draw upon them in the way that Emerson speaks of here is to recognize that they too have a source. To understand the words is not just to study but to participate in them, to "come into the point of view" of those who gave them passage. It is to live them in a way that differs from either memorizing or merely applying them. "When we live truly, we shall see truly." Voluntary thoughts and actions, Emerson writes, "are but roving," while perception "is not whimsical, but fatal" (p. 142). There is, for Emerson, a deep connection between living and seeing. To what, then, are we called upon to be true? We may think that we live our own lives, but seeing refers to something outside of us. "I must be my-self." *Whose* self? What is *its* ground, or source, if it does not lie in a choice that is empty (where that which chooses is simply identical with that which is chosen, like the self-referential "I think, therefore I am")? If it is not something that is determined, or made up, by others, is it something I determine or make for myself?

In a sense, it is. But, in what sense? Here, we approach the underlying insight of Emerson's essay. It must look to contemporary theorists as if the only alternatives are either a socially constructed ("made up") self or a self that is entirely its own doing ("self-made"). If we see no other way, it is because we have forgotten what making, or craft, might truly involve, or what there is to see in the well-made thing.

This is where Emerson arrives at his clearing:

And now at last the highest truth on this subject remains unsaid; probably cannot be said; for all that we say is the far-off remembering of the intuition. The thought, by what I can now nearest approach to say it, is this. When good is near you, when you have life in yourself, it is not by any known or accustomed way; you shall not discern the footprints of any other; you shall not see the face of man; you shall not hear any name;—the way, the thought, the good, shall be wholly strange and new. (P. 143)

This one fact the world hates, that the soul *becomes*; for that forever degrades the past, turns all riches to poverty, all reputation to a shame . . . Why, then, do we prate of self-reliance? Inasmuch as the soul is present, there will be power not confident but agent. To talk of reliance is a poor external way of speaking. Speak rather of that which relies, because it works and is . . . (P. 144)

[Y]our isolation must not be mechanical but spiritual, that is, must be elevation . . . I will so trust that what is deep is holy, that I will do strongly before the sun and moon whatever inly rejoices me, and the heart appoints . . . I do this not selfishly, but humbly and truly. (P. 145)

To *go* alone, as Emerson tells us we must do, is not necessarily to *stand* alone. "We first share the life by which things exist, and afterwards see them as appearances in nature . . ." Of course, if we assume that reality is merely a collection of objects, if that is how we perceive it, then self-reliance will look like an isolated individualism. If we see nature as a limitless field of possibilities for use, then truthfulness to oneself will have to appear as unfettered freedom. To see in either of these ways is to see generically. It is this way of seeing that Emerson would have us resist. To see "with one's own eyes" is to see *particularly*. For Emerson, such a way of seeing involves a connectedness with things that alone makes it possible for us to be connected with ourselves. The self that "relies" is not the self that makes itself secure, in the modern technological sense. It is the self that is present not by making sure of itself (like the Cartesian ego), but in the process of its own becoming. It "is" insofar as it "works," in the way that both the craftsman and the thing he makes can be said to work. It works not just in the sense of labor and production or when we say that something works as a practical solution.

What we see, in the soul's reliance, is what Heidegger would have us see in the silversmith's crafting of the chalice. It is what we saw in the *ergon* of the musician or in the harmoniously woven cloth; that is, a revealing for which the craftsman's work provides the occasion. It is before such "wonders to behold" that we may indeed stand in awe. Such things are brought forth, but they are not brought about, by us. To create such things is to acknowledge, and give thanks for—a gift that we do not simply give to ourselves. It is to this kind of work that the true craftsman is responsible; but

then, he himself is not entirely responsible for it. As a maker, he is respond-ing to something that is not just of his, or anyone else's, making.[11]

<div align="center">

★ ★ ★

</div>

"Inasmuch as the soul is present, there will be power not confident but agent." To be is our doing. But, this does not mean that our being, our life, is our own doing. "Your isolation . . . must be elevation." Elevation needs a ground. Where do we find this? Not in *self*-confidence (this is what needs to be grounded on something), but in trust. To be true to oneself one must be truly a self—one must truly see. That means that one must be true *to* something that is not just one's self. What could that be? If it is something one must ulti-mately trust, it cannot be anything one can count on, calculate, figure out, or ever make perfectly clear. These may be "sure things," but, as Heidegger suggests, it is for this very reason that they cannot really be trusted.

This chapter began by relating the abstract philosophical question "Who am I?" to a problem that seemed to trouble Emerson and Thoreau in particular, and that also troubled the Abstract Expressionists: what does it mean to be American? Now, we would suggest that Emerson's "Self-Reliance," both the essay and the exercise itself, is not a static but an active response to a question that lies at the root of the American democratic spirit as well as the spirit of American art. The question (as Jonathan Hale puts it) is whether there *is* a self we can trust.[12] Emerson saw his own culture as deeply mistrustful of anyone or anything that might claim to answer this question for us. What Emerson saw is what Heidegger saw: our progressive tendency to mistrust anything we have to take on trust, anything that is not "calculable." This would amount to a mistrust of what Pieper calls accept-ance or what Sloane means by reverence, of the power of art to transform us, or the very idea that philosophical contemplation might be the key to human happiness, of any appeal to "absolutes" or the wonder they are owed. Such things require an attitude of faith that limits our ability to be sure of ourselves by making certain what is otherwise mysterious. This deep mistrust—a mistrust of trust itself—is still very much with us today.

What have we lost? Our selves, Heidegger thinks. Emerson agrees. But he goes further, in a way, to remind us of what "reason" means, and where its source originally lies. "What is the aboriginal Self, on which a universal reliance may be grounded? What is the nature and power of *that science-baffling star . . . without calculable elements?*" Much as we would like to lay hold of this (to make sure of ourselves), our inquiry leads not to something that is up to us, but rather to "that source, at once the essence of genius . . . and of life." This "deep force" is nothing we can be certain of; it is the "last fact, behind which analysis cannot go." That we cannot grasp it, or make it clear, does not mean that there is nothing we can make of it. It is, on the contrary, what Motherwell saw himself as trying to put on canvas—something, as he himself once put it, that is "unnamable, but . . . humanly poetic."

In an address delivered in the mid-1950s, Heidegger warned that "calculative thinking may someday come to be accepted and practiced as *the only way* of thinking." In that event, he fears, "man would have denied and thrown away his own special nature."[13] Emerson speaks of "Intuition" as distinct from "tuition." Intuition, in his sense, is not just a vague hunch. Intuition literally means receiving, or "taking in." It is not a private, or merely personal, "notion" (as Emerson puts it), but a direct seeing. As such, it requires openness and a receptiveness to what is given. Emerson himself marks the contrast in the passages where he says that we are, for the most part, "like children who repeat by rote the sentences of granddames and tutors . . . painfully recollecting the exact words they spoke." The alternative is not to ignore the words others have spoken, but (as we have seen) to *understand* them by *participating* in and *living* them. It is in the very next sentence that Emerson tells us, "if we live truly, we shall see truly." How could one live truly by reading Plato? Rather than simply looking at the words on the page, it would be to see what Plato sees, and to practice the way of seeing that is realized in his work, so that his work becomes our work (as it has here). As with the tea ceremony, such practice would engage our bodies as well as our minds. It would have to involve the whole soul.

The problem with "tuition" is not that it is thoughtless or mechanical in the sense that repeating by rote is mechanical. The problem is that thinking can actually take this form, so that thinking mechanically comes to be mistaken for thoughtfulness itself. This is the danger Heidegger warns against. Emerson's tuition is the kind of thinking that is "enframed," in Heidegger's sense. In "Self Reliance," Emerson says about the "civilized man," that:

> [He] has built a coach, but has lost the use of his feet. He is supported on crutches, but lacks so much support of muscle. He has a fine Geneva watch, but he *fails of the skill* to tell the hour by the sun. A Greenwich nautical almanac he has, and so being sure of the information when he wants it, the man in the street does not know a star in the sky. The solstice he does not observe; the equinox he knows as little; and the whole bright calendar of the year is without a dial in his mind, His note-books impair his memory; his libraries overload his wit; the insurance-office increases the number of accidents; and it may be a question whether machinery does not encumber . . .[14] (Emphasis added)

Intuition, which because it is immediate may be mistaken for thoughtlessness, is like Thoreau's prepared vision. It is ultimately spontaneous, and free; but, it takes work. Like the painful ascent from Plato's cave, it is how we arrive at truthfulness. Thus, it is that, "if we live truly, we shall see truly."

For Emerson, seeing, feeling, and thinking (not to mention reading) can all be intuitive, or they can all be tuitive. What he is reminding us is that reason originally stems from intuition. Before you can calculate, you must

see. Emerson sees what Plato saw: that reason is really seeing in proportion (unless we cut it off at the root, in which case it dies).[15] But, if this is so, then mystery, what is incalculable, is as "rational" as clarity. "All revealing belongs within a harboring and a concealing," Heidegger writes, while "that which frees—the mystery—is concealed and always concealing itself." It was Aristotle who said that philosophy began with wonder, and issued in wisdom. But wisdom (what he called "science") does not ultimately take the form of a calculated "figuring out." It is more closely akin to the "reverential paying heed" of which Heidegger speaks.

If, in Aristotle's words, "all men begin . . . by wondering that things are as they are," the knowledge they seek does not eclipse the wonders they behold. The incommensurability of the diagonal of a square with the side "seems wonderful to all who have not yet seen the reason, that there is a thing that cannot be measured even by the smallest unity." But then, having seen the reason, "there is nothing that would surprise a geometer so much as if the diagonal turned out to *be* commensurable."[16] The geometer's inquiries begin with wonder and end in knowledge. He does not know how to measure the diagonal; he understands, he sees more deeply into its immeasurability than those who were not moved to inquire in the first place. This is what makes his knowledge philosophical. What he sees in the end is no less wonderful, no less incalculable, for its being rational. What it means for him to "see the reason" is to see the irrationality that the square's ratios must harbor and to which it owes its geometrical perfection. He sees things "as they are." So it is with Anaximander's sundial, which reveals only insofar as it conceals, or with Emerson's "science-baffling star." What the wise man sees in the diagonal of the square, is a figure that, being unmeasurable, is utterly particular and unique—incomparable to any other (that "reminds you of nothing else"). True individuality is thus seen only when it is thus bounded. Perhaps, then, it is no surprise that—when Emerson comes "at last" upon "the highest truth" of his subject, it "remains unsaid," and indeed, "probably cannot be said; for all that we say is the far-off remembering of the intuition." All he can utter is a thought he can but nearly approach.

If mystery is as rational as clarity, then so is art. Jackson Pollock was another Abstract Expressionist, and friend of Robert Motherwell. His seemingly chaotic paintings are portraits of Emersonian intuition. What looks, on the surface, like hopeless confusion belies the process that gave birth to them. Those who saw Pollock work (and we can still see it preserved on film) describe him as "dancing" over and around his canvas. Pollock's dance, where the paint traces the figure, is not the "anything goes" of a self that listens only to itself and follows its own subjective whim. His work, if we take more than a superficial look, is full of grace, harmony, and rhythm (the qualities of the just soul). It is full of "ratios," even if they are not calculable. The painting—the working as well as the work—makes *kosmos* visible. Dance (as we saw in Chapter Six) is no less rational than figuring out what you owe on your taxes. It is rationality embodied, like the craftsman's hand.

He is not "reasoning"; his knowledge is in his hand, as the dancer's is in her feet.

Emersonian intuition coincides with the power of abstraction in art. This is not simply a matter of "getting rid" of content and leaving only pure form. The "taking away" is, in effect, a concealing—allowing something to remain hidden in order to reveal the inner being (the substance or soul) of what we ordinarily see only the outside of. It functions in the way that Heidegger's clearing, or Anaximander's sundial, does. One might say—and the authors of this book would emphatically argue—that this is the power of all art: to complete the task of philosophy by revealing the hiddenness of reality ("the last fact behind which analysis cannot go") without robbing it of but rather celebrating it as a gift for which we can never fully account.

What, then, does Emerson represent? Emerson is an Abstract Expressionist! Reading his essay (any of his essays) is (or should be) like seeing a Motherwell. If one looks for a "subject" (a thesis, or doctrine) one is bound to end up confused. He says one thing, only to contradict it ("a foolish consistency is the hobgoblin of little minds"). Does that mean that there *is* no subject? The self that Emerson calls us to be, or to become, does not ultimately rely on or represent itself. It is not merely constructed, nor does it simply create itself out of nothing. Emerson would have us stand in awe of ourselves. This standing in awe presupposes a reverence for, in Heidegger's words, "that which, of ourselves, we can neither invent nor in any way make." This is something that Heidegger says we have a "share in revealing." It is by doing our share, through the practice of participatory seeing, that we enter into what Heidegger and Emerson both describe as the highest dignity of our essence. "This dignity lies," in Heidegger's words, "in keeping watch over the unconcealment—and with it, from the first, the concealment—of all coming to presence on this earth."[17] It lies, finally, in what Emerson says about prayer:

> Prayer that craves a particular commodity,—any thing less than all good,—is vicious. Prayer is the contemplation of the facts of life from the highest point of view. It is the soliloquy of a beholding and jubilant soul. But prayer as a means to effect a private end is meanness and theft . . . As soon as the man is at one with God, he will not beg. He will then see prayer in all action. The prayer of the farmer kneeling in his field to weed it, the prayer of the rower kneeling with the stroke of his oar, are true prayers heard throughout nature . . .[18]

This is what it means to speak of a "sense of being" that is "not diverse from things." It is what it means to practice mortality.

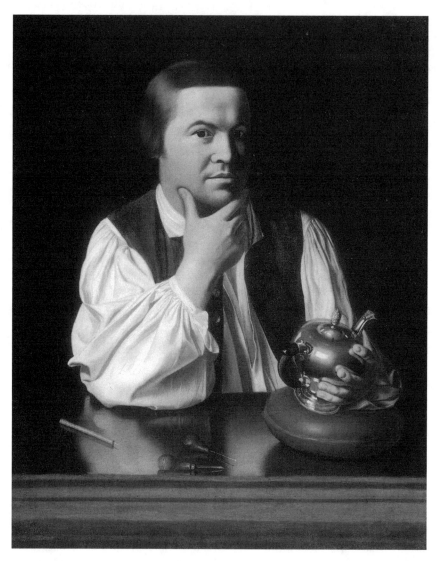

Plate 11 John Singleton Copley, *Paul Revere*, 1768 (Museum of Fine Arts, Boston). Courtesy of the Museum of Fine Arts, Boston

Epilogue: A Life Well Lived

> It is the conviction that nothing mysterious can ever happen in our everyday life that has destroyed the joy of abstract thought.
> —Wassily Kandinsky, *Concerning the Spiritual in Art*

What it means to be human is up to you in the way that the forming of the chalice is up to the craftsman. It is up to you to make it well, or not. In John Singleton Copley's well-known portrait of Paul Revere, the craftsman holds an object of his own making in one hand, and himself in the other. What is he looking at? His work. What does he see in it? Perhaps he sees a reflection of himself (Copley has rendered the reflective qualities of the silver in a remarkably sensitive way). But again, in what sense? Is it simply a mirroring, or self-affirmation (reflecting the sense that it was *he* who gave this matter its beautiful form)? Does he see only himself in it or does he see an extension, perhaps even a transformation of himself? Could he see *himself* as something that is made—something that owes its being to a source other than itself? Is the silver pot given its form by him, or is he given form by his work? Is he enlarged by what he sees, or does he see only what he has put there?

What is wonderful about the painting is what it conceals as well as what it reveals. What Revere is looking at, what he sees, is suspended in ambiguity. But there is much that we can see if we look closely and attend to the particulars.[1] We may notice, for instance, that Revere's chin, which he cradles in one hand, and the teapot he cradles in the other, have a similar form. It is solid with a strong physical presence. Both appear as *things*, in Heidegger's sense. Revere is not gazing directly at the pot. If anything, his gaze seems rather contemplative, as if he were wondering about something. Of course, one could insist based on what we know about him as a matter of historical fact that this was the defiant and prideful stare of the American patriot. But then, we might just as well not look at the painting at all.

The visual suggestion is not one of self-assuredness. The gaze is indefinite. It is, in any case, the hands that call for attention. Revere's hands are not at work, at the moment. Or perhaps they are. It is (Vincent Scully suggests) as if the craftsman knew himself and the *kosmos* through his hands and through

the handling of his tools. This knowing is a beholding, in the fullest and most original sense of the word.

We can actually see some of these tools in the painting, at rest but actively present (thanks again to Copley's acute rendering of them). These are engraving tools, but they are also suggestive of the painter's brushes. Their handles reflect the form of the hand that uses them, like the silver they are used to shape. These are not just utilitarian instruments (any more than the pot is); they are tools, in Sloane's sense. They are placed on the table. But then, Revere himself is also placed on the table—visually, at least. Copley has positioned him not so much at, or behind, as over and upon it. His body, seen in relation to the smooth and expansive surface is (as Scully puts it) strangely truncated and short. It is shaped like a pot. The visual qualities of the silver (the taut linearity, the light that reaches into the shadows without losing its sharpness) are the same qualities Copley represents his subject as having. He reflects it as much as it reflects him. He is the crafted object, as much as the pot is.

This "crafting" is what Copley has brought forth in his painting. Revere is made visible in the thing he has made. Copley's portrait—of a human being in the making—is itself a well-made thing. It is through such things, the making and the seeing of them, that we all might realize who and what we are. In this way, too, a well-lived life is made.

★ ★ ★

That living might be "practiced" as a craft is what we see in Copley's portrait. It is also what we have come to see in this book. This book has been all about seeing—seeing contemplatively, as we put it, and with full awareness. How is it that we have come to focus so intently on craft? The idea of contemplative seeing that has emerged over the course of these pages is distinctive. Contemplative seeing, we have argued, is not "active" in the ordinary sense, but neither is it utterly passive. Being active is usually associated with getting something done: if you are not getting anything done, you are not doing anything; you are inactive. But, this is simply not true. In this book, we have used the word "activity" in connection with contemplative seeing. We do so in order to mark an important distinction— one that is both philosophical and everyday. If you walk up the hill to collect your mail (where walking is a means to an end), that is an action. If, on the other hand, you walk up the hill in order to take a walk, you are every bit as active even though you are not getting anything done. You are performing an activity. What you are doing is by no means pointless. There is an end, or purpose, but it is not separate from the activity itself.

Craft, we have argued, is an activity of this sort. This is not to deny that it is also productive. Indeed, this is the way most people would distinguish craft from "art." What sets poetry, painting, music, and dance apart from pottery or carpentry is that the latter are useful in a way that the former need not be—or so we tend to think, and it is true on the whole. What this book

has brought to light, however, is something that is fundamental to both art and craft, as well as to philosophical contemplation. There is more to see in the craftsman's "work" than mere usefulness or productivity. It can also be seen as a revelation of something that the craftsman does not make—as the making visible of something divine. This is what makes it "practical" not just in the sense of being useful, but in a sense that should be familiar to anyone who has practiced any art or craft. Such activities take practice; we must prepare ourselves to perform them. They are also "practices," activities one must perform regularly or every day.

Contemplative seeing involves the same kind of work. It is actively practiced in the way that art or craft must be actively practiced. But then, it is not detached or "diverse" from things (as Emerson puts it), rather it is fully engaged with them. This engagement is sensuous as well as intellectual (like *theōria*). Only then, we argue, is it fully sensuous *or* intellectual (only then are we "in our senses," as Thoreau says). This is another distinctive feature of the account we have offered here. What Emerson is talking about in "Self-Reliance" is, as we put it, a sense of connectedness with things that alone makes it possible for us to be connected with ourselves. As Plato pictures it, to really see something requires an investment of the whole soul—desire and emotion as well as intellect—and of the whole body. Only then are we ourselves made whole. This harmony is not something that reason brings about or oversees. This *is* reason. For Plato, to be connected in this way is what it means to be rational.

Contemplation is, therefore, more "materialistic" than we tend to think of it as being. It is materialistic, not in the modern technological sense—which leads to the reduction of everything to mere possibilities for use—but in the Heideggerian sense of a "reverent paying heed" to things. This sense of what it means to see is one that is shared by all the authors and artists we have discussed in this book. Philosophy and art, we argue, both originate in this kind of active, enmattered seeing; they are both, therefore, fundamentally religious.

This is the conclusion we have reached. It may sound like an academic one, as if what we were proposing is basically a "theory" of contemplation, and of the (supposedly) divine origins of art and philosophy. Much of what we have said should be of academic interest. But, if we take seriously the thoughts to which we have been led, then our interest must extend beyond the academic. Pieper, Plato, Okakura, Thoreau, Emerson, Heidegger, Sloane, and Motherwell are all talking about how we live our lives. If we are going to take *them* seriously, we must be willing to talk about that, too. Like them, we must be willing to mean what we say. As this list of names serves to remind us, some of our sources are very old (even ancient). Some, like Motherwell, are downright modern. We have insisted throughout this book on the viability of the way of seeing they can all help us to realize. Indeed, it is not just viable, we believe, but vital (in the strongest sense of the word).

We return, therefore, to a question we hope has been answered over the course of this book, but which we may never cease to ponder: what does

this way of seeing have to offer us? We have spoken, more than occasionally, about contentment and the idea of living a "complete" life. Is such a thing possible for us?

To understand how it is possible, we must first understand what it could mean. A happy life, Aristotle argued, must be complete or "self-sufficient." He defined this as a life that is "lacking in nothing."[2] Such a life would be possible for us, Aristotle thought, but only insofar as we could live a life that was in some sense divine. Ultimately, this would be a life of philosophical contemplation. For this, Aristotle believed, consisted not only in the study of "divine objects"; it was itself a divine activity.[3]

What does it really mean to be "lacking in nothing?" The answer we have arrived at in this book is not exactly Aristotle's, though it is inspired by him.

Reflecting on the meaning of a complete life, Aristotle poetically observed that "one swallow does not make a summer, nor does one day; and so too one day, or a short time, does not make a man blessed and happy."[4] Does this mean that a life is not complete until it is over and done with, or until we have seen the end? What does it mean to see "the end"?

This is what we have been moved to wonder about, in this book. "Seeing the end" is what it means to practice mortality, to see—or better, to realize—what a human life is all about. "Above all," Thoreau writes, "we cannot afford not to live in the present."[5] But, what if the way things are makes it impossible for us to live in the present, or to *be* where we are? What then would make it possible to live in the present? Here again, Thoreau may be of help:

> My vicinity affords many good walks; and though for so many years I have walked almost every day . . . I have not yet exhausted them. An absolutely new prospect is a great happiness, and I can still get this any afternoon. Two or three hours walking will carry me to as strange a country as I expect ever to see . . . There is in fact a sort of harmony discoverable between the capabilities of the landscape within a circle of ten miles' radius, or the limits of an afternoon walk, and the three-score years and ten of human life. It will never become quite familiar to you. (Pp. 79–80)

The activity Thoreau is describing, the way of life he is inviting us to participate in, draws on an inexhaustible source . . . a source of wonder. The point of maintaining a standing reserve was to no longer rely on nature as a source. It is this *reliance* that makes Thoreau's life complete—that offers him a "great happiness." His way of finding happiness has this in common with Aristotle's. For our lives to be complete, Aristotle thinks, there must be something that we desire to do for its own sake—something that is not a means to something else, but is an end in itself. Otherwise, he says, our desire—indeed, our life as whole—would be "empty and vain"; our actions would go on "without limit."[6] It is such activities that make the difference between a life that is empty or pointless, and one that is fulfilled. But then,

it is not enough merely to supplement our ordinary actions with activities that are meaningful in themselves, or to look forward to them only on the weekend. To make these the point of one's life is what it would mean to live life for its own sake—to live a fully human (a fulfilled) life. This is what matters for our lives: that it not be the case that everything we do is done for the sake of something else. For then, why are we alive at all?

It is here that our thinking departs from Aristotle's, and from Pieper's, to some extent. Aristotle tends to set philosophy apart from everyday life in the same way that Pieper sets art apart from craft. We find it more promising to associate the idea of living well with that of the well-made thing, the practice of mortality with the practice of craft, and with the kind of "seeing" it essentially involves. We find this promising because it more fully acknowledges the practical side of our lives, and allows us to find fulfillment—to find God—in the everyday. We find it promising not because it makes things easier for us than if we had to live as artists or philosophers. Rather, we contend that this is what art and philosophy themselves are originally all about. This is why we say that living philosophically and artistically is what it means to be human.

This provides not just a model for making a life, but the substance for it as well. Pieper's idea of "an activity that is meaningful in itself," realizable "in countless actual forms" is one that is still available to us in the ways that we have talked about and tried to realize in this book. A life lived for its own sake—a life that is complete, or "one's own"—is a life connected with things, and with God. It is a life connected to sources that one does *not* own, but may yet discover within a short radius of where one lives.

What is required for this? There are two things that we have mentioned frequently, but mention here again for fear that they might be misunderstood. They are: leisure and a capacity for wonder.

The idea of "leisure" that has been operative throughout this discussion can be found, once again, in Aristotle (though it did not originate with him). "Happiness is thought to depend on leisure," Aristotle wrote, "for we are busy that we may have leisure, and make war that we may live in peace."[7] What Aristotle means when he speaks of leisure is very different from the conception that seems to prevail among our students. They may agree that happiness depends on leisure, but they generally understand (and pursue) leisure in negative terms—as a lack of occupation or direction, or the kind of "free" time that can be filled with . . . whatever one wants to fill it with. For Aristotle and for us, while leisure does have a great deal to do with time, it is not defined that way. The Greek expression for "engaging in leisure" is *scholen agein*. The Greek word for leisure is the source of our word "school." Going to school—studying—was not something one did with one's "leisure time" (that would be nonsense, like saying that school is what one does with one's school time, or leisure is what one does with one's leisure time). Leisure was not empty time that might or might not be filled with a certain activity. It *was* an activity. What it was not was an "action," or a means to an end. It was an activity that was meaningful in itself.[8] This is what leisure, like life, was *for*.

We are often told, by colleagues as well as by students, that this is not "their idea" of leisure. Perhaps not, but then the very idea that what leisure is (or is for), is a personal matter, or choice, is indicative of something. If there is any truth in what Heidegger says about our technological way of thinking, it should come as no surprise that our idea of leisure is an empty one, that it has essentially *no* meaning apart from the meaning we give to it. It is whatever we choose to fill it with. But, if this is what leisure has become for us, then we no longer experience leisure in Aristotle's sense. We no longer experience what he thought happiness, or human fulfillment, ultimately depends upon. We busy ourselves for the sake of leisure, he says. We do what we do for the sake of something else—something we do for its own sake. To conceive of leisure as essentially inactive, to associate activity only with "business," would seem to rule out the possibility of a meaningful life. It would be like saying that we are awake so that we may have sleep, or that we live simply in order to die. Sleep is good, but there is (we hope) more to life than that.

Having leisure, then, is not just a matter of "making time" and filling it with walks, tea ceremonies, woodworking, or what have you. It is not just a "break" in the sort of time by which our lives are otherwise enframed.[9] As Heidegger suggests, we cannot just free ourselves from this enframing, or free up our time. Our time, and our lives, would still be every bit as "managed" as they were before. Leisure, as we have come to understand it, is "defined," or filled, with things that require a different sort of time, both to make and to see. By providing the occasion for contemplative seeing, these constitute the true source of leisure. They do this in virtue of the kind attention they demand from us—an attention that is both deep and enduring, regular and sustained. It is purity of focus; not an unfocused lack of occupation but a freedom from distraction. This kind of attention does not come naturally (except perhaps to young children). *It has to be cultivated.* The very things that call for it can help us to cultivate it as we "practice" seeing them. Such practice is thus self-perpetuating as well as self-fulfilling.[10]

This book is about our being, or becoming, better seers. But, it is also about there being (or not being) better things to see. At the forefront has been the idea of seeing "forms"—eternal or ideal forms—in the "particulars"—in Pieper's ocean waves, or Sloane's barn. We have talked about meeting God in the woods and in works of art, in something that, even if it is made by us, is not just our own doing. This is partly a matter of how we see things. But, as Plato and Thoreau both remind us, we need things—particular things—not just to provide the occasion for this kind of seeing, but to help us develop the capacity for it. To learn to see, with wondering eyes, we must practice. We need help and guidance with this, but then we also need things to practice with.

What does it mean to wonder? Heidegger's clearing can help to illuminate this. If we associate "the mystery" only with the darkness of the surrounding forest, we may be led to conceive of wonder as something negative. Heidegger helps us to picture wonder not simply as a lack of

knowledge, but as a genuine form of insight. He would not have us cut down the trees in order to make everything clear, for then nothing would be revealed (there would no longer be a clearing). This does not mean, however, that to wonder is simply to let the forest be. Wonder is not a passive attitude, any more than contemplative seeing is. It too is active, and must be actively practiced. To wonder is not to answer a question, figure something out, or solve a problem. But, it is not the same as not asking any questions at all. It is not a refusal to think. As Plato pictures it, only the prisoners who emerge from the cave are truly *able* to wonder. These are the ones who are being educated, who see more than those who remain behind, and ultimately see more clearly. They do not "explain" what they see. They are transformed in being dazzled by it.

<p style="text-align:center">★　★　★</p>

We hope that our own readers have learned to see the similarity between Plato's and Heidegger's images. Drawing nearer to the sun is like drawing nearer to the mystery. This is something one must learn to see (one's eyes must become habituated). In doing so, one is making real intellectual and moral progress. But, one is not making everything clear. On the contrary, it is only by leaving this desire and expectation behind—turning away from it as one turns away from the shadows on the wall of the cave—that one truly advances in seeing and in thinking. The prisoners who emerge from the cave understand more than those who remain behind because all the parts of their souls are reoriented. They now see what Aristotle's geometer sees in the diagonal of the square.

What the prisoners are looking at is something real. But then, we have to appreciate something else we may have forgotten: that wonder is not just a subjective response to things. It is not just something we do. For the Greeks, *things* are (or are not) "wonders." We may be able to see this, or we may fail to see it, but the "wonder" is something that stands before. "To wonder" is to be responsive to an object of experience, to something that could have been made by us but is not just made up by us. But then, wonder itself is not just up to us. We do not make the world wonderful, although we can make (and have made) it less wonderful by exhausting both it and ourselves.

The ancient idea of "a wonder to behold" is one that we want very much to recover. It would be easy to become pessimistic at (or about) this point. Even if we ourselves, our own natures, have not been entirely consumed by the "standing reserve" (even Heidegger resists saying that it is), almost everything else seems to have been. Technology itself may remind us that not everything is under our control, if we are willing and able to see the problem for what it is, and there may yet be something to wonder about here. But this realization, by itself, will not help us to recover the attitude of mortality. Nature and art may be our only hope, if hope there is.

Perhaps, then, we have little choice but to be nostalgic (literally, homesick, from the Greek *nostos-algos*). Or, perhaps, we could hope

for . . . nothing. This is not meant as a perverse statement; or maybe it is, in Thoreau's sense. For, as we have said, if our vision is exhausted, it is not because we have nothing to see. It is because we have too much to see, and to hear—too much to "process."

It is the "impalpable void," Heidegger suggests, that makes the jug and is made visible by the craftsman's art. This is not the emptiness of free time. It is, like the darkness from which the seed emerges, the substance of life itself. Technology may or may not furnish us with more free time. It certainly furnishes us with a superabundance (a standing reserve) of images. Aristotle said that a happy life is one that is "lacking in nothing." But then, there may be a disturbing sense in which our lives *are* lacking in nothing—a sense in which there is almost no nothing left (of the sort that makes the jug). How, then, are we to recover what we hope to recover? It may be as simple as this: we need more nothing. We need less noise, and we need less light. How could that be? Don't we need light to see? How could less light make us more enlightened? This is a philosophical problem, but it is not just a problem for abstract thought. For consider: is there anything you cannot see with the lights on? Is there anything we would be able to see better if we made less light?

Among the wonders that move us to philosophize, Aristotle cites "the phenomena of the moon and those of the sun and the stars."[11] Emerson's inquiry led him, and us, to "that science-baffling star" on which we all have to rely ultimately. Stars are but one thing, among many, that we need less light to see.

But, there is this further, and in our view, final hope in contemplative seeing as a model for thinking and especially for education. This book has issued from our own thinking and living. These have informed, and been informed by, our academic research. But, it has issued primarily from our teaching—not the conclusions we reached (and sought to pass on to our students), but the not infrequent experience of wondering just what we were doing. We have found ourselves returning, again and again, to Plato's claim that "education is the craft concerned with doing this very thing, this turning around, and with how the soul can most easily . . . be led to do it." What would it mean to take Plato seriously? This book has been an attempt to answer this question, to demonstrate as fully and as concretely as we can what such an education would involve and why it is so vital. As Plato describes it, this would be an education not just "about" art, but an education in and by art. It would, at the same time, be education in philosophy and in life. What it would mean to take this seriously is a question to which we hope our fellow educators might respond.

NOTES

Preface

1. There are exceptions, of course. For a notable example of a scholar who has passionately taken on Postmodernism's "crisis," see Spretnak, *States of Grace* and idem, *The Resurgence of the Real*.
2. Art historian Griselda Pollock has been revising the canon in art history for quite some time. She reviews the canon and surrounding issues in her *Differencing the Canon*.
3. We wish to acknowledge Brian Stock's important work in the area of "contemplative reading." See for instance his *Augustine the Reader* and *Augustine*. In this regard, also see Carruthers, *The Craft of Thought*.
4. A brief word here about the use of "we" and "our." Because of the dual authorship, both we and our will sometimes refer to the authors, and in some instances to the public at large, and from time to time to both. We hope that the context will make the meaning clear.

Introduction: What it Means to See

1. Pieper, *Only the Lover Sings*, p. 31.
2. Sloane, *Diary of an Early American Boy*, p. 40.
3. We are indebted for many of the points mentioned to Indra McEwen's fine book, *Socrates' Ancestor: An Essay in Architectural Beginnings*.
4. Heidegger, "Science and Reflection," in *The Question Concerning Technology*, p. 164.
5. Pieper, *Only the Lover Sings*, p. 23.
6. Dustin, "The Liturgy of Theory." Much of the discussion of *theōria* that appears here is adapted from this article.
7. Emerson, "Self-Reliance," in *The Selected Writings of Ralph Waldo Emerson*, p. 141.
8. Lewis, *An Experiment in Criticism*, pp. 140–41.

Chapter One Walking: Thoreau's Prepared Vision

1. Thoreau, "Walden," in *Walden and Civil Disobedience*, p. 204.
2. See Foster, *Thoreau's Country*.
3. See McKibben, *The End of Nature*.
4. Thoreau published only two books—*A Week on the Concord and Merrimack Rivers* and *Walden*. *Cape Cod* and *The Maine Woods* were each book-length collections of essays. His other writings consist entirely of essays, several of which were published posthumously, some only recently.
5. Thoreau, "Natural History of Massachusetts," in *Natural History Essays*, p. 29.
6. See Elder's "Introduction" to *Nature/Walking*, p. xiv. In his "Introduction" to Thoreau's *Natural History Essays*, Robert Sattelmeyer reminds us that much of Thoreau's life was actively devoted "to the acquisition of something approaching a professional competence as a naturalist. [Starting in the mid-1840s, he] began to botanize systematically, acquired a basic library of botanical guides, and

learned taxonomy. He corresponded with and collected specimens for Louis Agassiz of Harvard, America's leading scientist. He also knew the work of Asa Gray, Harvard's other eminent natural scientist . . . He made a study of limnology and of the fishes of Concord rivers and ponds. He read Kirby and Spence and others on insects, and struck up a professional acquaintance with Thaddeus Harris, a prominent entomologist and the librarian of Harvard College. He had been interested in ornithology since boyhood . . . and he compiled a large collection of birds' nests and eggs. In 1850 he was elected a corresponding member of the Boston Society of Natural History, to which he contributed specimens and various written accounts over the years, and whose library and collections he used regularly in pursuing his studies" (pp. xix–xx). Thoreau was even proposed for membership in the Association for the Advancement of Science in 1853, but did not apply, fearing that his vision of (what Sattelmeyer aptly terms) a "humane science" would not be understood, let alone shared, by his fellow naturalists.

7. Thoreau, "Natural History of Massachusetts," p. 28.
8. Thoreau, *Natural History Essays*, p. ix.
9. Pieper, *Only the Lover Sings*, pp. 33–34.
10. Pollan, *Second Nature*, p. 114. See also pp. 112, 128, and 135.
11. Thoreau, "Walking," in *Nature/Walking*, p. 115.
12. Pieper, *Only the Lover Sings*, p. 73.
13. Thoreau, "Walking," p. 72.
14. These are phrases John Elder uses to describe Thoreau's walking style. But they also seem to fit the nature of his writing, as well as the style of reading such writing calls for. See Elder's "Introduction" to *Nature/Walking*, pp. xiii, xiv.
15. Thoreau, "A Winter Walk," in *Natural History Essays*, pp. 51–52.
16. Pieper, *Only the Lover Sings*, p. 26.
17. Thoreau, "A Winter Walk," p. 55.
18. Thoreau, "Walking," p. 99.
19. In a similar way, "Walking"—Thoreau's epic hymn to this visionary questing—consistently stresses the *proximity* of village and forest.
20. Thoreau, "A Winter Walk," p. 61.
21. Thoreau, "Walking," pp. 78–79.
22. Thoreau, "A Winter Walk," p. 45.
23. Heidegger, "The Thing," in *Poetry, Language, Thought*, pp. 165–66.
24. See the wonderful children's book by Johnson, *Henry Hikes to Fitchburg*.
25. Pieper, *Only the Lover Sings*, pp. 74–75.
26. Thoreau, "Autumnal Tints," in *Natural History Essays*, pp. 173–74.
27. Of course, this is not true of any and all naturalists. Thoreau, after all, was a naturalist (as well as a poet), and there may well be others like him, even in academic departments.
28. Thoreau, "Walking," pp. 77, 81–82, 85.
29. Pieper, *Only the Lover Sings*, p. 34.
30. Thoreau, "Walking," p. 71.
31. Pieper, *Only the Lover Sings*, p. 23.
32. Thoreau, "Autumnal Tints," pp. 175–76.
33. Pieper, *Only the Lover Sings*, p. 25.
34. Pollan, *Second Nature*, p. 199.
35. Thoreau, "Walking," p. 122.

Chapter Two The Beatification of the Mundane

1. Okakura, *The Book of Tea*.
2. Schwartz, *The Paradox of Choice*.
3. The biographical material is taken from Elise Grilli's "Foreword" and "Biographical Sketch" in *The Book of Tea*, pp. ix–xvii and pp. 119–33.
4. Gallen-Kallela-Sirén, "Axel Gallen and the Constructed Nation: Art and Nationlism in Young Finland, 1880–1900," Ph.D. Diss. idem, "Akseli Gallen-Kallela and the Pursuit of New History and New Art: Inventing Finnish Art Nouveau," in *Now the Light Comes from the North*, pp. 42–50; and idem, "Akseli Gallen-Kallela et l'invention de la tradition," in *Visions du Nord*, pp. 31–35.

5. Okakura, *The Book of Tea*, p. 6.
6. de Waal in *Seeking God* makes a similar point in her lovely essay on Benedictine spirituality, showing us that it can be practiced day in and day out in the most ordinary activities, such as washing dishes or folding laundry.
7. Okakura, *The Book of Tea*, p. 52.
8. Carter, *Civility*.
9. Okakura, *The Book of Tea*, p. 113.
10. Lewis, *An Experiment in Criticism*, pp. 140–41.
11. Okakura, *The Book of Tea*, p. 78.

Chapter Three Turning the Soul Around

1. Plato, *Republic*, in *Plato: Complete Works*, 327a. All quotations from Plato are from this edition. Following standard practice, when citing Plato, we shall refer not to page numbers but to so-called Stephanus or line numbers. These are consistent throughout all editions and translations of Plato's works. For shorter quotations, these numbers appear in parentheses in the main body of our text.
2. As evidence of the care with which Plato crafted his words, we are told that he labored painstakingly over the very first sentence of the *Republic*, and that several versions (varying in their poetic form) were found among his tablets. Why should Plato have taken such care with a sentence that, from a "philosophical" point of view (i.e., in terms of the theoretical argument), seems insignificant? Why should variations in meter—how the words *sound*—have mattered so much to him?
3. The Thoreauvian portrait of Socrates is even clearer in Plato's *Phaedrus*, as we shall see in Chapter 4.
4. Plato, *Republic*, 328a.
5. The Greek work *dikaiosyne* has a broader meaning than our "justice." It encompasses the "right" (or what is right, as in "doing the right thing"), but is not limited to what is usually meant when we talk about "rights." It would be a mistake to translate it as the "morally good," because we tend to associate morality with a set of rules and the Greeks thought more in terms of virtues than of rules. "Ethical" is a better word, in this context, than "moral." The latter is derived from the Latin. "Ethical" is derived from the Greek *ethos*, meaning character or way of life. Justice, for Plato, is not synonymous with ethics but is central to it.
6. Plato, *Republic*, 343c.
7. Glaucon's thought-experiment could be extended in this way. We might imagine a ring-like device—a pill, say—that could make us invisible to ourselves, or at least enable us to disregard the opinions we have of ourselves by silencing our conscience (or superego) or eliminating all feelings of guilt. The question is not just how this would change us, or how differently we would act, but what it would reveal about us or what dimensions of our character would emerge. A further question is whether we would even dare to take such a pill, or whether our conscience would prohibit even this much. If the very thought of taking it made us feel guilty, that would already reveal something.
8. Plato, *Republic*, 366e, 367b.

Chapter Four Plato's Art

1. Plato, *Republic*, 443c–e.
2. Okakura, *The Book of Tea*, p. 110.
3. Greenberg makes the point in his 1939 essay, "Avant-Garde and Kitsch" that kitsch is dangerous precisely because it offers us impressions; it is, in his words, "pre-digested." It is dangerous because it requires no contemplation or reflection, just what is occasioned by avant-garde art. See Greenberg's *Art and Culture*, pp. 3–21.
4. Plato, *Republic*, 377b–c.
5. Carpenter, *The Esthetic Basis of Greek Art*, p. 107.
6. See Plato, *Phaedo*, 100d, and, e.g, *Republic*, 476d.
7. Paintings are also occasions for this kind of enactment. See Ziegler, "Practice Makes Reception: The Role of Contemplative Ritual in Approaching Art," in *Vocation and the Intellectual Life*, pp. 31–42; and Collins, *Twelve Views of Manet's Bar*.
8. We recall that the origin of our "rationality" lies in the Latin *ratio*.
9. See Lear, "Inside and Outside the *Republic*," pp. 184–215; and *Love and Its Place in Nature*.

10. Plato, *Republic*, 401a–d.
11. Okakura, *The Book of Tea*, p. 78.
12. Aristotle, *Metaphysics*, in *The Basic Works of Aristotle*, I.2, 982b10.
13. Plato, *Phaedrus*, 230b–c.
14. Plato, *Republic*, 500c.
15. Pieper, *Only the Lover Sings*, p. 23.
16. Plato, *Republic*, 402c.
17. Contributing to the strangeness is the suggestion that this is actually an image *of* an image. The cave is (in some sense) a "likeness" of the Good. But then, the dwelling that Socrates asks us to imagine is itself a likeness of a cave (he himself describes it as "cavelike").
18. Plato, *Republic*, 515c–d.

Chapter Five A Reverence for Wood

1. Sloane, *A Reverence for Wood*, p. 99.
2. Pieper, *Only the Lover Sings*, p. 31.
3. Sloane, *A Reverence for Wood*, p. 72.
4. Thus we may find that for a younger generation, e-mail and instant messaging provide a vital means of communication. Many find themselves very much at home with this, and may indeed have heart-to-heart conversations online, whereas sitting in a room together they are apt to respond to one another in monosyllables. From this, one might conclude that the technology makes possible a kind of communication that would not be possible otherwise (that on e-mail, for instance, there may be a candid, frank display of positive or negative feeling that is glossed over in person). We are grateful to Lisa Dunn for sharing this observation. In our view, while this may furnish evidence of a kind of communication that technology makes possible, it also furnishes evidence of what Pieper sees as our declining ability to communicate truly as human beings, face to face or physically "present" to one another.
5. Sloane, *American Yesterday*, p. 7.
6. Sloane, *A Reverence for Wood*, p. 72.
7. Sloane, *American Yesterday*, p. 20.
8. Sloane, *A Reverence for Wood* (Author's note).
9. Bachelard, *The Poetics of Space*.
10. Sloane, *A Reverence for Wood*, p. 41.
11. The connection between the life cycles of nature and our own did not escape another responsive eye—that of E.B. White—whose observations on it are written with characteristic incisiveness. But, in this instance, seasoned love has animated White's customary flair with heart-rending legibility. In the introduction to the 1979 edition of the late Katherine S. White's essays on garden catalogs— *Onward and Upward in the Garden*—her renowned husband recalls the annual fall planting of new bulbs: "As the years went by and age overtook her, there was something comical yet touching in her bedraggled appearance on this awesome occasion—the small, hunched-over figure, her studied absorption in the implausible notion that there would be yet another spring, oblivious to the ending of her own days, which she knew perfectly well was near at hand, sitting there with her detailed chart under those dark skies in the dying October, calmly plotting the resurrection."

Chapter Six Making *Kosmos* Visible

1. Plato, *Republic*, 500c–d.
2. Pieper, *Only the Lover Sings*, p. 22.
3. McEwen, *Socrates' Ancestor*, pp. 21–22.
4. Portions of the following discussion are drawn from Dustin, "The Liturgy of Theory."
5. McEwen, *Socrates' Ancestor*, p. 127.
6. See Heidegger, "The Question Concerning Technology," in *The Question Concerning Technology*, pp. 5–14, and McEwen, *Socrates' Ancestor*, pp. 41–125.
7. McEwen, *Socrates' Ancestor*, p. 47.
8. This is why Plato suggests that philosophers must study astronomy: "We should consider the decorations in the sky to be the most beautiful . . . of visible things," Socrates says, "seeing that they're embroidered on a visible surface" (*Republic*, 529c).

9. There is a sizeable body of literature dealing with the notion that art brings us "closer to God," for instance, Drury's excellent *Painting the Word* and MacGregor's *Seeing Salvation*. Michelangelo comes to mind here as the paradigm of the artistic genius, uniquely able to bring viewer (and artist) closer to God through art. In many ways, though, this view of the divinely inspired genius continues to prevent us from seeing that craft might promise a similar goal.

10. McEwen, *Socrates' Ancestor*, p. 51.

11. Heidegger, "The Question Concerning Technology," p. 9.

12. McEwen, *Socrates' Ancestor*, p. 72.

13. See Aristotle, *Nicomachean Ethics*, 1103a30.

14. Aristotle, *Metaphysics* I.2, 983a5.

15. See (hear) especially the work of Schroeder-Sheker, *Transitus*.

Chapter Seven Having Different Things to See

1. Pieper, *Only the Lover Sings*, p. 31.

2. Compare a painting by Nicolas Poussin, e.g., his *Massacre of the Innocents* (Chantilly: Musée Condé, 1632) with Quentin Tarantino's *Pulp Fiction*. It could be argued that both images are violent in their content and are, therefore, more similar than not. Important, though, is the fact that Poussin treats a scene of slaughter with such grace and power of line, such taut composition, that it becomes a scene not of bloodshed as much as of despair; it is sublime in forcing what is terrible to be governed by, indeed to be one with, what is beautiful. Tarantino's treatment, however "brilliant," remains far too literal for the bloodshed to transcend its "real" hold on the viewer.

3. Okakura, *The Book of Tea*, p. 3.

4. For a discussion of the title and translations, see Ziegler "Worringer's Theory of Transcendental Space in Gothic Architecture: A Medievalist's Perspective," in *Invisible Cathedrals*, pp. 104–18.

5. The idea presented throughout this book—that we "take in" forms and that form matters—stands quite apart from the methodology (or imprecise terminology) known to the discipline of art history as "formalism" with which it may be confused. In light of our treatment, we would urge that "formalism" be examined anew, not as mere empty form (due to treating it without respect to the production) but more about the ways that content lives and is embodied in particular ways in form itself (quite apart from context but very much affecting reception). See Summers, " 'Form,' Nineteenth-Century Physics, and the Problem of Art Historical Description," in *The Art of Art History*, pp. 127–42.

6. From *Dance as a Theatre Art*, Cohen, ed., pp. 135–36.

7. Tharp, in Cohen, p. 233.

Chapter Eight Thinking as Craft: Heidegger and the Challenge of Modern Technology

1. Pieper, *Only the Lover Sings*, p. 24.

2. Heidegger, "The Word of Nietzsche," in *The Question Concerning Technology*, p. 55.

3. Heidegger, Epilogue to "The Thing," p. 186.

4. If we are not simply presupposing what Heidegger himself thinks, there may still be the danger that we are reading more into his text than is actually there, when we experience it for ourselves. In another passage from "The Word of Nietzsche," Heidegger reflects on this problem: "Every exposition," he writes, "must of course not only draw upon the substance of the text; it must also, without presuming, imperceptibly give to the text something of its own substance. This part that is added is what the layman, judging on the basis of what he holds to be the content of the text, constantly perceives as a meaning read in, and with the right that he claims for himself criticizes as an arbitrary imposition [this is also true of some 'scholarly' readers]. Still, while a right elucidation never understands the text better than the author understood it, it does surely understand it differently. Yet this difference must be of such a kind as to touch upon the Same toward which the elucidated text is thinking" (p. 58). What Heidegger means by "the Same" is what we suggested earlier, in realizing the implications of thinking as following a path.

5. Heidegger, "The Question Concerning Technology," in *The Question Concerning Technology*, pp. 3–4.

6. Pollan, "An American Transplant," in *The New York Times Magazine* (Sunday May 16, 2004), pp. 72–75 deals with this in comparing gardening in New England with (his new experience of)

gardening in coastal California—that there are things in each locale that can or cannot be done, plants can or cannot be forced.

7. Heidegger, "The Question Concerning Technology," pp. 11–12.
8. Heidegger, "The Origin of the Work of Art," in *Poetry, Language, Thought*, p. 47.
9. In "The Origin of the Work of Art," Heidegger seems not to think so. Here, he draws a contrast between the work of the (fine) artist and the "fabrication" of equipment. In the latter case (the making of an ax, e.g.), he suggests that the wood and iron *are* "used up," that they "disappear into usefulness," and that "the material is all the better and more suitable the less it resists" this "perishing" (p. 46). Sloane would disagree, and so would we. Without venturing any further into the forest of Heidegger interpretation, the claim could be made that Heidegger himself seems to tell a rather different story in some of his later essays. This is certainly the case in "The Question Concerning Technology," where the broader meaning of *technē*, as encompassing both craft and the "fine" arts, is emphasized. In "Building, Dwelling, Thinking," and "The Thing," Heidegger also treats humbler artifacts—modest bridges and jugs—as occasions for revelation, and not just objects of use.
10. We are grateful to James Kee for sharing this idea with us.
11. Tattersall, *Becoming Human*.
12. Heidegger, "The Question Concerning Technology," pp. 14–15.
13. Soane, *A Reverence for Wood*, p. 72.
14. Heidegger, "The Thing," p. 169.
15. Heidegger, "The Question Concerning Technology," p. 16.
16. For a "fictional" look at this same problem, see Kingsolver's *Poisonwood Bible*.
17. Muir, *Reflections in Bullough's Pond*, pp. 248–49 (emphasis added).

Chapter Nine Dwelling

1. Heidegger, "Building, Dwelling, Thinking," in *Poetry, Language, Thought*, p. 151.
2. Heidegger, "The Question Concerning Technology," in *The Question Concerning Technology*, p. 16.
3. McKibben helps us to see this even more concretely in *The End of Nature*.
4. Heidegger, "The Question Concerning Technology," p. 17.
5. An advertisement for "iLife '04," from Apple, says "It's like Microsoft Office for the rest of your life." Who would have thought that human beings might ever want the rest of their life to be like their office?
6. Heidegger, "The Question Concerning Technology," p. 24.
7. This is the paradox that is slowly dawning (one hopes): total freedom and total "regulation," in the modern technological sense, go hand-in-hand.
8. Heidegger, "The Question Concerning Technology," pp. 25–26.
9. In his most recent book, *Enough: Staying Human in an Engineered Age*, McKibben goes even further to show that it is not just the nature "out there" that has become our own doing. It is also the nature "in here"—human nature itself has not only been remade, but made into something that is makeable by us.
10. Heidegger, "The Question Concerning Technology," pp. 26–27.
11. The contemporary cultural phenomenon of coveting thrills seems to go hand-in-hand with this.

Chapter Ten "Not diverse from things":
Emersonian Materialism

1. Heidegger, "Building, Dwelling, Thinking," in *Poetry, Language, Thought*, p. 151.
2. Heidegger, "The Question Concerning Technology," in *The Question Concerning Technology*, pp. 33–35.
3. Okakura, *The Book of Tea*, pp. 110 and 78.
4. Thoreau, "Autumnal Tints," in *Natural History Essays*, p. 174 (emphasis added).
5. Heidegger, "The Question Concerning Technology," pp. 26–27.
6. Motherwell, *Robert Motherwell and the New York School*.
7. See Cavell, *This New Yet Unapproachable America*; "Thinking of Emerson," and "An Emerson Mood," in *The Senses of Walden*.

8. Emerson, "Self-Reliance," in *The Selected Writings of Ralph Waldo Emerson*, p. 133.

9. Kant, "What is Enlightenment?," in *Foundations of the Metaphysics of Morals, and What is Enlightenment?*, pp. 85–86.

10. Emerson, "Self-Reliance," pp. 150–51.

11. John Elder ("Introduction" to *Nature/Walking*) sees a contrast between Thoreau, as a "walker," and Emerson, whom he describes as a "gazer." We see Emerson differently, as someone for whom the idea of making is vitally important. Thus, we believe Emerson's vision is as active as Thoreau's.

12. See Hale, *The Old Way of Seeing*, p. 171.

13. Heidegger, "Memorial Address," in *Discourse on Thinking*, p. 56; also quoted by Hale, *The Old Way of Seeing*, p. 165.

14. Emerson, "Self-Reliance," p. 151.

15. We owe this phrase to Hale, *The Old Way of Seeing*, p. 166.

16. Aristotle, *Metaphysics*, I.2, 983a15–20.

17. Heidegger, *The Question Concerning Technology*, p. 32.

18. Emerson, "Self-Reliance," p. 147.

Epilogue A Life Well Lived

1. Several of the following observations are inspired by Scully's incisive analysis of this painting, in *New World Visions of Household Gods & Sacred Places*, p. 46.

2. Aristotle, *Nicomachean Ethics*, I.7, 1097b15.

3. Aristotle, *Metaphysics*, I.2, 983a5.

4. Aristotle, *Nicomachean Ethics*, I.7, 1098a15.

5. Thoreau, "Walking," in *Nature/Walking,* p. 119.

6. Aristotle, *Nicomachean Ethics*, I.2, 1094a20.

7. Aristotle, *Metaphysics*, X.7, 1177b5.

8. See Pieper, *Only the Lover Sings*, pp. 15–27. Pieper points out that the German word *Ferien*, which is used to refer to "vacation time," literally means "festive time," or time that is designated for feast.

9. We find it interesting how many of our students (and our colleagues) refer to the holidays that punctuate the academic calendar as "breaks." Pieper is right. Linguistically, at least, we have forgotten how to celebrate a feast.

10. We are grateful to Lisa Dunn for helping us to articulate this very important point.

11. See Aristotle, *Metaphysics*, esp. I.2, 982b15.

BIBLIOGRAPHY

Aristotle. *Metaphysics and Nicomachean Ethics*. In *The Basic Works of Aristotle*. Edited by Richard McKeon. New York: Random House, 1941.

Bachelard, Gaston. *The Poetics of Space: The Classic Look at How We Experience Intimate Places*. Reprint, 1958; Boston, MA: Beacon Press, 1994.

Carpenter, Rhys. *The Esthetic Basis of Greek Art*. Bloomington, Indiana: Indiana University Press, 1959.

Carrier, David. *Artwriting*. Amherst, MA: The University of Massachusetts Press, 1987.

Carruthers, Mary. *The Craft of Thought: Meditation, Rhetoric, and the Making of Images, 400–1200*. Cambridge, U.K., New York: Cambridge University Press, 1998.

Carter, Stephen L. *Civility: Manners, Morals, and the Etiquette of Democracy*. New York: Basic Books, 1998.

Cavell, Stanley, *This New Yet Unapproachable America*. Chicago: University of Chicago Press, 1989.

 The Senses of Walden. San Francisco: North Point Press, 1972.

Cohen, Selma Jeanne, ed. *Dance as a Theater Art: Source Readings in Dance History from 1581 to the Present*. 1974, second edition; Pennington, NJ: A Dance Horizons Book, 1992.

Collins, Bradford, R., ed. *Twelve Views of Manet's Bar*. Princeton, NJ: Princeton University Press, 1996.

de Waal, Esther. *Seeking God: The Way of St. Benedict*. Collegeville, MN: The Liturgical Press, 1984.

Drury, John. *Painting the Word: Christian Pictures and Their Meaning*. New Haven and London: Yale University Press, 1999.

Dustin, Christopher A. "The Liturgy of Theory: Lessons on Beauty and Craft." *Colloquium: Music, Worship, Arts* 1 (September 2004).

Emerson, Ralph Waldo. *The Selected Writings of Ralph Waldo Emerson*. Edited by Brooks Atkinson. New York: The Modern Library, 1992.

Foster, David. *Thoreau's Country: Journey Through a Transformed Landscape*. Cambridge, MA: Harvard University Press, 1999.

Frost, Robert. *Collected Poems, Prose, and Plays*. Edited by R. Poirier and M. Richardson. New York: Library of America, 1995.

Gallen-Kallel-Sirén, Janne. "Axel Gallen and the Constructed Nation: Art and Nationalism in Young Finland, 1880–1900." Ph.D. diss, New York University, 2001.

 "Akseli Gallen-Kallela et l'invention de la tradition." In *Visions du Nord*. Edited by Suzanne Pagé. Exh.cat. Paris: Musée d'Art moderne de la Ville de Paris, 1998.

 "Akseli Gallen-Kallela and the Pursuit of New History and New Art: Inventing Finnish Art Nouveau." In *Now the Light Comes from the North: Art Nouveau in Finland*. Edited by Ingeborg Becker and Sigrid Melchior. Exh Cat. Berlin: Broehan-Museum, 2002.

Greenberg, Clement. *Art and Culture: Critical Essays*. Boston: Beacon Press, 1989.

Hale, Jonathan. *The Old Way of Seeing*. Boston: Houghton Mifflin, 1994.

Heidegger, Martin. *Discourse on Thinking*. Translated by John M. Anderson and E. Hans Freund. New York: Harper & Row, 1966.

—— *Poetry, Language, Thought*. Translated by Albert Hofstadter. New York: Harper & Row, 1971.

—— *The Question Concerning Technology*. Translated by William Lovitt. New York: Harper & Row, 1977.

Johnson, D.B. *Henry Hikes to Fitchburg*. Boston: Houghton Mifflin, 2000.

Kakuzo, Okakura. *The Book of Tea*. Rutland,VT and Tokyo, Japan:The Charles E.Tuttle Company, Inc., 1958.

Kant, Immanuel. In *Foundations of the Metaphysics of Morals, and What is Enlightenment?* Translated by Lewis White Beck. New York: Bobbs Merrill, 1959.

Kingsolver, Barbara. *Poisonwood Bible*. New York: Perennial, 1999.

Lear, Jonathan. *Love and its Place in Nature: A Philosophical Interpretation of Freudian Psychoanalysis*. New York: Farrar, Straus, & Giroux, 1990.

—— "Inside and Outside the Republic." *Phronesis* 37/no. 2, 1992.

Lewis, C.S. *An Experiment in Criticism*. 1961; Cambridge: Cambridge University Press, 2002.

MacGregor, Neil. *Seeing Salvation: Images of Christ in Art*. New Haven and London: Yale University Press, 2000.

McEwen, Indra Kagis. *Socrates' Ancestor: An Essay in Architectural Beginnings*. Cambridge, MA: Massachusetts Institute of Technology, 1993.

McKibben, Bill. *The End of Nature*. New York: Anchor, 1997.

—— *Enough: Staying Human in an Engineered Age*. New York: Henry Holt and Company, 2003.

Motherwell, Robert. *Robert Motherwell and the New York School: Storming the Citadel*. Directed by Catherine Tatge.Video, New York: International Cultural Programming, 1990.

Muir, Diana. *Reflections in Bullough's Pond: Economy and Ecosystem in New England*. Hanover and London: University Press of New England, 2000.

Pieper, Josef. *Only the Lover Sings: Art and Contemplation*. Translated by Lothar Krauth. San Francisco: Ignatius Press, 1990.

Plato. *Plato: Complete Works*. Edited by John M. Cooper. Indianapolis: Hackett Publishing Co., 1997.

Pollan, Michael. *The Botany of Desire: A Plant's-Eye View of the World*. New York: Random House, 2001.

—— *Second Nature: A Gardener's Education*. Reprint, New York: Grove Press, 2003.

—— "An American Transplant." *The New York Times Magazine*. Sunday, May 16, 2004.

Pollock, Griselda. *Differencing the Canon: Feminist Desire and the Writing of Art's Histories*. New York: Routledge, 1999.

Schroeder-Sheker,Therese. *Transitus: A Blessed Death in the Modern World*. Misssoula: St. Dunstan's Press, 2001.

Schwartz, Barry. *The Paradox of Choice: Why More is Less*. Ecco: Harper Collins, 2004.

Scully,Vincent. *New World Visions of Household Gods & Sacred Places: American Art 1650–1914*. Boston: Little, Brown and Co., 1988.

Sloane, Eric. *Diary of an Early American Boy: Noah Blake, 1805*. Reprint, 1965. New York: Ballantine Books, 1974.

—— *American Yesterday*. New York:Wilfred Funk, Inc., 1956.

—— *A Reverence for Wood*. Reprint, 1965. New York: Ballantine Books, 1973.

Spretnak, Charlene. *States of Grace: The Recovery of Meaning in the Postmodern Age*. New York: HarperCollins, 1991.

—— *The Resurgence of the Real: Body, Nature, and Place in a Hypermodern World*. New York: Routledge, 1997.

Stock, Brian. *Augustine the Reader: Meditation, Self-Knowledge, and Ethics of Interpretation*. Cambridge, MA: Harvard University Press, 1996.

—— *Augustine: The Meditative Reader and the Text (Material Texts)*. Philadelphia: University of Pennsylvania Press, 2001.

Summers, David. " 'Form', Nineteenth-Century Physics, and the Problem of Art Historical Description." In *The Art of Art History: A Critical Anthology*. Edited by Donald Preziosi. New York: Oxford University Press, 1999.

Tattersall, Ian. *Becoming Human: Evolution and Human Uniqueness*. New York: Harcourt Brace & Company, 1998.

Thoreau, Henry David. *Walden and Civil Disobedience*. Edited by Owen Thomas. New York: WW Norton, 1966.

—— *Natural History Essays*. Edited by Robert Sattelmeyer. Salt Lake City: Gibbs-Smith, 1980.

—— *Nature/Walking*. Edited by John Elder. Boston: Beacon Press, 1991.

White, Katherine S. *Onward and Upward in the Garden*. Edited by E.B.White. New York: Farrar, Straus, Giroux, 1979.

Ziegler, Joanna E. "Worringer's Theory of Transcendental Space in Gothic Architecture: A Medievalist's Perspective." In *Invisible Cathedrals: The Expressionist Art History of Wilhelm Worringer*. Edited by Neil Donahue. University Park, PA: Penn State Press, 1995.

—— "Practice Makes Reception: The Role of Contemplative Ritual in Approaching Art," in *Vocation and the Intellectual Life*. Edited by Tom Landy. Franklin, WI: Sheed & Ward, 2001.

INDEX